FRANCIS SULTANA

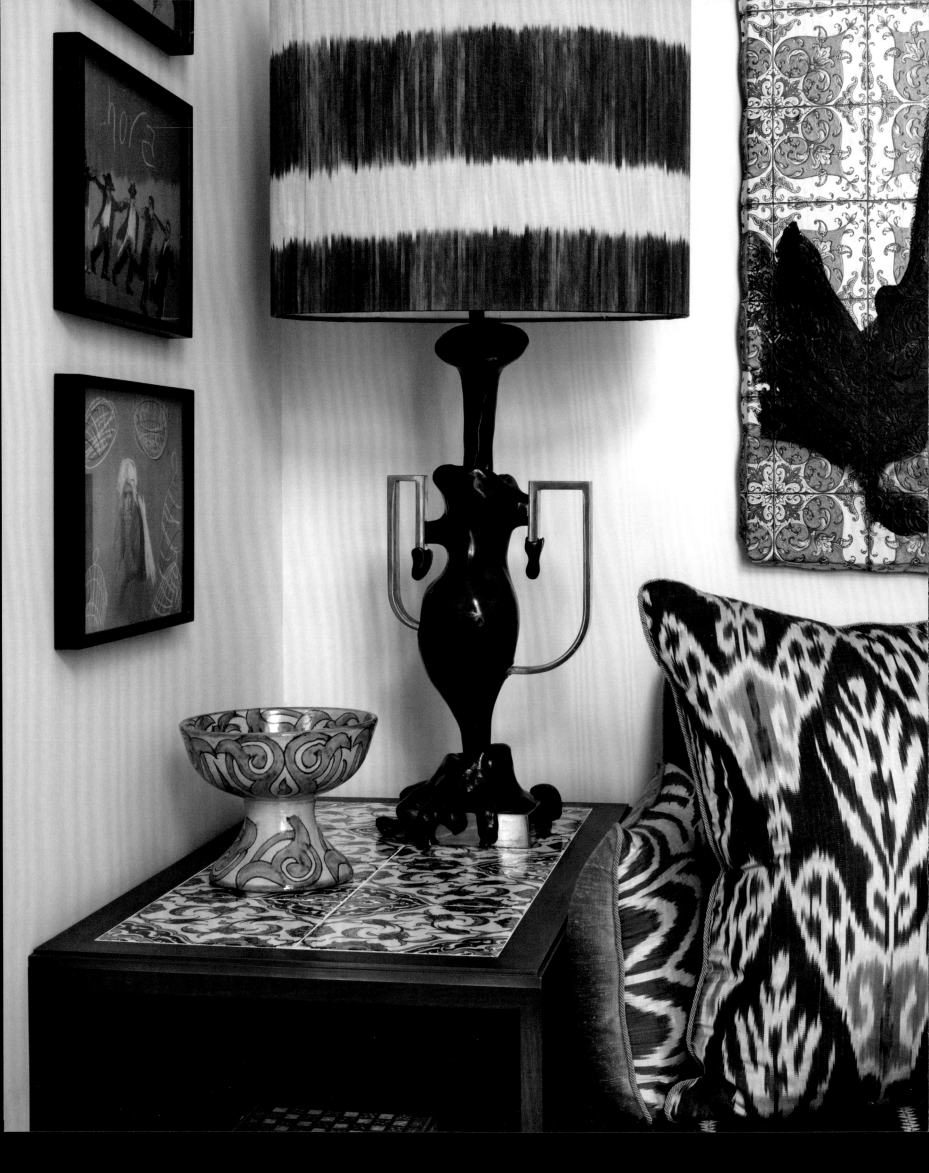

FRANCIS SULTANA

Designs & Interiors

EDITED BY
BRONWYN COSGRAVE

VENDOME

FOREWORD

Yana Peel

I met Francis Sultana over a decade ago, after I had embarked on renovating a historic London property which had been uninhabited for 50 years. The restoration process was daunting and so I sought the advice of a neighbor, who happens to be a renowned collector of art and design. She is also known for her bold choices. After pleading my case, she responded briskly: "You must meet a boy on the Fulham Road."

Promptly I visited that "boy." He happened to be a thirtysomething Francis, who was then operating the David Gill Gallery at its original headquarters on Fulham Road in Chelsea, London. The result of our first meeting was an inspiring creative collaboration on my home as well as a lasting friendship.

Amidst it all, Francis and I have spent countless hours poring over books, and after years of planning, Francis now has a book illuminating his own near-lifelong pursuit of interior design.

"Books do furnish a room," the British novelist, Anthony Powell has written. The well-thumbed tomes lining the shelves in Francis's office and his homes, testify to his belief in mining the past to inform the future as well as his commitment to his craft. Books, which are invaluable to Francis, feed his inventiveness. Poring over books—and hunting them down—are among his greatest pleasures. Just recently, he called me in a state of rapture to tell me that he had finally found a rare book featuring 500 black-and-white prints documenting the genius of the Cuban-Irish architect and designer Emilio Terry. Francis had been patiently trying to find it for 27 years!

So much of the spirit of Francis's work comes down to his talent for bringing out the best in his collaborators. Just like those great designers whose legacy he channels—Jean-Michel Frank, Jean Royère and Émile-Jacques Ruhlmann—he truly enables his co-creators to go further than they could do so on their own. And as so beautifully represented on these pages, his collaborations with artistic visionaries such as Barnaby Barford, Mattia Bonetti, Michele Oka Doner, and Jorge Pardo, among others, bring both light and heat to the meaning of living in our modern times.

"We cannot predict the future, but we can invent it," the British-Hungarian physicist Dennis Gabor once said. Francis does exactly this by integrating fragments from the past into his designs. This is seemingly motivated by his personal history, which began on Gozo, a tiny island of the Maltese archipelago in the Mediterranean that has been influenced over the centuries by its varied inhabitants, including Phoenicians, Romans, Arabs, Sicilians, the French, and the British. A place of itinerant populations, Gozo, and the island of Malta itself, has always inspired Francis's artistry.

Valletta's magnificent 16th-century Roman Catholic church, Saint John's Co-Cathedral, is beautified by Caravaggio's *The Beheading of St John the Baptist*, and it is considered one of Europe's finest examples of high Baroque architecture. It appears in this book because it has always served as a pilgrimage point to Francis and draws a trajectory that is manifested in his nearby home. A six-story limestone edifice, it was built in the 15th century for Francesco de Torres, a member of the medieval Catholic military order, the Knights of St John. A symphony of contemporary art and design, the palazzo juxtaposes the ancient and the modern, in Francis's signature style.

A group of Francis's friends had the tremendous privilege of celebrating his 2018 appointment as the country's Ambassador of Culture by Malta's Prime Minister, Joseph Muscat. The event took place in Valletta, coinciding with the concept launch of the Malta International Contemporary Art Space (MICAS). With the institution's chairperson, Phyllis Muscat, Francis is helping to realize MICAS as the leading platform for visual arts emanating from Malta and its surrounding Euro-Mediterranean region.

Now, as I fondly reflect on being introduced to that "boy," and the way Francis has inspired me ever since, I see a man who is an accomplished designer, a cultural figure, and a dear friend whom I admire completely.

P2: Mattia Bonetti's "Merveilleuse" patinated bronze table lamp, 2012, between three pastels to the left and "Lufthansa" oil on linoleum, 1991, to the right, all by Aldo Mondino. **P4:** "Spencer" occasional table from the Francis Sultana collection, autumn 2019, on Albany Carpet designed by Mattia Bonetti, 2019. **OPPOSITE:** Francis in the kitchen at Albany, seen from the dining room. Beside the door is Mattia Bonetti's gilded metal and bronze metal mesh "Torchère", 2018.

INTRODUCTION
Bronwyn Cosgrave

This book explores the private homes and furniture collections conceived by Francis Sultana and is published to commemorate the 10th anniversary of his eponymous London interior design studio.

Over the last decade as Francis has toiled, his daring interiors and inimitable designs have been consistently recognized by *Architectural Digest*. Since 2016, he has ranked on the AD100. This annual list is published by the magazine's U.S. edition featuring 100 of the world's finest architects and designers. In 2018, Malta's Prime Minister, Joseph Muscat, appointed Francis to be one of the country's two Ambassadors of Culture. This honor recognizes Francis's work returning his homeland to the 2017 Venice Biennale as well as his ongoing quest to establish the Malta International Contemporary Art Space (MICAS). Francis is a board member of this museum, which, when it opens in 2022, will prove to be the leading institution showcasing visual arts from Malta as well as its surrounding Euro-Mediterranean region.

I met Francis and his partner, David Gill, in July 2002, in Hydra, Greece where we traveled for the opening of a Hydra Workshop exhibition. It was seven years before Francis launched his practice and, at the time, he was about four years into his tenure as the creative director of the David Gill Gallery. David's London gallery is renowned for its work at the forefront of contemporary art and design. The objects and furniture produced by his stable of innovative decorative artists are found in the collections of some of the world's greatest museums because they are landmarks in their field.

I had known about David Gill since I had moved to London in 1992, mostly because his work creating avant-garde furniture with contemporary artists was unprecedented

and his gallery had also revived important designers. So while I was pleased to finally encounter the legend—at an Athens Airport luggage carrousel—Francis and I hung out the whole time on that memorable trip. When we were not swimming, eating or strolling around on Hydra, Francis was sketching. His beautiful, detailed and whimsical handiwork captivated me and, ultimately, his drawings proved to be the blueprints of the masterly furniture he produces today. The night before we left Hydra, he suggested an early morning swim at a remote location. Promptly at dawn the next day, he knocked on my hotel door and we set off.

I often shadowed Francis while he was at work. So, on our way to lunch in Venice, he'd spontaneously divert down a backstreet to visit a historic workshop and check in on an ongoing project. We went to the inaugural Basel Miami as well as the first iterations of the Frieze Art Fair and the Pavilion of Art & Design. I visited his Gozo home, met his kind, loving mother, Maria, and went on some madcap beach expeditions. All the while, even though we were always having fun, I was receiving a superlative design education from Francis. Curating a David Gill Gallery exhibition and writing catalogues for Francis, I discovered some of the qualities that might explain his talent and success. Francis is an innately gifted designer. His generous spirit, open-minded outlook and disciplined work ethic seem to allow him to effortlessly and cohesively channel the disparate influences that fuel his design process.

Francis is noted in his field for his technical design abilities, including his perception of scale and proportion. He has an extraordinary flair for interpreting color, which is comparable to some of fashion's great designers. His ability to channel history is acute so it just comes off casually. Then

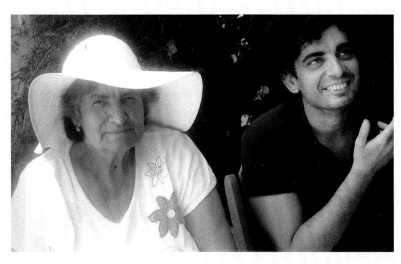

P8: Francis photographed on the stairwell at Palazzo de Torres. Suspended above is the light installation *My Madinah*. *In Pursuit of My Ermitage*, Jason Rhoades, 2004. **ABOVE:** Francis and his mother, Maria, at his family home in Gozo in 2001. **OPPOSITE:** Francis photographed with David Gill in the "Blue Drawing Room," Albany, London, 2017.

THERE IS HIS INSPIRING DRIVE. I'VE OFTEN RECEIVED PHONE CALLS FROM FRANCIS ANNOUNCING A CHANGE OF ADDRESS (HOME AND WORK), AND IN MERELY WEEKS HE HAD MASTERMINDED AN OTHERWORLDLY ENVIRON.

WHILE DAVID AND FRANCIS BECAME MY MENTORS, THEY ALSO ARE MY FRIENDS AND, AS A CLOSE COMRADE, I WATCHED FRANCIS BUILD ON HIS TALENT AND DEPLOY HIS EXPERTISE TO CREATE HIS INVENTIVE PRACTICE. THIS BOOK TRACES ITS GENESIS AND HIS EVOLUTION AS AN INTERNATIONALLY RECOGNIZED DESIGNER OF FURNITURE AND INTERIORS. IN "MALTA," BRITISH *VOGUE*'S STYLE EDITOR, GIANLUCA LONGO, TRACES THE BEGINNING OF FRANCIS'S CAREER TO HIS CHILDHOOD, GROWING UP IN NADUR. HE ALSO INVESTIGATES THE CRAFT AND CREATIVE PROCESS INVOLVED IN THE RESTORATION OF FRANCIS AND DAVID'S VALLETTA ABODE—THE SIX-STORY LIMESTONE PALAZZO DE TORRES (WHICH WAS BUILT IN THE 16TH CENTURY FOR FRANCESCO DE TORRES, A MEMBER OF THE MEDIEVAL CATHOLIC MILITARY ORDER FOUNDED BY THE KNIGHTS OF ST. JOHN HOSPITALLER). IN

"INSPIRATIONS," DESIGN EXPERT BROOK MASON ARGUES THAT FRANCIS'S SKILL RELIES ON HIS ABILITY TO INTERPRET ART DECO IN A CONTEMPORARY MANNER. ALL THE WHILE A MEDITERRANEAN FLAMBOYANCE—EVOKED BY HIS FEARLESS COLOR SENSE OR HIS ENTHUSIASM FOR GENEROUS PROPORTIONS—GUIDES HIS HAND.

FRANCIS SULTANA'S WORLD IS A RAREFIED PLACE. "PROJECTS" PORTRAYS THE SUMPTUOUS DOMESTIC SPACES THAT FRANCIS HAS CONCEIVED FOR PHILANTHROPISTS AND BUSINESS TITANS TO MAKE THE MOST OF THEIR SURROUNDINGS AS WELL AS THEIR CONTEMPORARY ART AND DESIGN HOLDINGS. FOR "LONDON," I HAD THE PLEASURE OF CHARTING FRANCIS'S HOMES AT ALBANY. THIS IS THE FIRST APARTMENT COMPLEX BUILT IN LONDON—AND ONE OF ITS FINEST ADDRESSES. AND IN "THE FIRST SET" I REVISIT FRANCIS'S ORIGINAL ALBANY HOME—A SET (AS ALBANY'S QUARTERS ARE KNOWN). "THE DOUBLE SET" DISPLAYS THE EXPANSIVE HOME IN WHICH FRANCIS AND DAVID NOW RESIDE WITHIN ALBANY'S "MANSION."

THIS STATELY RED BRICK AND STONE BUILDING WAS CONSTRUCTED BY SIR WILLIAM CHAMBERS IN 1771. ONE OF THE LEADING PALLADIAN ARCHITECTS OF HIS DAY, CHAMBERS SERVED AS TUTOR AND ARCHITECT TO GEORGE III. HE CONCEIVED ALBANY AS A MAJESTIC PALACE. IN TIME, IT WAS GUTTED, EXTENDED AND DIVIDED INTO APARTMENTS, AFTER WHICH CHAMBERS'S BUILDING BECAME KNOWN AS ALBANY'S "MANSION." FRANCIS AND DAVID'S APARTMENT WITHIN THIS FORMER PALACE INCLUDES ITS ORIGINAL STATE DRESSING ROOM. LOOMING ABOVE IT IS ALBANY'S "ONLY SURVIVING WILLIAM CHAMBERS-DESIGNED CEILING," WHICH INSPIRED FRANCIS'S DRAWING ROOM DESIGN. I REVEAL THE STORY OF THE YEARS OF PAINSTAKING RESTORATION WORK, WHICH HE CONDUCTED WITH A SPECIALIST TEAM OF 30. SIMILAR TO THE REST OF FRANCIS'S HANDIWORK, THIS ALBANY DREAM HOME IS TRULY ONE-OF-A-KIND.

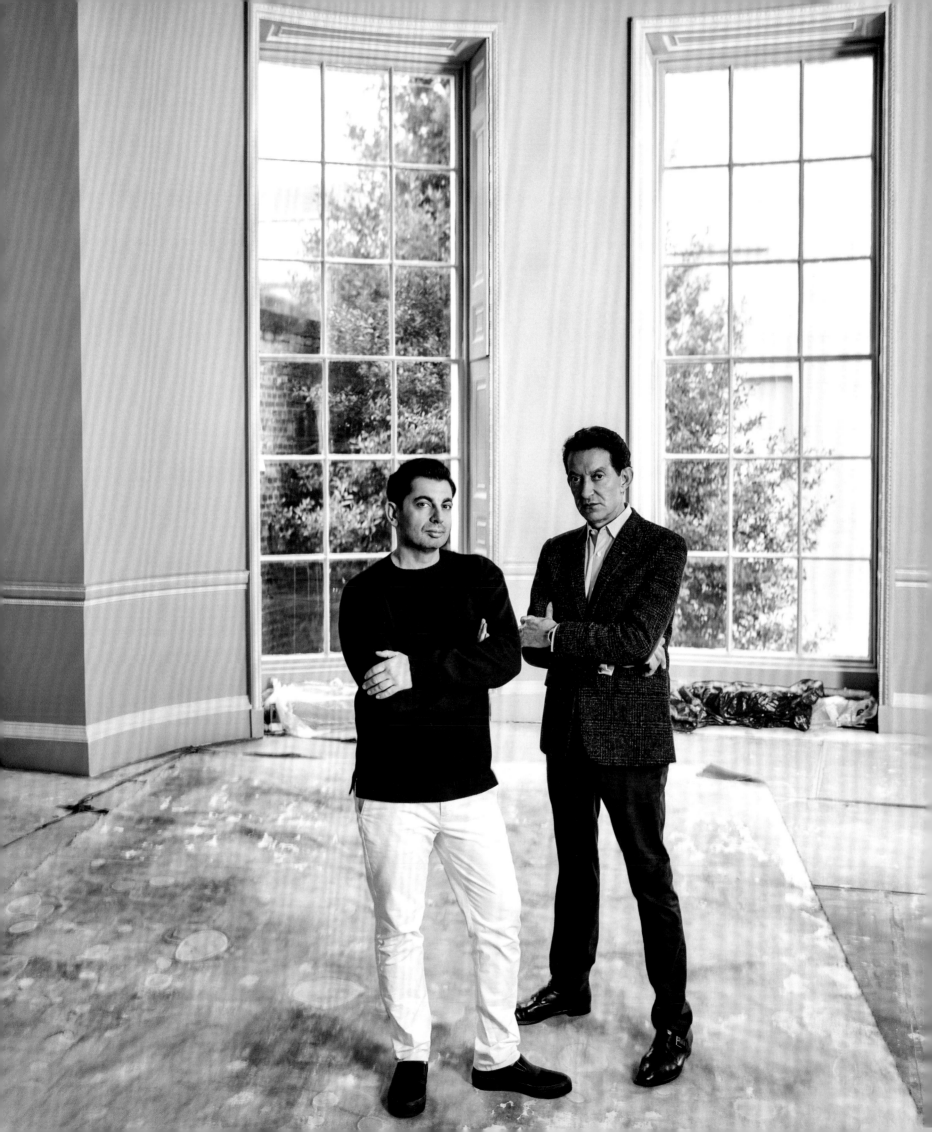

MALTA

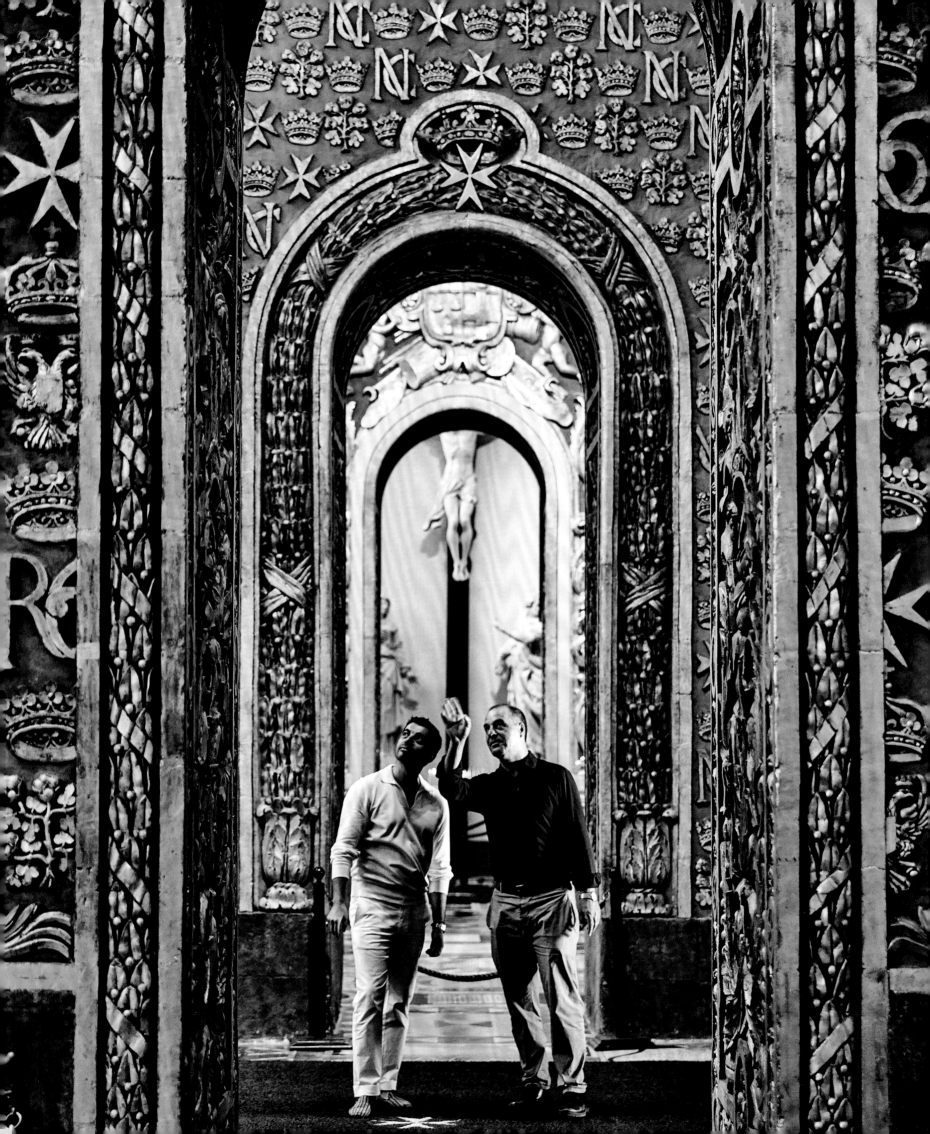

MALTA
Gianluca Longo

As a child growing up in Nadur, a tiny village on the Maltese island of Gozo, Francis Sultana would gaze out his bedroom windows and dream of living in a bigger world. Today he often points out, proudly, that "Nadur" means "to see" in the language of the Phoenicians, the ancient Mediterranean civilization that occupied Malta circa 750 BC. But Francis's real window to the world that he would eventually inhabit were the magazines that he devoured in his teenage years, such as *House & Garden*, *Vogue Living*, and *World of Interiors*. Although these decorating bibles always arrived on the isolated archipelago of Malta a few months after their original publication date, he never missed an issue.

In design magazines Francis discovered his craft. As a teenager he learnt about the French artist duo Les Lalannes, as well as Garouste & Bonetti. By the time he was 17, and dreaming of living in London, he was well versed in the decorative arts. He wanted to be part of the design world, and while he needed to escape his homeland to do so, Francis has never left Malta behind.

Recalling his teenage years there in the Eighties, he often romantically compares the austerity he experienced to Cuba's Havana. There was rationing, and Francis always laughs as he recalls that frequent power cuts often dispensed with the airing of *Dynasty*. Back then, Malta was a socialist country. Its Labour Party had ruled since 1971, and four years later, when the country became a republic, the government initiated socialist-style nationalization programs. Francis, being a very bright student, was sent to a special school for high achievers. By 16, he was ready for university. But he refused to enroll in the University of Malta's faculty of architecture and urban design, although these subjects were closest to interior design. He was still dreaming of London. And although he was unaware of it then, his decorative aesthetic was taking shape.

The culture of Malta is reflected in a mixture of Arab and Italian traditions. The Italian painter, Caravaggio, and Dun Karm, the Maltese priest and poet, are considered its chief cultural forces. Mattia Preti, the Italian artist, spent several years in Malta and devoted his time to religious artwork. He conceived altarpieces for several parish churches. His masterwork is the monolithic series of ceiling paintings illuminating the life and martyrdom of St. John the Baptist. These adorn the vaulted ceilings at Saint John's Co-Cathedral. The baroque style of Valletta's co-cathedral, which is dedicated to John the Baptist, along with its gilded brocades and crystal chandeliers, evokes the grandeur of Sicily and Southern Spain. It has always proved to be an inspirational pilgrimage point for Francis.

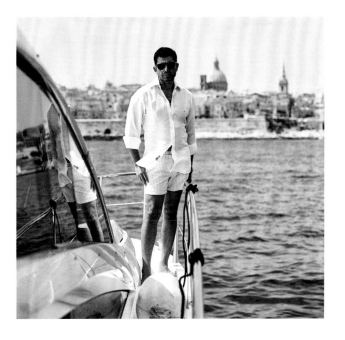

OPPOSITE: Valletta's richly gilded 16th-century Roman Catholic church, St John's Co-Cathedral, has always been a pilgrimage point for Francis, who is seen here with the Reverend Father Charles Vella. **ABOVE:** Francis aboard a yacht with Valletta in the background.

THERE ARE ALSO UNIQUE NEOLITHIC RUINS IN MALTA, AND IMPORTANT EXAMPLES OF 17TH AND 18TH CENTURY ARCHITECTURAL SCHOOLS, MOSTLY CLASSICAL WITH A BALANCED OVERLAY OF BAROQUE DECORATION. INFLUENCE ALSO EXTENDS FROM THE COUNTRY'S HISTORY OF FOREIGN DOMINATION AS WELL AS ITS FOLK TRADITIONS. THE ANNUAL SUMMER "FESTAS," FOR EXAMPLE, CELEBRATE THE PATRON SAINTS OF MALTA'S VILLAGES WITH COLOURFUL PROCESSIONS AND FIREWORKS.

IN THE 20TH CENTURY, MANY MALTESE ARTISTS AND SCHOLARS ENRICHED THE COUNTRY'S CULTURAL HERITAGE IN THE FIELDS OF ARCHITECTURE, MUSIC, PAINTING, SCULPTURE, LITERATURE, AND THEATRE. AN OBVIOUS EXAMPLE IS THE VERNACULAR ARCHITECTURE DEVELOPED BY THE EMINENT ISLANDER RICHARD ENGLAND. HIS DESIGN PHILOSOPHY IS BASED ON IDEAS THAT FRANCIS WOULD EVENTUALLY APPLY TO HIS WORK. ENGLAND, FOR EXAMPLE, BELIEVES IN "EVOLUTION AS OPPOSED TO REVOLUTION," AND MAINTAINS "ARCHITECTURE SHOULD BE APPROPRIATE TO BOTH PLACE AND TIME AND THAT IT SHOULD EVOKE THE SPIRIT OF THE PLACE."

FRANCIS INTERPRETS CONTEMPORARY DESIGN WITH A CLASSICIST'S HAND, WHICH LENDS A TIMELESSNESS TO HIS WORK. HE HAS ALSO DESCRIBED HIMSELF AS AN ART DIRECTOR, RATHER THAN AN INTERIOR DESIGNER WHO IMPOSES A PARTICULAR STYLE. TODAY, HIS SIGNATURE IS TO MIX THE ANTIQUE WITH THE CONTEMPORARY, AS WELL AS BESPOKE COMMISSIONED DESIGNS. THE SKILL OF EXECUTING THESE LATTER ELEMENTS OF HIS OEUVRE DEVELOPED AFTER FRANCIS, AT AGE 20, MOVED

TO LONDON. THERE, HE MET DAVID GILL AND ROSE FROM ART DIRECTOR TO CEO OF DAVID'S GALLERY, WHICH IS WORLD RENOWNED FOR SHOWCASING GROUNDBREAKING CONTEMPORARY FURNITURE.

LOOKING BACK ON HIS EARLY YEARS WITH DAVID, FRANCIS CLAIMS A TURNING POINT IN HIS OWN PERSONAL DESIGN CAREER HAPPENED WHEN MADONNA STOPPED BY THE GALLERY IN 2002. THE PERFORMER WAS PREPARING HER STARRING ROLE IN THE 2002 WEST END PRODUCTION OF *UP FOR GRABS*. THE DAVID WILLIAMSON PLAY EXPLORED THE INTERNATIONAL ART WORLD, WHICH WAS BOOMING, AND LONDON WAS ITS CENTER.

BY THEN, FRANCIS HAD SPENT OVER A DECADE HONING HIS CRAFT BY SUPPORTING DAVID AS HE WORKED WITH A TIGHT-KNIT CIRCLE OF ARTISTS AND COLLECTORS. MEETING THESE CREATIVE FIGURES, STUDYING AUCTION CATALOGUES, VISITING THE V&A AS WELL AS BEAUTIFULLY DECORATED HOUSES HAD PROVED AN EDUCATION. FRANCIS DISCOVERED EDWARD JAMES, BRITAIN'S GREATEST SURREALIST COLLECTOR AS WELL AS HIS WEST SUSSEX HOME, WEST DEAN. EMILIO TERRY, THE CUBAN IRISH ARCHITECT, ARTIST, INTERIOR DECORATOR, AND LANDSCAPE DESIGNER, PROVED A SOURCE OF INSPIRATION FOR THE STYLE OF CREATIVE PROFESSIONAL FRANCIS ASPIRED TO BE.

BUT IT WAS STEPHEN TENNANT WHOM FRANCIS AND MADONNA DISCUSSED. FRANCIS HAD JUST FINISHED PHILIP HOARE'S BIOGRAPHY OF THE "BRIGHTEST OF THE BRIGHT YOUNG PEOPLE," REFERRING TO THE DECADENT FIGUREHEAD OF THE ARISTOCRATIC BOHEMIANS WHO POPULATED BRITISH HIGH SOCIETY IN THE 1920S. MADONNA, SEEMINGLY CHARMED BY THE EXCHANGE, ASKED FRANCIS TO SELECT ALL OF THE FURNITURE FOR THE *UP FOR GRABS* STAGE SET .

FROM THEN ON, FRANCIS FILLED HIS COLLECTION OF ORANGE LEATHER-BOUND HERMÈS NOTEBOOKS WITH HUNDREDS OF DRAWINGS OF FURNITURE AND FANCIFUL DESIGNS. HIS VISUAL MEMORY OF MALTA

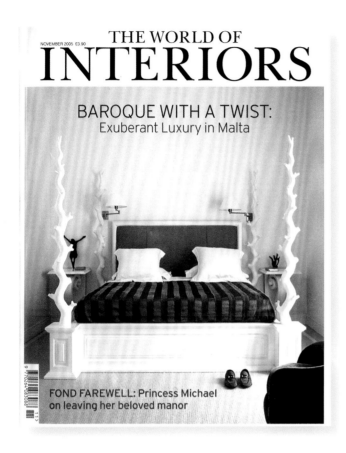

FUELED HIS CREATIVE PROCESS. EVIDENCE OF THIS WAS THE STAMP OF THE MALTESE CROSS WITH WHICH HE BEGAN TO MARK HIS APPROVED SKETCHES. THIS CROSS, WITH ARMS OF EQUAL LENGTH THAT STRETCH OUT FROM THE CENTER AND HAVE THEIR ENDS INDENTED IN A SHALLOW V-SHAPE, HAS BEEN ASSOCIATED WITH THE ORDER OF ST. JOHN AND THE SOVEREIGN MILITARY ORDER OF MALTA SINCE THE 16TH CENTURY.

NEXT CAME WORK ON HIS CHILDHOOD HOME IN NADUR. RESTORING THIS HOUSE, WHICH FRANCIS'S LATE MOTHER, MARIA, HAD BUILT AS THEIR FAMILY HOME IN 1981, WAS A LABOR OF LOVE. HIS INSPIRATION FOCUSED ON ICONIC DWELLINGS THAT HE REVERES, LIKE STEPHEN TENNANT'S WILSFORD MANOR. HE ALSO ENLISTED ARTISTS, WITH WHOM HE HAD FORGED CLOSE BONDS WHILE WORKING AT DAVID GILL, TO INTERPRET THE CHARACTER OF HIS HOMELAND. SO AMIDST GILDED SCREENS AND HEAVING CHANDELIERS, HE HUNG WORKS BY THE ARGENTINE ARTIST VICTOR HUGO "GRILLO" DEMO, INCLUDING A WHITE ROSE MALTA EXECUTED ON A STRETCH OF ANTIQUE B K VELVET. THE MYTH OF CALYPSO—THE NYMF WHO ALLEGEDLY ENSNARED ODYSSEUS ON THE ISLAND OF GOZO— INFORMED A MASSIVE GILDED BUST BY THE CERAMIC ARTIST ORIEL HARWOOD. IT TOWERED OVER THE OUTDOOR SWIMMING POOL.

WITH SPIRALING MINARETS THAT HARWOOD CRAFTED FROM RESIN—TO RECALL THE CORAL WASHING ASHORE GOZO'S RUGGED BEACHES— FRANCIS PRODUCED A FOUR-POSTER BED. IT BECAME FAMOUS WHEN *WORLD OF INTERIORS* SPLASHED THE DESIGN ACROSS THE COVER OF THE NOVEMBER 2005 ISSUE, WHICH FEATURED A TEN-PAGE STORY ON THE GOZO HOUSE.

MEANWHILE, BIG PROJECTS—LIKE THE SPRAWLING HYDE PARK, LONDON, HOME THAT FRANCIS DESIGNED FOR HIS FRIENDS, STEVEN AND YANA PEEL—CAME ALONG. NEXT WAS FRANCIS SULTANA EDITIONS. THE ARRESTING BEAUTY OF THIS FURNITURE COLLECTION, WHICH FRANCIS RENEWS ANNUALLY, IS A

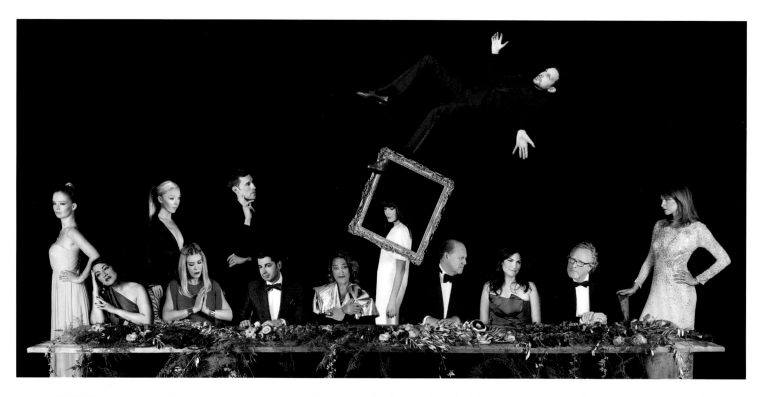

ABOVE: Francis was one of several noted society figures invited to pose for photographer Alistair Morrison's *Last Supper*, in aid of the charity Art Gala fundraising event held by the National Society for the Prevention of Cruelty to Children (NSPCC) in London in 2015.

RESULT OF HIS CLEVER MIX OF THIRTIES ART DECO REFERENCES WITH A NEO BAROQUE FLAIR EMPHASIZED BY BOLD MEDITERRANEAN COLORS AND BESPOKE MATERIALS THAT OFTEN HAVE A TEXTURAL QUALITY EVOKING MALTA'S RUGGED VEGETATION.

VALLETTA, HOWEVER, EVENTUALLY BECKONED FRANCIS AWAY FROM GOZO. AFTER VISITING MALTA'S CAPITAL IN 1830, BRITISH STATESMAN AND NOVELIST BENJAMIN DISRAELI DESCRIBED IT AS "A CITY OF PALACES BUILT BY GENTLEMEN FOR GENTLEMEN." WITH THAT IN MIND, FRANCIS AND DAVID ACQUIRED THEIR OWN VALLETTA PALACE. SITUATED IN A NARROW STREET AMIDST THE CAPITAL'S BUSTLING CENTER, THE GRAND-SCALE HOME WAS ORIGINALLY THE RESIDENCE OF A MEMBER OF THE MEDIEVAL CATHOLIC MILITARY ORDER THE KNIGHTS OF MALTA.

GROWING UP IN MALTA, FRANCIS WAS ALWAYS STRUCK BY THE STYLE OF VALLETTA'S PALACES WITH THEIR WONDERFUL LIMESTONE FACADES AND VERDANT BALCONIES. HE HAS ALSO ALWAYS ADMIRED THE CONCENTRATION OF SO MANY POWERFUL VISUAL ELEMENTS IN SUCH A SMALL PLACE. (MALTA, WHICH IS APPROXIMATELY 316 SQUARE KILOMETERS, IS CLOSE TO BRITAIN'S ISLE OF WIGHT IN TERMS OF SIZE). FROM A STREET CORNER WITH STATUES OF ANGELS AND SAINTS, TO A CARVED PINEAPPLE EMBELLISHING A BUILDING TOP, TO THE SWIRLING COLUMNS OF A DOOR FRAME, AND, OF COURSE, THE EXAGGERATED GILDED CHURCHES, FRANCIS LOVES THE MASH-UP COMPRISING MALTA'S DECORATIVE SPLENDOR. AND HE INFUSED HIS PALAZZO WITH A RAREFIED INTERPRETATION OF THAT ECLECTICISM. BECAUSE THE ORIGINAL CARVED MARBLED ARCHITRAVE (ONCE THE ENTRANCE TO THE KNIGHT'S APARTMENT) BROUGHT TO MIND THE ATMOSPHERE OF ST JOHN'S CO-CATHEDRAL, FRANCIS REPLICATED ITS BLUE WALLS, WITH MALTESE CROSSES ADORNING THE PALAZZO'S DINING ROOM.

BAROQUE, ORIENTALISM, AND CONTEMPORARY WERE THE THREE MAIN ELEMENTS THAT ULTIMATELY INFORMED HIS RESTORATION PROCESS. TO WIT, BANQUET SEATING FEATURES IN MOST ROOMS. IKAT PRINT CUSHIONS ARE SCATTERED EVERYWHERE. MAJOR CONTEMPORARY ART WORKS ARE AROUND EVERY CORNER, FROM A FRANCIS BACON TRIPTYCH IN THE STUDY TO A SITE-SPECIFIC DANIEL BUREN

INSTALLATION OF MIRRORS AND COLORED STRIPES UPON THE DRAWING ROOM CEILING, AND AN ILLUMINATED JASON RHOADES INSTALLATION SUSPENDED ABOVE THE SPIRAL STAIRCASE.

THERE IS PLENTY OF WORK BY ARTISTS WHO HAVE LONG BEEN A PART OF THE DAVID GILL FOLD, INCLUDING MATTIA BONETTI (CONSOLES AND CHAIRS), CAMPANA BROTHERS (SIDE TABLES), AND ORIEL HARWOOD (VASES). CRYSTAL TABLES BY FREDRIKSON STALLARD ALSO DECORATE THE MASTER BEDROOM.

AMIDST IT ALL ARE LAVISH FURNITURE AND FIXTURES EXECUTED BY FRANCIS, SUCH AS BRONZE OUTDOOR POOL LAMPS AND BLUE SCAGLIOLA CONSOLES. HE DESIGNED DOOR HANDLES AND OUTDOOR SEATING FROM METAL SHAPED TO RESEMBLE TREE BRANCHES AND FOLIAGE. NOT WITHOUT DIFFICULTY, AN ELEVATOR WAS ADDED AT THE BACK OF THE HOUSE AND A POOL EXCAVATED IN THE BASEMENT, WHICH WAS ONCE THE HORSES' STABLES.

EXPRESSING SUCH A BOLD CREATIVITY MUST BE THE RESULT OF GROWING UP ON A ROCK, A SOLID ROCK IN THE MIDDLE OF THE SEA, THAT IS MALTA, THAT HAS ENDURED SO MUCH—A BOLDNESS AND STRENGTH THAT COMES FROM BEING OPEN TO MYRIAD INVASIONS, FROM ALL PARTS OF THE MEDITERRANEAN BASIN, AND HAS PUSHED THE INHABITANTS TO RESIST THEM ALL, AND BE VERY PROUD. "IT'S THE PEOPLE WHO MADE THE FORTRESS," REFLECTS FRANCIS.

THEIR VALOR WAS RECOGNIZED WHEN THE ISLAND OF MALTA WAS AWARDED THE GEORGE CROSS. THIS IS BRITAIN'S HIGHEST CIVILIAN DECORATION. BESTOWING THE HONOR IN 1943 TO THE ISLAND'S GOVERNOR, LIEUTENANT-GENERAL SIR WILLIAM DOBBIE, KING GEORGE VI EXPLAINED THAT IT WAS TESTAMENT TO THE "HEROISM AND DEVOTION" DEMONSTRATED BY MALTA'S PEOPLE DURING THE SIEGE OF MALTA. DURING THIS BATTLE, WHICH ENSUED FOR TWO YEARS FROM 1940, ITALY AND GERMANY FOUGHT AGAINST THE ROYAL AIR FORCE AND THE ROYAL NAVY FOR CONTROL OF MALTA. THE ALLIED VICTORY IN MALTA PLAYED A MAJOR ROLE IN THEIR EVENTUAL SUCCESS IN NORTH AFRICA AND, THANKS TO THE FORTITUDE OF THE MALTESE PEOPLE, THE CATHOLIC RELIGION WAS PROTECTED AND SAVED FOR ALL OF SOUTHERN EUROPE.

FRANCIS RARELY MISSES CHURCH, ESPECIALLY WHEN HE IS BACK ON MALTA. THE SCENT OF THE INCENSE IS SO PLEASING TO HIM THAT HE TRANSPORTS IT BACK TO LONDON.

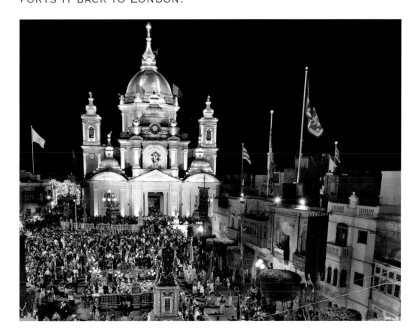

ABOVE: Malta's annual summer "festas" celebrate the patron saints of its villages with effusive processions and vibrant fireworks. Francis grew up in the small village of Nadur, Gozo, where the Roman Catholic Basilica of St. Peter and St. Paul is the focal point for the religious feast of St. Peter and St. Paul, held each year on 29th June.

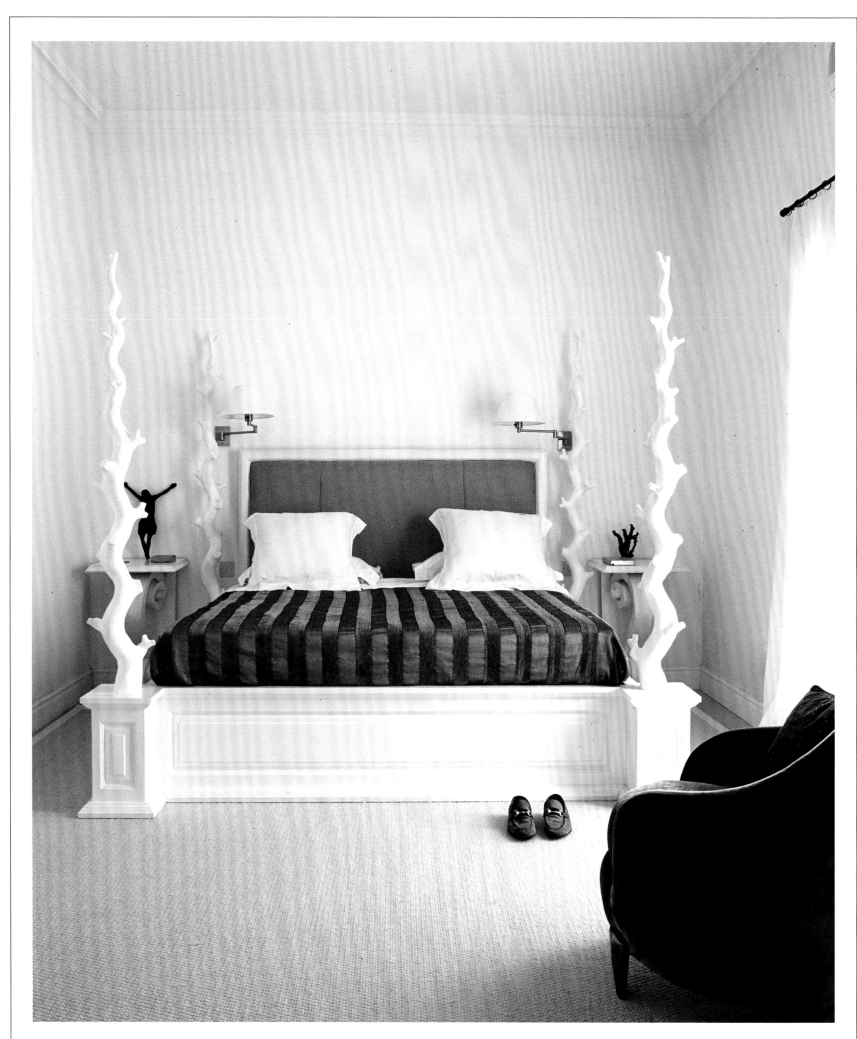

Made in Malta
Nadur, Gozo

In the early Eighties, Maria Sultana built a house in which to live with her son, Francis, in Nadur, the village where she raised him on the tiny Maltese island, Gozo. Two decades later, as Francis launched his career as an interior designer, he set to work conjuring a magical atmosphere within his family home.

"Nadur" as he refers to this house, proved to be Francis's first design project to appear on the cover of *World of Interiors*. "The touches of fairy tale and faint exotica that pervade the interior ... remind one most of louche English aristocrat Stephen Tennant's Wilsford Manor," wrote James Sherwood in *World of Interiors*. "Gilded screens, groaning chandeliers, couches fit for a pasha, and gilded Rococo grotto-work consoles are a passion Sultana and Tennant share."

Modernizing Tennant's Twenties glamour, Francis seamlessly infused it with Malta's High Catholic atmosphere, and this inimitable combination remains one of his signatures. Designing Nadur, he forged other distinctive hallmarks that continue to guide his hand. Among them, a unique approach to contrasting colors and conjuring drama with the strategic placement of furniture alongside large-scale contemporary art. A sense of the bleached heat of the island during the height of summer was evoked by the use of cooling white.

Nadur also debuted the patterns and textures that would come to define Francis's work, from feisty tiger print to terrazzo and scagliola. Lending majesty to the modestly sized Nadur home, was "Calypso." This monolithic, gilded bust by Oriel Harwood, towered above the swimming pool. Teaming with trailing ivy, it functioned as a grand-scale planter. Needless to say, Francis did his mother proud.

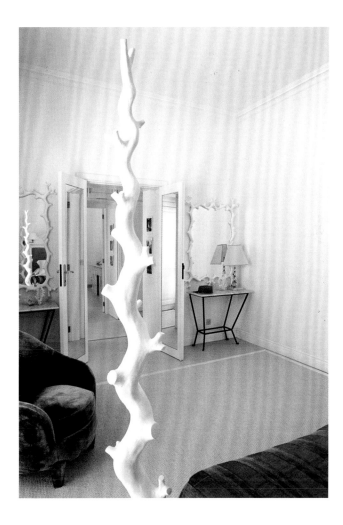

The process of restoring his childhood home on Nadur became a labor of love for Francis. He took inspiration from iconic dwellings such as Stephen Tennant's Wilsford Manor. He also enlisted artists with whom he had forged close bonds to interpret the character of his homeland, Malta.

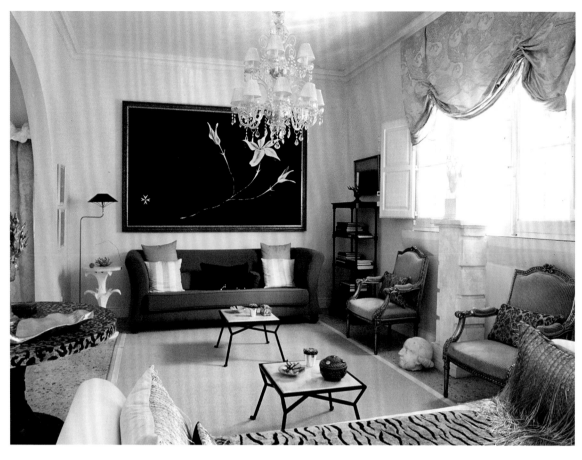

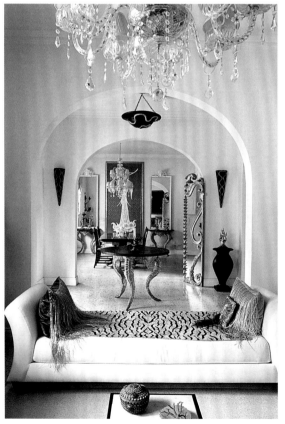

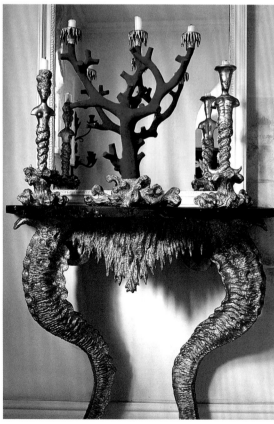

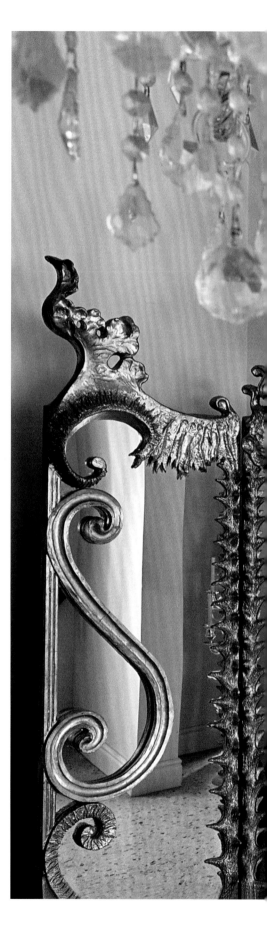

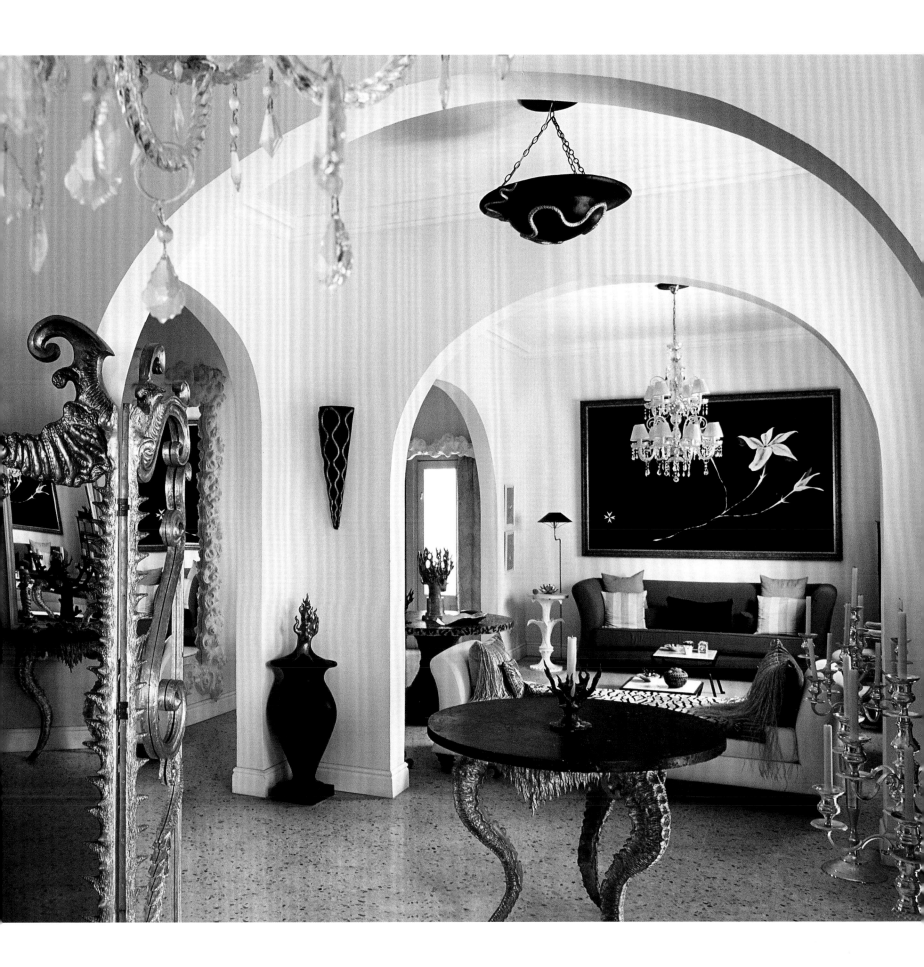

P20: A bed collaboratively designed by Francis Sultana and Oriel Harwood, with chair by Garouste & Bonetti. **PP22–23:** "Francis Sultana's affection for the sparkle and panache of the Bright Young Things" inspired the opulence of his house on Gozo, noted *World Of Interiors* in November 2005. **LEFT:** Grillo Demo's *Madonna*, a pair of 20th century tub chairs upholstered in Rubelli green velvet stripe, and Nicky Haslam Grecian-urn lamps beautify this room, in which Francis often used to take tea and play backgammon. **ABOVE:** A console with an Etruscan-inspired, bronze-finished resin mirror, and three-headed harpy candle-sticks, all by Oriel Harwood.

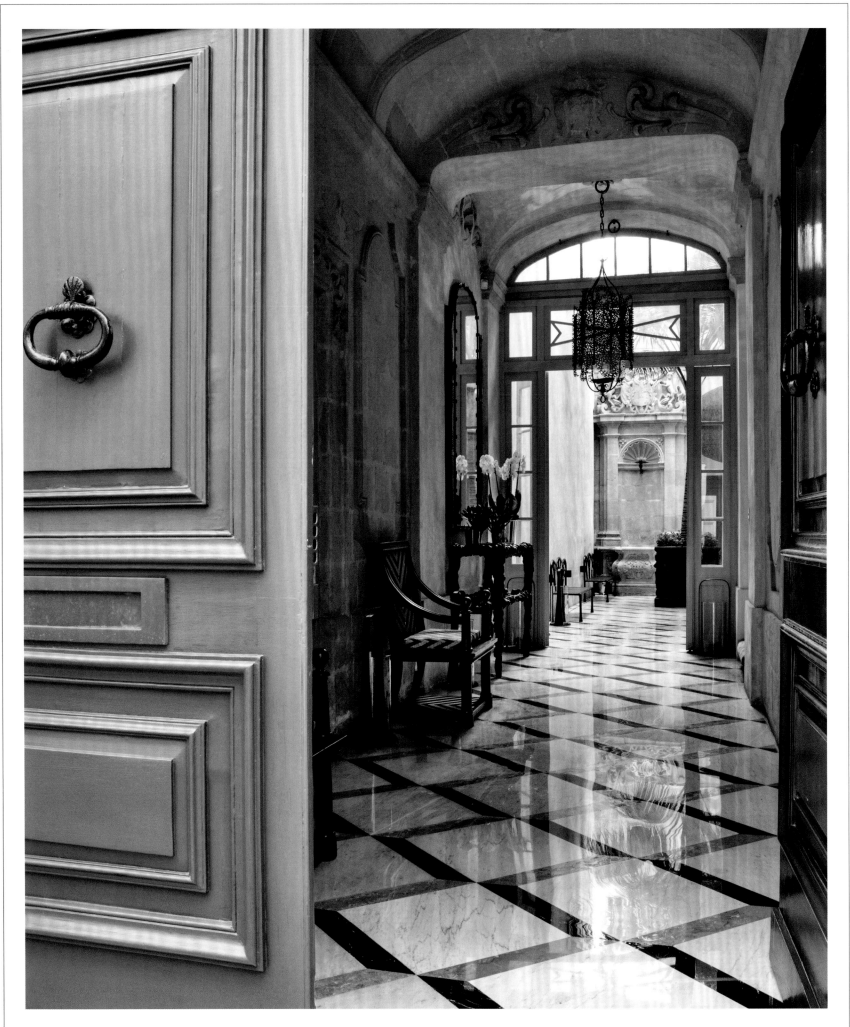

Palazzo de Torres
Valletta, Malta

Originally built in the 16th century as a home for Francesco de Torres, a member of the medieval Catholic military order the Knights of Malta, the six-story limestone palace had stood empty since World War II. After purchasing it in 2006, Francis spent over a decade restoring its grandeur and transforming it into a Baroque palace that works for today as his second home and also a showplace to entertain guests. For convenience, a lift was installed. For fun—and exercise—the basement was excavated to make way for a lap pool.

Amidst his work on "Palazzo de Torres" as Francis describes his palatial abode, he was appointed Ambassador of Culture by Malta's Prime Minister. Francis also progressed work on establishing the country's first contemporary art museum. His home reflects a vision for collecting art that is shared by his partner, David Gill. It also displays the painstakingly crafted furniture and fixtures from the signature bespoke line Francis established in 2010.

And so in the salons, velvet sofas and bronze tables by Francis Sultana Editions are majestically offset by otherworldly masterworks by Mattia Bonetti and the surreal elegance of the Campana Brothers. And while the bespoke kitchen is beautified by Francis's hand-tooled cabinetry, the roof deck—with its panoramic view of Valletta's Grand Harbour—is his favorite spot.

The old has been transformed into the new, the contemporary is in harmony with the traditional. As with all his interiors, Francis has been the editor of his own life in this home, merging motifs from Malta within a modern context.

Growing up, Francis was always struck by the style of Valletta's palaces with their wonderful limestone façades. Today, he marvels at how so many powerful visual elements are concentrated in such a small domain.

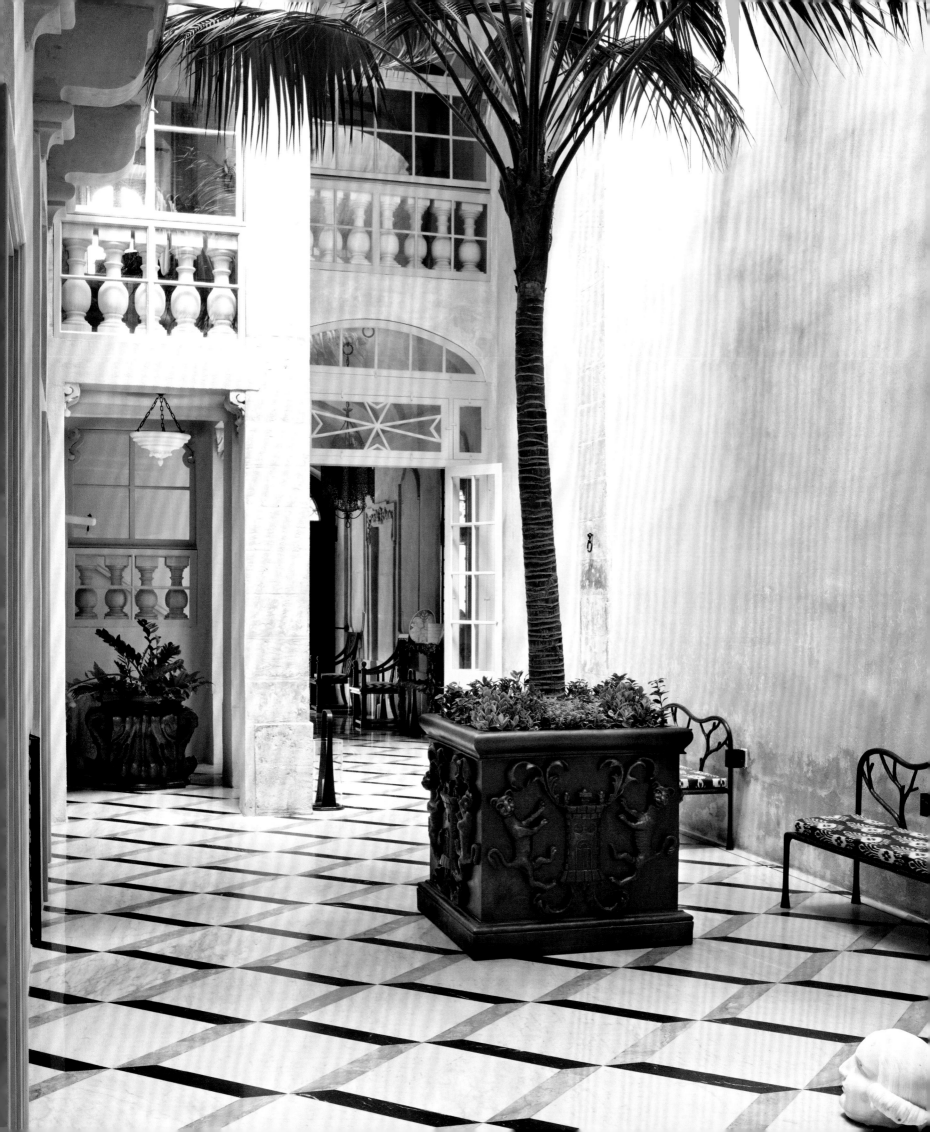

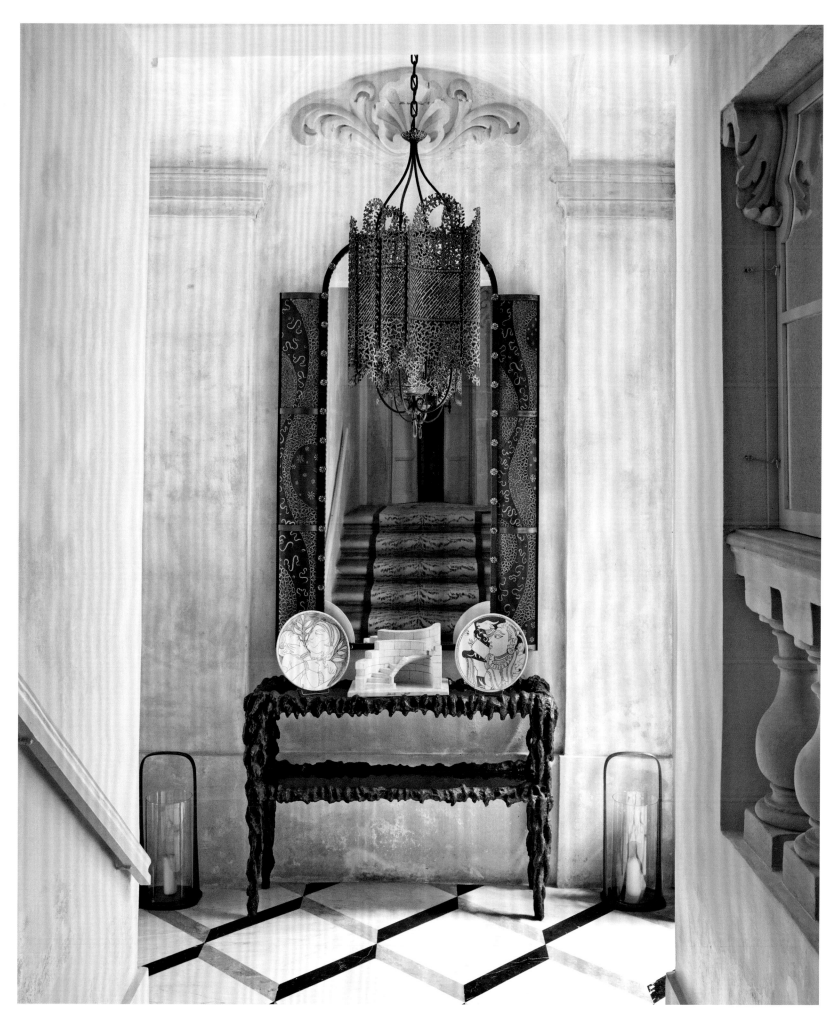

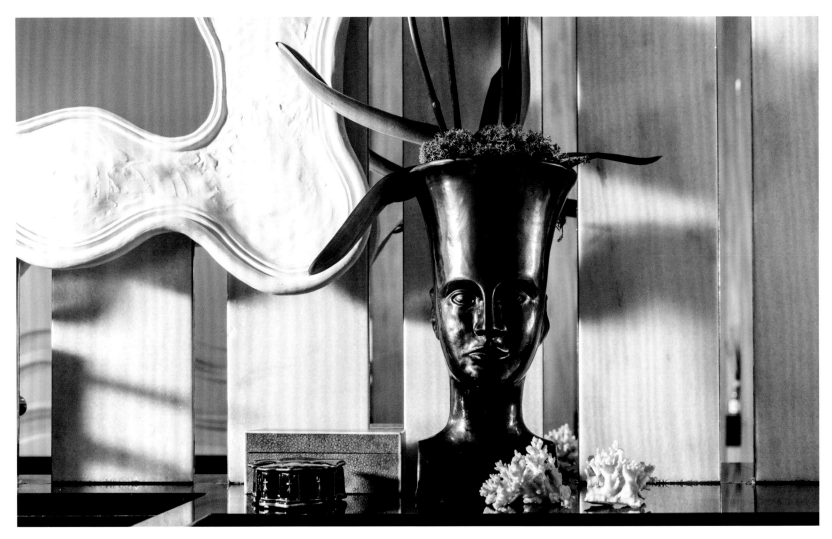

P26: In the entry hall, chairs originally conceived for Carlos de Beistegui's Château de Groussay, just west of Paris. Lantern and mirror by André Dubreuil; console by Mattia Bonetti. P28: In the courtyard, an urn by Oriel Harwood, Francis Sultana "Twig" banquettes in bronze with ikat, and a 19th-century bust in marble. P29: Hurricane lanterns by Francis Sultana stand either side of Mattia Bonetti's "Atlantis" console, with mirror and hanging lantern by André Dubreuil.

ABOVE: "Head" vase by Oriel Harwood. RIGHT: Above a Madeleine Castaing tiger-print carpet on the main staircase hangs Ida Ekblad's *Tracks*, 2013, in acrylic and latex paint on printed linen. OPPOSITE: A hanging light sculpture, *Introvert Sun*, 2010, by Olafur Eliasson shares the landing with a sculpture by Eva Rothschild, entitled *Us Women*, 2011.

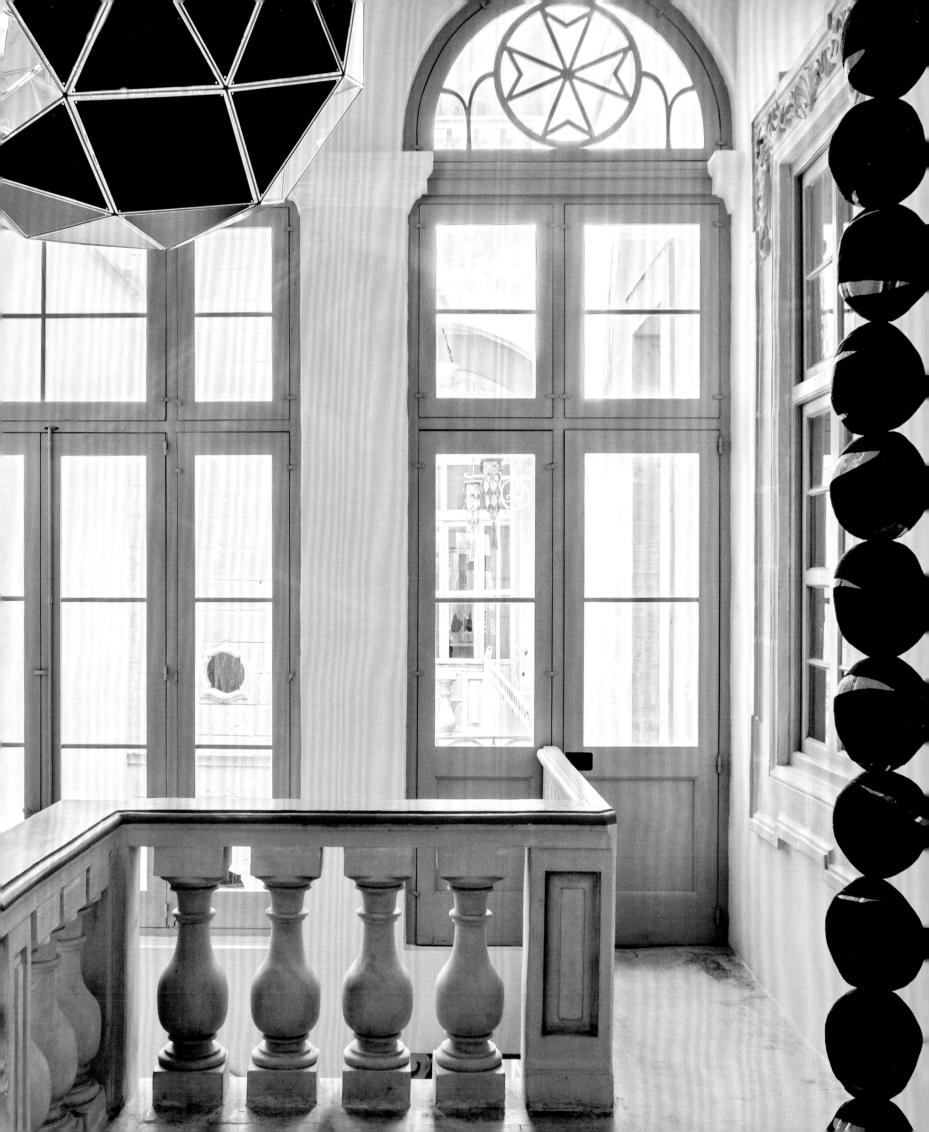

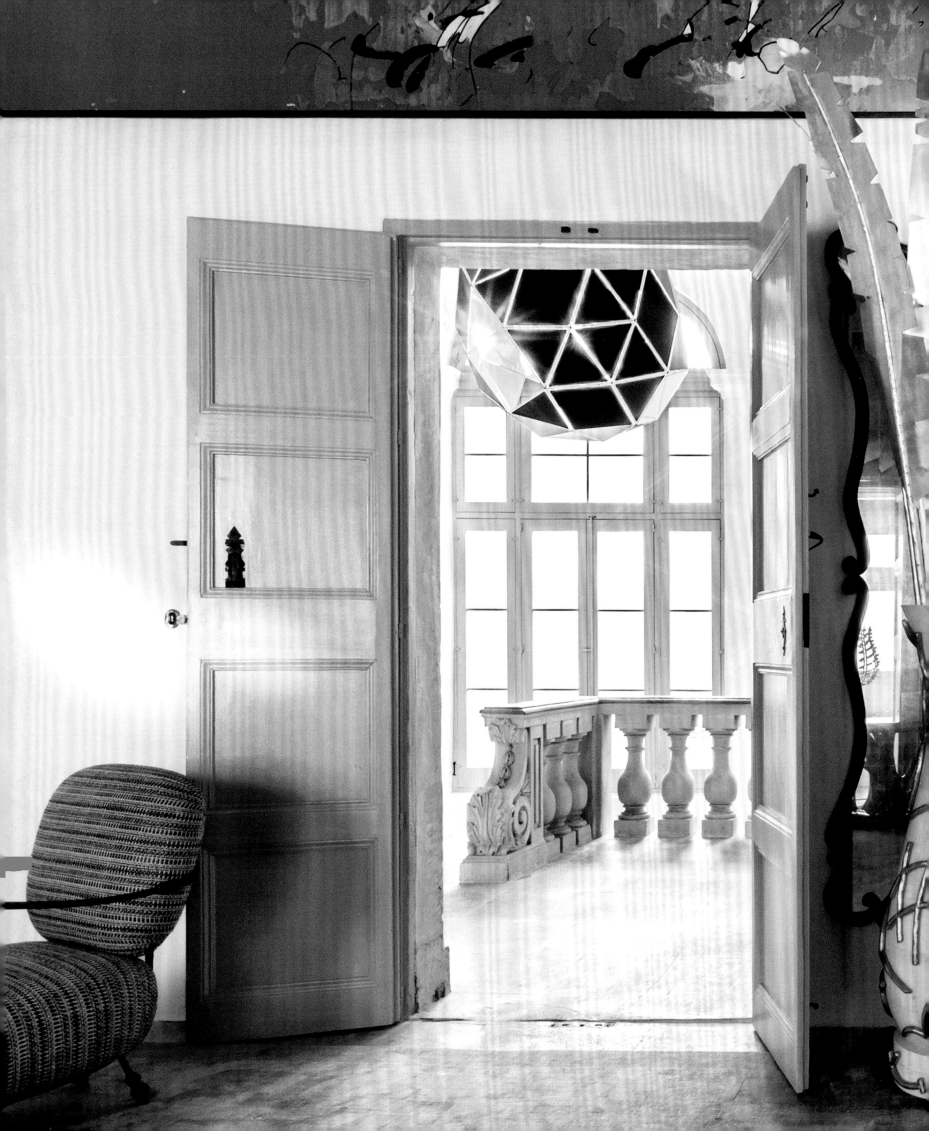

PP31–32: The grand rooms of the historic palace have been made dynamic with Francis's judicious placement of contemporary artworks.

ABOVE: Léon Bakst's vibrant Ballets Russes costumes are inspirational to Francis, exemplified in a pair of vintage Italian dishes in gilded silver with ruby and sapphire embellishment. RIGHT: Ikat fabrics purchased in Istanbul have become cushion covers. OPPOSITE: In the grand salon, a candelabra by André Dubreuil illuminates Mattia Bonetti's "Abyss" console, 2004. The "Congo" armchair, 2014, and table lamps, 2017, are also by Bonetti, as are the cocktail tables, which are inspired by the rocks of Malta. Oriel Harwood mirrors flank the French windows overlooking the garden. A painting by Secundino Hernandez, *Untitled*, 2018, hangs above a Francis Sultana sofa upholstered in a Dedar fabric. The ceiling art is by Daniel Buren, 2015.

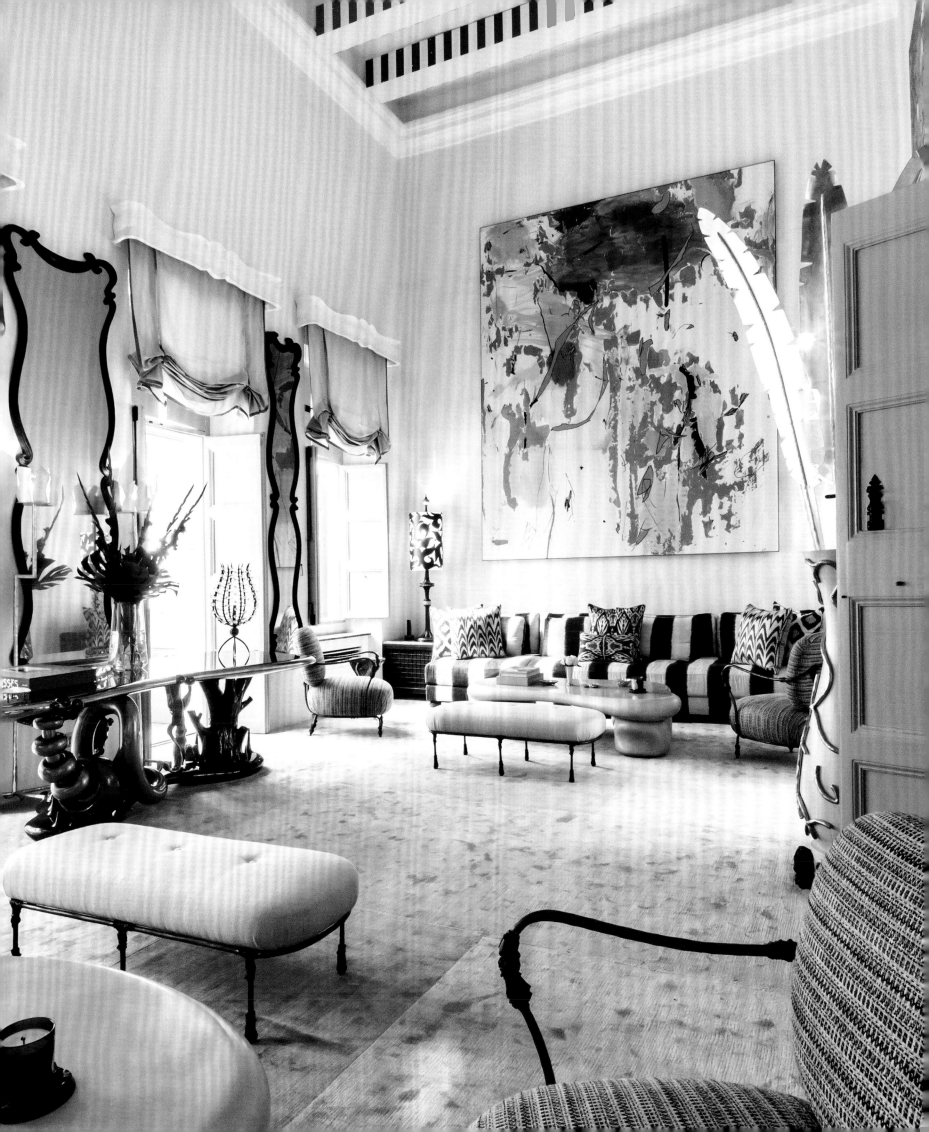

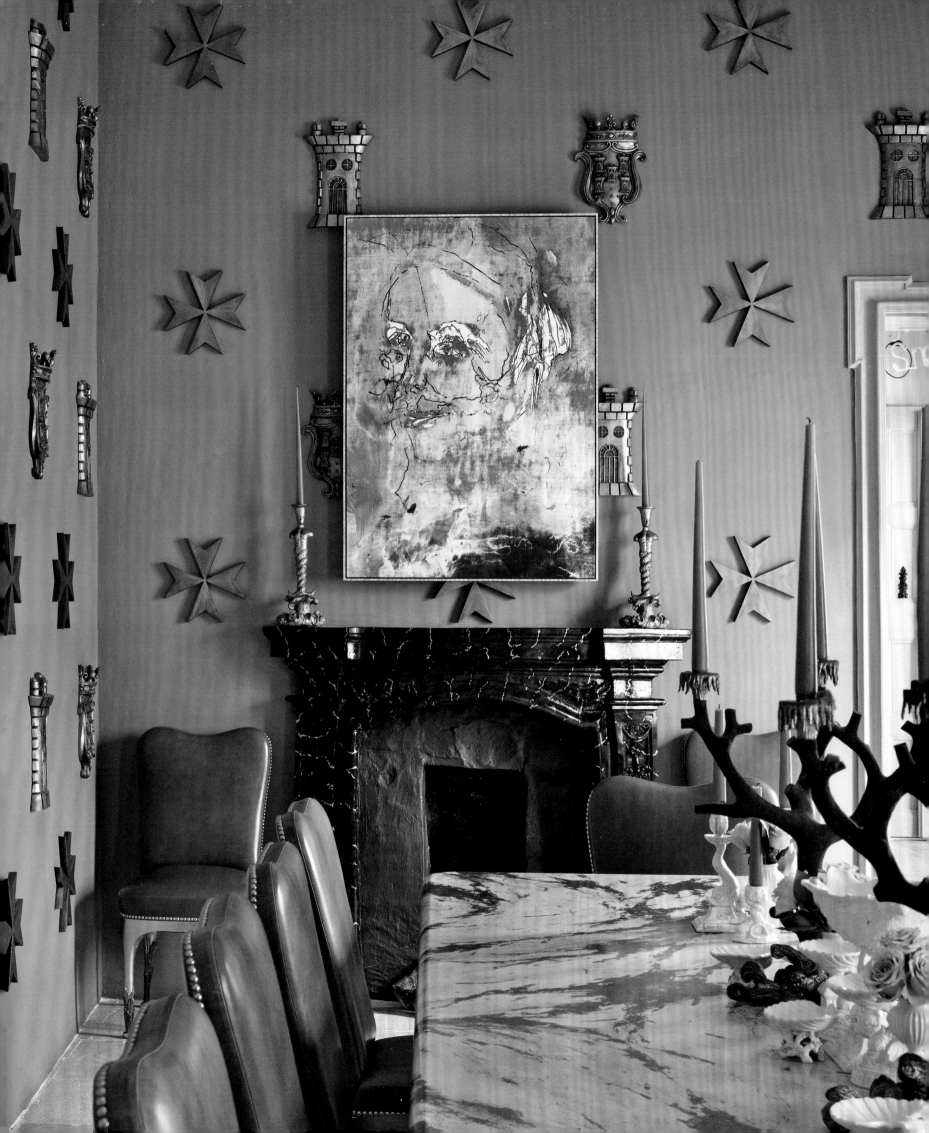

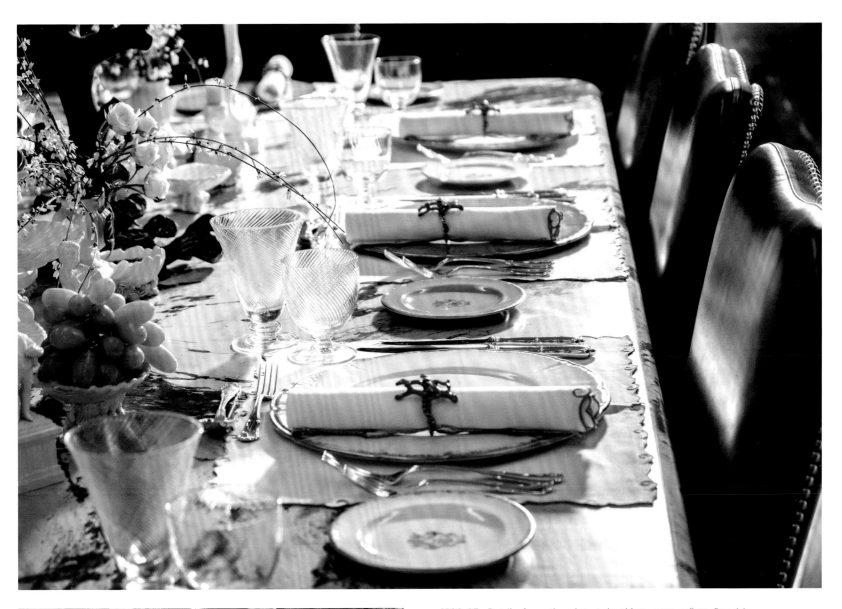

PP36–37: Details from the elegant breakfast room reflect Francis's approach to design, mixing antique, contemporary, new, and commissioned.

OPPOSITE: In the dining room, "Palm" chairs by Mattia Bonetti surround a Garouste & Bonetti dining table, against a backdrop of gilded Maltese crosses and towers fixed to blue walls. The "Blue Coral" candelabras are by Oriel Harwood. Above the mantelpiece hangs Secundino Hernandez's, *Untitled*, 2017, in acrylic, alkyd, oil and lacquer on linen. **ABOVE & LEFT:** The porcelain dinner service is a bespoke design from Laboratorio Parravicini, Milan.

ABOVE: Bespoke cabinets by Francis Sultana line the pantry. RIGHT: In the breakfast room, 19th-century Venetian chairs surround Garouste & Bonetti's "Salome" table. The artworks are from Aldo Mondino's *Iznik* series of 2000 in oil on glass.

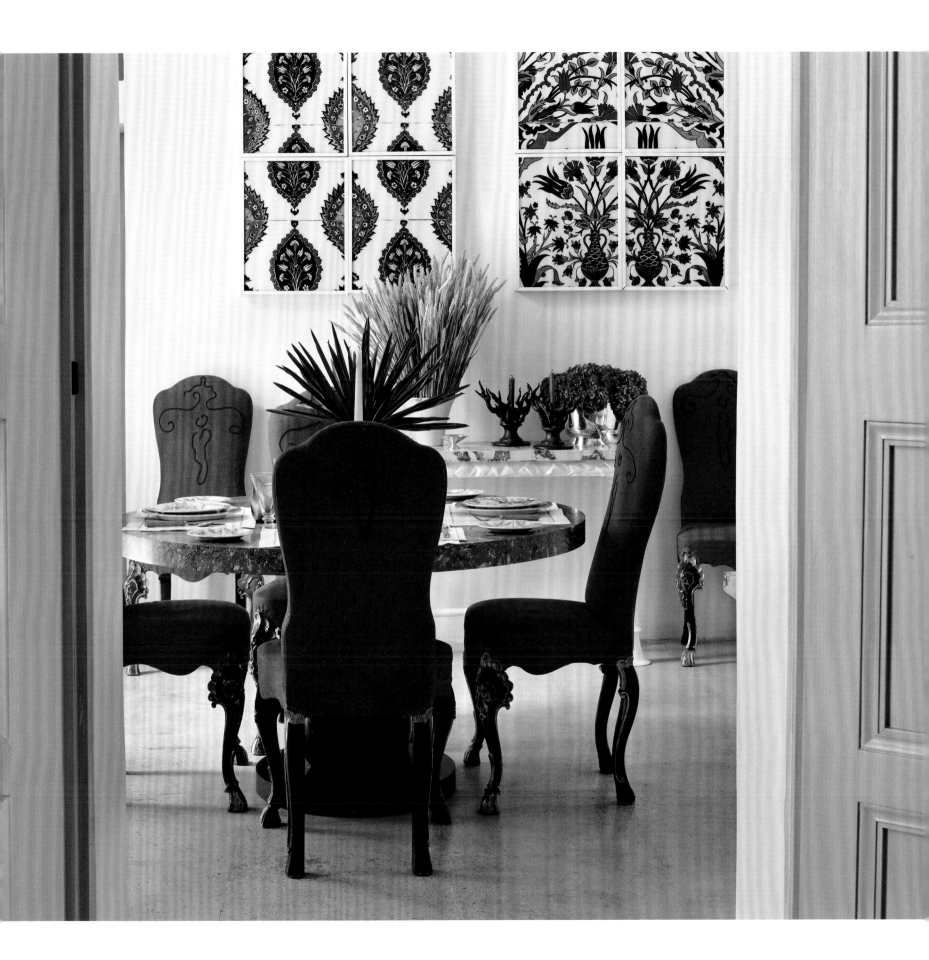

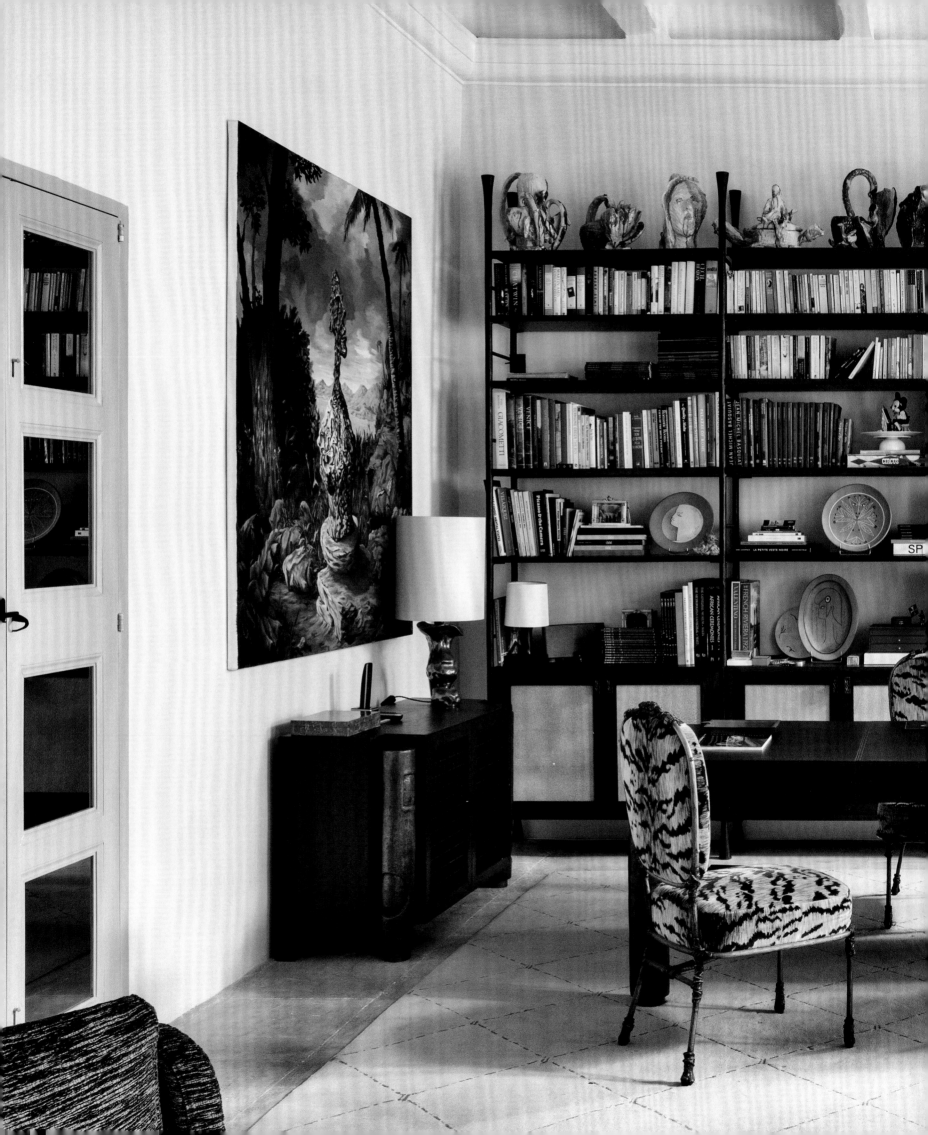

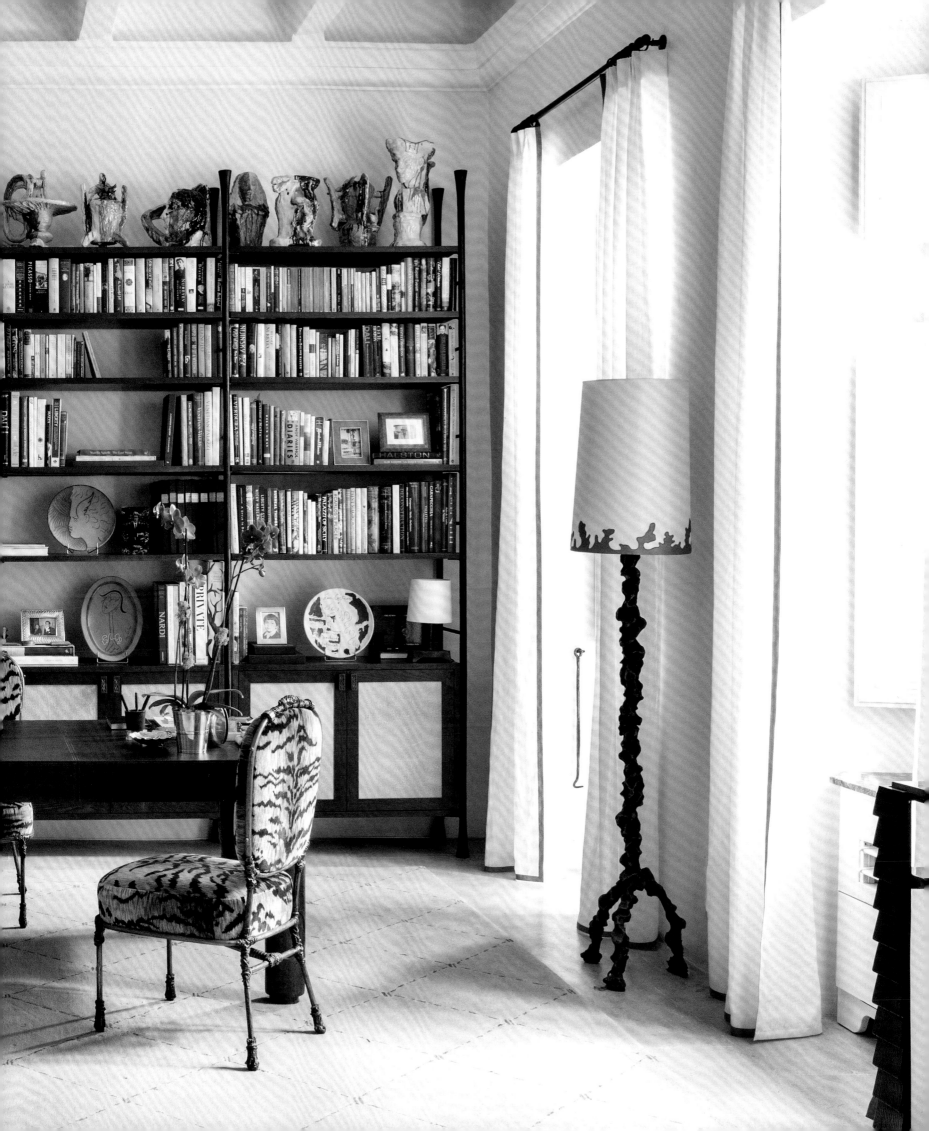

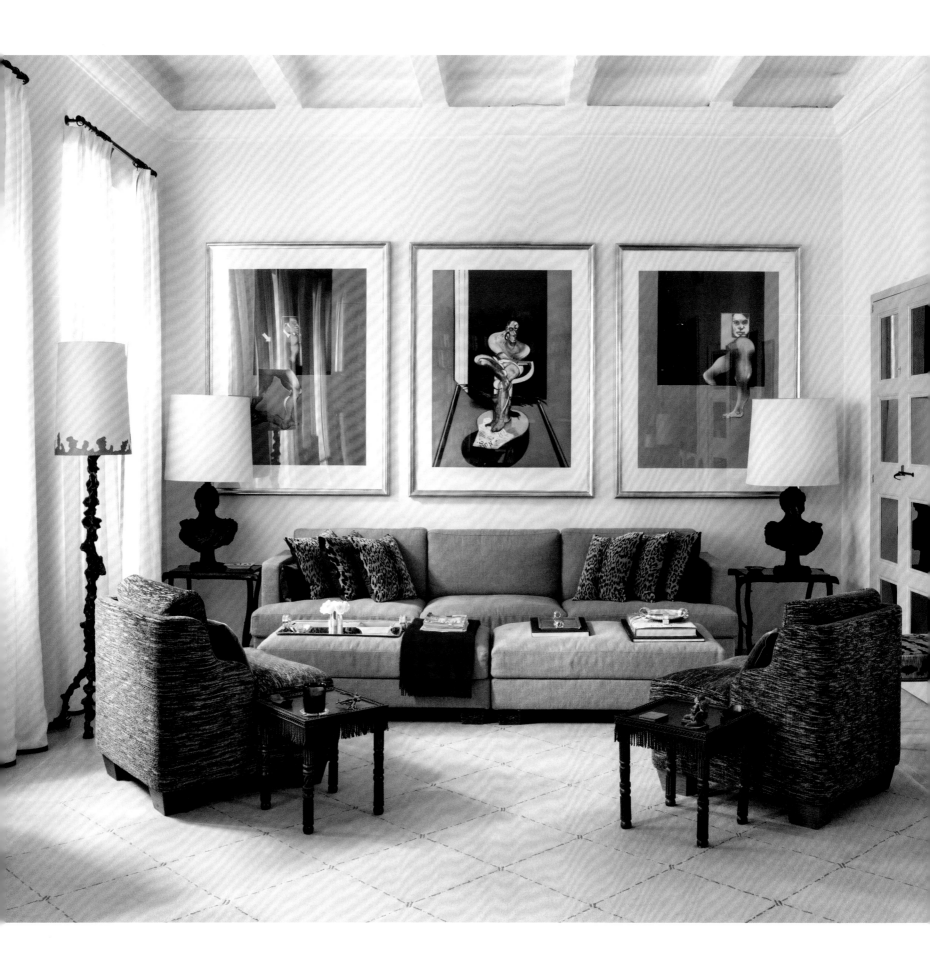

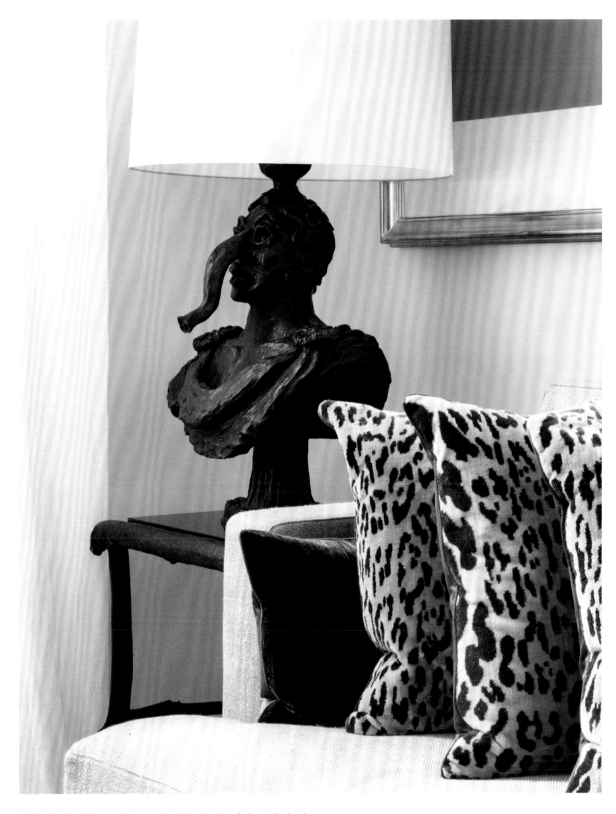

PP42–43: The library, with ceramics by Andrew Lord above the bookcase.

ABOVE: "Emperor" table lamp by Mattia Bonetti, 1999, alongside Luigi Bevilacqua leopard cushions. LEFT: Limited edition prints by Francis Bacon hang above the sofa by Francis Sultana, with lamps and side tables by Garouste & Bonetti.

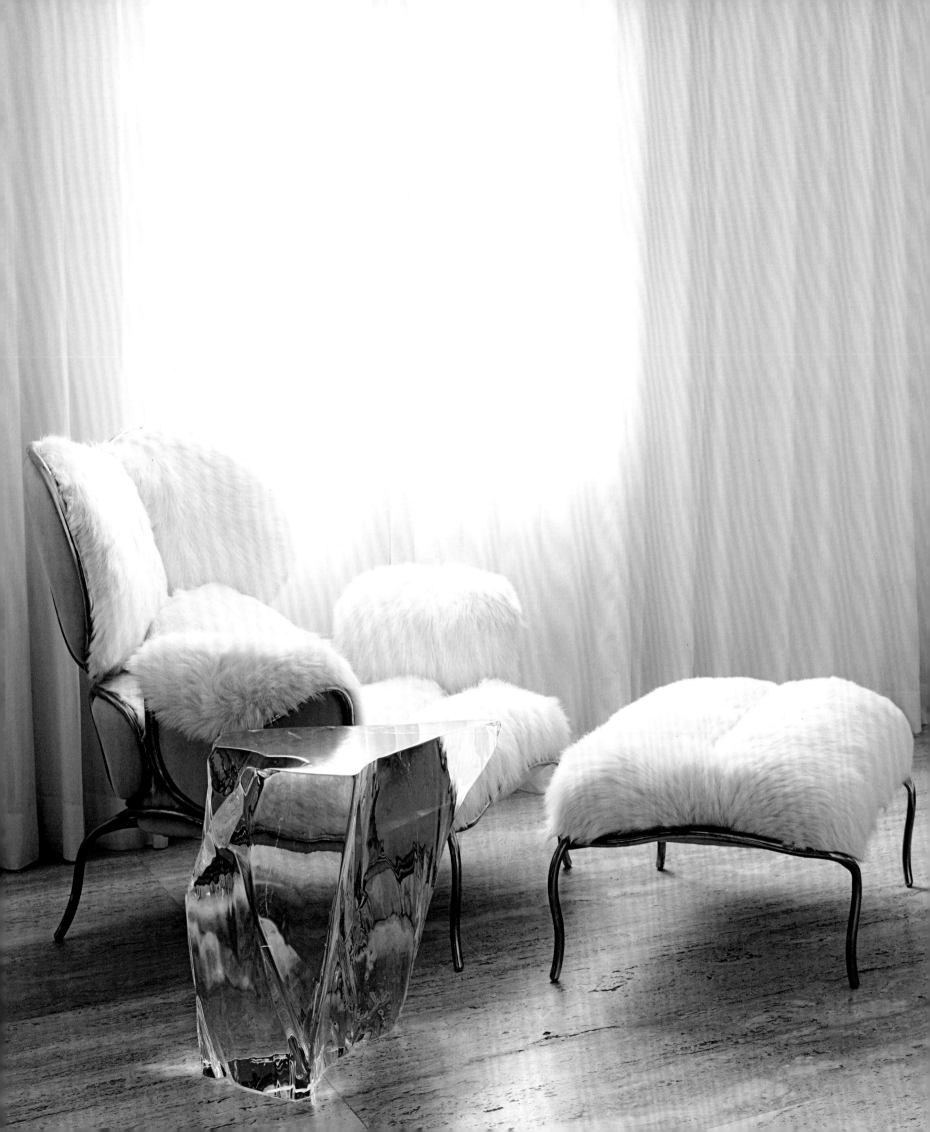

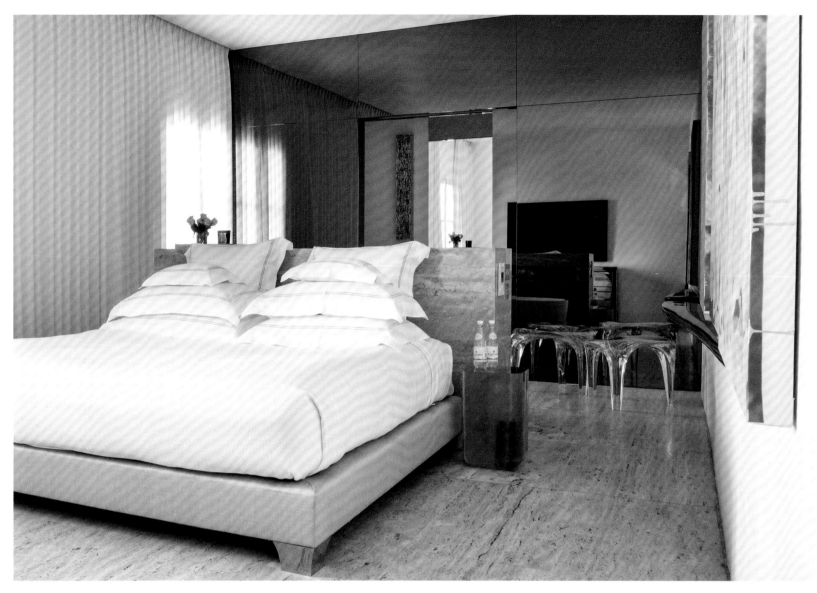

PP46–47 & ABOVE: In the minimalist master suite on the top floor, the bed is by Francis Sultana, with bedside table by Martin Szekely. The "Big Jim" armchair and ottoman, with a nickel-plated steel frame upholstered in fur and suede, is by Mattia Bonetti. The stools and shelf are by Zaha Hadid. RIGHT: Indicative of Francis's discerning eye for contemporary art, a collage by Grillo Demo and ceramics by Barnaby Barford. OPPOSITE: A marble partition serves as a bedhead on one side, and as a shelving unit for the bathtub on the other side. The paintings are by Stefan Brüggemann.

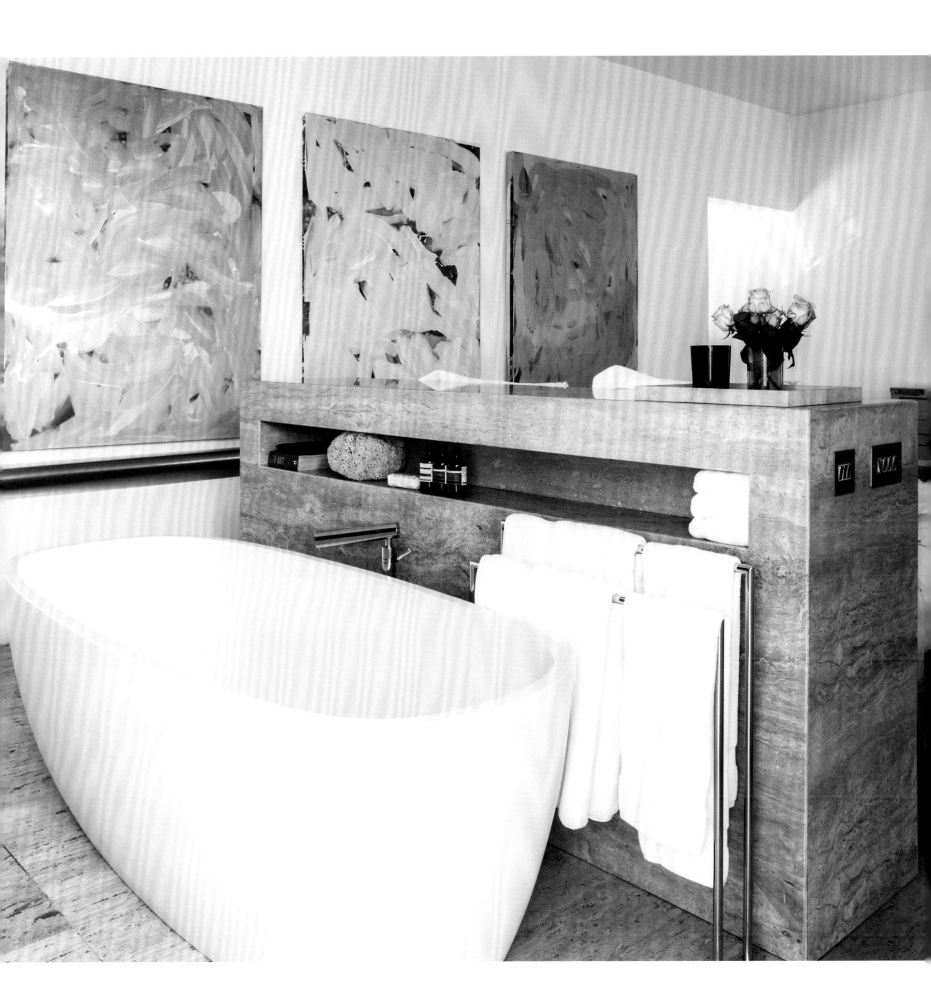

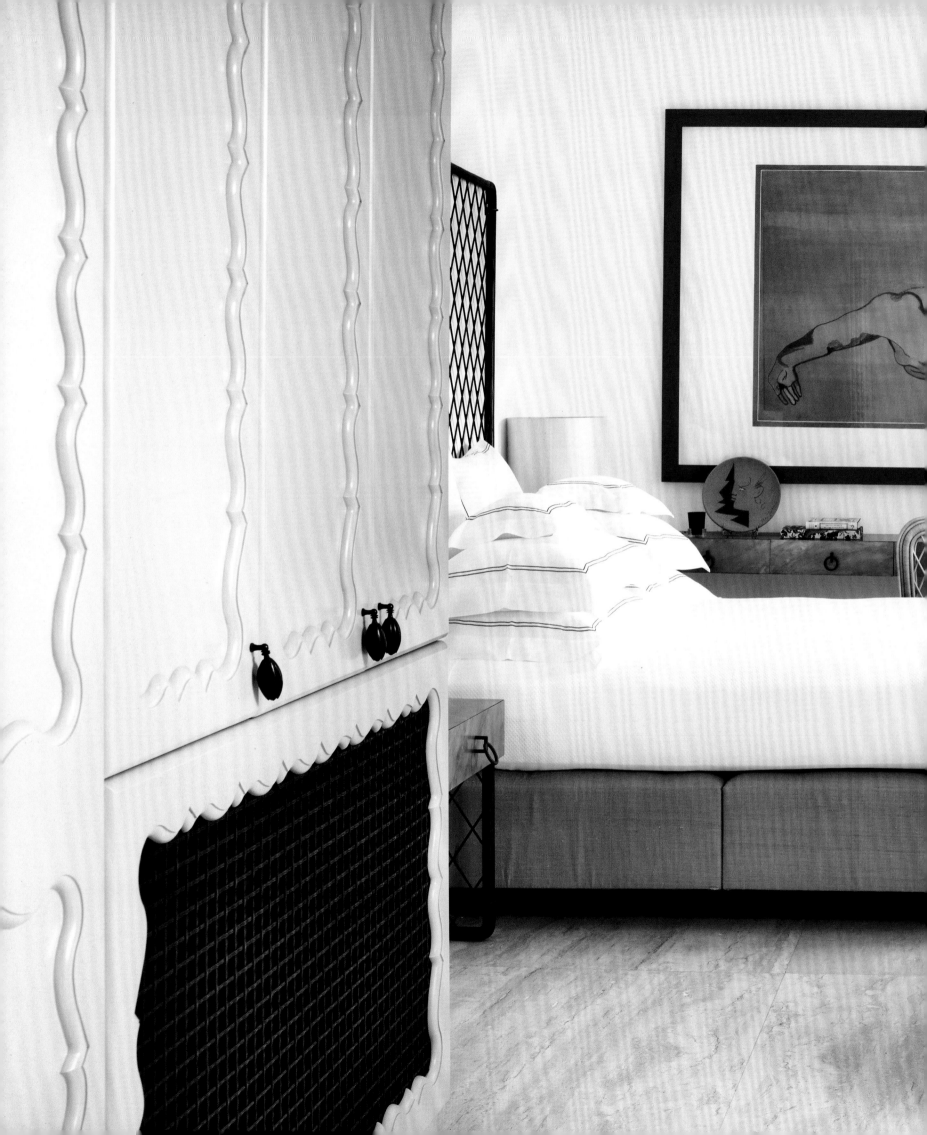

PP50–51: In a guest room, Francesco Clemente's *Semen*, 1987, hangs above a "St. Tropez" desk and bed by Francis Sultana. The rattan chair is by Bonacina 1889, and the curtains are from Loro Piana Interiors.

ABOVE & RIGHT: Complementing a headboard and bedside table by Francis Sultana are Garouste & Bonetti's bronze "Belgravia" lamps with silk shades. OPPOSITE: In another guest room, an ottoman by Mattia Bonetti and rug by Garouste & Bonetti nestle at the foot of a bed with matching bedside tables by Francis Sultana.

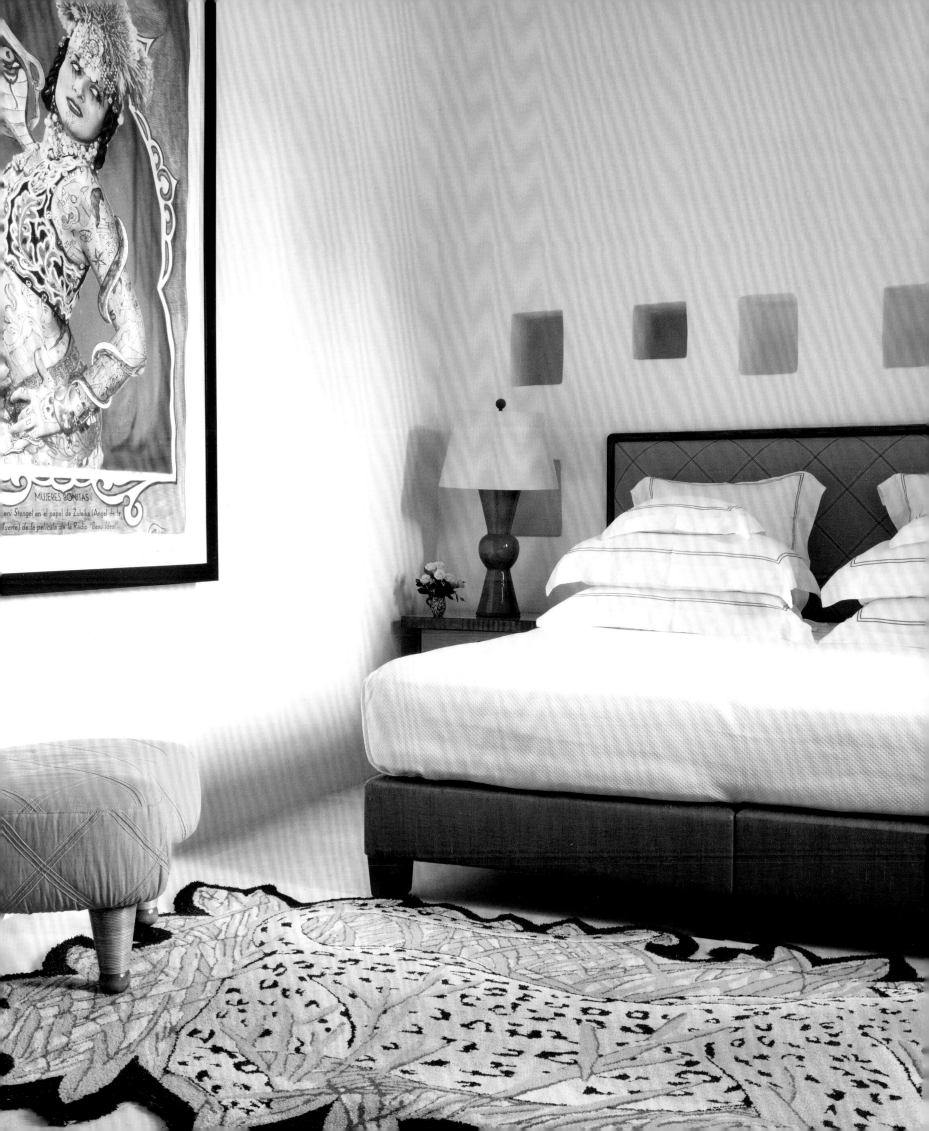

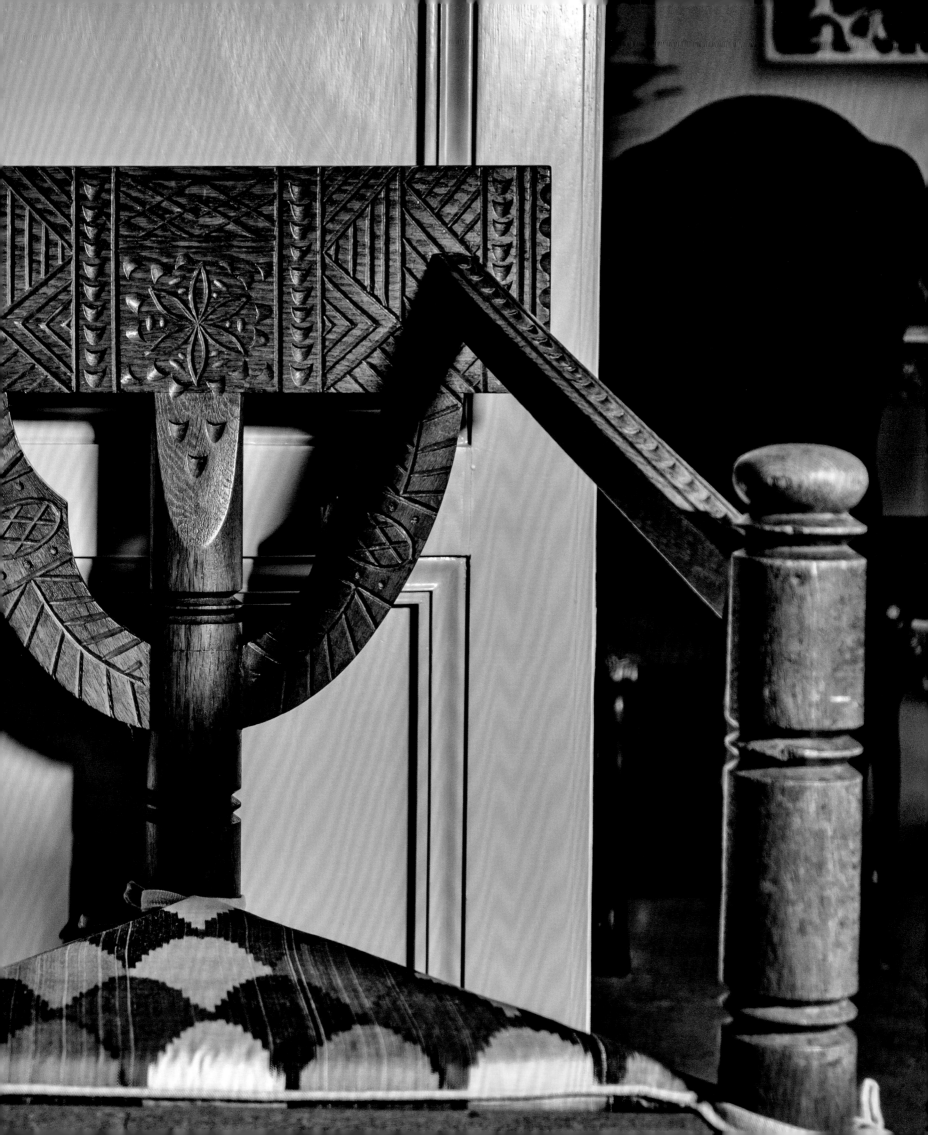

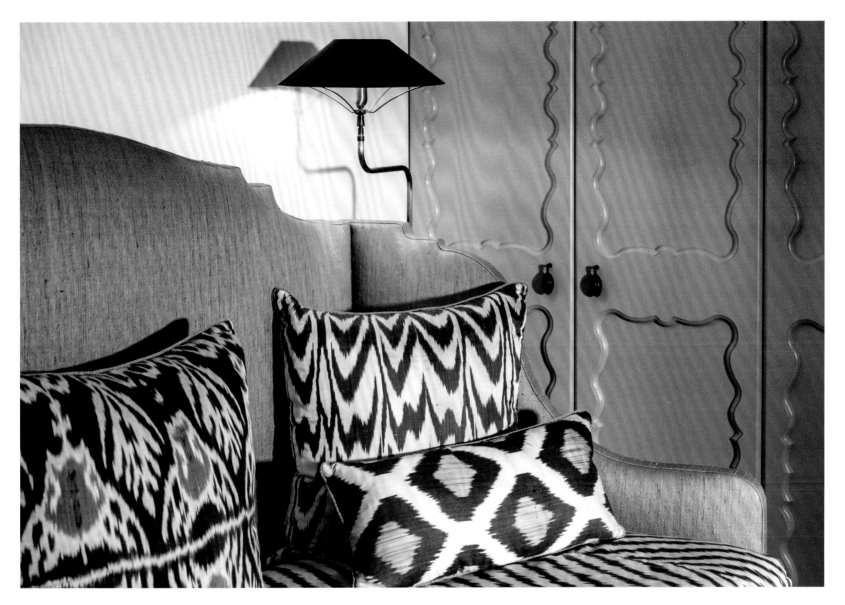

OPPOSITE: An antique carved wooden chair with a triangular seat and cushion. ABOVE: Custom made cupboards by Francis Sultana behind sofas and cushions, upholstered in ikat fabric from Istanbul. LEFT: A console with "Minotaur" candlesticks by Oriel Harwood and a vase by Constance Spry.

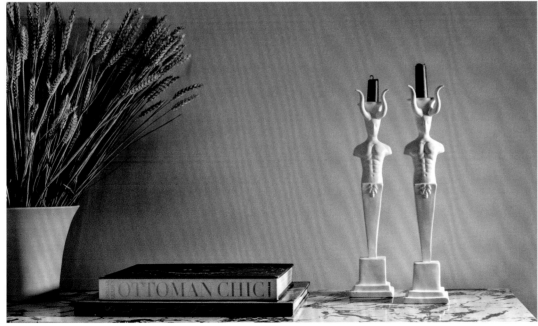

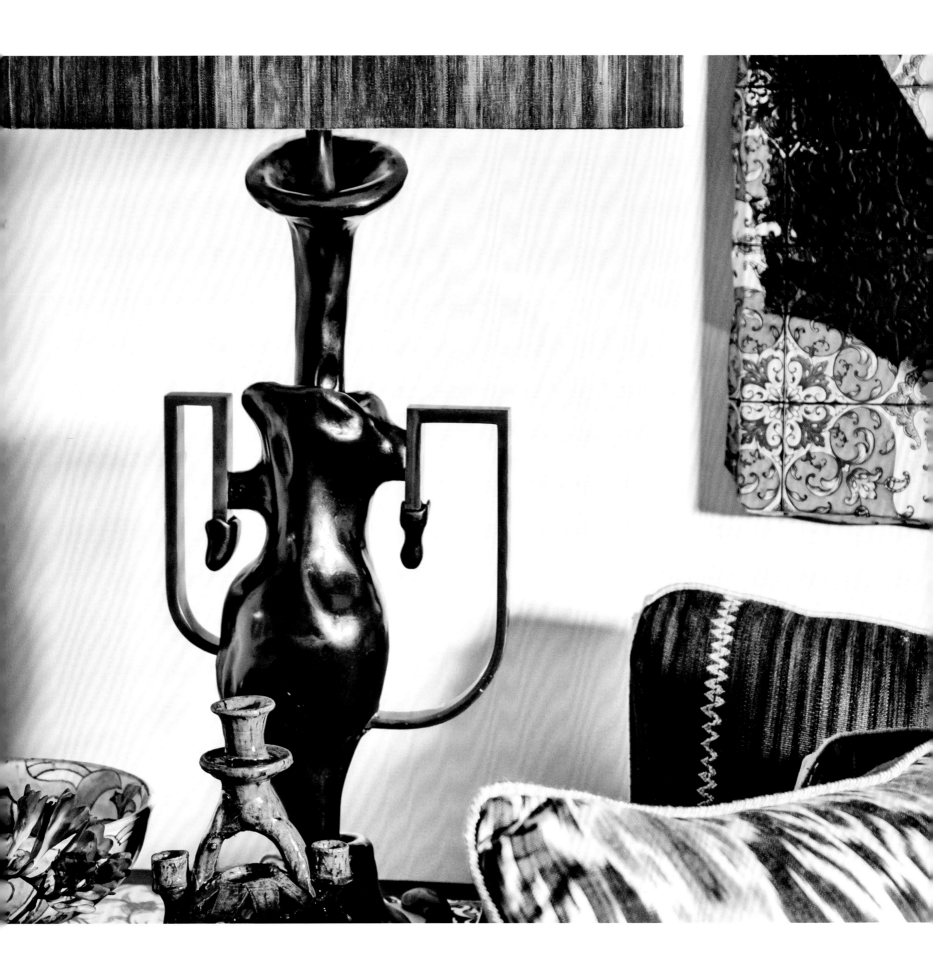

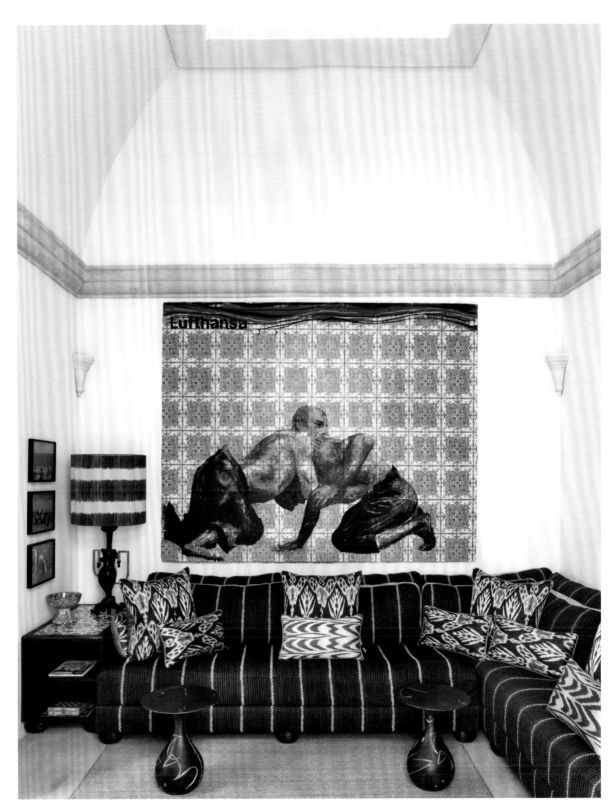

LEFT & ABOVE: In the Oriental-themed sitting room, Aldo Mondino's *Lufthansa*, 1991, in oil on linoleum, hangs above a sofa with ikat cushions by Francis Sultana. The patinated bronze "Merveilleuse" table lamp is by Mattia Bonetti, 2012.

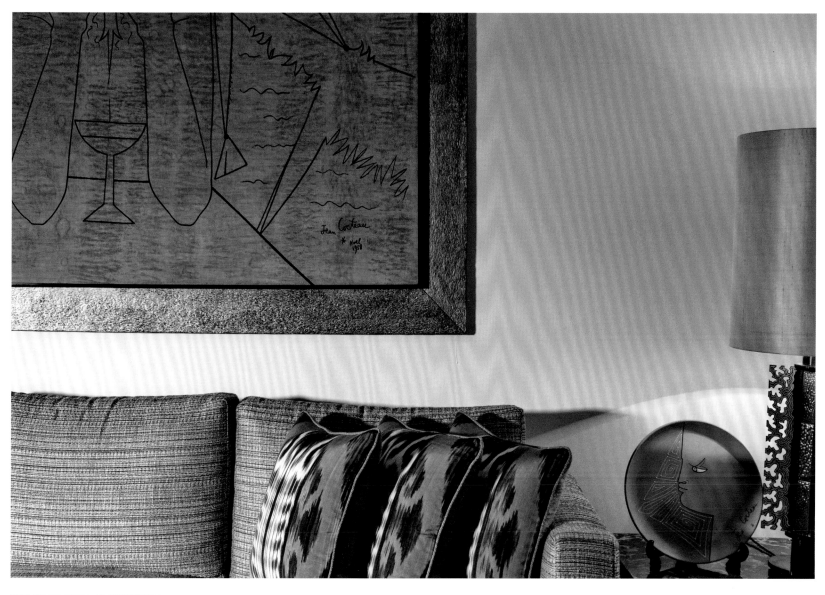

ABOVE: In the sitting room of a guest suite, *Antiquité bouclée, Jeunesse de l'éternité*, ink on paper, by Jean Cocteau, 1958, hangs above a Francis Sultana Bridgehampton Sofa. LEFT: Rattan jugs are juxtaposed with a Cocteau plate and an Oriel Harwood candlestick. OPPOSITE: A lantern by André Dubreuil, whom Francis has named as one of his favorite contemporary designers, hangs in the entrance hall.

PP60–61: The mansion is built around a courtyard, an unusual feature in Valletta.

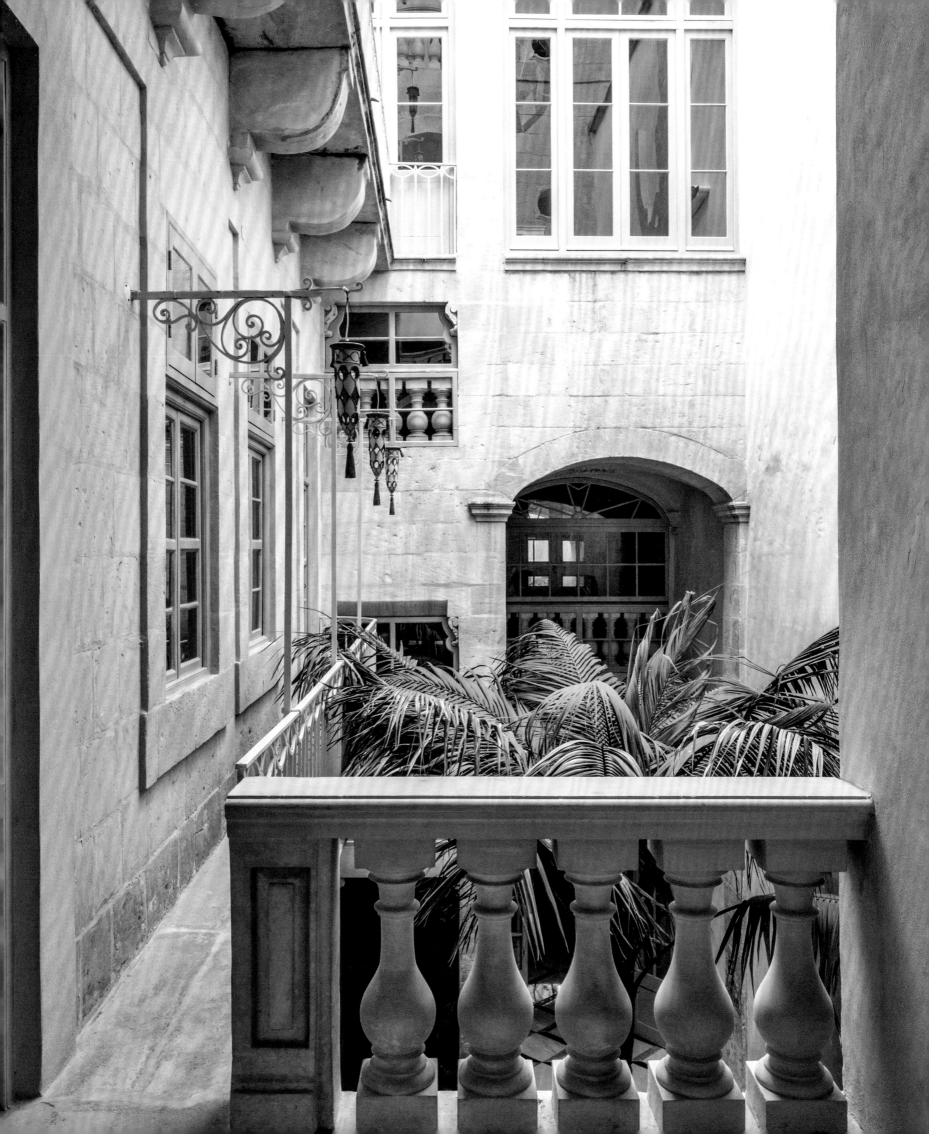

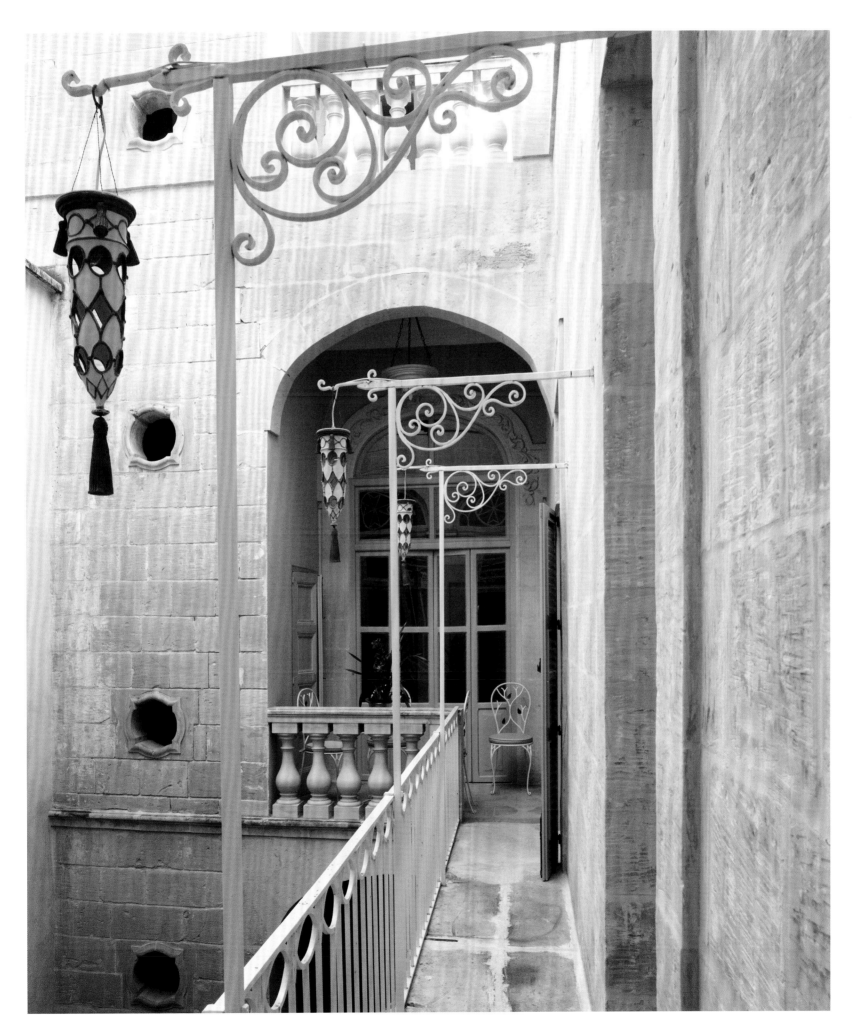

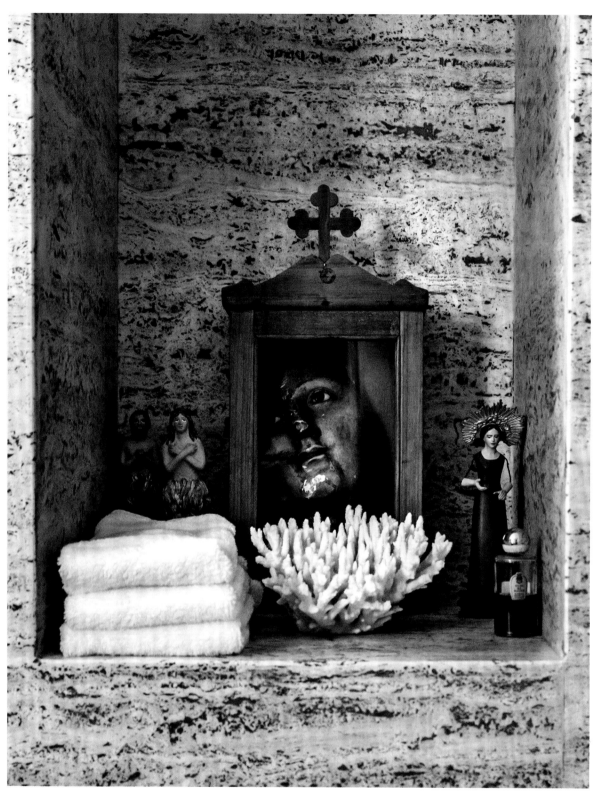

ABOVE & RIGHT: The basement poolside area is adorned with *Plastic Fantastic* masks, by Djordje Ozbolt, 2013, lit from below by hurricane lamps designed by Francis Sultana. In one shelving alcove an antique Spanish relic is on display beside towels for the pool.

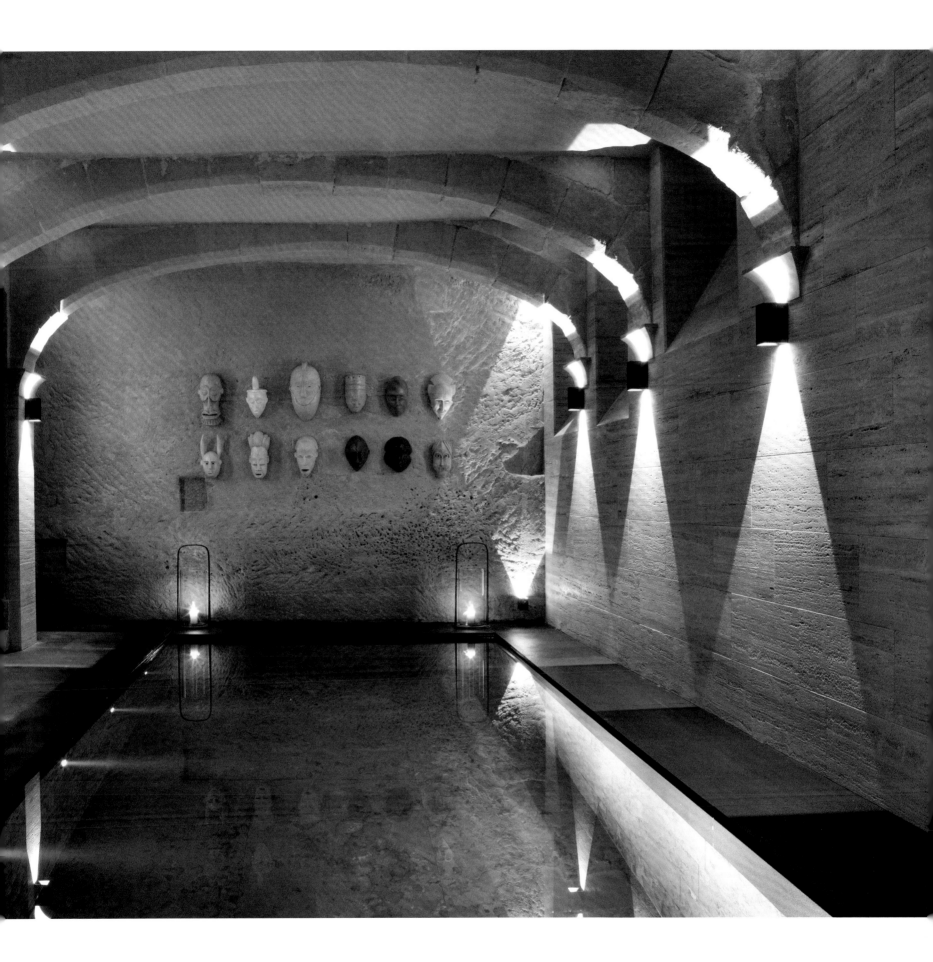

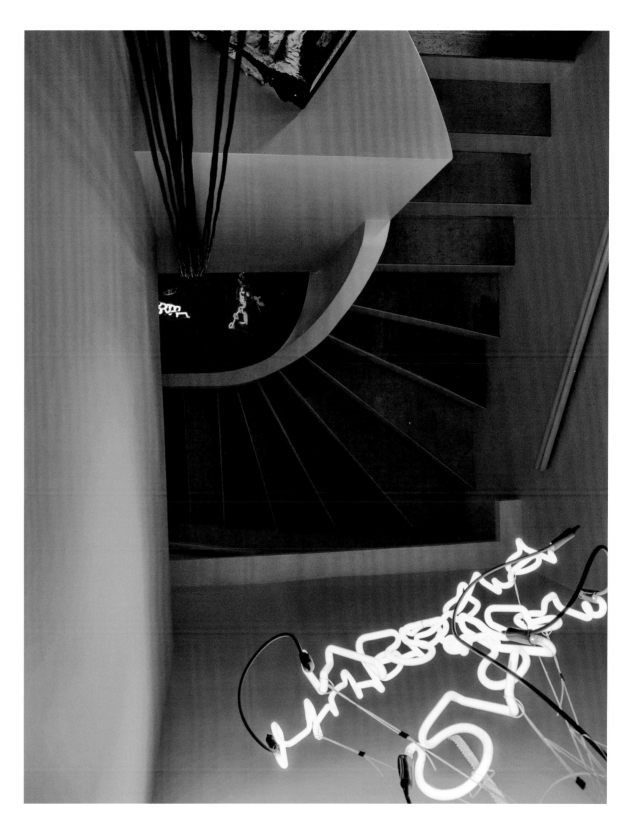

LEFT & ABOVE: A winding Garigor staircase, originally conceived for the domestic staff, leads from the rear of the courtyard to the guest suites. A light installation, *My Madinah. In Pursuit of My Ermitage* by Jason Rhoades, 2004, hangs above the stairwell.

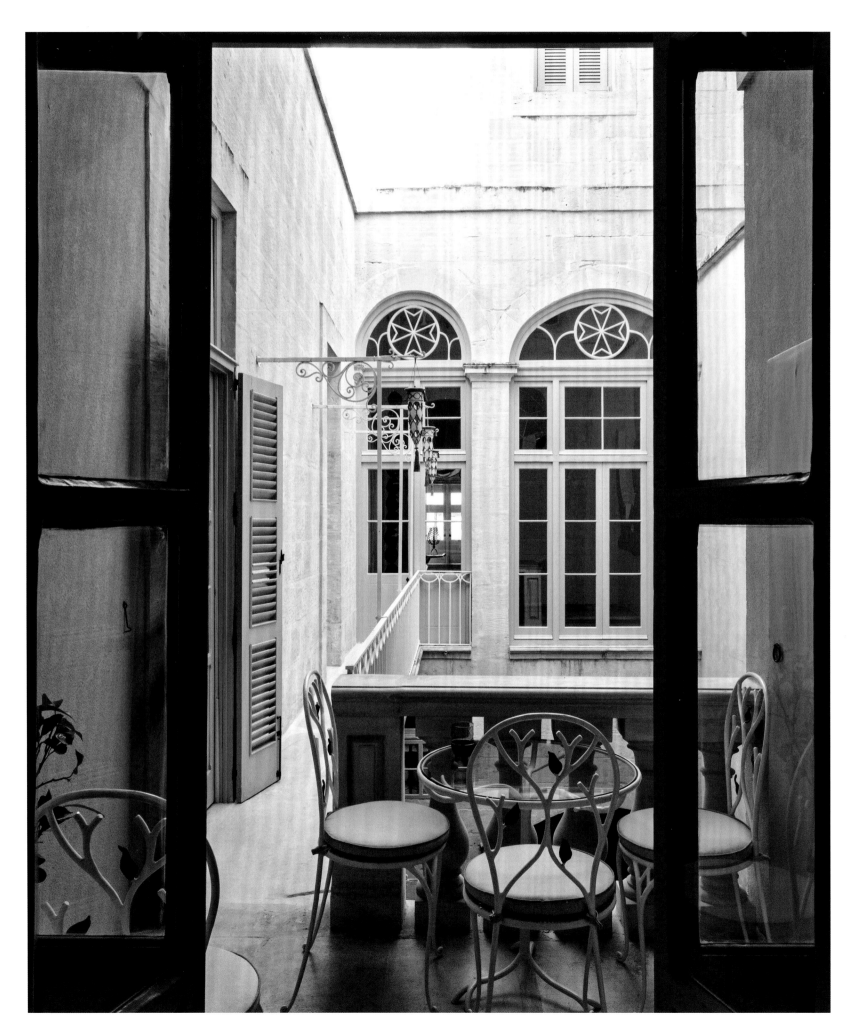

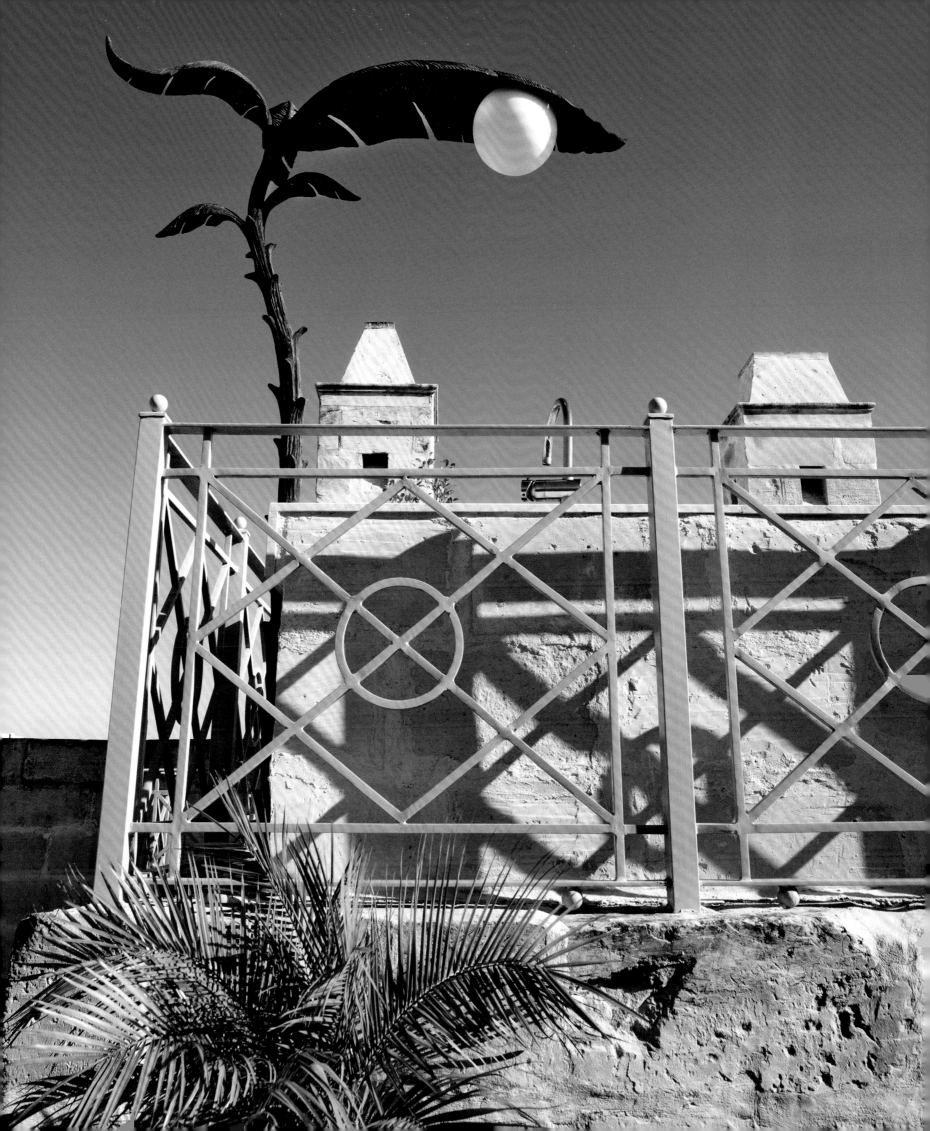

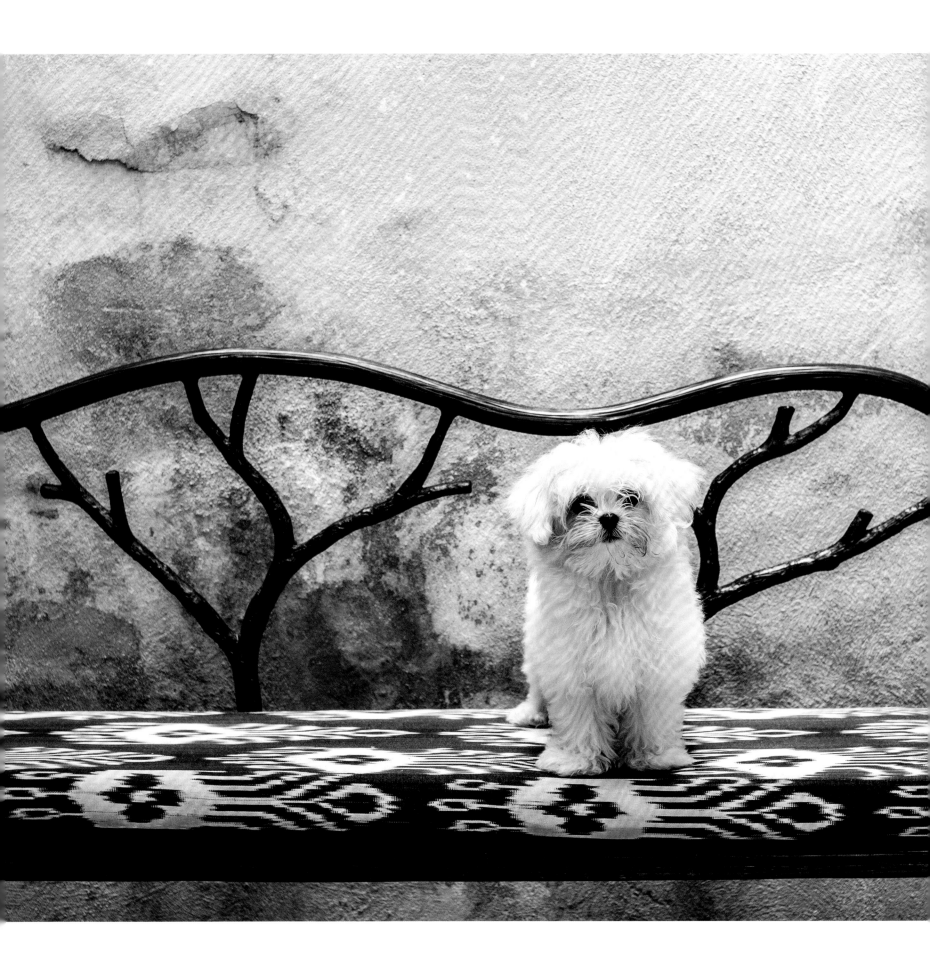

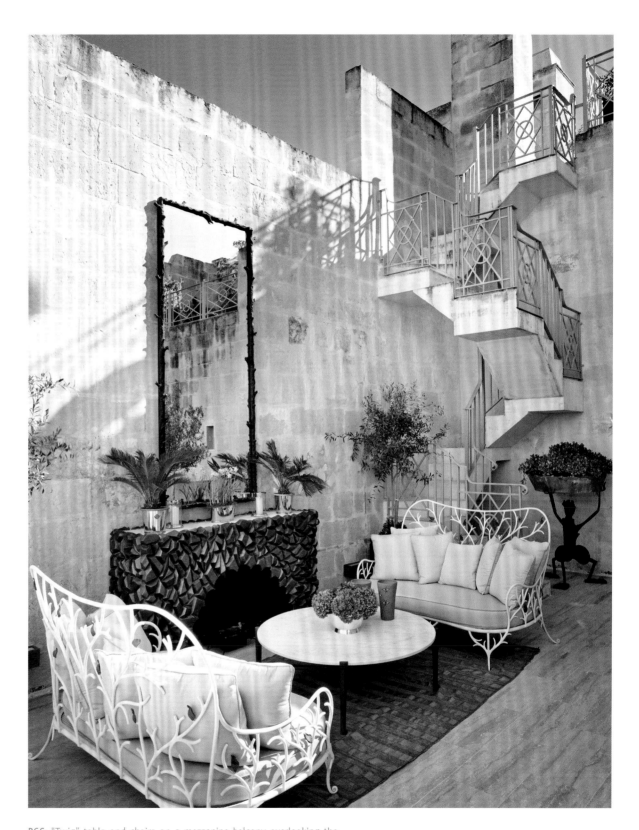

P66: "Twig" table and chairs on a mezzanine balcony overlooking the inner courtyard. P67: A rooftop terrace illuminated by an Oriel Harwood lantern at night.

LEFT & ABOVE: On the indoor-outdoor terrace, a pair of "Twig" sofas flank a fireplace Francis designed together with Oriel Harwood. "Tyga", Francis's Maltese terrier, looks on from atop a "Twig" bronze banquette.

OVERLEAF: Sunset view across Valletta Harbour from the upper terrace..

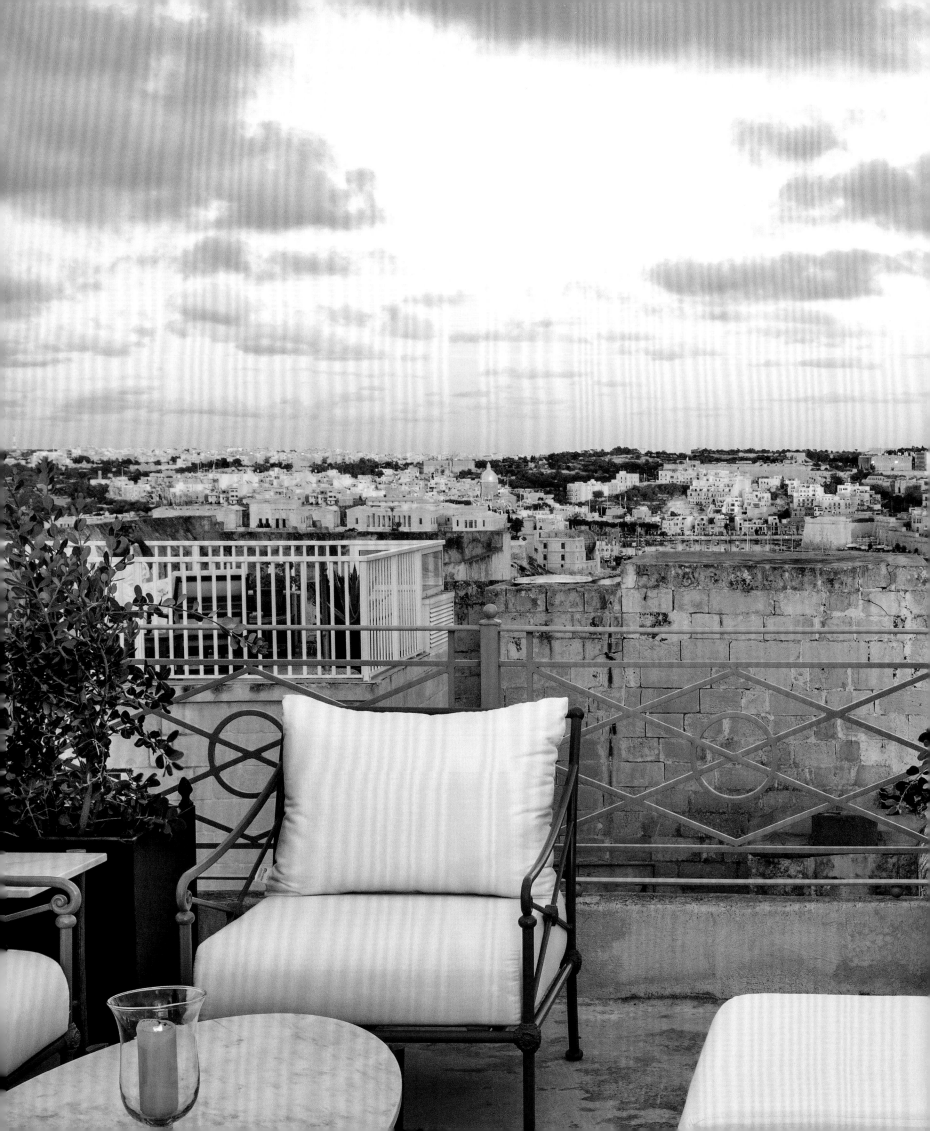

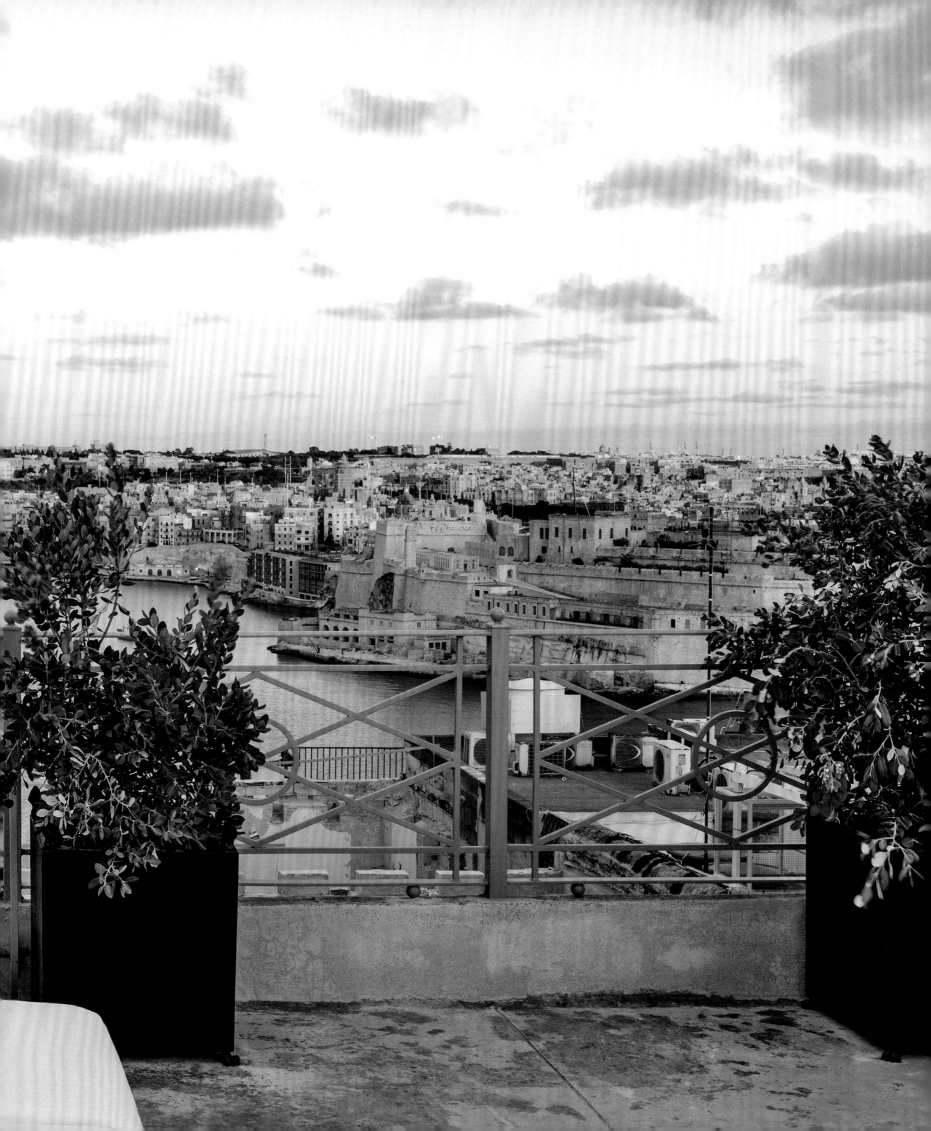

LONDON

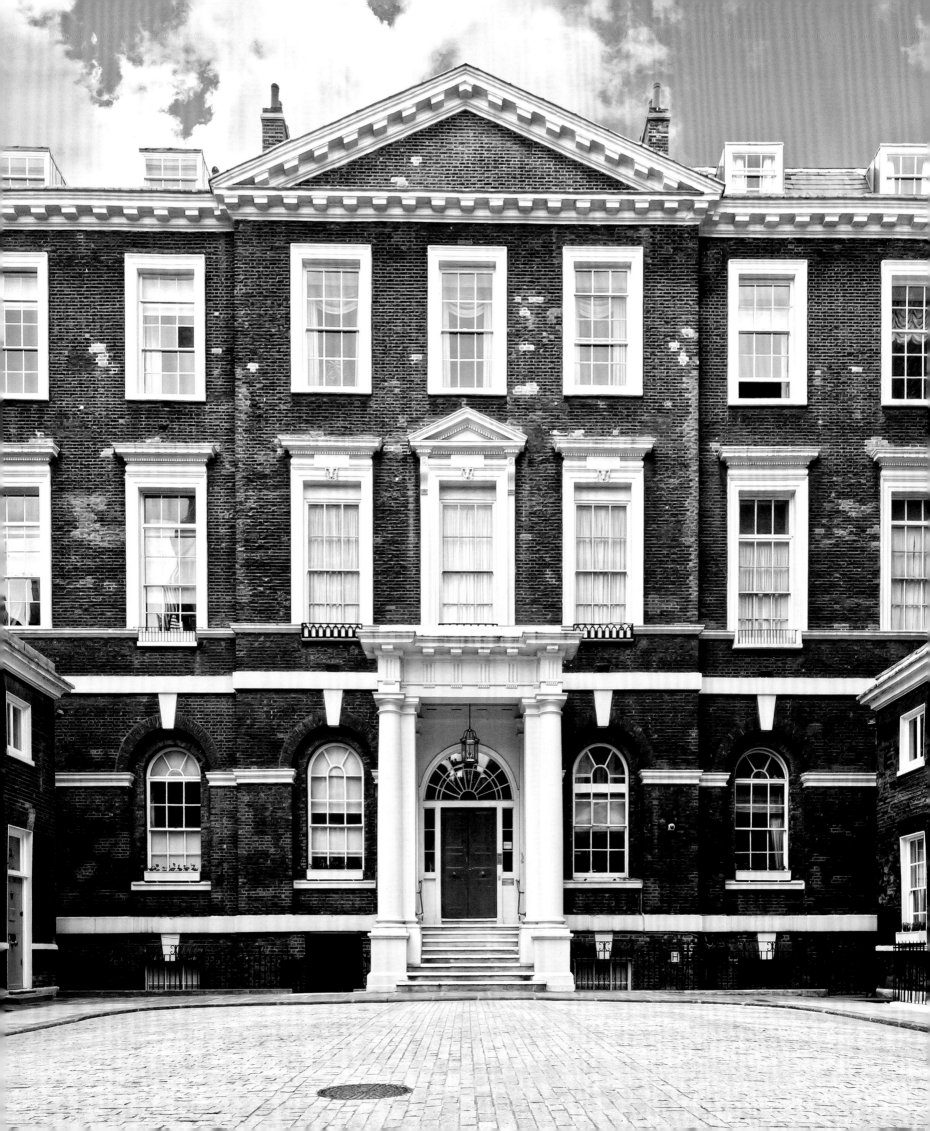

LONDON
Bronwyn Cosgrave

ALBANY IS CONSIDERED TO BE THE FIRST APART-MENT COMPLEX BUILT IN LONDON AND ONE OF THE BRITISH CAPITAL'S FINEST ADDRESSES. THIS REPUTATION IS DUE TO ALBANY'S LOCATION IN THE HEART OF PICCADILLY, WHERE IT NEIGHBORS THE ROYAL ACADEMY OF ARTS IN BURLINGTON HOUSE, AND STANDS ACROSS FROM SOME VENER-ABLE RETAIL LANDMARKS INCLUDING FORTNUM & MASON, THE DEPARTMENT STORE ESTABLISHED BY A ROYAL HOUSEHOLD FOOTMAN IN 1707, AND HATCHARDS, GREAT BRITAIN'S OLDEST BOOKSHOP. GENERATIONS OF FLAMBOYANT GRANDEES HAVE ALL CALLED ALBANY HOME OVER THE LAST FEW CENTURIES, WHICH HAS ALSO BURNISHED ITS REPUTATION. THE ROLL CALL INCLUDES ACTORS, AUTHORS, EXPLORERS, ENTERTAINERS, GRAND DAMES (AFTER WOMEN WERE PERMITTED TO LIVE ON SITE IN THE 1880S), FASHIONABLE PHOTOGRA-PHERS, POETS, PRIME MINISTERS, AND PATRONS OF THE ARTS AND CULTURE.

GEORGETTE HEYER, THE BEST-SELLING ROMANCE NOVELIST WHO LIVED AT ALBANY FOR 30 YEARS FROM 1943, CLAIMED THAT HER WHITE BULL TER-RIER, JOHNNY, DETECTED THE GHOST OF THOMAS BABINGTON MACAULAY, WHO HAD AUTHORED HIS FIVE-VOLUME TOME, *THE HISTORY OF ENGLAND*, ON HER PREMISES. FRANCIS SULTANA AND DAVID GILL, NEVER ENCOUNTERED MACAULAY'S APPARITION WHEN, IN 2003, THEY MOVED INTO THE DUPLEX AT ALBANY IN WHICH HEYER HAD LIVED. FRANCIS AND DAVID'S LAIR BECAME A LIVELY SOCIAL HUB (THEY ARE FANTASTIC PARTY HOSTS), AS WELL AS THE HAUNT OF INNUMERABLE JOURNALISTS WHO WERE DAZZLED BY THE POSTMODERN BRAND OF SURREAL ELEGANCE THE PAIR CONJURED BY SHOWCASING THE *NE PLUS ULTRA* OF CONTEMPORARY ART AND DESIGN AGAINST THE BACKDROP OF ALBANY'S RAR-EFIED GEORGIAN ARCHITECTURE.

OPPOSITE: Albany was constructed from 1771 by Sir William Chambers. One of the leading Palladian architects of his day, Chambers served as tutor and architect to George III. **RIGHT:** Albany's serene central garden path, protected by a cast iron canopy, is known as the Rope Walk.

BUT WHEN ANOTHER HISTORICALLY SIGNIFICANT ALBANY ABODE CAME UP FOR SALE IN 2016, FRANCIS AND DAVID CHANGED RESIDENCES. THEIR NEW HOME WITHIN ALBANY APPEALED BECAUSE OF ITS SIZE—A DOUBLE "SET" (AS ALBANY'S QUAR-TERS ARE KNOWN)—AND ALSO ITS POSITION WITHIN ALBANY'S "MANSION."

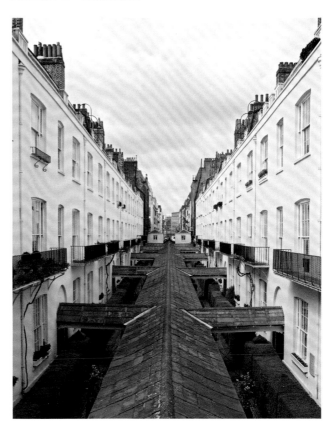

THIS IMPOSING RED BRICK AND STONE BUILDING WAS CONSTRUCTED FROM 1771 BY SIR WILLIAM CHAMBERS. ONE OF THE LEADING PALLADIAN ARCHITECTS OF HIS DAY, ALONG WITH ROBERT ADAM, CHAMBERS SERVED AS TUTOR AND ARCHITECT TO GEORGE III. AND AT THE TIME HE CREATED THE PAL-ACE THAT BECAME KNOWN AS ALBANY'S MANSION, HE HAD ALREADY REMODELED THE QUEEN'S HOUSE (LATER BUCKINGHAM PALACE), FOR GEORGE III'S WIFE, CHARLOTTE OF MECKLENBURG-STRELITZ. CHAMBERS WENT ON TO ACHIEVE RENOWN AS HEAD

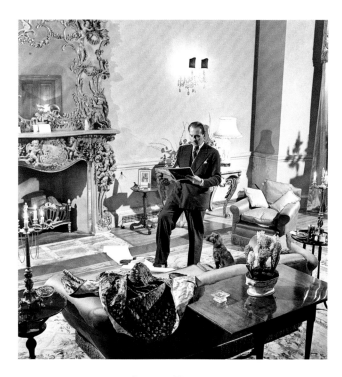

LEFT: Fashion designer Michael Sherard lived at Albany for two years (in the set now occupied by Francis and David), together with business partner John Fraser and two daschunds, Hansel and Humperdinck. He is pictured here in 1950, sketching his latest collection. BELOW: A porter on the covered passageway known as the "Rope Walk" during the 1940s—Albany etiquette was not to engage in conversation when encountering other residents; a nod or touch of the hat was considered sufficient.

BY WILLIAM HOGARTH, DEVISED CHIMNEY PIECES FOR THE STATE ROOMS OF MELBOURNE HOUSE, AND THOMAS CHIPPENDALE'S ST. MARTIN'S LANE WORKSHOP PRODUCED THE FURNITURE.

ACCOMPANYING FRANCIS ON A WALK FROM HIS ST. JAMES'S OFFICE TO HIS NEW HOME IN ALBANY'S MANSION, HOWEVER, IT IS EASY TO BYPASS THE MASTERPIECE THAT WAS MELBOURNE HOUSE. ALBANY IS SET BACK FROM PICCADILLY. ITS "SOBER YET ELEGANT" FAÇADE—WHICH IS VISIBLE FROM THE STREET ACROSS ITS PAVEMENT FORECOURT—BELIES THE MAGNIFICENCE CONJURED BY CHAMBERS AND HIS TEAM OF PROFESSIONALS AND ARTISANS. HOWEVER, VESTIGES OF MELBOURNE HOUSE'S GRANDIOSITY REMAIN INTACT, INCLUDING THE DRAMATIC ROUTE THROUGH THE ENTRYWAY OF ALBANY'S MANSION, WHICH WAS ORIGINALLY CHRISTENED "STAIRCASE HALL" AND NOW LEADS TO FRANCIS'S FRONT DOOR. AMIDST THIS MAJESTIC ENVIRON IS A WIDE STONE STAIRWELL, AND FROM ITS LANDINGS FLOW THE SWEEPING SERIES OF ROOMS THAT CHAMBERS STRATEGIZED FOR LORD MELBOURNE'S PALACE. GONE, HOWEVER, IS THE ORIGINAL ORNAMENTAL PLASTERWORK THAT BEAUTIFIED THE AREA, AS WELL AS THE NEOCLASSICAL

OF BUILDING FOR GREAT BRITAIN—DURING WHICH TIME HE CONSTRUCTED LONDON'S "FIRST GREAT PUBLIC BUILDING," SOMERSET HOUSE, IN 1782. HOWEVER, ALBANY'S MANSION IS CONSIDERED HIS "FINEST AND MOST LAVISH COMMISSION," IN THE WORDS OF THE ARCHITECTURAL HISTORIAN JOSEPH FRIEDMAN. IT WAS ALSO THE "LARGEST AND MOST IMPORTANT" OF APPROXIMATELY TWENTY TOWNHOUSES DESIGNED BY CHAMBERS, RANKING AMONG "SOME OF THE FINEST EVER BUILT IN BRITAIN," ADDED FRIEDMAN.

THREE GRAND HOUSES HAD ONCE STOOD ON THE SPRAWLING PATCH OF PICCADILLY WHERE CHAMBERS SET TO WORK IN 1771. HIS REMIT WAS TO CONSTRUCT A LONDON FAMILY HOME FOR SIR PENISTON LAMB, FIRST VISCOUNT MELBOURNE. THE FIRST RESIDENT OF MELBOURNE HOUSE (AS ALBANY'S MANSION WAS ORIGINALLY KNOWN), 26-YEAR-OLD LORD MELBOURNE WAS DESCRIBED BY FRIEDMAN AS A "POLITICIAN ... COURTIER, PATRON AND COLLECTOR, SOCIETY HOST AND BON VIVANT ... [WHO HAD] INHERITED A FORTUNE."

THE STRATOSPHERIC £100,000 HE ALLOCATED FOR THE CONSTRUCTION OF MELBOURNE HOUSE MEANT THAT CHAMBERS COULD EMPLOY THE FINEST CRAFTSMEN OF THE DAY, INCLUDING DECORATIVE ARTISTS GIOVANNI BATTISTA CIPRIANI AND WILLIAM MARLOW. JAMES PAINE, AN ARCHITECT SCHOOLED

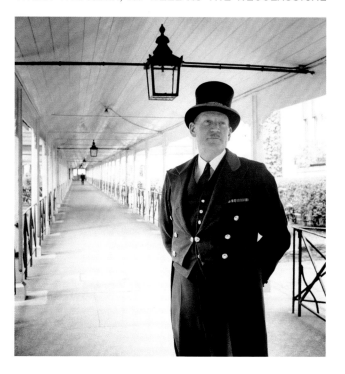

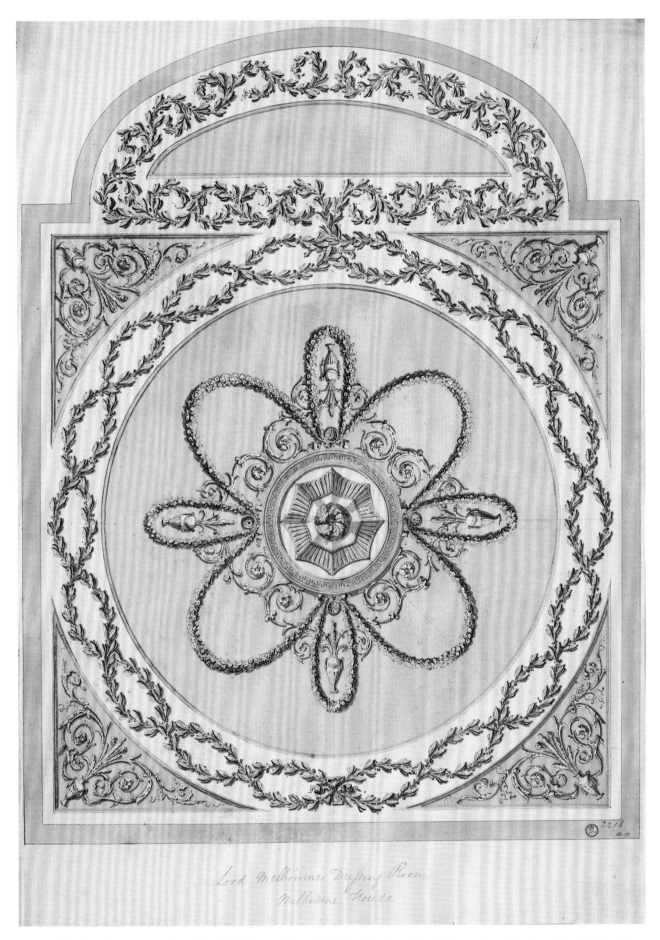

Lord Melbourne's Dressing Room
Melbourne House

ABOVE: Albany's only surviving ceiling design for Melbourne House by William Chambers hints at the grandeur of the decorative plasterwork.

SCULPTURE THAT THE STAIRWELL'S ALCOVES ONCE
EXHIBITED.

MERELY THREE DECADES AFTER MELBOURNE
HOUSE WAS BUILT, ITS FURNITURE, FIXTURES, AND
THE PAINTINGS OVER WHICH CHAMBERS AND HIS
SQUAD HAD LABORED, WERE AUCTIONED OFF IN
1802. BY NOW, THE DEVELOPER-ARCHITECT TEAM
OF ALEXANDER COPLAND AND HENRY HOLLAND
HAD ACQUIRED MELBOURNE HOUSE FROM GEORGE
III'S SON, PRINCE FREDERICK, DUKE OF YORK AND
ALBANY. HOLLAND PROCEEDED TO BUILD THE COM-
PLEX THAT IS TODAY KNOWN AS ALBANY, FIRST BY
DIVIDING UP MELBOURNE HOUSE INTO SINGLE-UNIT
BACHELOR'S QUARTERS AND, NEXT, ERECTING TWO
RANGES OF CHAMBERS THAT STRETCHED NORTH
FROM MELBOURNE HOUSE TO VIGO STREET AND
BURLINGTON GARDENS. THE COMPOUND EVENTU-
ALLY BECAME KNOWN AS "ALBANY" (TO COMMEM-
ORATE ITS ONE-TIME ROYAL OCCUPANT), RATHER

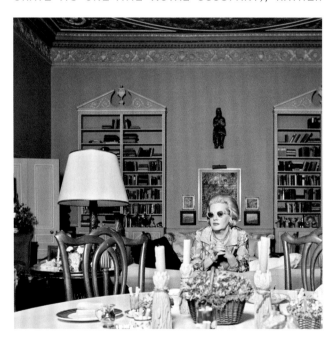

ABOVE: Fleur Cowles, the American writer, artist, and founder of the
directional fashion magazine *Flair*, lived in what is now Francis's "set" at
Albany for some 50 years from 1954.

THAN "THE ALBANY" BECAUSE, ACCORDING TO THE
PROPERTY'S LORE, ALBANY'S TRUSTEES (WHO SET
THE HOUSE RULES), DECIDED THAT THE LATTER
TITLE BROUGHT TO MIND "A PUBLIC HOUSE."

REFLECTING ON THE GUTTING OF MELBOURNE
HOUSE, DR. OLIVIA HORSFALL TURNER—THE
BRITISH ARCHITECTURAL HISTORIAN WHO IS THE
VICTORIA & ALBERT MUSEUM'S SENIOR CURATOR,
DESIGNS, AND LEAD CURATOR, V&A + RIBA
ARCHITECTURE PARTNERSHIP—REFLECTS: "THE
DEMOLITION MAY SEEM WASTEFUL TODAY. BUT
GIVEN THAT CONSPICUOUS CONSUMPTION DOMI-
NATED LONDON IN THE 18TH CENTURY IT WAS NOT
UNUSUAL. LORD MELBOURNE HAD ALSO GIVEN UP
HIS PALACE SO THERE WAS NO FAMILIAL LINK TO
PROTECT IT."

ONE ORIGINAL ARTIFACT THAT DATES BACK TO
THE BEGINNING OF MELBOURNE HOUSE IS THE
BUILDING'S ONLY SURVIVING WILLIAM CHAMBERS-
DESIGNED CEILING. THE DECORATIVE PLASTER-
WORK, WHICH DR. HORSFALL TURNER SUCCINCTLY
DESCRIBES AS "A CENTRAL MOTIF SURROUNDED
BY AN INTERWOVEN LAUREL LEAF BORDER, WITH
ARABESQUES IN THE SPANDRELS," WAS THE INSPI-
RATION FOR THE CEILING THAT TODAY LOOMS 5.3
METERS (17 FEET) ABOVE THE IMMENSE DRAWING
ROOM FOUND WITHIN FRANCIS AND DAVID'S NEW
ALBANY MANSION HOME. (IT WAS ORIGINALLY CON-
CEIVED AS MELBOURNE HOUSE'S STATE DRESSING
ROOM). CHAMBERS PLANS FOR THIS ORNATE CEIL-
ING DESIGN, WHICH HAVE BEEN PRESERVED AT
THE V&A SINCE 1857, REVEAL ITS "DELICATE"
YELLOW AND GREEN COLOR SCHEME. THESE PAS-
TEL SHADES ONCE COATED THE ENTIRE ROOM. BUT
WHEN FRANCIS FIRST ENTERED THE DOMAIN, THE
CEILING AND WALLS WERE COATED IN A "POWDERY,
PAINT-SHOP BLUE", HE EXPLAINS.

THIS HUE WAS THE HANDIWORK OF THE PREVIOUS
OCCUPANT OF HIS DWELLING, FLEUR COWLES. THIS
ARTIST, AUTHOR AND EDITOR OF THE SHORT-LIVED
FASHION MAGAZINE *FLAIR* OCCUPIED FRANCIS'S
SET FOR ABOUT A HALF-CENTURY FROM 1954, WHEN

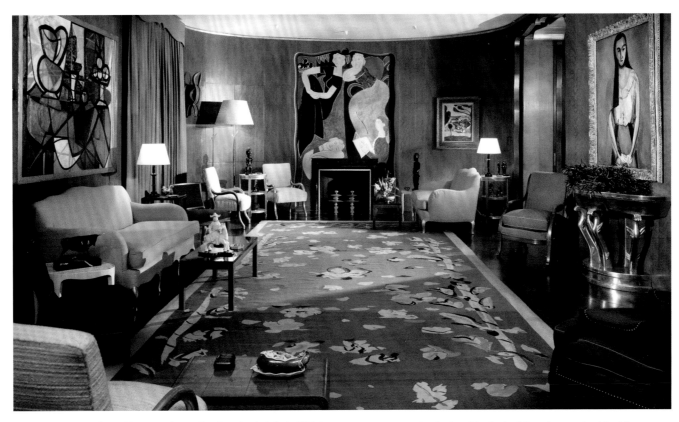

ABOVE: Jean-Michel Frank's 1930s décor of Nelson Rockefeller's Fifth Avenue apartment was inspirational to the look Francis conceived for Albany.

SHE MARRIED THE APARTMENT'S OWNER, TOM MONTAGUE-MEYER CBE, WHO BECAME HER FOURTH HUSBAND. AFTER THE BRITISH TIMBER TYCOON'S PASSING, FRANCIS OBTAINED THE PROPERTY.

COWLES "COULD HAVE BEEN A MILESTONE DECORATOR," BELIEVED HER GOOD FRIEND ELEANOR LAMBERT, THE NEW YORK FASHION PUBLICIST WHO CREATED THE INTERNATIONAL BEST DRESSED LIST. NEVERTHELESS, COWLES ENLISTED *FLAIR*'S ART DIRECTOR, FEDERICO PALLAVICINI (WHO DID OVER HELENA RUBINSTEIN'S PARK AVENUE, NEW YORK, APARTMENT IN THE 1950S) TO WORK WITH HER ON ALBANY. AND AFTER 10 MONTHS OF THEM TOILING TOGETHER (DURING WHICH TIME COWLES MONITORED THE DÉCOR FROM A TEMPORARY BASE AT THE NEARBY RITZ HOTEL) MR. & MRS. MONTAGUE-MEYER'S NEW HOME FEATURED AN INTERIOR WHICH REMAINED INTACT FOR A HALF-CENTURY. IT INCLUDED A "CANDY-PINK-COLORED BANQUETTE," GOLD-LEAF PANELS, A "WINDOWLESS" LEOPARD-PRINT-LADEN "MILK-YELLOW" STUDY (A REPLICA OF WHICH IS NOW THE FLEUR COWLES ROOM AT THE HARRY RANSOM CENTER IN AUSTIN, TEXAS), AND EVENTUALLY HER "ROMAN FORUM," AS COWLES CLASSIFIED HER BLUE DRAWING ROOM. HERE, SHE HOSTED AN ANNUAL BIRTHDAY PARTY FOR HER "BEST FRIEND" QUEEN ELIZABETH, THE QUEEN MOTHER. "PEOPLE ON BOTH SIDES OF THE ATLANTIC TALKED ABOUT FLEUR'S SALON-LIKE PARTIES, AT WHICH WRITERS, MOVIE STARS AND PAINTERS MIXED WITH LONDON SWELLS AND THE OCCASIONAL ROYAL," RECALLED DOMINICK DUNNE.

TODAY, FRANCIS'S DRAWING ROOM REMAINS BLUE. HOWEVER, IT IS A BOLDER SHADE OF BLUE THAN THAT WHICH COWLES HAD UTILIZED. FRANCIS DEVISED THE HUE TO EVOKE ONE HE HAD UNEARTHED IN THE DRAWING ROOM DURING THE 16-MONTHS HE DEVOTED TO REVIVING THE GLORY OF HIS SPECTACULAR HOME. THE TEAM OF 30 BUILDERS AND CRAFTSPEOPLE WITH WHOM HE CONDUCTED THE PRESERVATION WORK WAS NECESSARY DUE TO ALBANY'S STATUS AS A GRADE I LISTED BUILDING OF "EXCEPTIONAL INTEREST," WHICH, ACCORDING TO HISTORIC ENGLAND'S LEGISLATIVE LISTS, PREVENTS IT FROM DEMOLITION, EXTENSION, OR ALTERATION, WITHOUT "SPECIAL PERMISSION." PEELING BACK CENTURIES OF PLASTERWORK, FRANCIS UNEARTHED THE COLOR, WHICH INSTANTLY BROUGHT TO HIS MIND PORTLAND BLUE. THIS SHADE WAS PIONEERED IN 1775 AS A HALLMARK OF JOSIAH WEDGWOOD'S NAMESAKE CHINA AND PORCELAIN FIRM. "IT IS SUCH A BEAUTIFUL COLOR AND IT JUST NEEDED RESTORING," EXPLAINED FRANCIS OF THE SHADE NOW ENLIVENING HIS DRAWING ROOM.

LIKE MOST EVERYTHING WITHIN HIS ALBANY MANSION HOME—THE FIXTURES, FITTINGS, AND

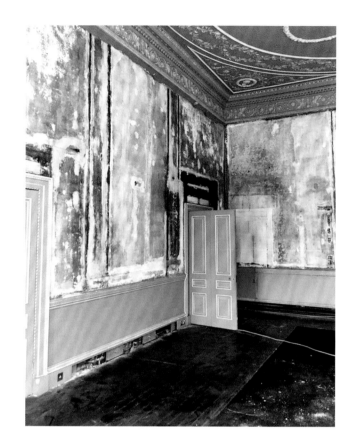

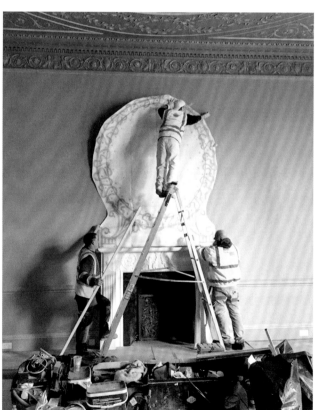

ABOVE: A team of 30 specialists was required for the restoration at Albany, due to its status as a Grade I listed building of "exceptional interest."

MOST OF THE FURNITURE—THE PAINT IS A SITE-SPE-CIFIC-INSPIRED ONE-OFF. "I WANTED EVERYTHING HERE TO BE CUSTOM MADE, EXACTLY THE WAY I WANTED IT," SAYS FRANCIS. "I DID NOT WANT ANY-THING 'READY.'" THIS METHOD OF PAINSTAKING CRAFTSMANSHIP, HE HOPES, "WILL PROVE INSPIR-ING TO SOMEONE, SOMEDAY."

BUT EVEN IF COWLES' SOFT COLOR SCHEME AND HER DECORATIVE FLOURISHES HAVE GONE THE WAY OF LORD MELBOURNE'S TREASURES, FRANCIS HAR-BORS AN AIM SIMILAR TO THAT OF HIS ASH-BLOND DOMESTIC PREDECESSOR—NAMELY, TO CREATE AN ENVIRON THAT WILL BE REMEMBERED AS "HIS-TORIC," HE ADMITS.

ONLY TIME WILL TELL IF HIS MISSION SUCCEEDS. BUT, EMBARKING UPON IT, FRANCIS MADE A WISE MOVE BY FACING UP TO THE FACT THAT THE STATE DRESSING ROOM CEILING OF WILLIAM CHAMBERS WILL ALWAYS BE THE STAR OF ALBANY'S MANSION. LOGICALLY, IMPORTANT DECORATIVE ASPECTS OVER WHICH THAT CEILING NOW HOVERS IN THE BLUE DRAWING ROOM WERE SIMPLY MOTIVATED BY FRANCIS, DAVID, AND THEIR PRIMARY COLLABORA-TOR, MATTIA BONETTI, LOOKING SKYWARD. "THE CEILING WAS A BIG INSPIRATION," CONCEDES FRANCIS. IT MOTIVATED A WHIMSICAL PATTERN EMBELLISHING A SIDEBOARD, FOR EXAMPLE, DESIGNED BY BONETTI TO "COVER THE RADIATOR," HE DIVULGES.

THE LAUREL LEAF PATTERN ADORNING A DAZZLING MATTIA BONETTI GILDED MIRROR—WHICH EMA-NATES FROM STYLIZED CORNUCOPIAS ABOVE THE MANTELPIECE—IS ANOTHER NOD TO THE ORNATE HISTORIC CEILING. HOWEVER, THE MIRROR'S MAS-SIVE HEIGHT OF 2.8 METERS (9 FEET) EVOKES THE GRAND PROPORTIONS THAT BONETTI IS RENOWNED FOR MANIPULATING TO CREATE THEATRICAL ATMO-SPHERE. RADIATING TOTAL GLAMOUR AS IT PRE-SIDES OVER THE DRAWING ROOM LIKE A PERFECT SUNSET, THE LOOKING GLASS IS PURE BONETTI—IN OTHER WORDS, "MONUMENTAL AND DEMAND[S] YOUR ATTENTION," AS PENELOPE GREEN OF THE

NEW YORK TIMES HAS DESCRIBED THE SWISS-BORN ARTIST'S TENDENCY TO WORK WITH EPIC DIMEN-SIONS TO CONJURE BRILLIANT DESIGNS.

"IT IS A CONTEMPORARY CHIPPENDALE," SAYS FRANCIS OF THE GLEAMING MIRROR THAT GLEANS MODERNITY FROM ITS RESIN MATERIAL, RATHER THAN THE GILTWOOD ONCE UTILIZED IN THE CABI-NETMAKER'S WORKSHOPS OF THE 18TH CENTURY. "IT'S A FREE INTERPRETATION OF SUCH THINGS," OBSERVES BONETTI OF THE CHIPPENDALE REFER-ENCE. "MAYBE MY STYLE IS TO LOOK BACK BUT ALSO TO LOOK FORWARD AND COMBINE BOTH IN A CON-TEMPORARY WAY."

ABOVE: Francis Sultana photographed by Chris Floyd in 2017 during the restoration of the Albany Mansion set.

THE HARMONY GOVERNING FRANCIS AND DAVID'S COLLABORATION WITH BONETTI ON ALBANY CERTAINLY PROVED THE ANTITHESIS TO CHIPPENDALE'S EXPERIENCE WORKING WITH WILLIAM CHAMBERS THERE. THE SWEDISH-SCOTTISH ARCHITECT WAS A MICRO-MANAGER WHO DESCRIBED HIMSELF TO LORD MELBOURNE AS A "CONNOISSEUR IN FURNITURE." HE CLASHED WITH CHIPPENDALE DURING THE CONSTRUCTION OF MELBOURNE HOUSE BECAUSE THE ARCHITECT FELT THE CABINET MAKER WAS OPERATING "ALTOGETHER TOO INDEPENDENTLY" AFTER HE HAD BELATEDLY DELIVERED SOME DRAWINGS.

BY CONTRAST, THE PROCESS OF ENLIVENING FRANCIS AND DAVID'S DOUBLE SET FOR THE 21ST CENTURY EVOLVED ORGANICALLY, BONETTI RECALLS, LARGELY BECAUSE OF THEIR FAMILIARITY. BONETTI HAS BEEN REPRESENTED BY THE DAVID GILL GALLERY SINCE 1988, EVOLVING FROM THE PARISIAN "BARBARIAN" FAMED FOR UPENDING THE TRADITION OF HIS MÉTIER—WITH THE RADICAL INTERIOR DESIGN HE AND HIS FORMER PARTNER, ELIZABETH GAROUSTE, EXECUTED FOR LE PALACE NIGHTCLUB, CHRISTIAN LACROIX'S COUTURE HOUSE, AND GLORIA, PRINCESS OF THURN AND TAXIS' RESIDENCES, AMONG OTHERS—TO HIS CURRENT IDENTITY AS A SOLO ARTIST FAMED FOR CRAFTING THE "FANTASTICAL," LIKE HIS STEEL AND BRONZE "ABYSS" DINING TABLE, AND, RECENTLY, A HONG KONG BUILDING INCORPORATING FOUR APARTMENTS FOR THE EXTENDED FAMILY OF A LOYAL COLLECTOR. "WE SHARE THE SAME REFERENCES," BONETTI SAYS OF HIS LONGTIME PROFESSIONAL RELATIONSHIP WITH FRANCIS AND DAVID: "THEY ARE ALSO VERY FREE WITH THEIR CHOICES SO I CAN LET MYSELF GO, WHICH IS A GOOD WAY TO WORK."

FRANCIS ATTRIBUTES THE INSPIRATION FOR THE REST OF THE DRAWING ROOM—THE RADIANT COLOR SCHEME OF HIS BRONZE UPHOLSTERED FURNITURE, BONETTI'S MAGNIFICENT FLORAL CARPET, AND THE GILDED HUES EMPLOYED AMIDST THE REST OF THIS ALBANY MANSION HOUSEHOLD—TO ANOTHER LANDMARK DECORATIVE COLLABORATION THAT TOOK PLACE CENTURIES AFTER THE GEORGIAN ERA, NOT TO MENTION ACROSS THE POND, IN UPPER MANHATTAN, ON THE EVE OF WORLD WAR II. THIS WAS THE MASTERMINDING OF NELSON ROCKEFELLER'S 32-ROOM TRIPLEX APARTMENT AT 810 FIFTH AVENUE, ON WHICH THE SCION OF THE STANDARD OIL FAMILY (AND LATTER-DAY POLITICIAN) WORKED WITH THE ARCHITECT WALLACE K. HARRISON AND JEAN-MICHEL FRANK, WHO IS ONE OF FRANCIS'S DESIGN HEROES. "JEAN-MICHEL FRANK IS ONE OF MY MOST IMPORTANT INFLUENCES—BOTH THE WAY HE WORKED AND THE CLIENTS HE HAD," EXPLAINS FRANCIS. "THE MOST OUTSTANDING HISTORICAL ROOM, TO ME, OF THE 20TH CENTURY—ONE OF THE GREAT SALONS—WAS THE ONE FRANK DESIGNED FOR NELSON ROCKEFELLER'S FIFTH AVENUE APARTMENT."

IT MAY SEEM UNLIKELY THAT IN OUR POLITICALLY FRAUGHT ERA FRANCIS SOUGHT INSPIRATION IN AN HISTORICAL FIGURE WHO SERVED AS THE 41ST VICE PRESIDENT OF THE UNITED STATES. HOWEVER, FRANCIS—WHO HAS RANKED ON THE AD100 CONSECUTIVELY FOR THREE YEARS SINCE 2016—AND ROCKEFELLER, THE GRANDSON OF STANDARD OIL'S CO-FOUNDER, JOHN D. ROCKEFELLER, ARE SURPRISINGLY SIMILAR. BOTH EMBARKED ON THEIR AMBITIOUS DOMESTIC DESIGN PROJECTS AS THEY FOSTERED ART INSTITUTIONS. TO WIT, AMIDST HIS RESTORATION OF ALBANY, FRANCIS WAS NAMED AMBASSADOR OF CULTURE TO MALTA. THIS DIPLOMATIC POSITION HONORS HIS LONGSTANDING CHAMPIONING OF HIS HOMELAND INTERNATIONALLY, AS WELL AS HIS WORK SECURING MALTA'S RETURN TO THE VENICE BIENNALE. WITH PHYLLIS MUSCAT, CHAIRPERSON OF THE MALTA INTERNATIONAL CONTEMPORARY ART SPACE (MICAS), FRANCIS IS HELPING TO MAKE THIS INSTITUTION (WHICH OPENS IN 2021) THE LEADING PLATFORM FOR VISUAL ARTS EMANATING FROM MALTA AND ITS SURROUNDING EURO-MEDITERRANEAN REGION.

AS FOR ROCKEFELLER, IN THE 1930S, WHILE HE SUPPORTED HIS MOTHER, ABBY ALDRICH ROCKEFELLER'S AMBITION TO OPEN NEW YORK'S MUSEUM OF MODERN ART (MOMA)—FIRST AS A MEMBER OF ITS ACQUISITIONS COMMITTEE AND, BY 1939, AS ITS PRESIDENT—HE SET OUT TO "DECORATE" HIS FIFTH AVENUE PENTHOUSE IN THE "MODERN STYLE" COMPLETE WITH A "SETTING" CONJURED BY FRANK TO "LAVISHLY ENTERTAIN."

BY THE TIME ROCKEFELLER HAD ENGAGED FRANK'S

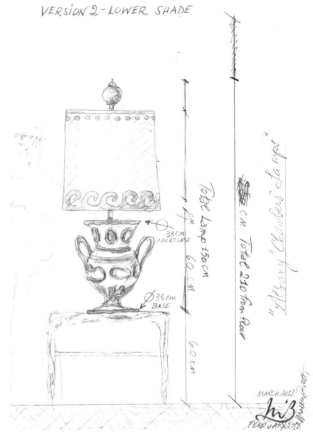

VERSION 2 - LOWER SHADE

Mattia Bonetti's preliminary drawings of lamps and a sideboard he designed for Albany's blue drawing room. These include (top right) a set of four handmade, mouth-blown Venetian lamps, and (top and bottom, left) two floor lights featuring white sculpted Carrara marble bases and stems of hand-carved, painted wood. The urns, painted in a trompe-l'oeil of porphyry, were made of sculpted wood with and handles and base of wrought iron gold leaf. The console drawing (above) depicts a blue-black body of lacquered wood, with garlands and feet of black patinated cast bronze, and a white Carrara marble top.

"The Albany" Drawing Room, Rug
Wool & Silk

OCTOBER 2017

ABOVE: Mattia Bonetti's sketch of a hand-tufted wool-and-silk rug for the blue drawing room.

SERVICES IN 1938, HE WAS ALREADY A NOTE-WORTHY COLLECTOR WHOSE "FAVORITE WEEKEND RECREATION WAS TO GRAB A HAMMER, STUFF HIS POCKETS WITH NAILS AND REARRANGE CANVASES SIGNED BY PICASSO, MIRÓ, HOPPER, GRIS AND OTHER GIANTS OF 20TH-CENTURY PAINTING," NOTED HIS BIOGRAPHER, RICHARD NORTON SMITH. MEANWHILE, AS THE DISASTER OF WORLD WAR II LOOMED AND HIS "BUSINESS FELL OFF," FRANK HAD "TONED DOWN," HIS "NO FRILLS" STARK MINI-MALISM. IF SHAGREEN AND PARCHMENT WERE UTI-LIZED "LESS FREQUENTLY," LOUIS XV-INSPIRED PRECIOUS MATERIALS ABOUNDED, INCLUDING THOSE WHICH FRANCIS HAS WORKED LIBERALLY THROUGHOUT ALBANY, INCLUDING GILDING AND GOLD LEAF AS WELL AS ROCK CRYSTAL.

WITHIN ROCKEFELLER'S ENTERTAINING DOMAIN, THE TYCOON AND HIS DECORATOR WORKED WITH HENRI MATISSE AND FERNAND LÉGER TO CON-CEIVE FLOOR-TO-CEILING MURALS, WHICH WERE INCORPORATED INTO WOOD PANELING SURROUND-ING THE DRAWING ROOM FIREPLACES. IN FRANCIS'S BLUE DRAWING ROOM HANG A SERIES OF 2014 MIRROR PAINTINGS BY ARTE POVERA'S FOUNDER, MICHELANGELO PISTOLETTO. AND THERE IS OVID-BATHER, THE OIL PAINTING CONCEIVED BY CHRIS OFILI IN REPLY TO THE INVITATION OF THE NATIONAL GALLERY, LONDON, TO SPEND TWO YEARS INTER-PRETING THREE TITIANS.

MATTIA BONETTI'S ABSTRACT TAKE ON THE BRONZE LAMPS THAT ALBERTO AND DIEGO GIACOMETTI CRAFTED FOR ROCKEFELLER—AS A RESPONSE TO THE ANTIQUITIES DISCOVERED BY HOWARD CARTER IN KING TUTANKHAMUN'S VALLEY OF THE KINGS TOMB IN 1922—ARE A PAIR OF POSTMODERN CAN-DELABRAS. BONETTI'S ALLURING LIGHT FIXTURES ARE GROUNDED BY HAND-CARVED WHITE CARRARA MARBLE CUBES FROM WHICH EMANATE ORNAMEN-TAL PLINTHS TOPPED WITH FAUX PORPHYRY URNS. "THE IDEA IS ARCHEOLOGY—TO EVOKE THE GRAN-DEUR AND LOOK OF A POMPEII EXCAVATION," SAYS MATTIA, OF THE JAGGED EDGES ON HIS DAZZLING VESSELS. "THE BROKEN-LIKE ASPECT OF THE URNS SUGGEST THAT THESE WERE UNEARTHED OBJECTS. THESE PIECES ARE THEATER."

ROCKEFELLER'S UPPER MANHATTAN LAIR PROVED TO BE JEAN-MICHEL FRANK'S FINAL PROJECT. UNABLE TO PSYCHOLOGICALLY WEATHER THE PER-SECUTION OF HITLER'S REGIME IN PARIS—UNLIKE HIS DECORATIVE COLLABORATORS—HE LEAPT TO HIS DEATH FROM A WINDOW AT NEW YORK'S ST. REGIS HOTEL IN 1941, TWO YEARS AFTER COM-PLETING WORK ON 810 FIFTH AVENUE.

FRANCIS'S JOYOUS ODE TO FRANK'S MASTERLY DÉCOR FOR ROCKEFELLER, MUCH OF WHICH WAS AUCTIONED BY SOTHEBY'S IN NOVEMBER 2018, IS A SUMPTUOUS HAND-TUFTED MATTIA BONETTI FLO-RAL RUG BEAUTIFYING THE DRAWING ROOM. CONJURING ITS MADCAP DESIGN, FRANCIS AND MATTIA LOOKED TO A LEGENDARY PAIR OF AUBUSSON CARPETS THAT FRANK HAD COMMISSIONED THE ART-IST CHRISTIAN BÉRARD TO MAKE FOR 810 FIFTH AVENUE. ALBANY'S HOMAGE FEATURES A TUR-BO-CHARGED TAKE ON THE PLAYFUL MOTIFS THAT BÉRARD PRODUCED IN A MANNER RECALLING THE ILLUSTRATIONS HE MADE FOR THE INTERNATIONAL EDITIONS OF VOGUE AND GABRIELLE "COCO" CHANEL, AMONG OTHER COUTURIERS WITH WHOM HE WAS FRIENDLY. "BÉRARD WAS ALWAYS ABOUT FLOWERS," STATES FRANCIS. "AND PEOPLE TODAY ARE OFTEN AFRAID OF FLOWERS, IN A FUNNY WAY. BUT I HAD TO HAVE NO FEAR IN THIS ROOM. THE ONLY THING THAT CONCERNED ME IN TERMS OF ITS INTERIOR DESIGN WAS WHETHER TO HANG CUR-TAINS." FRANCIS DECIDED AGAINST DOING THAT, AT LEAST FOR THE MOMENT.

AS FOR THE RUG, HE DESCRIBES THE GIANT BLOOMS AS A CROSS "BETWEEN BÉRARD'S DELICATE FLO-RALS AND ANDY WARHOL'S POPPIES." "THEY JUMP OUT AT YOU, WHICH IS WHAT I LOVE," HE EXPLAINS. I DISCUSSED THE COLORS WITH MATTIA. I WANTED PASTELS SO WE WENT FOR BABY BLUE, THE PINK, THE YELLOW AND THE GREEN BECAUSE THEY WENT WITH ALL OF MY UPHOLSTERY FABRICS IN THE ROOM. AND THE BLUE WAS IMPORTANT BECAUSE THIS ROOM IS BLUE. YOU CAN'T CHANGE HISTORY. WHY WOULD YOU?"

INDEED.

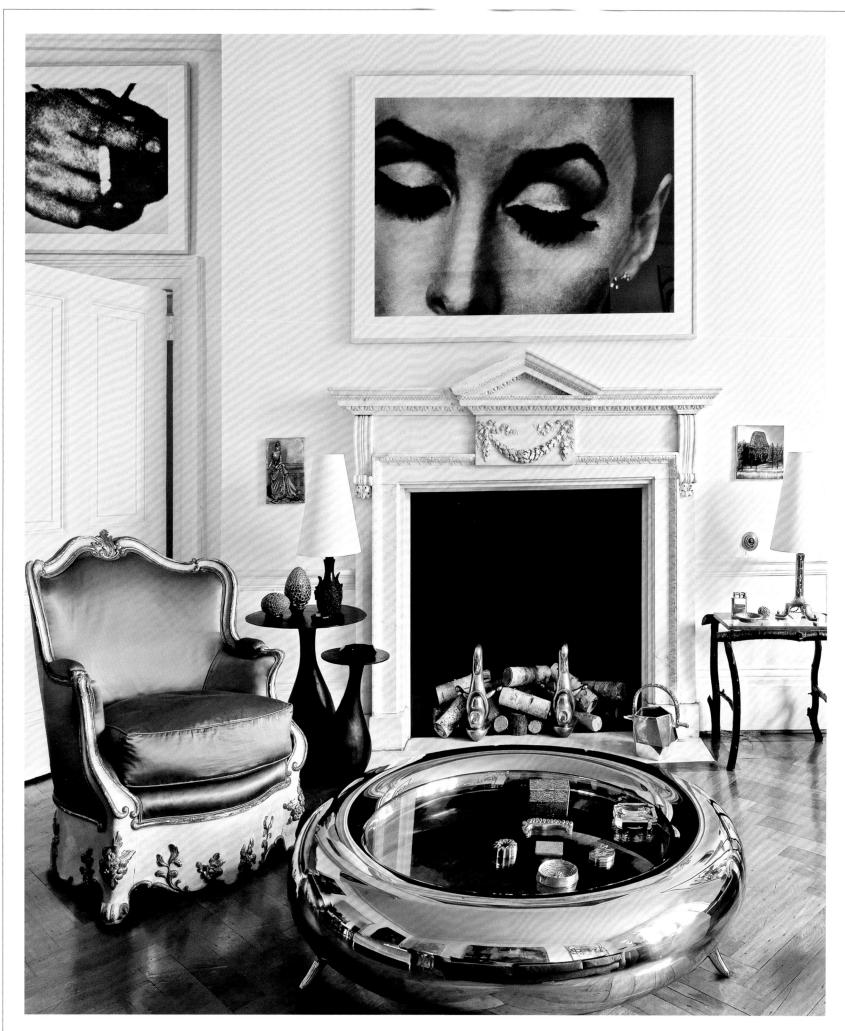

The First Set
Albany, London

Francis Sultana moved into a duplex apartment at Albany in the summer of 2007 and masterminded its décor in merely eight weeks. Over time, furniture came and went. However, the radical Baroque aesthetic he originally conceived always defined the atmosphere. The look—by turns startling and seductive—was the result of Francis's fearless mix of museum-worthy art with groundbreaking designs mostly produced by the decorative artists with whom he worked closely at the David Gill Gallery.

The heart of his first Albany apartment was Francis's trophy—the "Beistegui" chair. The armchair rendered its name from its original recipient, Carlos de Beistegui. It was made by Emilio Terry in the 1930s for the Champs-Élysées penthouse apartment Le Corbusier created for the eccentric French-born Spanish collector. Making it his own for Albany's drawing room, Francis had it upholstered in lavish emerald silk.

Elizabeth Garouste and Mattia Bonetti's iconic 1999 chrome "Ring" coffee table proved the drawing room's centerpiece. Ulrika Liljedahl cushions, beautified by manually applied shimmering sequins, rested upon supple velvet sofas. There were sinuous resin and metal shelving units from Zaha Hadid's Dune Formations furniture line, which debuted at the 2007 Venice Biennale.

Above Francis's drawing room mantelpiece hung an early Richard Prince photograph, *Untitled (eyelashes)*, 1982–1984. Above the dining room mantelpiece was another work by Prince, produced for his *Cowboy* series. Intensifying the spectacle of this domain—in which Francis hosted great dinner parties— were an unusual set of 1950s dining chairs (auctioned from nearby Fortnum & Mason), along with dramatic Josh Smith expressionist canvases. These hung above a pair of André Arbus stone consoles that rested upon cherub pedestals.

Francis Sultana and David Gill's original Albany home dazzled onlookers due to the surreal, postmodern elegance the pair conjured by displaying the *NE PLUS ULTRA* of contemporary art and design against a rarefied Georgian backdrop.

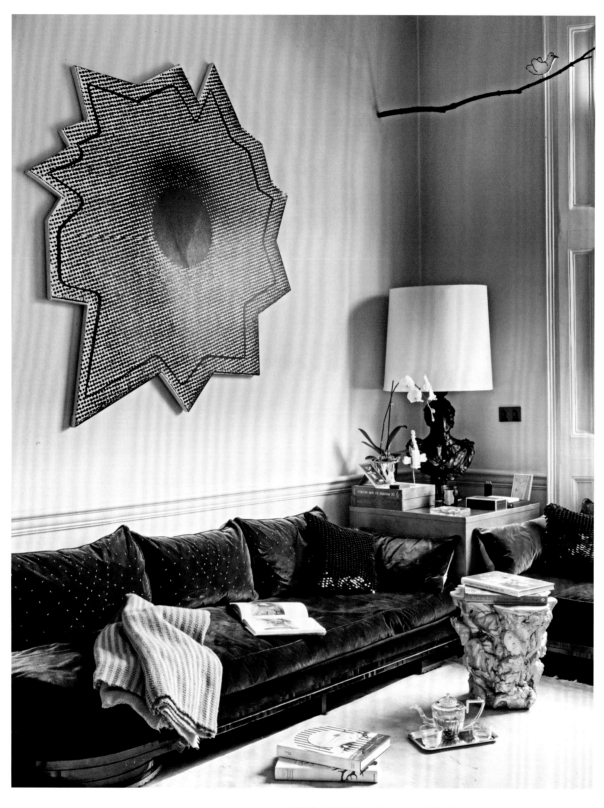

ABOVE & RIGHT: In the study, Ulrika Liljedahl sequined cushions adorn a pair of deep purple Eugene Printz sofas, with Fredrikson Stallard's "Rubber (Gold)" side table, 2007, at arm's reach. Liljedahl's sequined cushions reappear in the main living room on silver-grey velvet sofas by Francis Sultana, arranged around his "Astrid" coffee table.

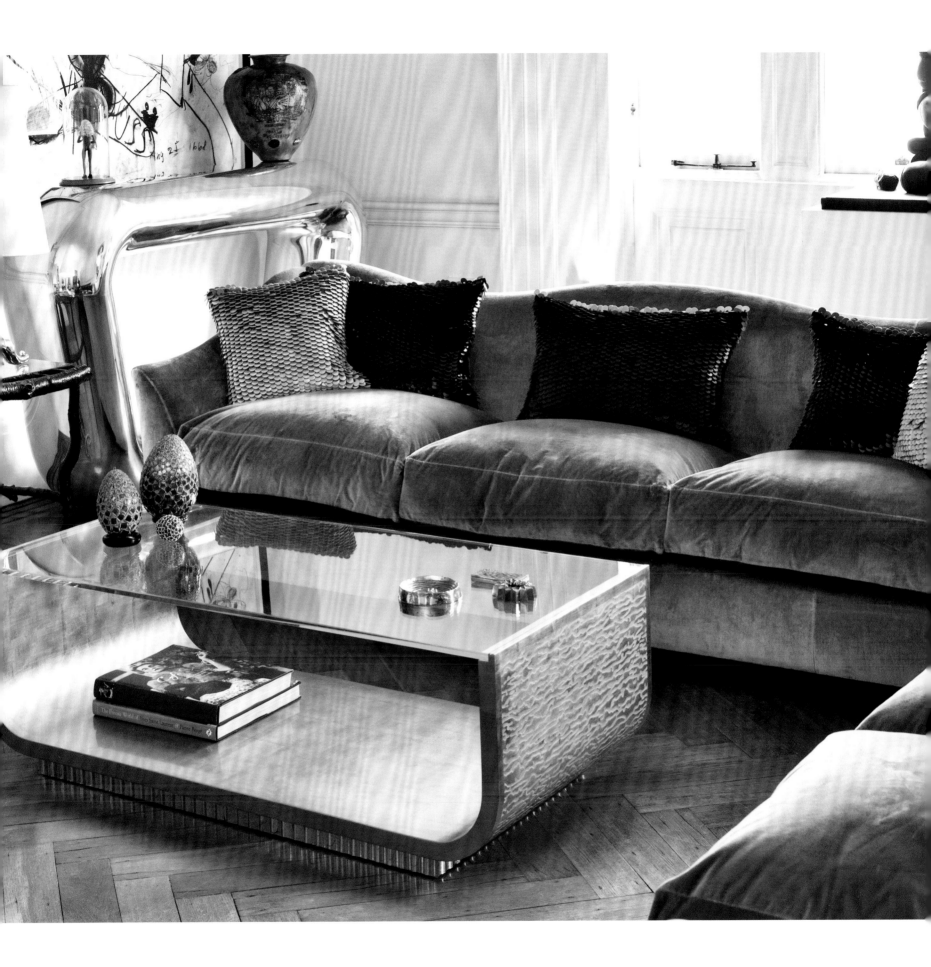

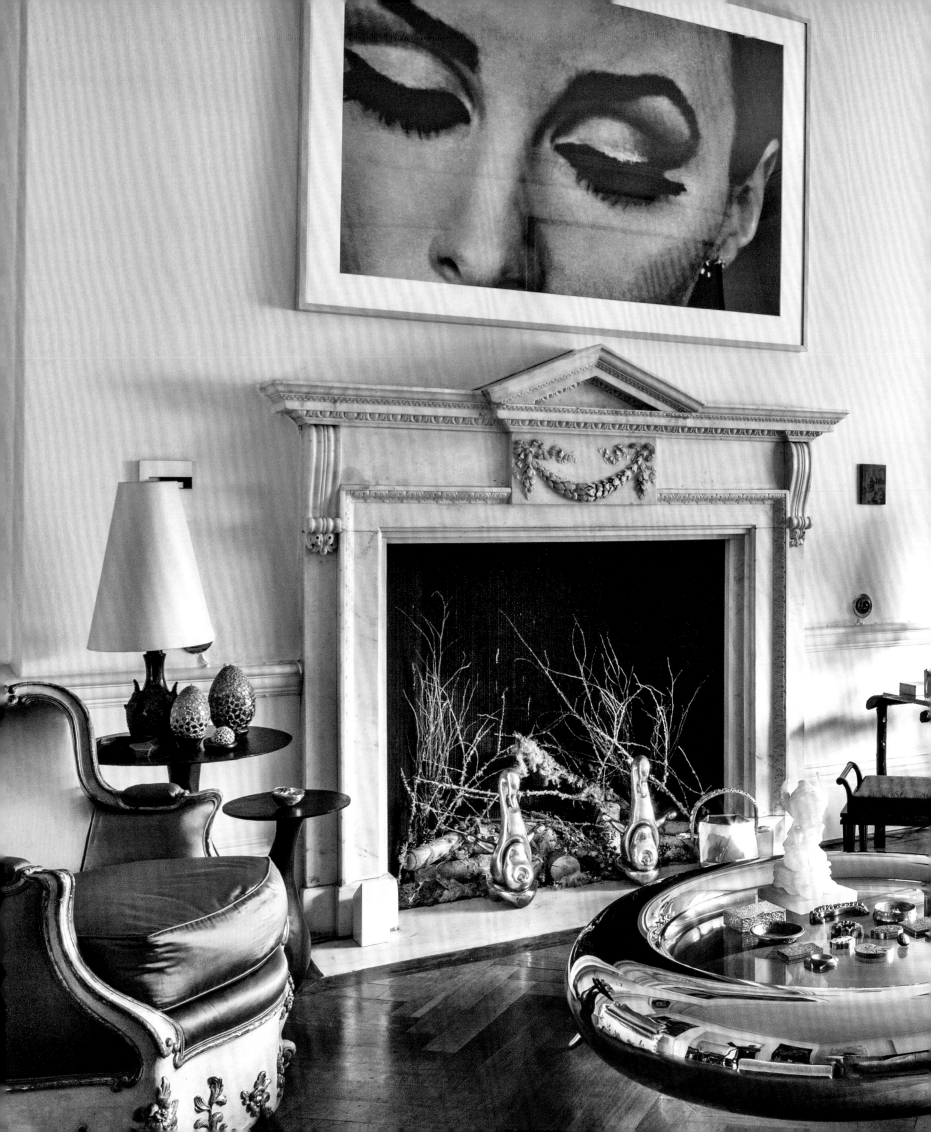

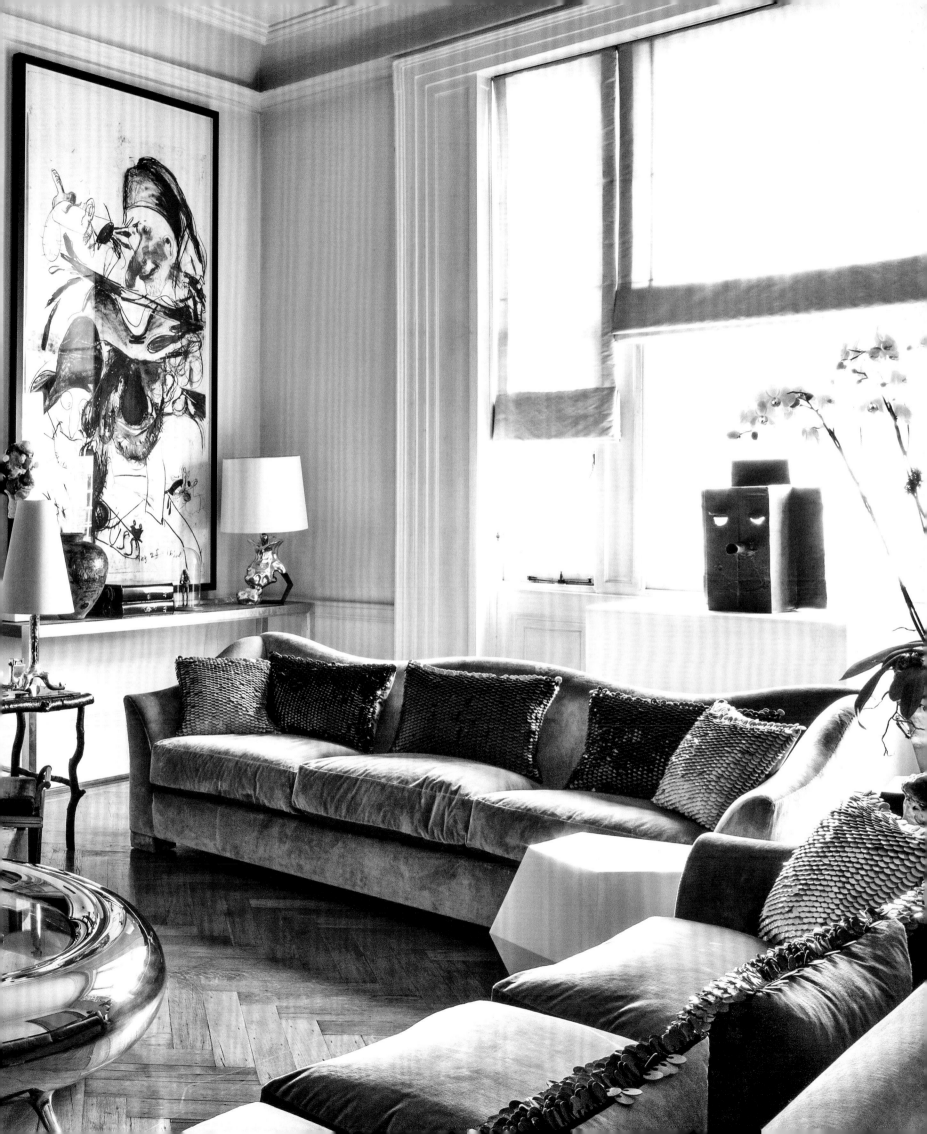

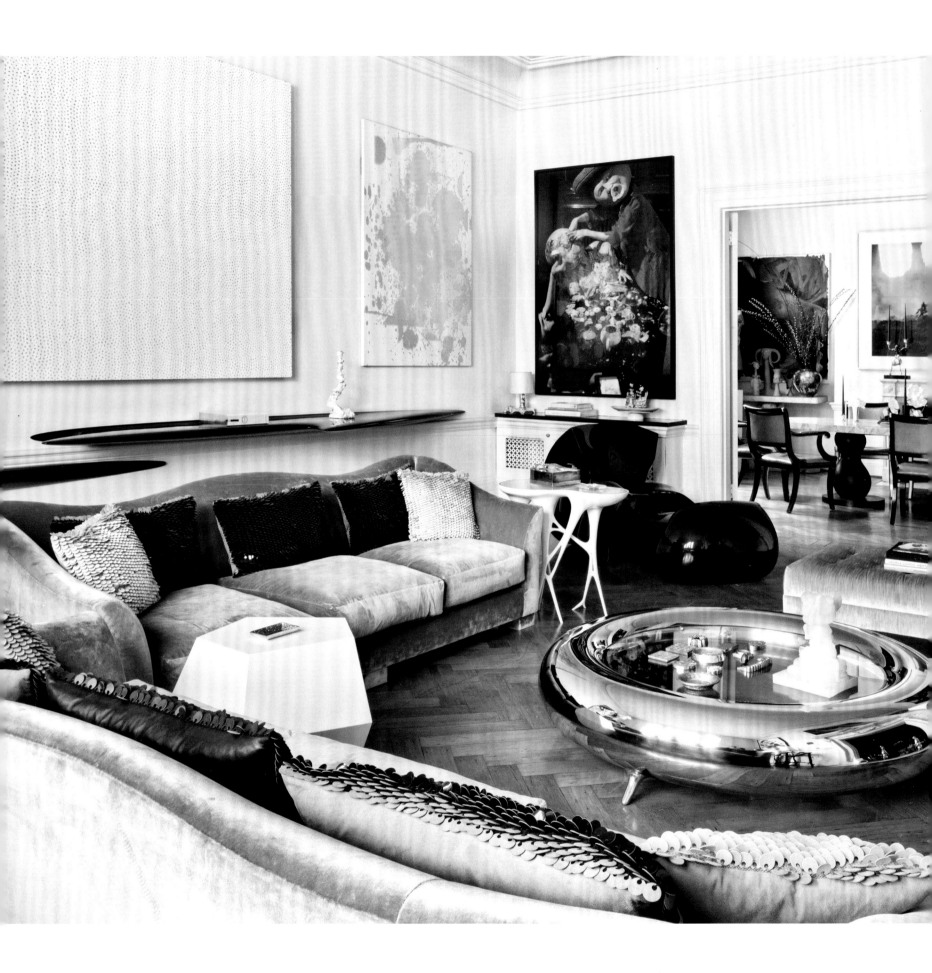

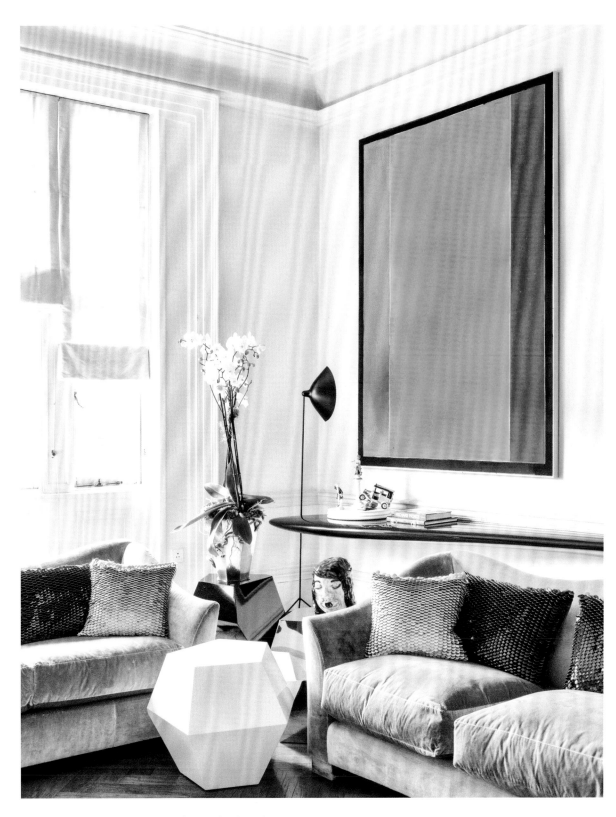

PP90–91, LEFT & ABOVE: Francis Sultana sofas share the sitting room with a green satin "Beistegui" chair by Emilio Terry and Fredrikson Stallard's black fiberglass "King Bonk" armchair and ottoman, 2007. In the center of the room, Garouste & Bonetti's "Ring" coffee table, 1999, underpins a collection of Line Vautrin boxes and the small silicone *Pinocchio* by Paul McCarthy, 2000.

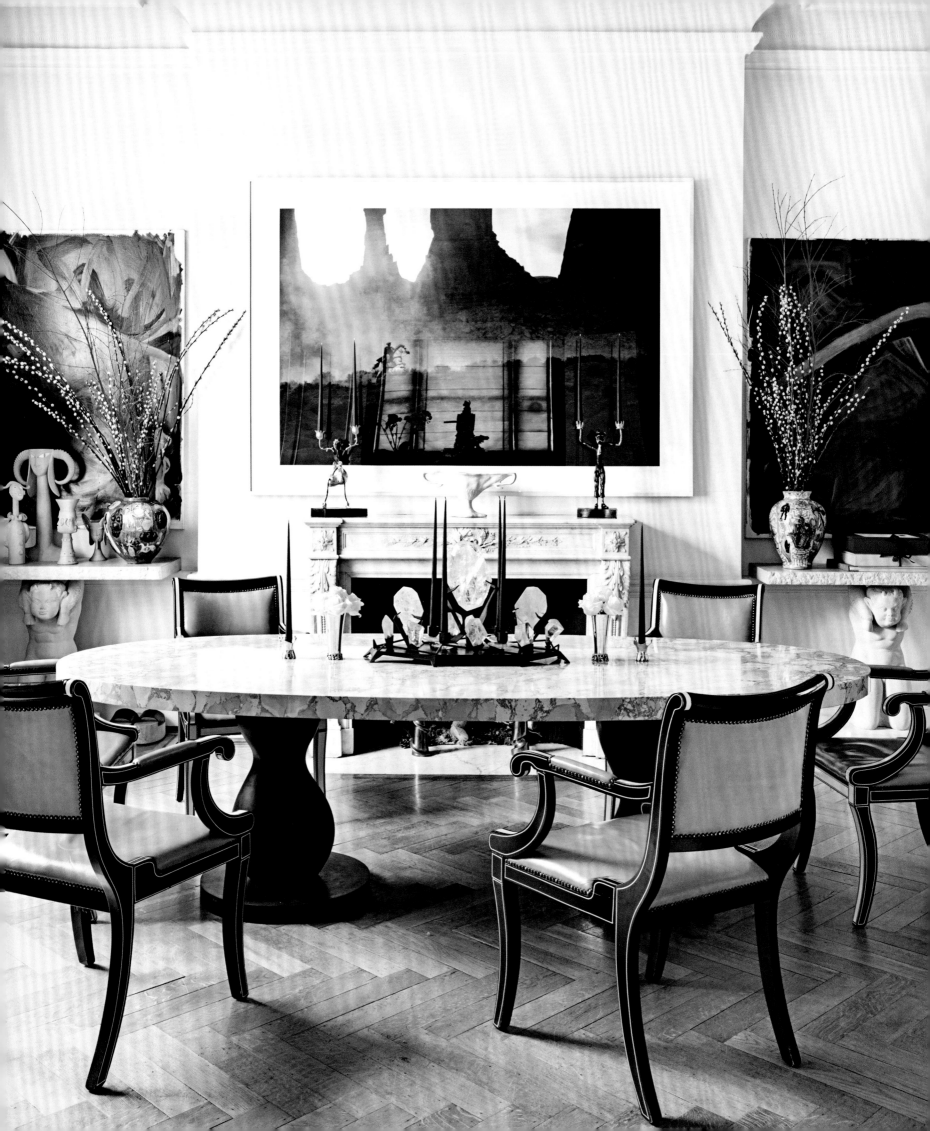

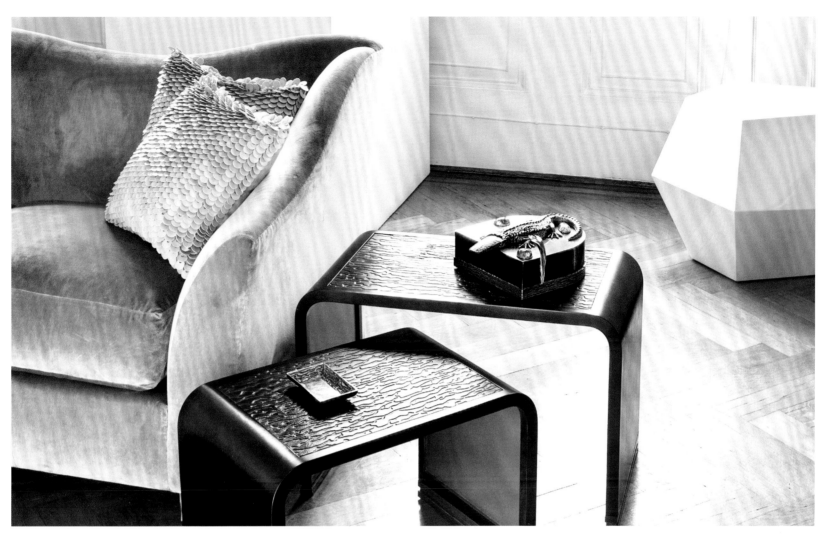

OPPOSITE: On the bespoke scagliola marbleized top of Garouste & Bonetti's "Salome" dining table are silver vases by Richard Vallis and candelabra by André Dubreuil. *Untitled* by Richard Prince, 1997, hangs on the wall behind "Boy" and "Girl" candlesticks by Garouste & Bonetti, 1994, and a Constance Spry vase. Flanking the chimney breast in front of Josh Smith paintings are two Grayson Perry vases atop vintage 1940s cherub consoles. ABOVE: Ulrika Liljedahl cushions nestle on one end of Francis Sultana's sofa, next to his "Diala" nest of tables. In the corner is Mattia Bonetti's white "Polyhedral," 2004. LEFT: Francis Sultana's "Eduardo" table lamp and a Grayson Perry vase stand on an "Alu" polished aluminum console by Mattia Bonetti.

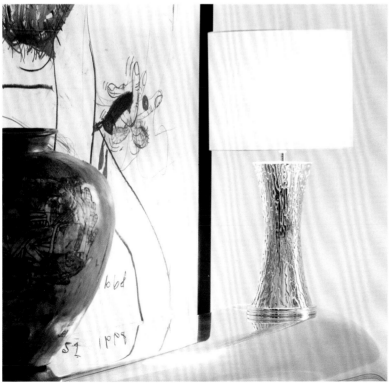

ABOVE: Sunlight streams in through Albany's original Georgian sash windows to brighten a corner of the study. RIGHT: A white bedroom scheme along 1930s lines is given a whimsical twist with an artwork based on vintage movie posters.

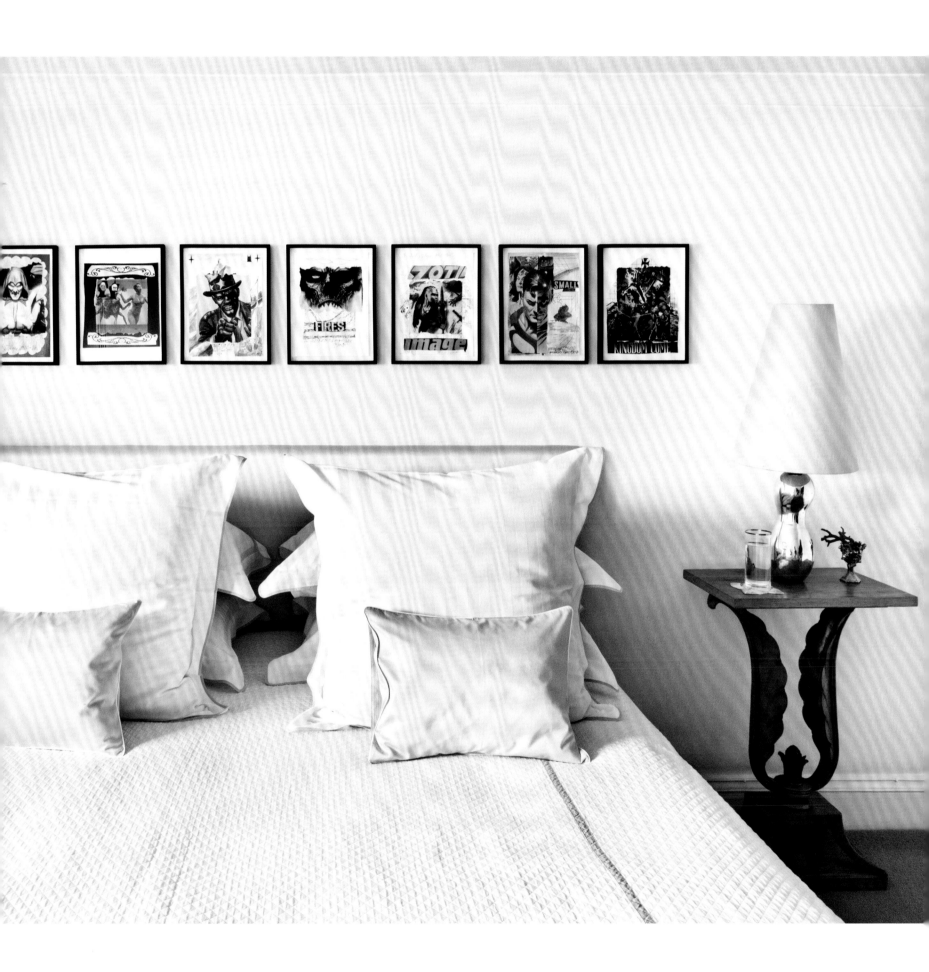

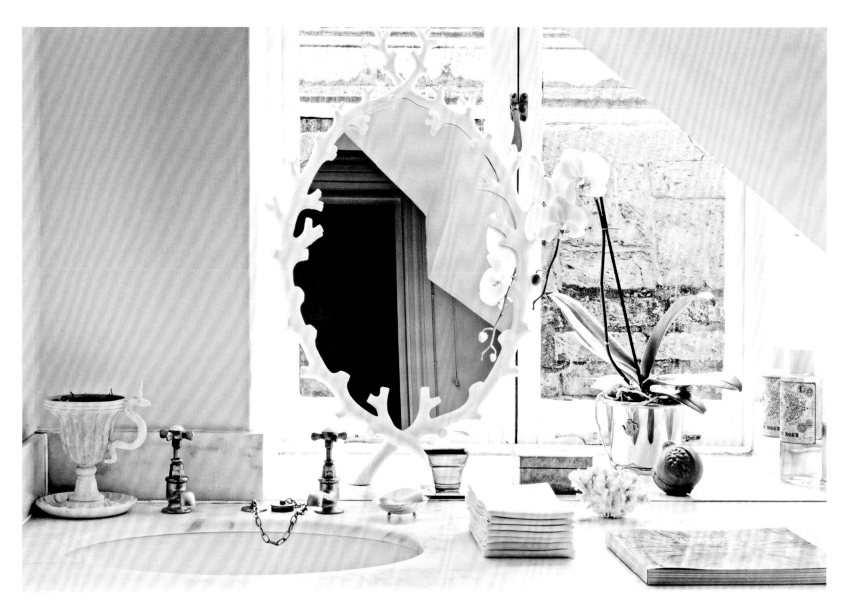

ABOVE: In a marble bathroom, a "Coral" mirror by Oriel Harwood and a white orchid stand beside one another on the deep window sill. RIGHT: In one corner of the kitchen, glass shelves are lined with a neat arrangement of vintage silverware, tea canisters, and candles. OPPOSITE: Oriel Harwood's "Palm" mirror accentuates a classical black and white bathroom scheme.

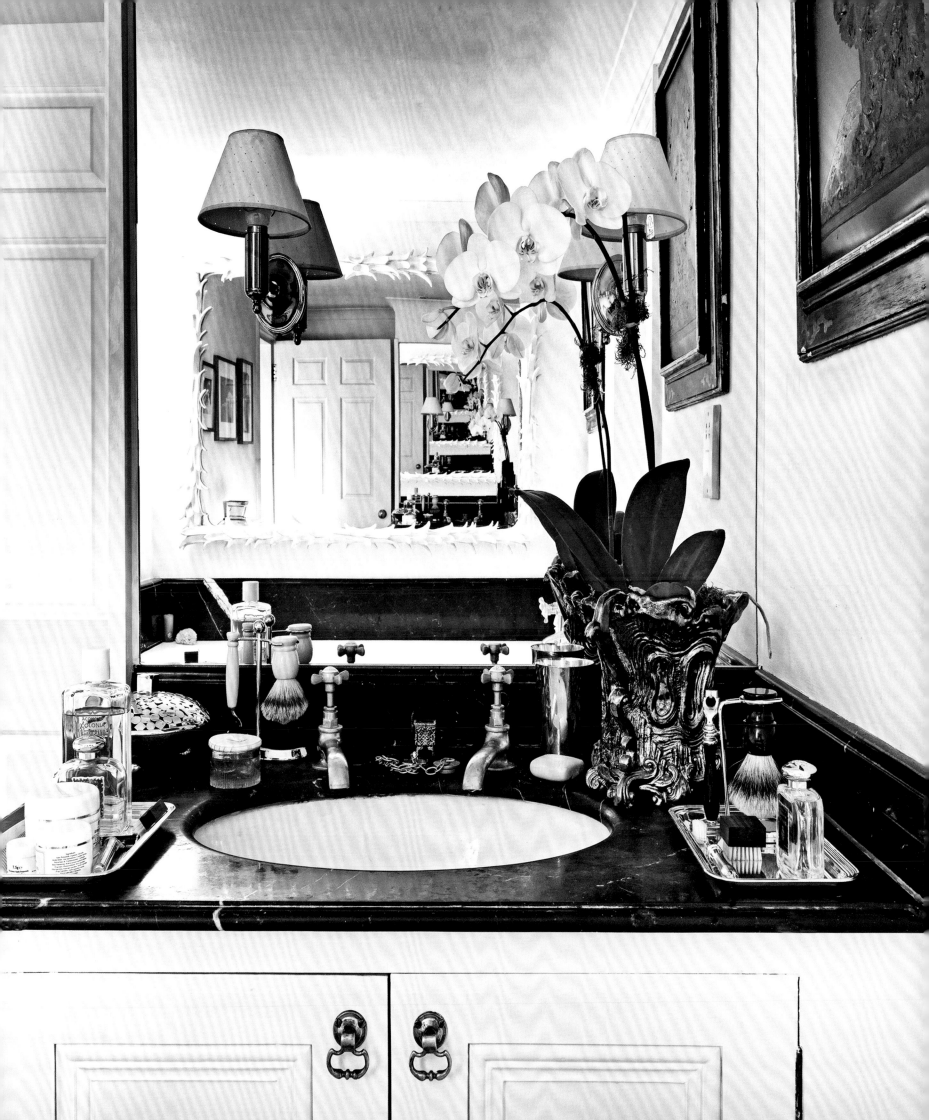

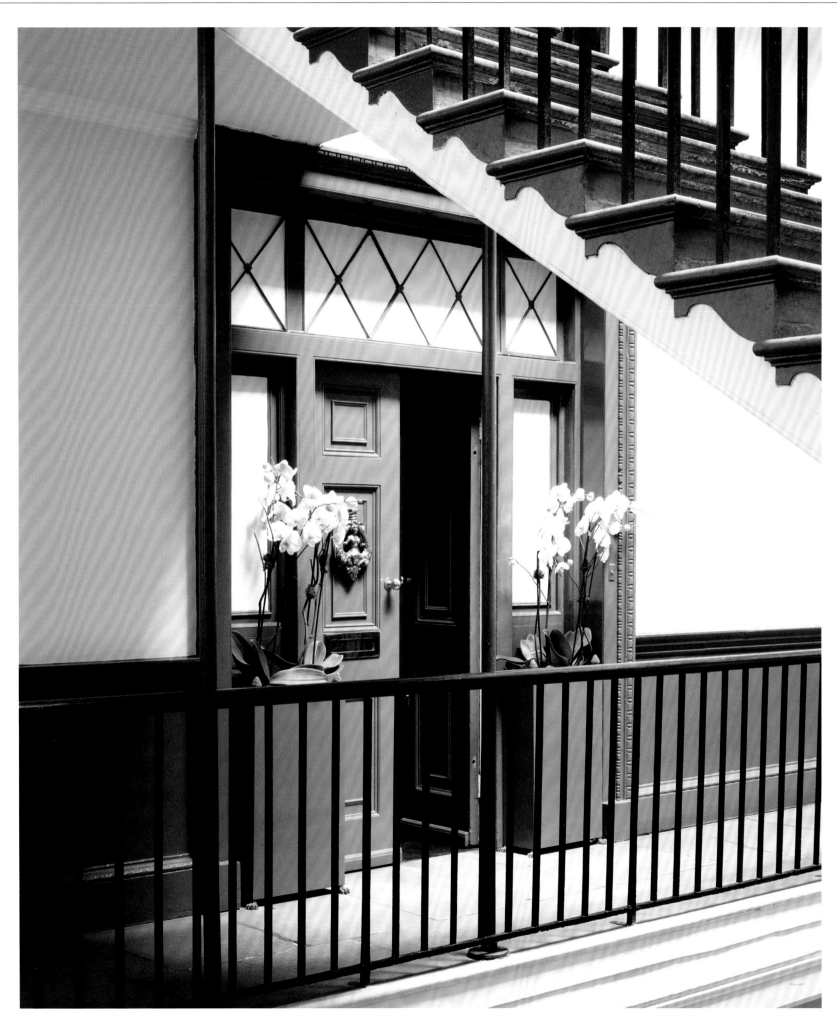

THE DOUBLE SET
ALBANY, LONDON

IN 2016 FRANCIS SULTANA MOVED FROM HIS ALBANY DUPLEX TO A MORE EXPANSIVE SETUP WITHIN ALBANY'S "MANSION". THIS BUILDING WAS ORIGINALLY CONCEIVED IN 1771 AS A PALACE (CALLED MELBOURNE HOUSE) FOR PENISTON LAMB, FIRST VISCOUNT MELBOURNE, BY THE SCOTTISH-SWEDISH ARCHITECT SIR WILLIAM CHAMBERS.

FRANCIS'S DWELLING WITHIN THE MANSION FEATURES A DRAWING ROOM THAT ONCE SERVED AS LORD MELBOURNE'S STATE DRESSING ROOM (OR VIP GUESTROOM). LOOMING ABOVE THIS AWE-INSPIRING DOMAIN IS A RARE ARTIFACT—NAMELY, AN ORNATE PLASTERWORK CEILING DESIGNED BY CHAMBERS.

DURING THE 16-MONTH RENOVATION PERIOD THAT FRANCIS CONDUCTED WITH A TEAM OF 30 BUILDERS AND CRAFTSPEOPLE, CHAMBERS'S CEILING WAS RESTORED TO ITS FORMER GLORY. AND WHILE THE DIMENSIONS OF FRANCIS'S ABODE MAY BE IMPOSING, ITS CHARM AND AWE-INSPIRING SUMPTUOUSNESS ARE DERIVED FROM HIS ADHERENCE TO A PRACTICE OF LUXURIANT CONSISTENCY, AS MAINTAINED BY ONE HIS GREATEST INFLUENCES, JEAN-MICHEL FRANK. AS *VOGUE* ONCE OBSERVED OF A SAN FRANCISCO APARTMENT DESIGNED IN 1929 BY THE LEGENDARY FRENCH MINIMALIST: "THE LITTLE ROOMS OF THE HOUSE ARE DESIGNED WITH THE SAME CARE FOR EXQUISITE DETAIL AS ARE THE MORE IMPORTANT ONES."

AND SO IT IS WITHIN FRANCIS'S ALBANY MANSION HOME. FROM ITS GILDED POWDER ROOM TO THE ROBERT ADAM-INSPIRED AMBIENCE OF ITS BESPOKE KITCHEN, THE "KUSAMA DINING ROOM" FEATURING A TRIO OF IMPORTANT WORKS BY THE JAPANESE CONTEMPORARY ARTIST, THE "PRELLE ET CIE" BEDROOM BLINDS, AN INTRICATELY STIPPLED STAIRCASE, THE BREATHTAKING "BLUE SALON" AND THE SPECIFIC CELADON HUE OF D. PORTHAULT BATH TOWELS—EACH SPACE AND EVERY ASPECT OF THIS MASTERWORK RESIDENCE HAS BEEN PAINSTAKINGLY CREATED BY FRANCIS.

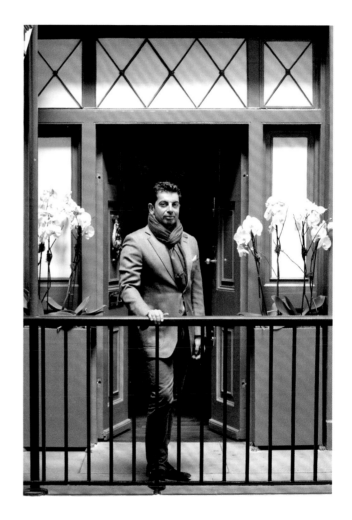

FRANCIS AND DAVID'S NEW HOME WITHIN ALBANY APPEALED BECAUSE OF ITS SIZE—A DOUBLE "SET," AS THE COMPLEX'S QUARTERS ARE KNOWN—AND ALSO ITS POSITION WITHIN ALBANY'S "MANSION."

ABOVE: Serving as both art and functional device, a metal radiator cover-console by Michele Oka Doner in the entry hall. **RIGHT:** In the hallway, conceptual artist Rosemarie Trockel's bold *Portable Ocean*, 2001 in acrylic on paper.

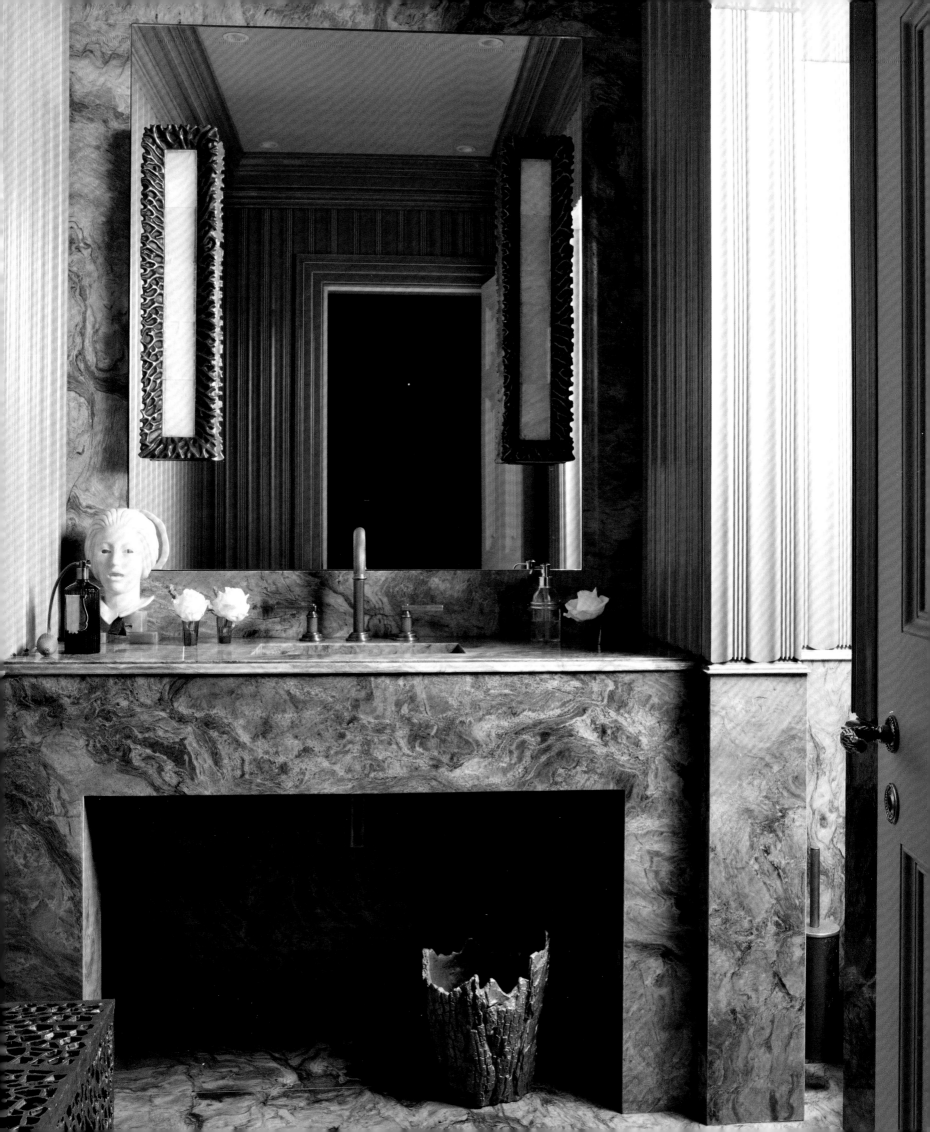

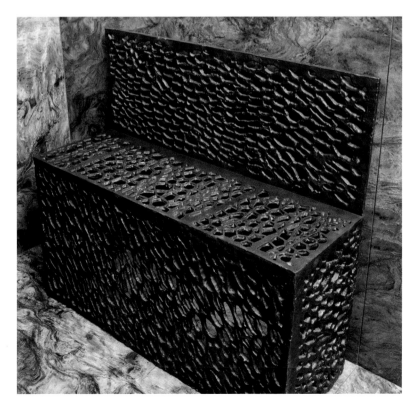

OPPOSITE, ABOVE & BELOW: The refined and the raw, the classical and the ethereal, merge in this evocative marble bathroom, where an elegant fluted wall treatment meets richly veined marble. Textured metallic elements with organic shapes add a sense of poetry. The bin and bench by Michelle Oka Doner, which appear to be in a state of decay, evoke the fleeting nature of existence. The wall lights are by Francis Sultana.

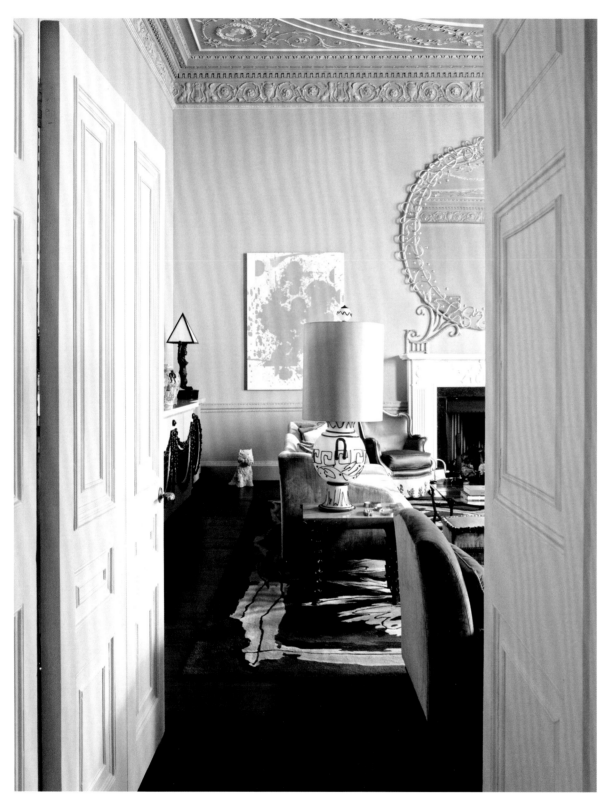

ABOVE & RIGHT: When approaching the daunting task of decorating the main living space, Francis had to shed any preconceived ideas. "I had to have no fear in this room," he explained of his flamboyant décor for the "Blue Salon."

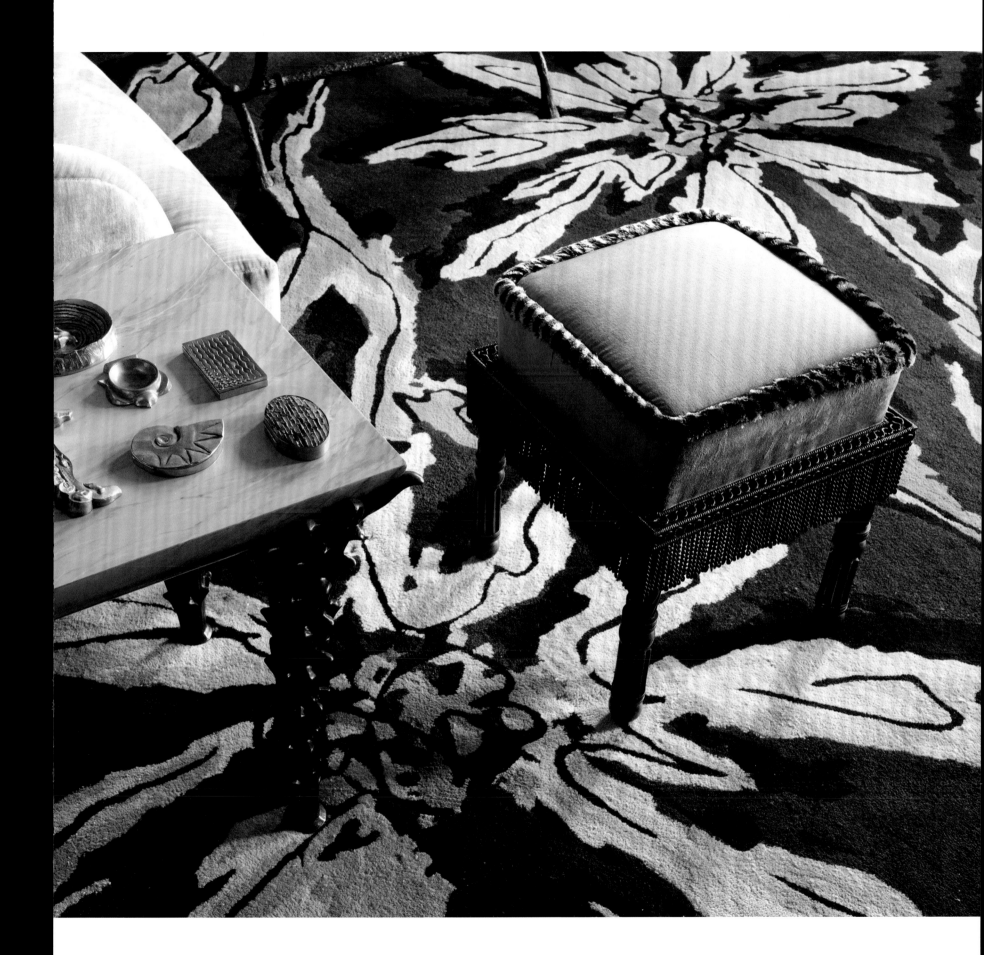

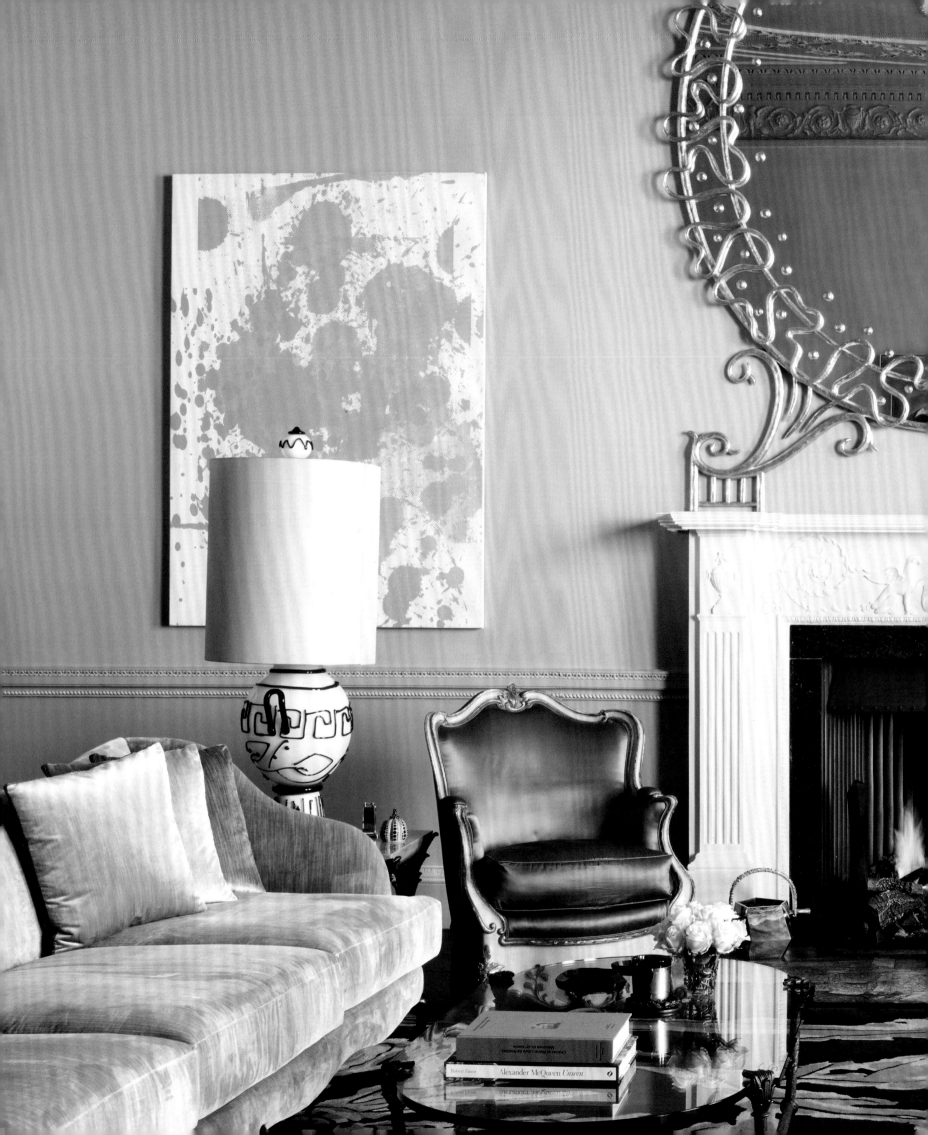

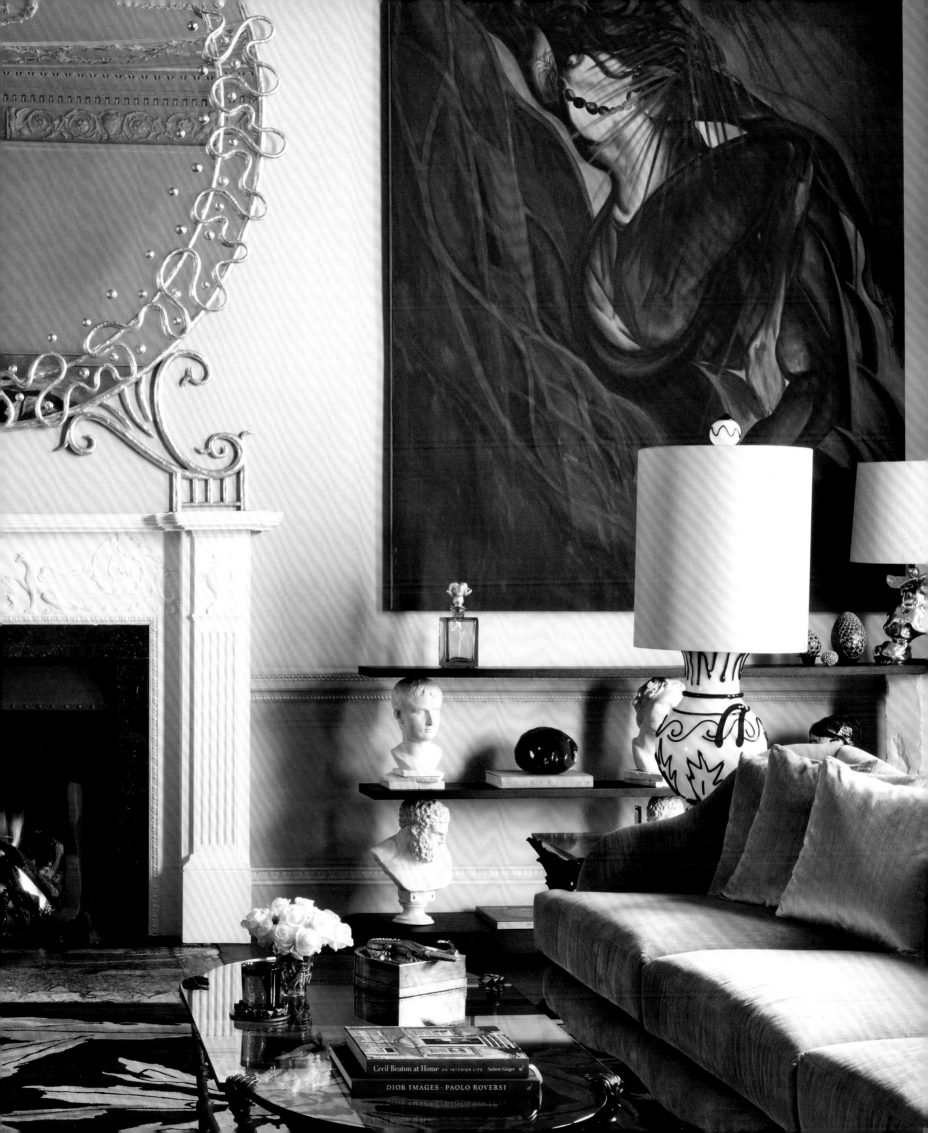

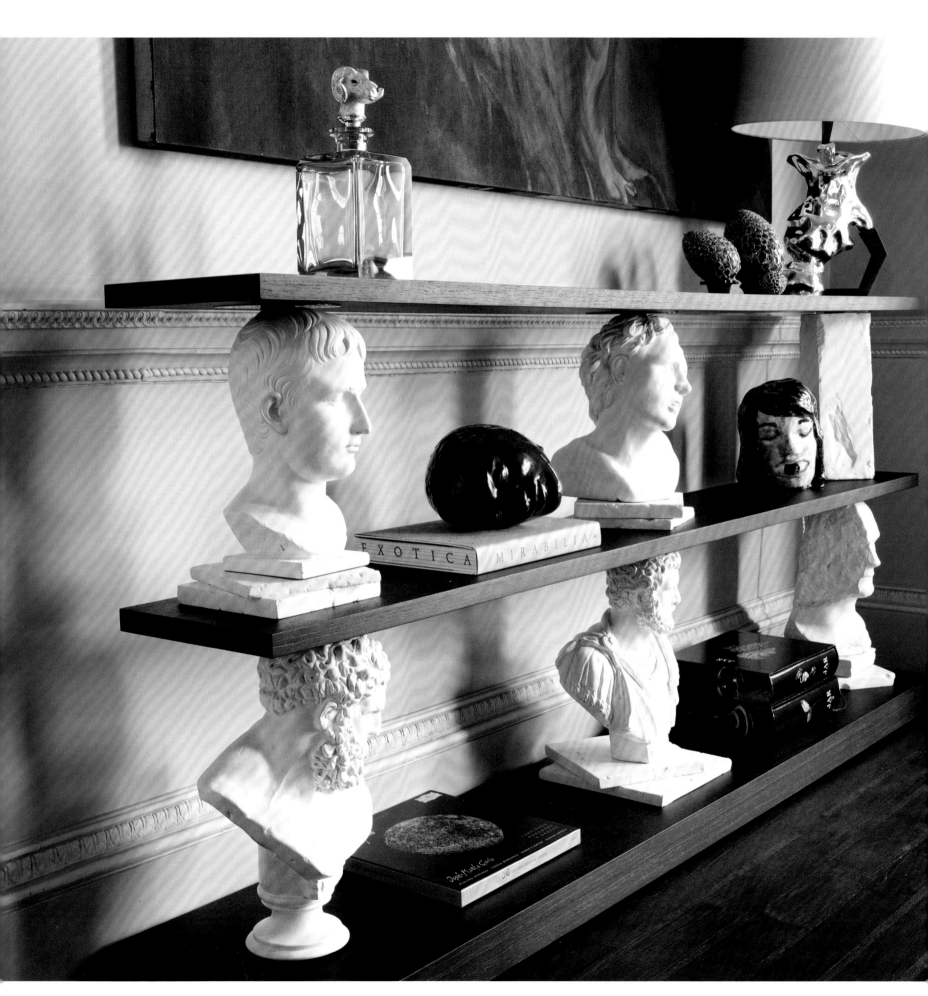

PP108–109: The drawing room is anchored by a pair of Francis Sultana sofas upholstered in ice-blue velvet. Francis's beloved "Beistegui" chair draws the eye to the enormous fireplace. Above it hangs Mattia Bonetti's gold leaf mirror, which reflects both natural and ambient light back into the room. *Untitled*, 2001, by Christopher Wool is left of the fireplace, to the right is *Ovid-Bather*, 2010–2012, by Chris Ofili.

OPPOSITE: Albany's Neo-classical aesthetic is echoed in Sebastian Errazuriz's, "Bust" shelves, 2018. On the top shelf are eggs by Line Vautrin. On the middle shelf, Andro Weekna's *Never Sleep With A Strawberry In Your Mouth* rests its head on a book; at the far end is *Brown Eyed Girl* by Klara Kristalora, 2009. ABOVE: A detail of Mattia Bonetti's flamboyant carpet is glimpsed through the glass top of a Francis Sultana side table. LEFT: Velvet cushions in sugared-almond shades complement the emerald silk-satin "Beistegui" chair by Emilio Terry.

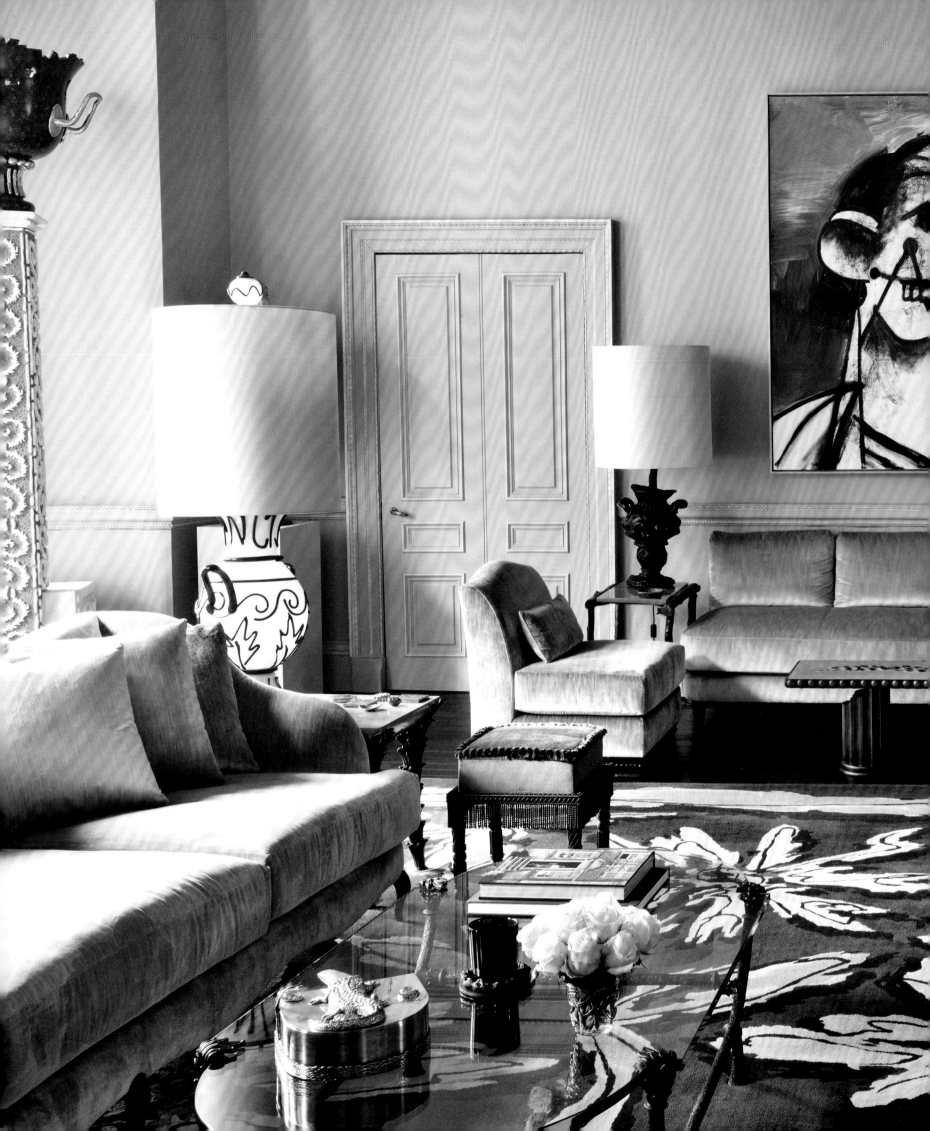

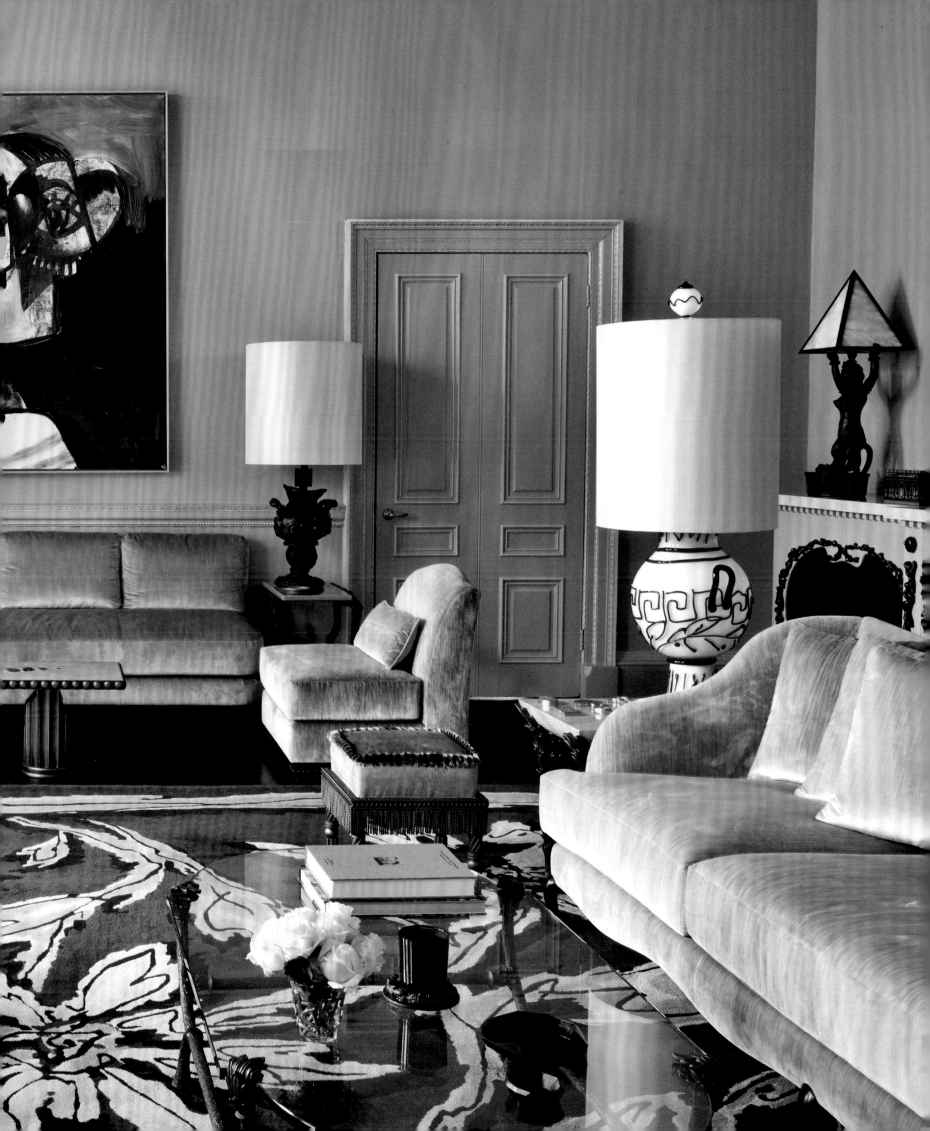

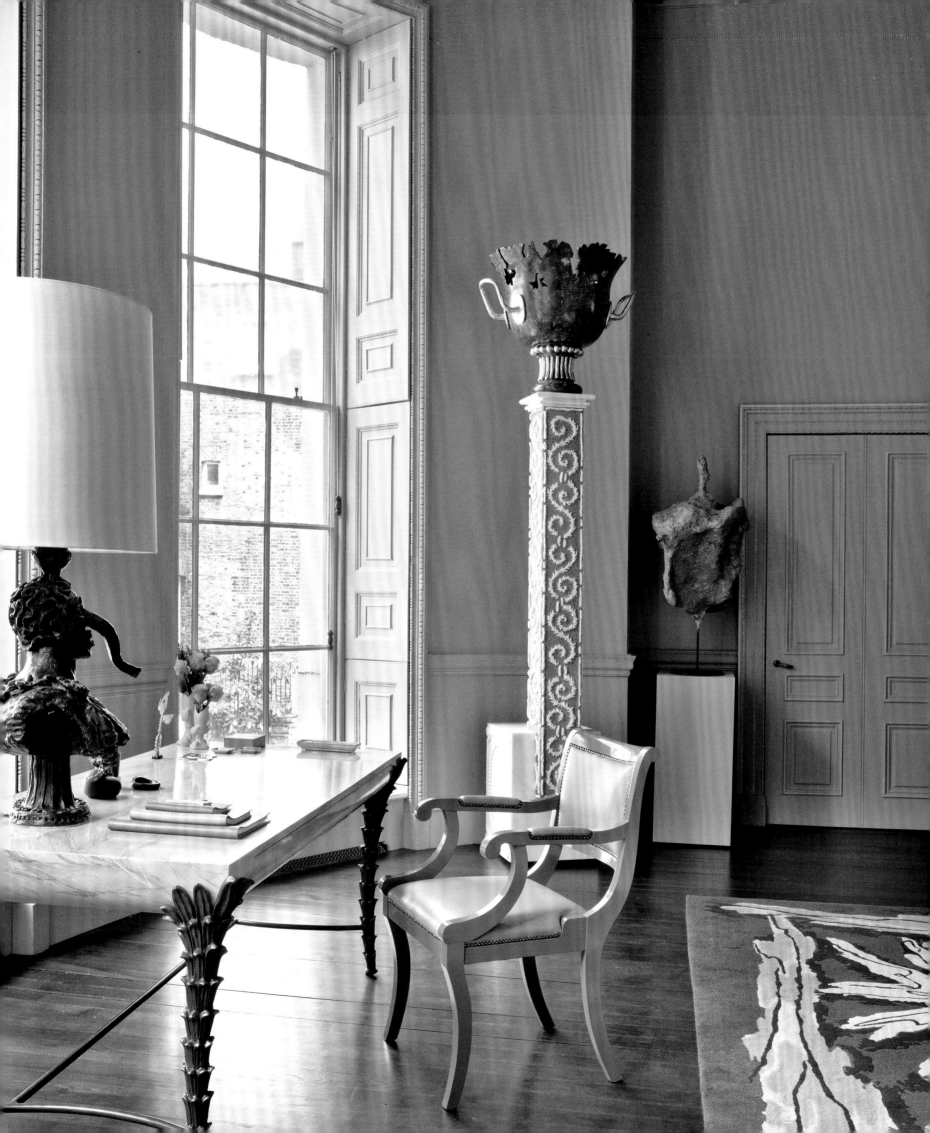

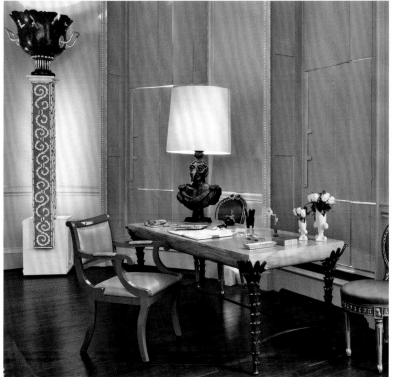

PP112–113: At the opposite end of the drawing room, a more informal tone is set with contemporary artwork above a Francis Sultana sofa.

OPPOSITE, LEFT & ABOVE: Mattia Bonetti's column of Carrara marble—with hand-carved, painted wood and wrought-iron gold leaf—stands sentinel over a desk, lamp, and chair by Francis Sultana. The chair was inspired by an English antique. Francis utilizes the drawing room as a working space to produce watercolor preliminaries for his designs.

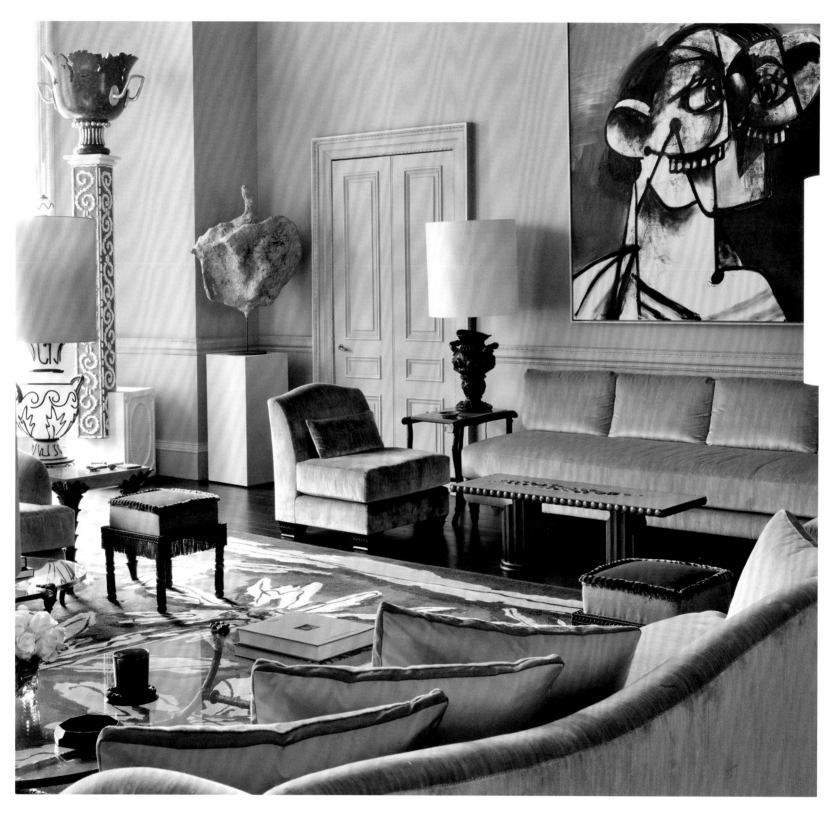

ABOVE & OPPOSITE: A color palette that includes golden yellow and pistachio, with hints of ultraviolet, brings vibrancy to the "Blue Salon" and unifies the grand space.

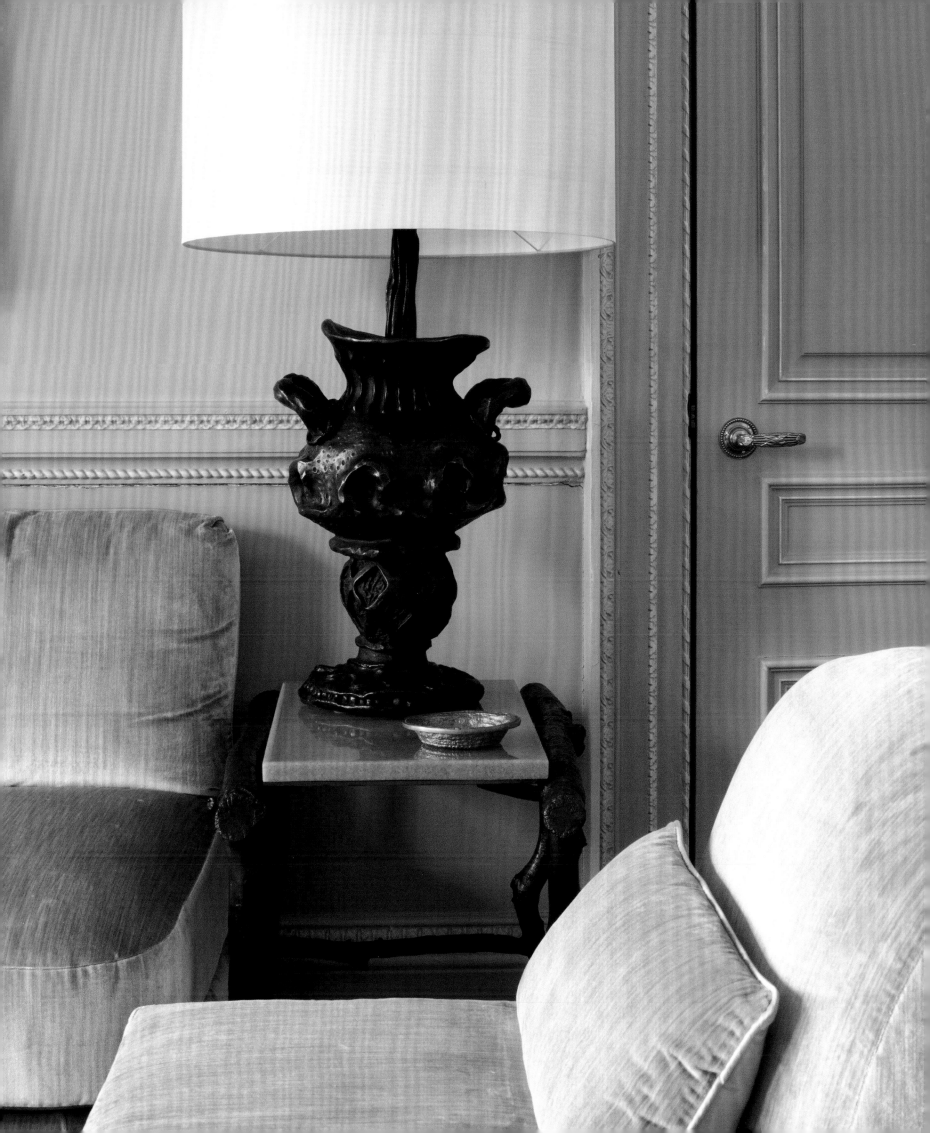

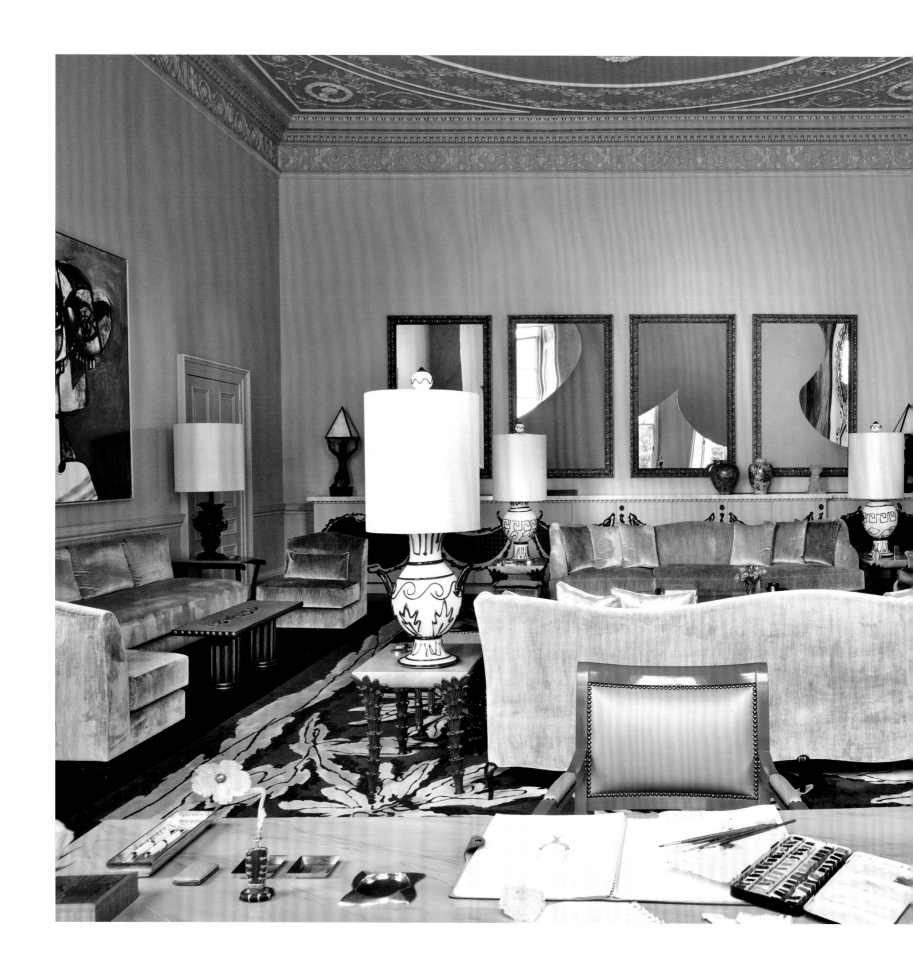

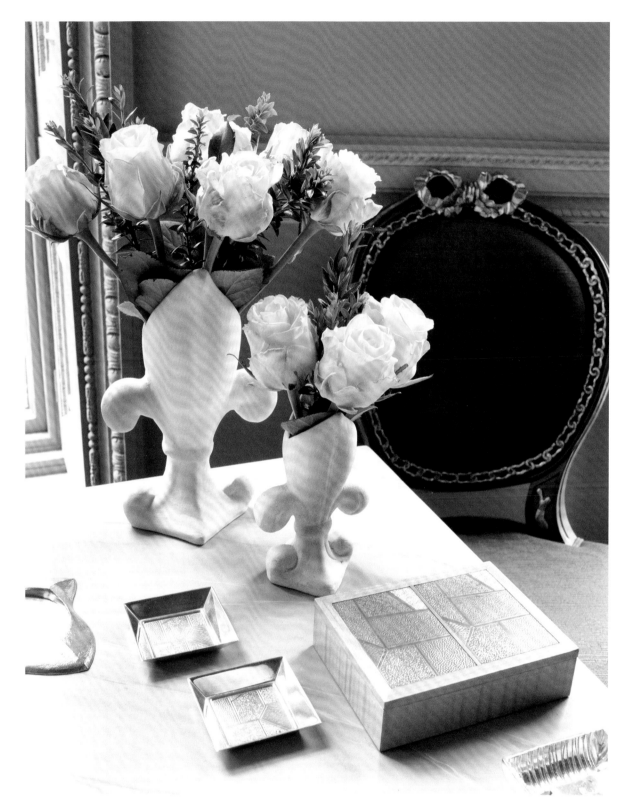

LEFT & ABOVE: Hand-blown glass lamps by Mattia Bonetti on side tables by Francis Sultana anchor the sofas and create a sense of symmetry. Michelangelo Pistoletto's series of four "mirror paintings" reflect light from the windows on the other side of the room. On the desk, Constance Spry vases of yellow roses strike a romantic note.

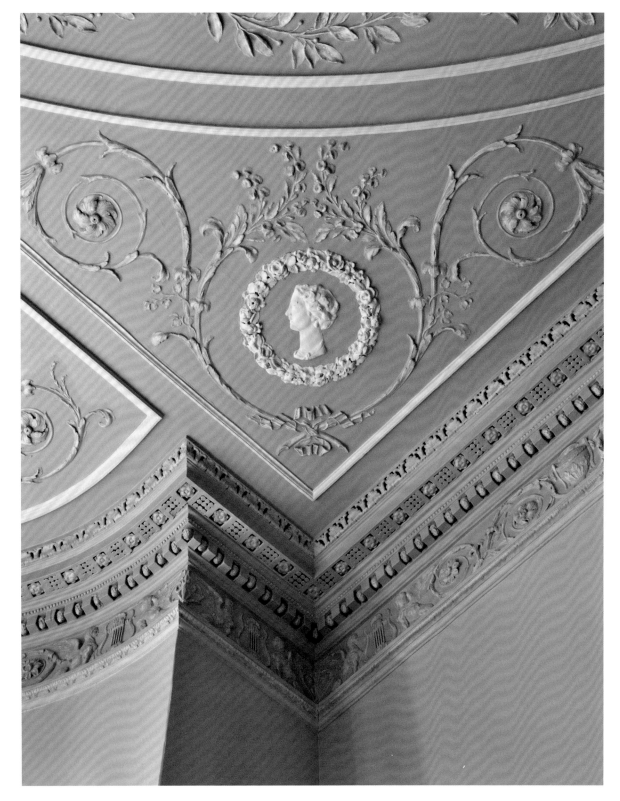

ABOVE & RIGHT: "The ceiling was a big inspiration," says Francis, acknowledging that important decorative aspects of the blue drawing room were motivated by looking skyward. The lighting in the drawing room is enhanced by Mattia Bonetti's over-the-fireplace mirror.

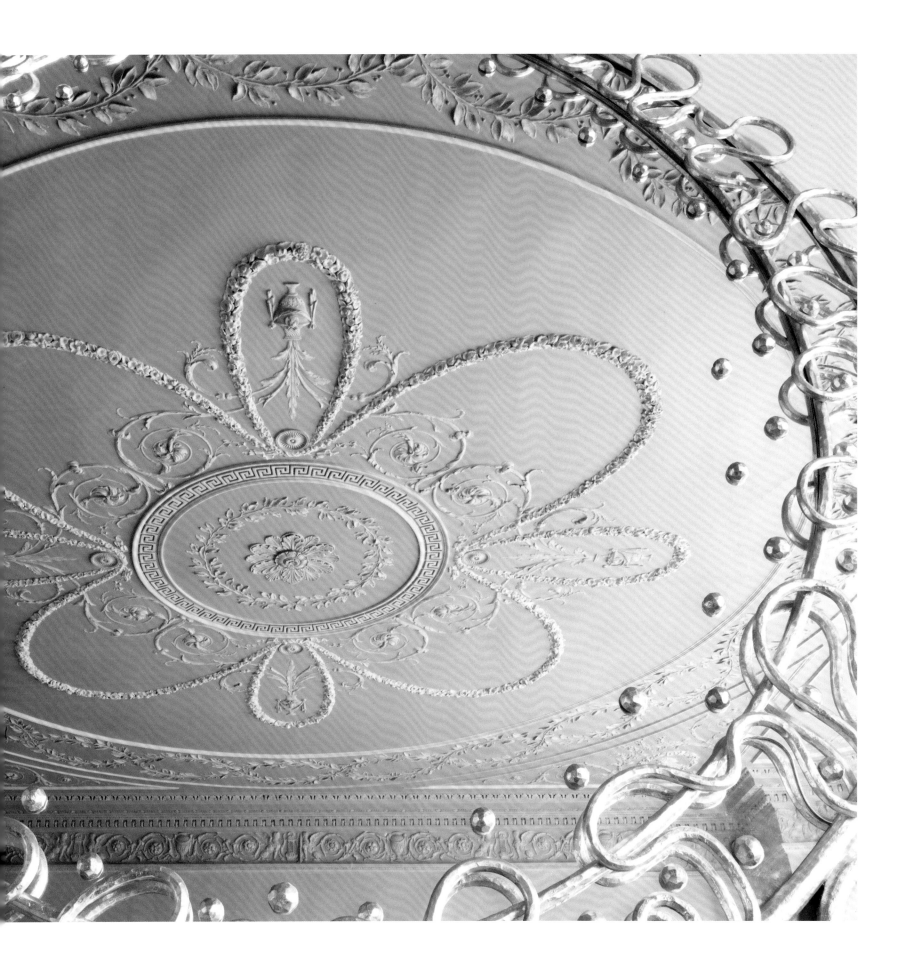

ABOVE, RIGHT & OPPOSITE: The delicate blue hue of the Poston sofa by Francis Sultana was intended to complement, but not compete with, the walls and ceiling. Against the Regency-inspired palette, bright pops of bold color are found in a whimsical Kusama pumpkin, Mattia Bonetti lamps, and Christopher Wool's yellow *Untitled* of 2001.

PP124–125: "The only thing that concerned me in terms of interior design was whether to hang curtains," explains Francis of the drawing room. He decided against doing so.

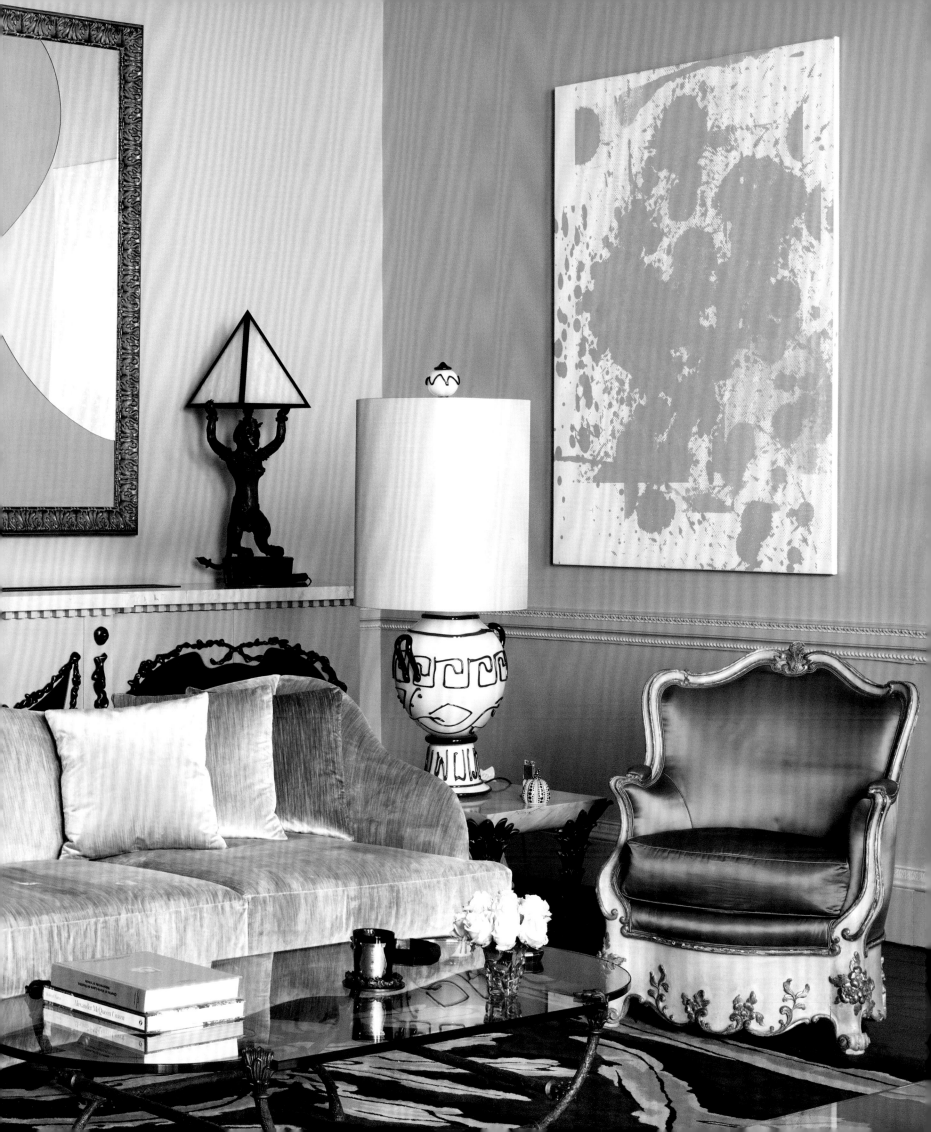

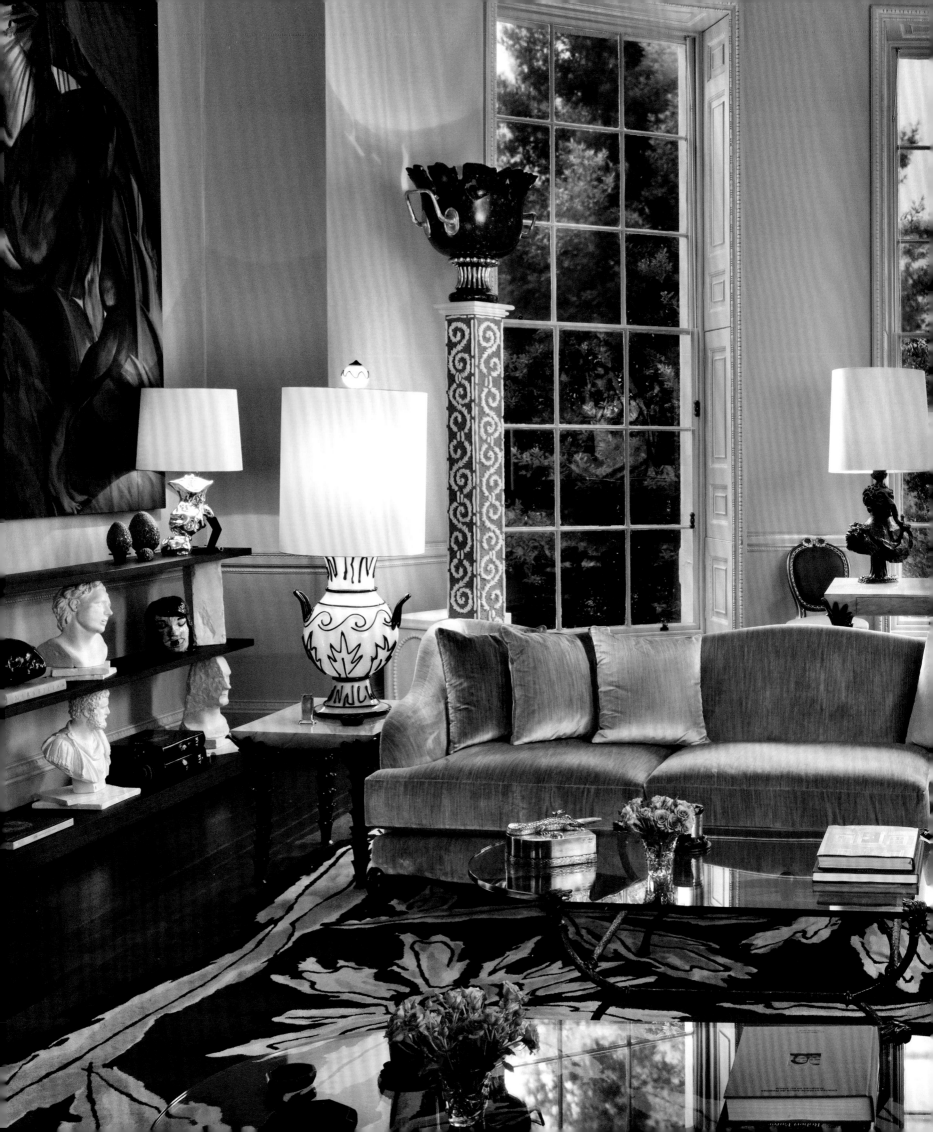

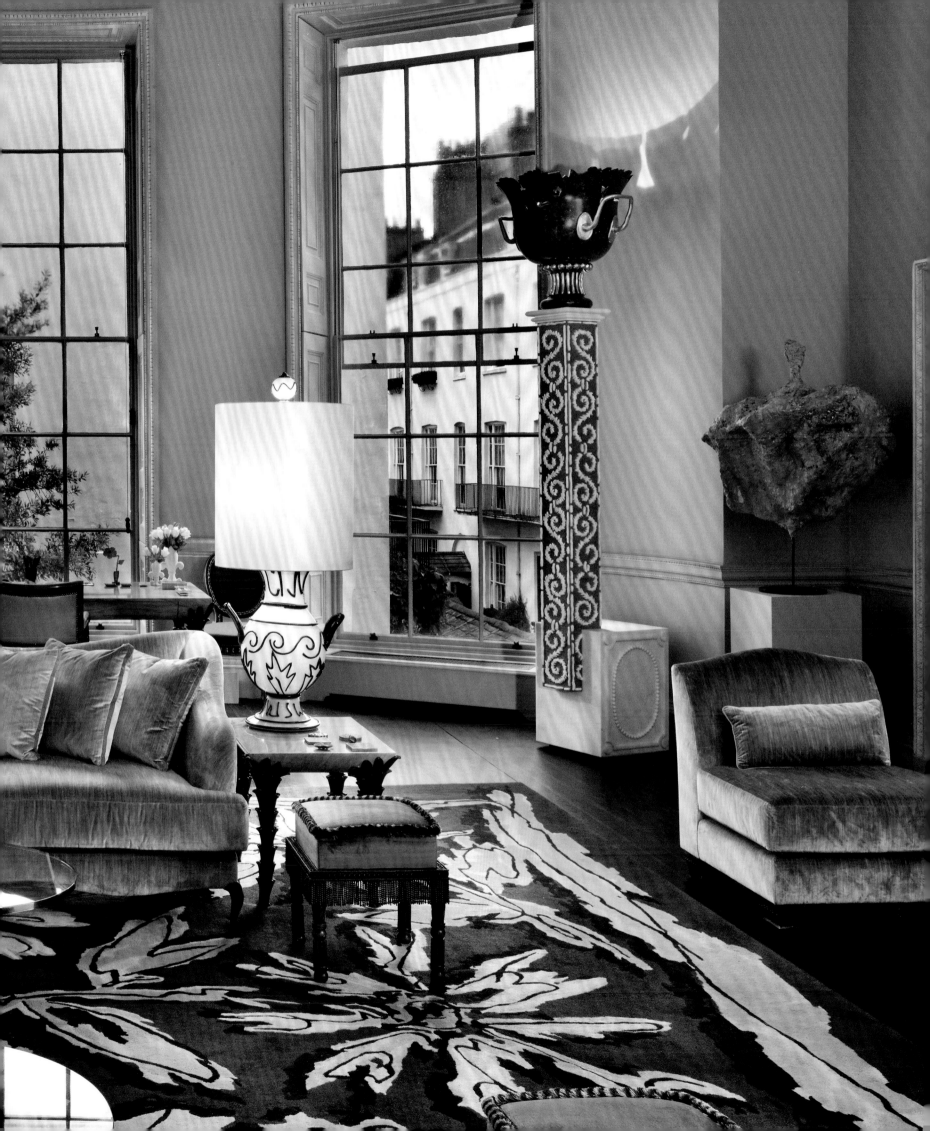

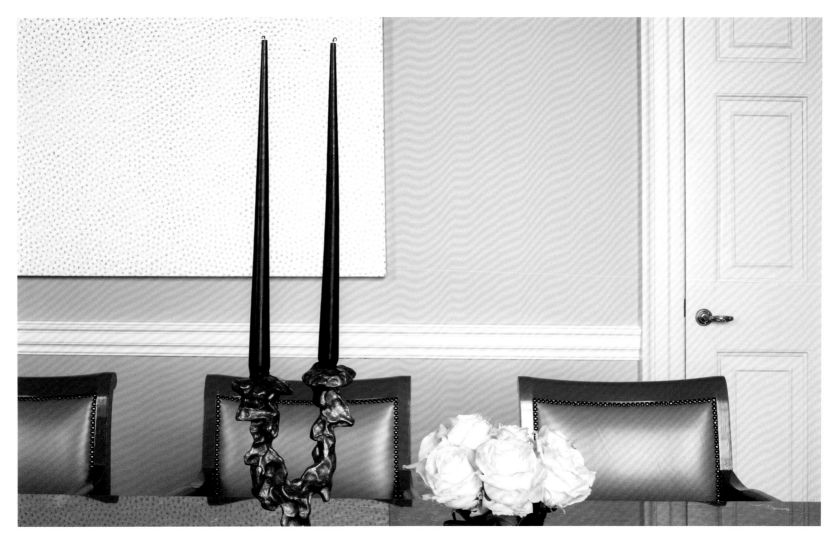

PP126–127: Turquoise dining chairs rest on a coral-colored hand-tufted rug of 100% wool, made especially for the room by Mattia Bonetti.

ABOVE, RIGHT & OPPOSITE: Of the "Kusama Dining Room," (named for a trio of works by the Japanese painter Yayoi Kusama), David Gill explains: "The subtle beauty of color adds a visual clarity to the room and its architecture." The set of four torchères are site-specific pieces by Mattia Bonetti. The torchères have bases of bronze metal mesh, and the top branches are made of wrought iron covered in gold leaf. "The table bases are made of cast bronze, whereas the top is an 'assemblage' of red marble," explains Bonetti.

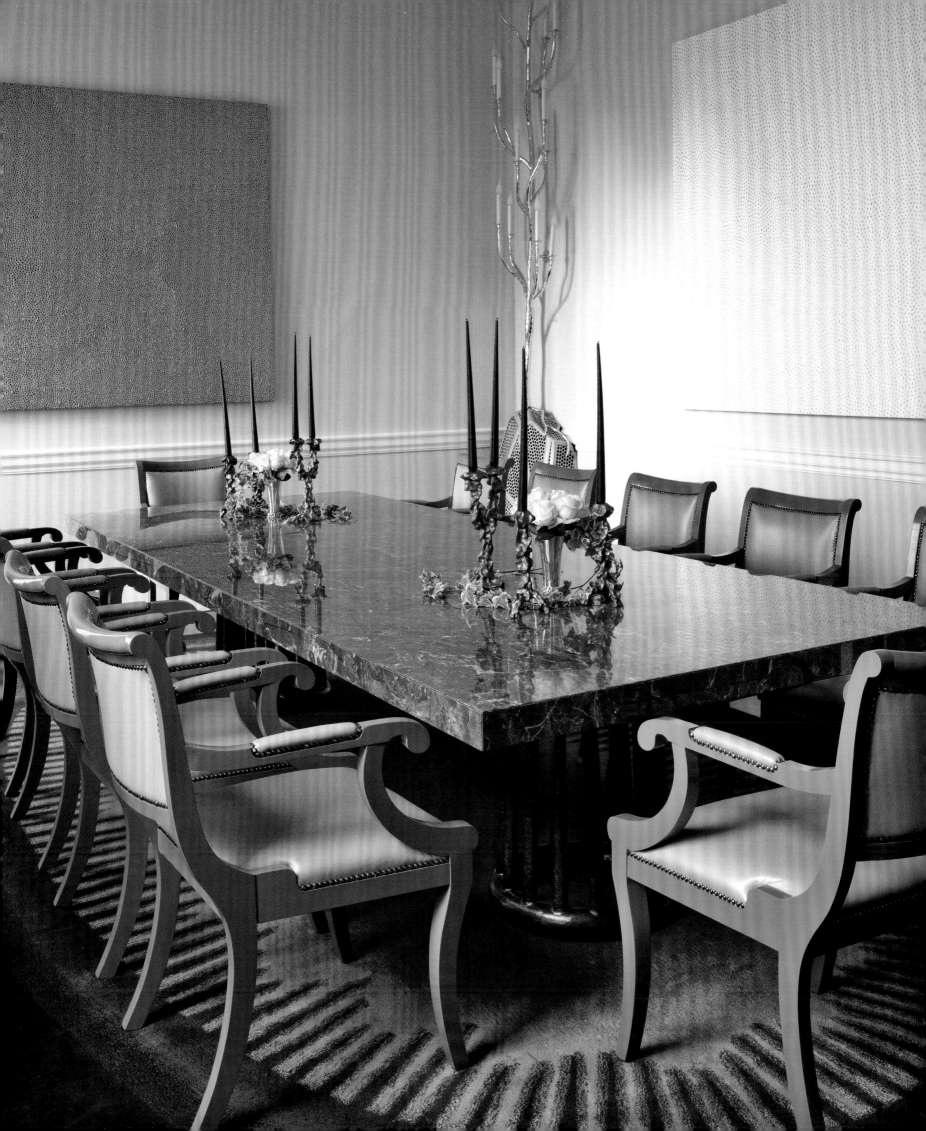

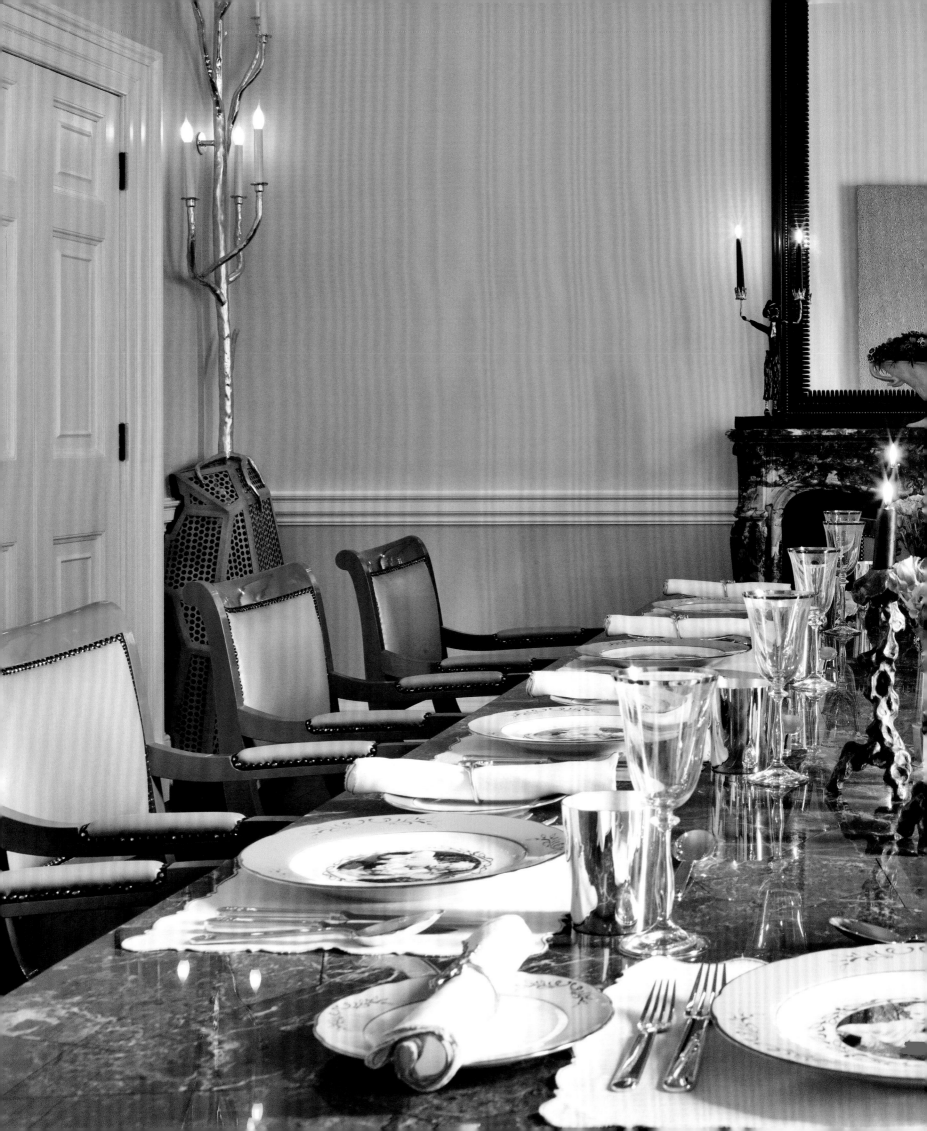

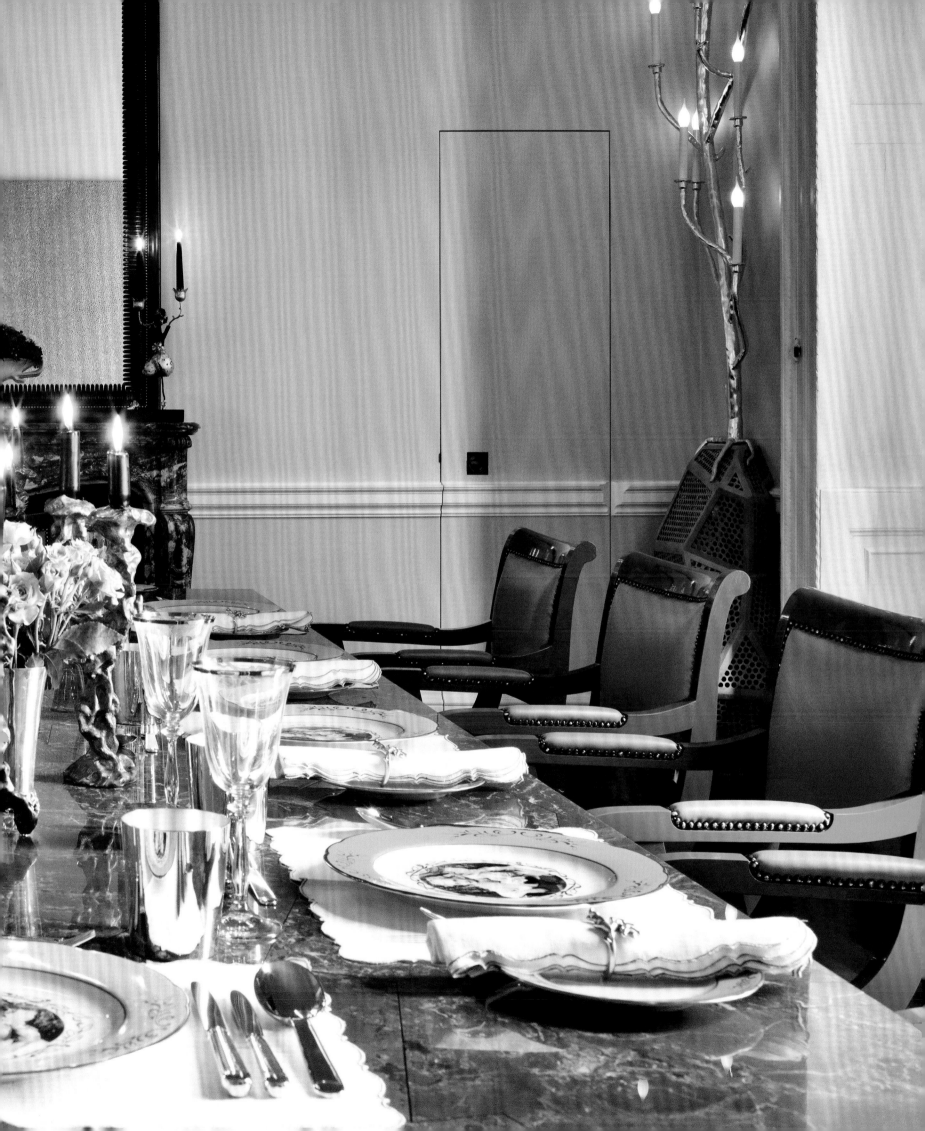

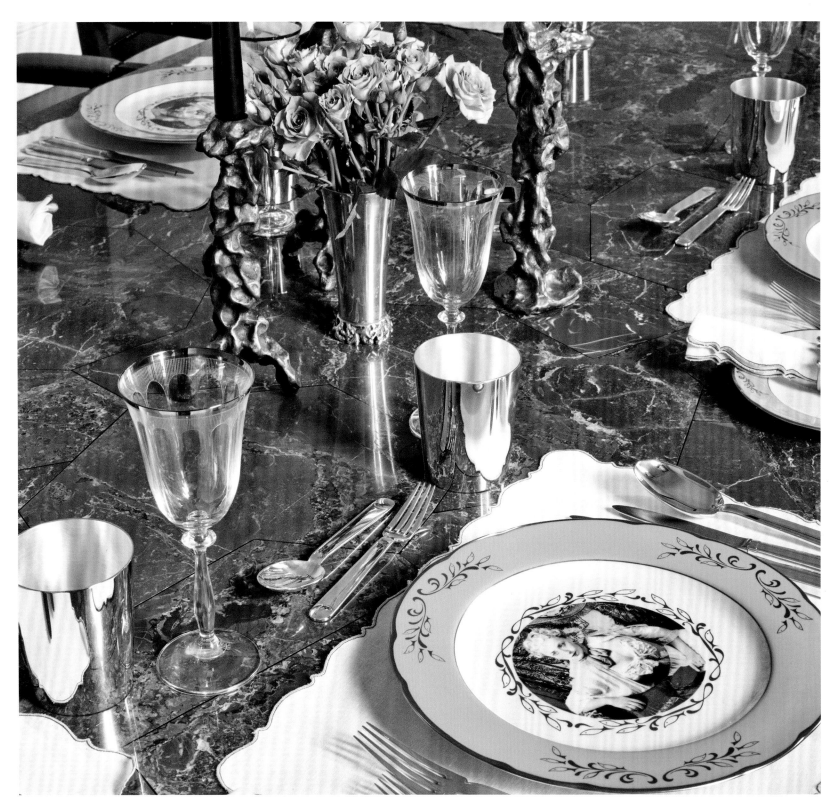

PP130–131: Mattia Bonetti's red marble table is set for a candlelit dinner with tableware drawn from Francis's favorite artists and artisans, both traditional and contemporary.

ABOVE & RIGHT: A dinner service by Cindy Sherman, silver service by the House of Puiforcat, and "Grotto" candlesticks by Mattia Bonetti are indicative of Francis's playful approach to formality. Above the fireplace is a Francis Sultana mirror, reflecting a Constance Spry vase between "Boy" and "Girl" candlesticks by Garouste & Bonetti.

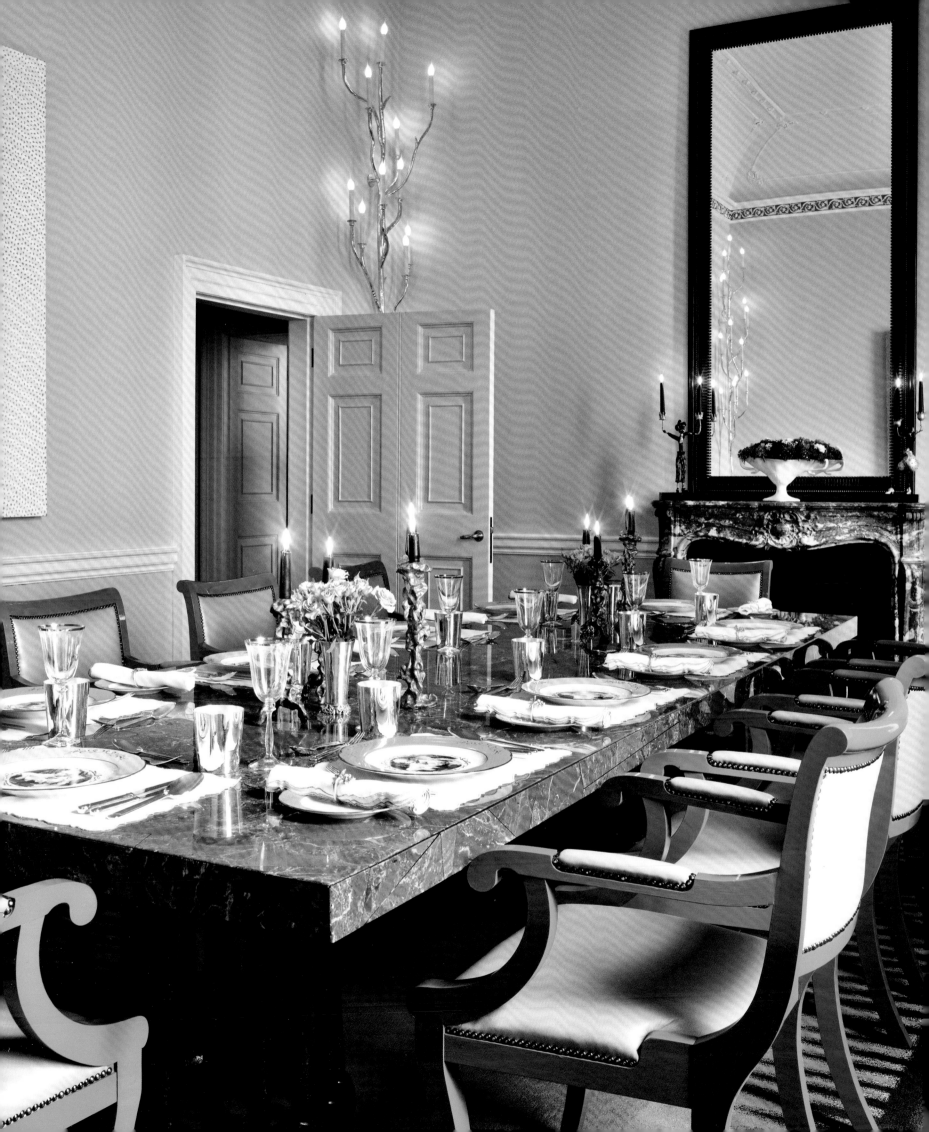

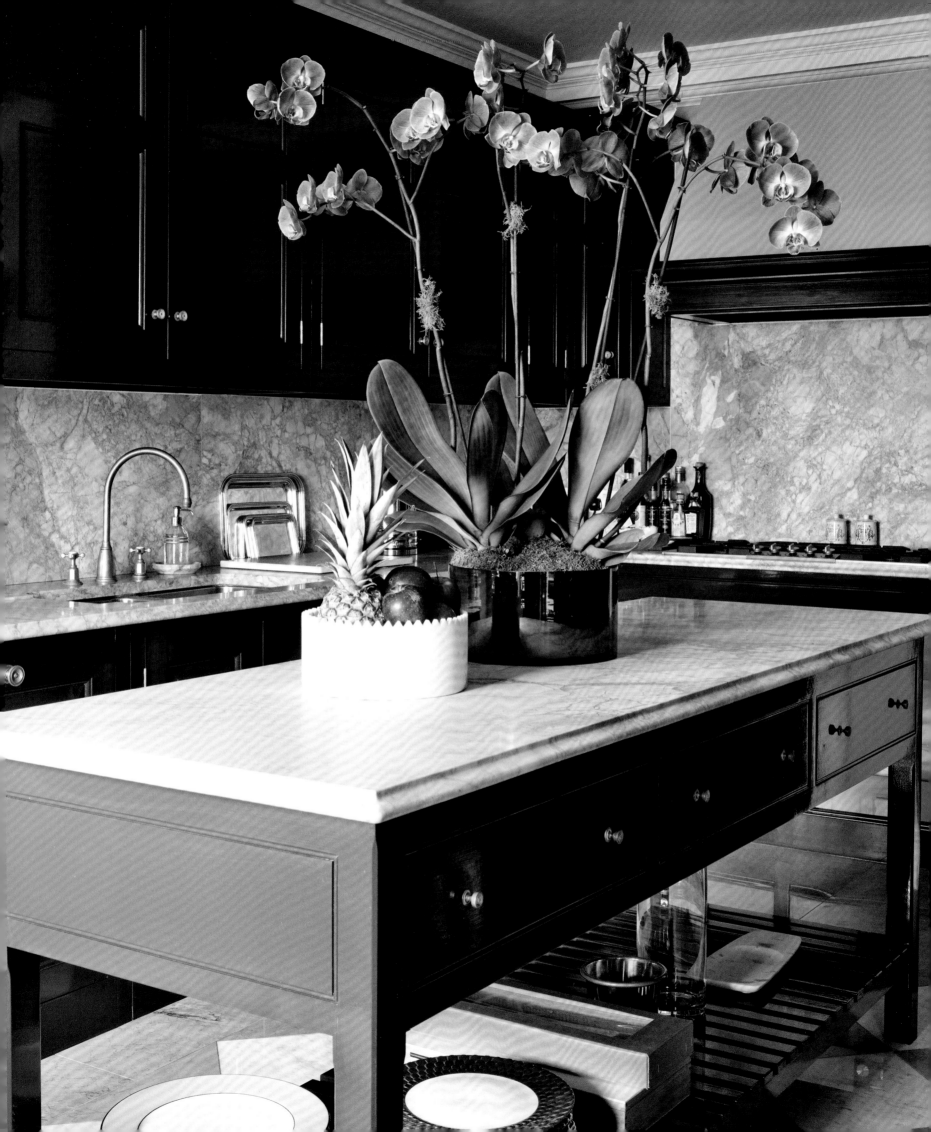

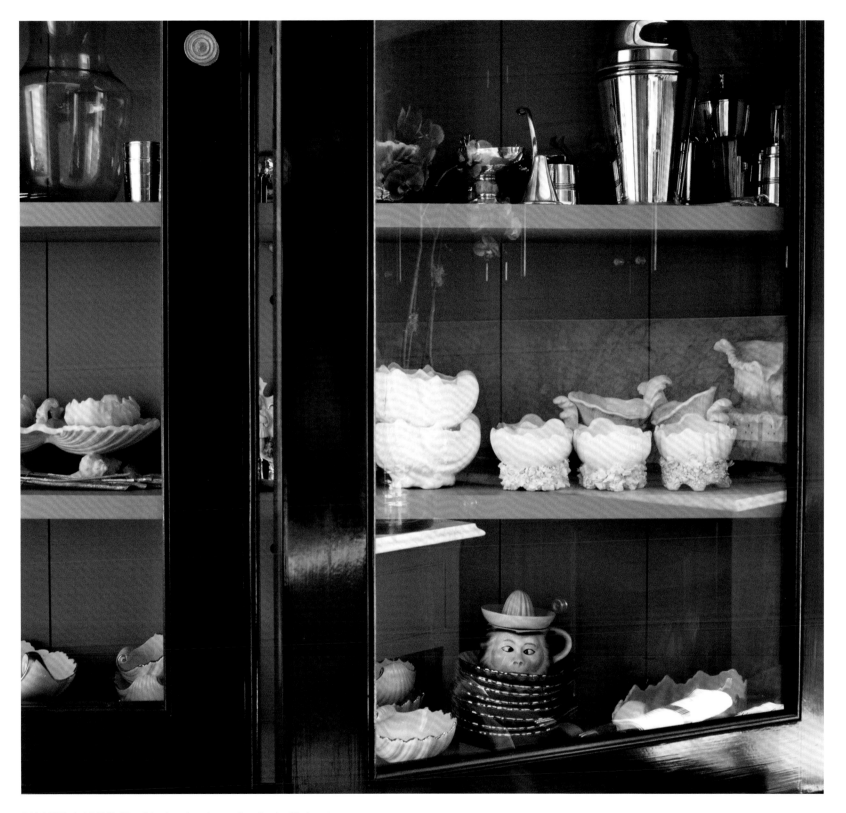

OPPOSITE & ABOVE: The rich chocolate brown hue in the kitchen is "very Albany," explains Francis of its Georgian-era inspiration. The chef's preparation area is made to measure, allowing enough space for a dinner for 16 to be plated.

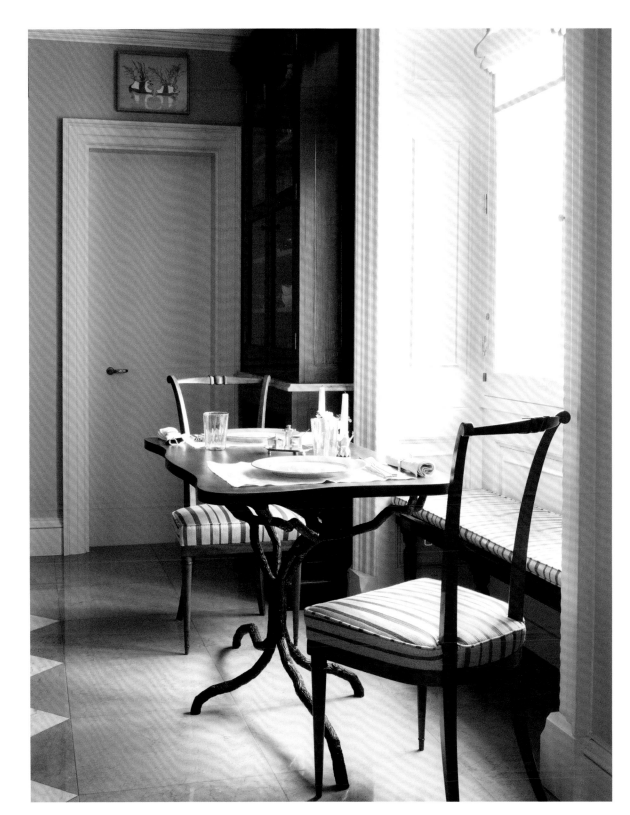

LEFT & ABOVE: "This is my oasis," explains Francis referring to his kitchen nook. André Arbus chairs surround a table by Francis Sultana. A window seat built into the Georgian sash window has been upholstered to match the chairs, creating a relaxed breakfast setting.

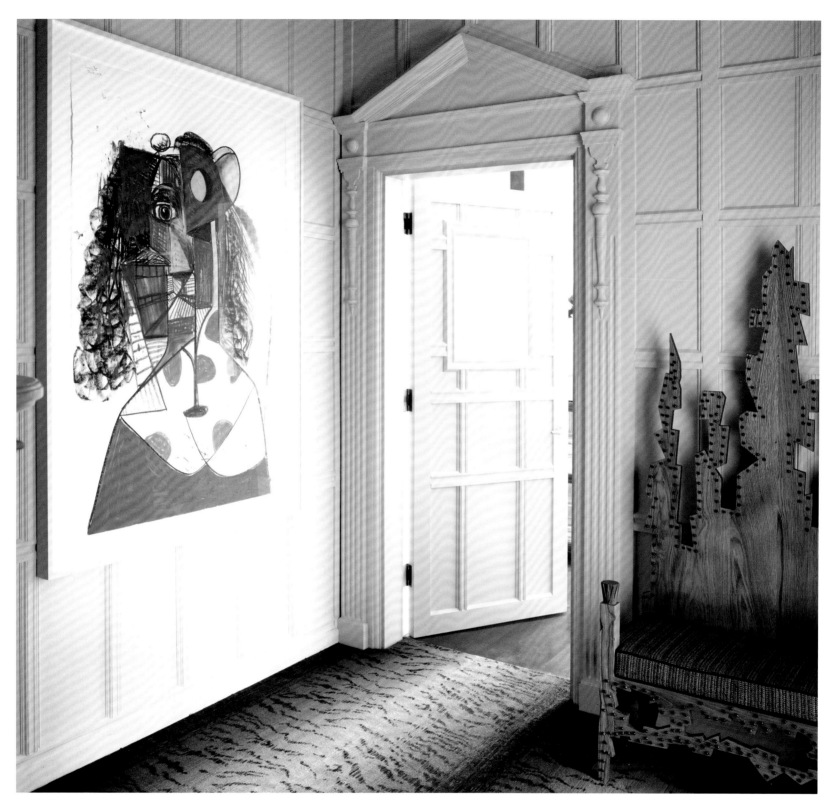

ABOVE & RIGHT: The aesthetics of Georgian-era joinery are given a contemporary twist by Francis. In the stairwell, a mirror installation by Mattia Bonetti both reflects and distorts the symmetry and proportion of the paneled walls.

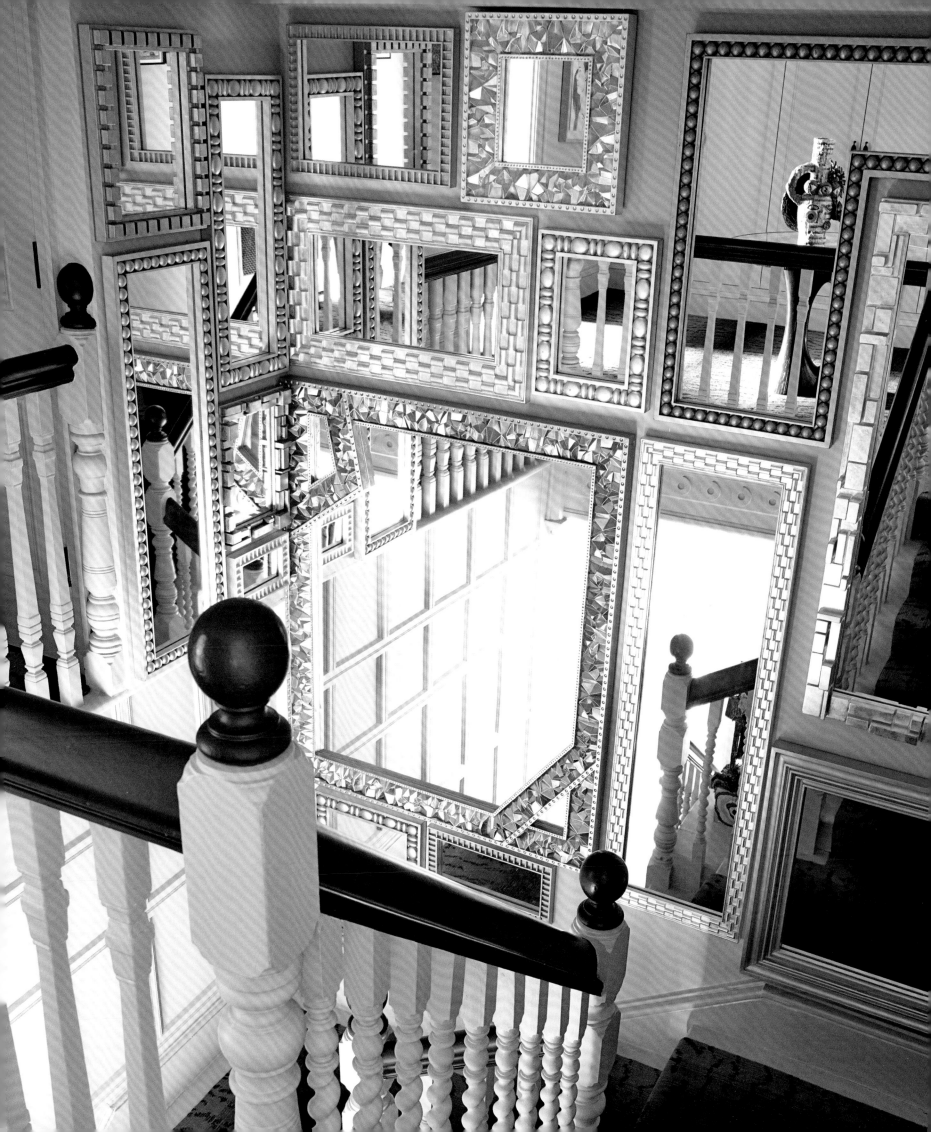

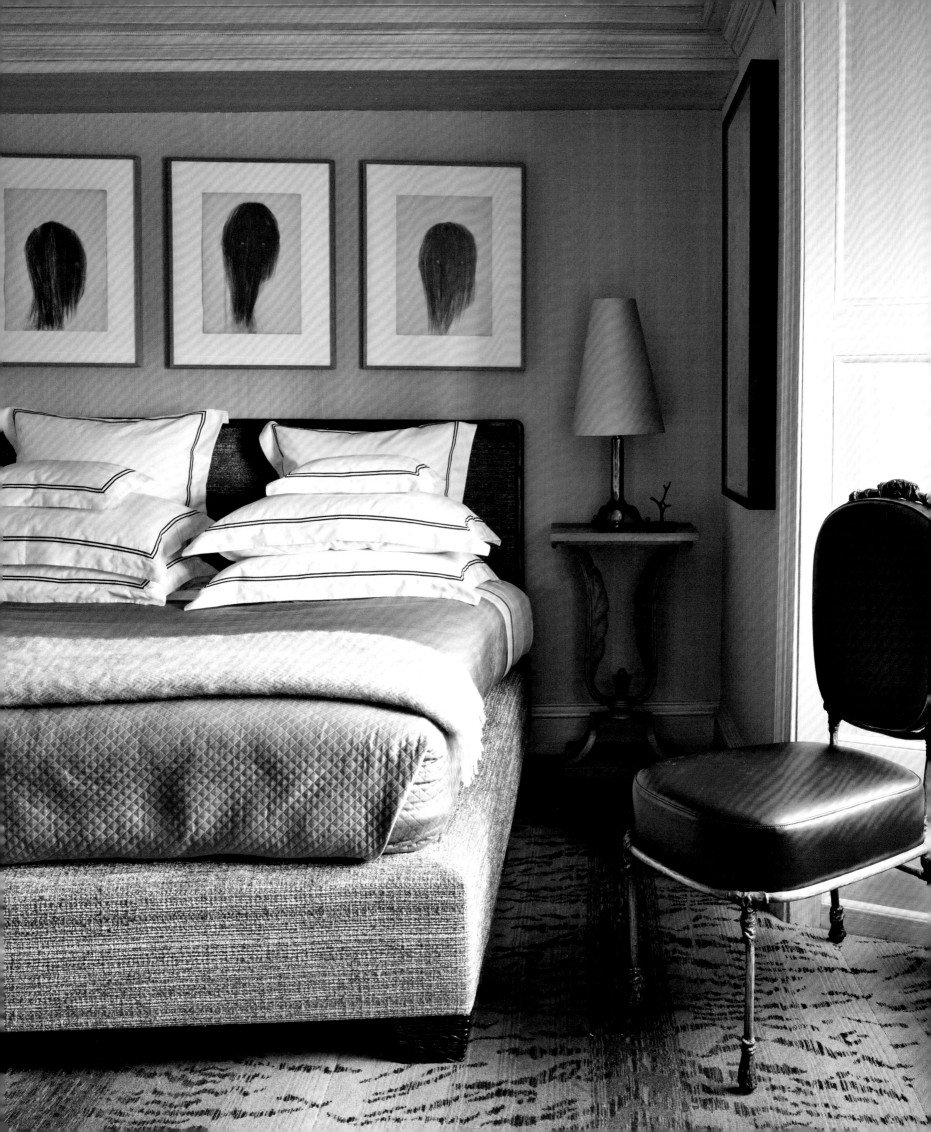

OPPOSITE, ABOVE & LEFT: The audaciousness of a degradé green tiger print carpet and fancy scarlet leather chair is tempered by crisp white cotton pillows, earth-toned bedding, and raffia walls.

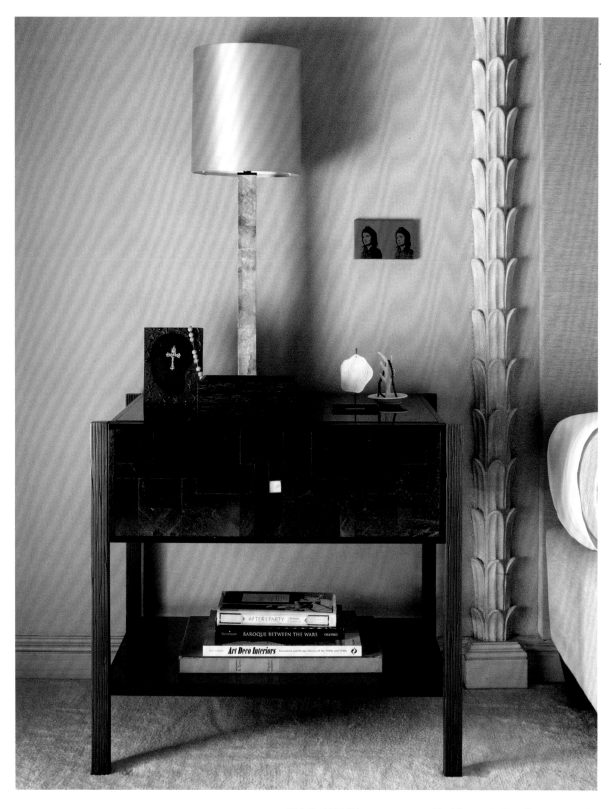

PP142–143: White monogrammed bed linen quite literally expresses the importance that Francis places on personalizing the spaces he designs.

ABOVE & RIGHT: Slender palm-like columns visually elongate the wall height of the master bedroom, while simultaneously recalling both the Georgian fascination with exotic botanicals and 1930s Hollywood glamour.

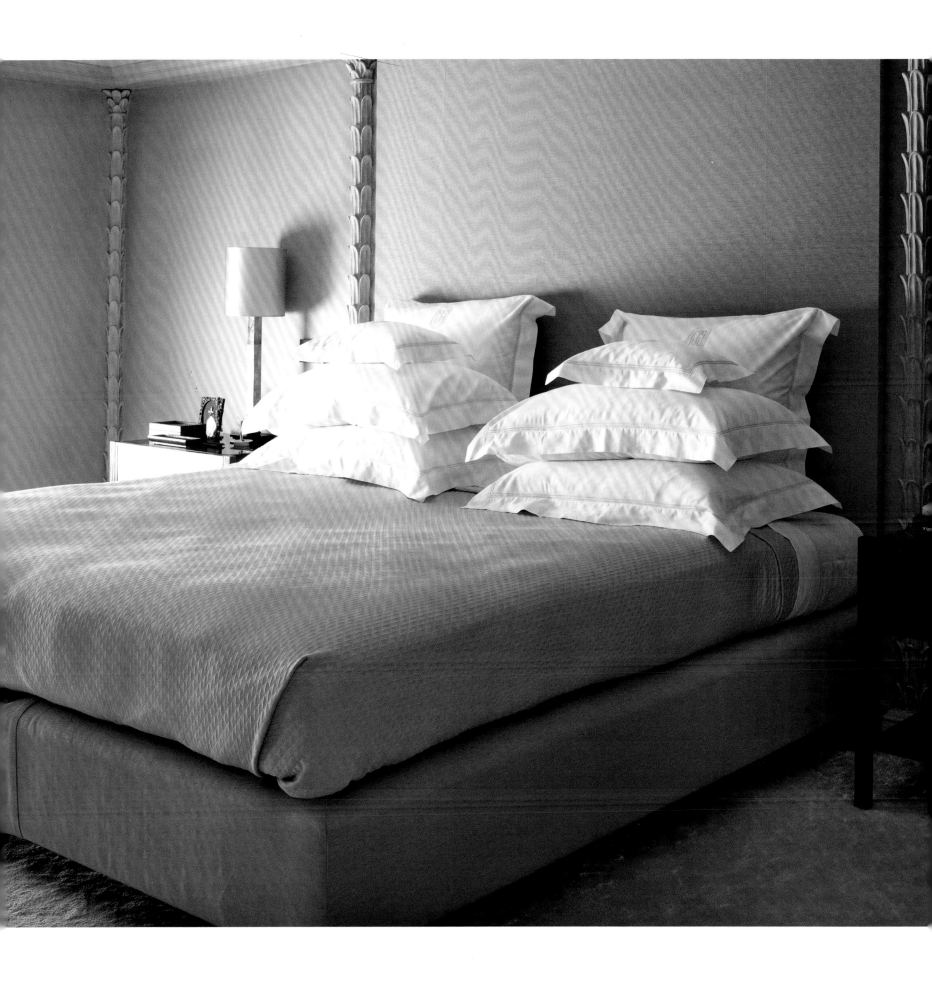

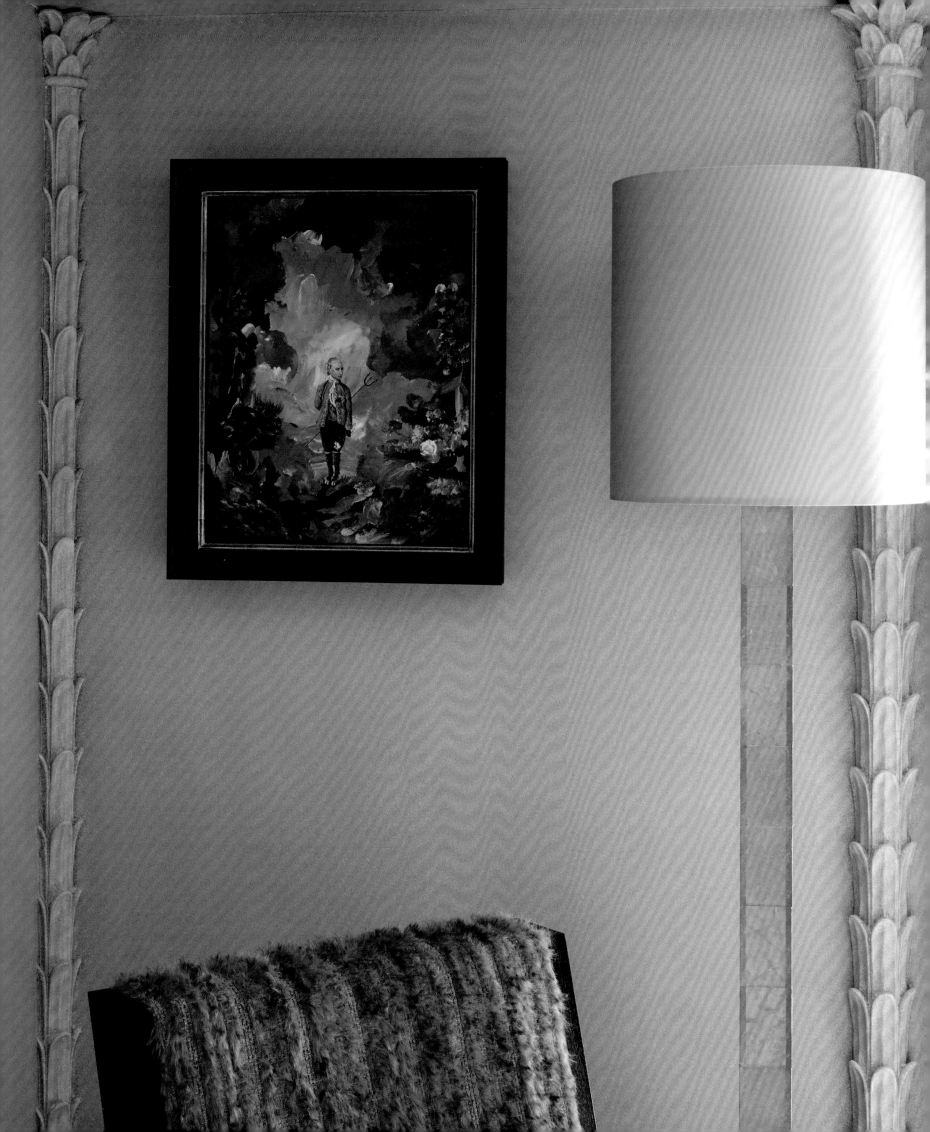

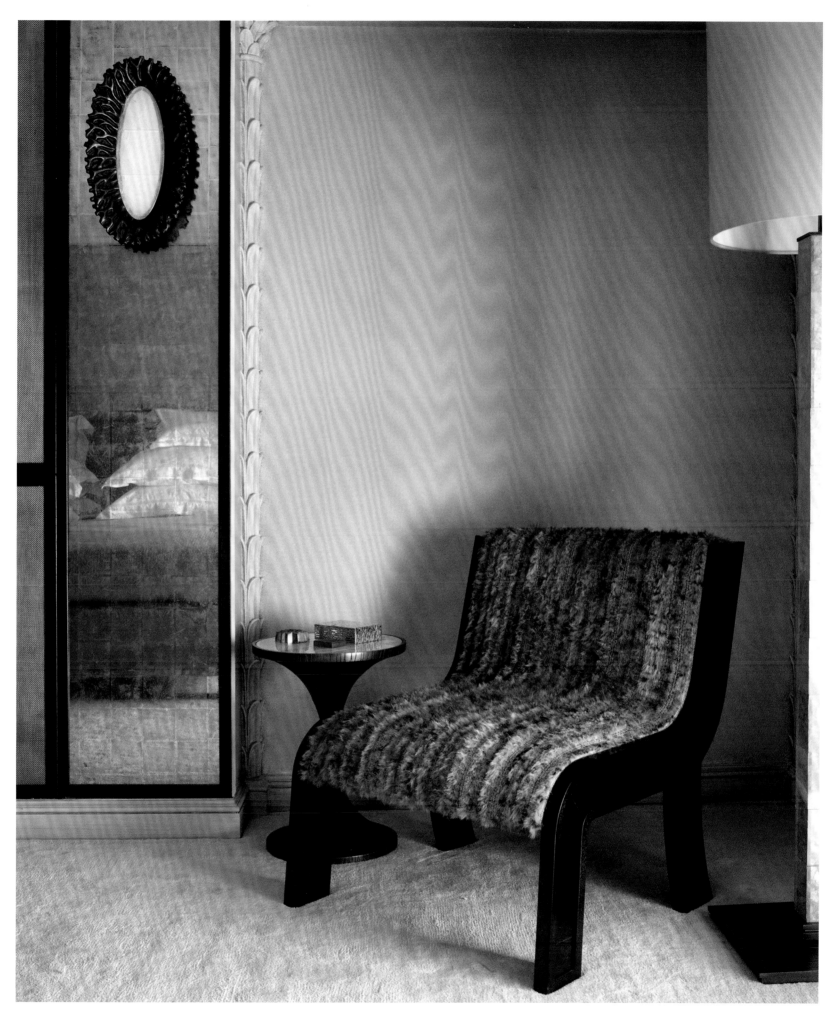

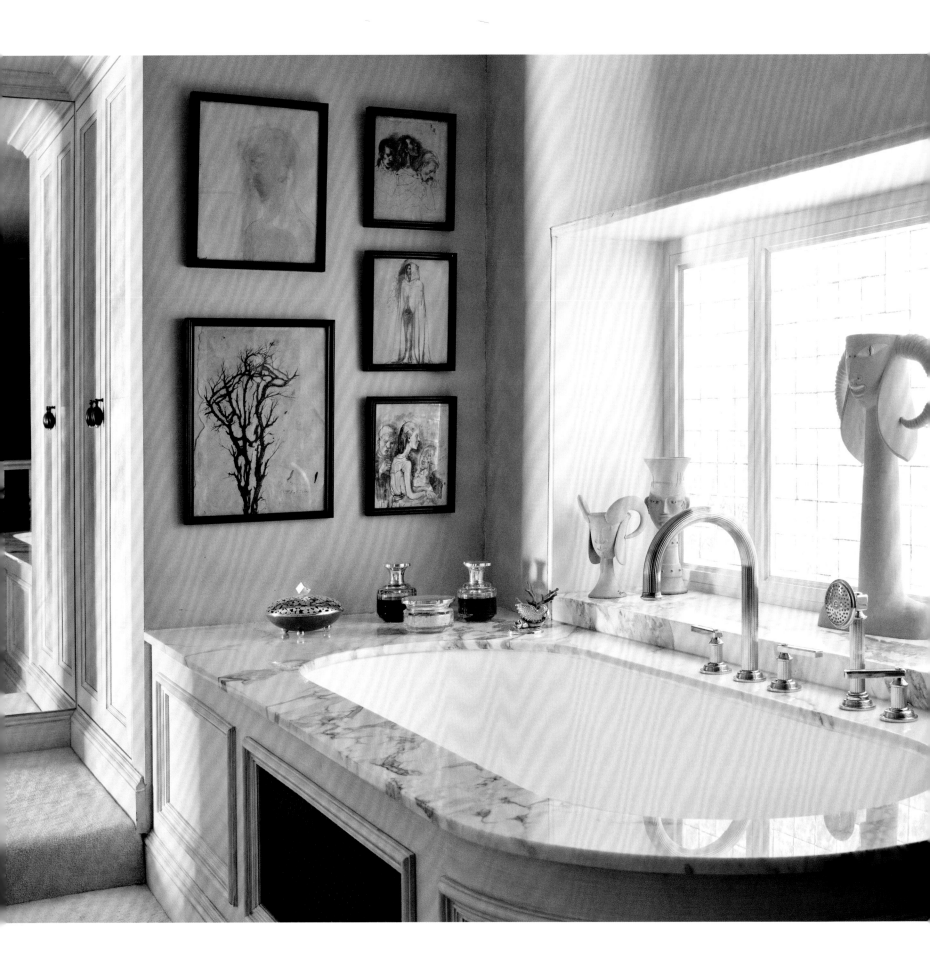

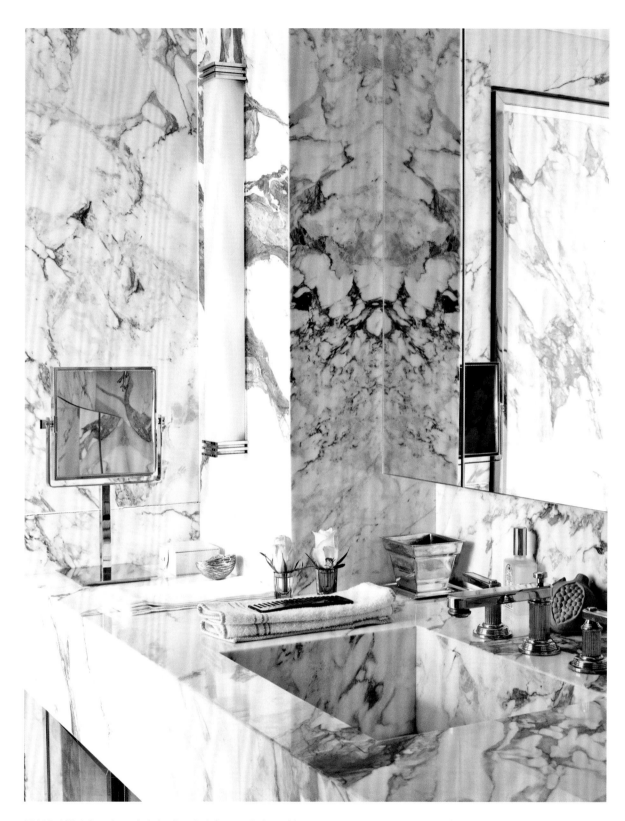

PP146–147: A luxurious chair by Francis Sultana upholstered in woven fur tweed, together with the designer's floor lamp and side table. The painting is by Djordje Ozbolt.

LEFT & ABOVE: The master bathroom is a backdrop for further displays of favorite artwork, including drawings by Pavel Tchelitchew, Jean Cocteau ceramics, and an assortment of Art Deco objects.

PROJECTS

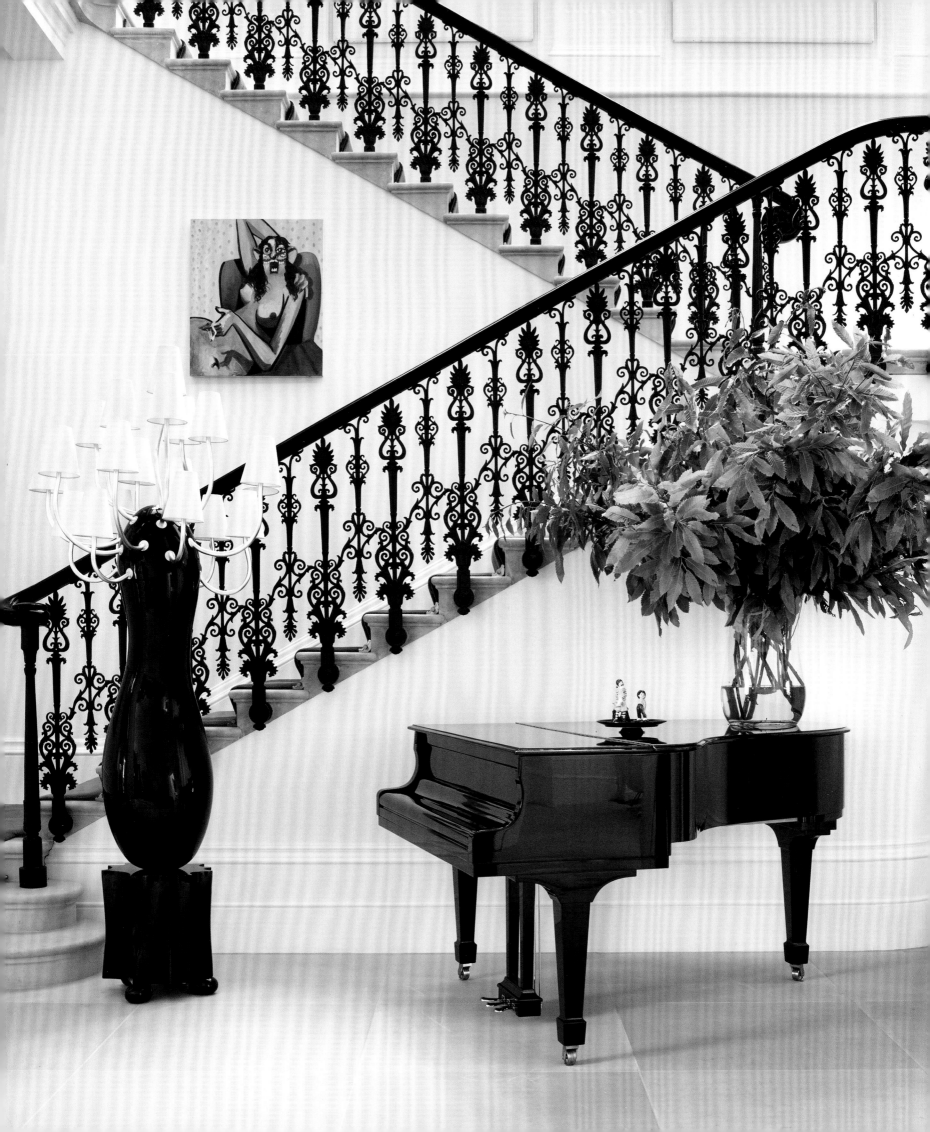

ART APARTMENT
LONDON

FRANCIS SULTANA IS SOUGHT OUT BY ART COLLEC-
TORS TO CONCEIVE HOMES THAT NOT ONLY MAKE THE
MOST OF THEIR SURROUNDINGS BUT ALSO MAXIMIZE
THE BEAUTY AND IMPACT OF THEIR CONTEMPORARY
ART AND DESIGN HOLDINGS, WHICH ARE TYPICALLY
LARGE-SCALE VISUAL ART, SCULPTURE AND INSTAL-
LATION PIECES. RATHER THAN DICTATE HIS OWN
PERSONAL STYLE, HE ADAPTS HIS VISION TO A
"PATRON'S TASTE AND ASPIRATIONS," HE EXPLAINS.
"THE PEOPLE FOR WHOM I DECORATE HAVE GREAT
INSTINCT. SO THE FINAL RESULT MAY BE AT MY INSTI-
GATION BUT, ULTIMATELY, IT'S A COLLABORATION."

AND SO AS FRANCIS AND THE ARCHITECT TOM CROFT
GOT TO WORK IN 2008, RESTORING THIS FIVE-STORY
GEORGIAN MANSION FOR A BUSINESS WOMAN/
PHILANTHROPIST AND HER FAMILY, THE OWNER'S
INPUT DETERMINED THE DIRECTION. OUT WENT THE
DARK PANELING AND TO SHOWCASE THE COLLEC-
TION—WHICH IS NOTABLE FOR ITS CONTEMPORARY
PAINTINGS—THE WALLS WERE COATED IN CLASSIC
WHITE. AVANT-GARDE LIGHTING—FROM A SURREAL
ILLUMINATED GAROUSTE & BONETTI SCULPTURE TO
A MONOLITHIC FIXTURE BY FREDRIKSON STALLARD
ILLUMINATING A TRIO OF AI WEIWEI VASES ON THE
DINING ROOM TABLE—LENDS THEATRICALITY TO THE
HOME AND ALSO HIGHLIGHTS ITS SUMPTUOUSLY
CORNICED, TOWERING CEILINGS.

THE HERITAGE OF THE DWELLING, WHICH IN
THE 1910S WAS THE EXHIBITION SPACE FOR THE
BLOOMSBURY GROUP'S EXPERIMENTAL DESIGN
COLLECTIVE, THE OMEGA WORKSHOPS, APPEALED
TO THE OWNER. FOR FRANCIS AND CROFT, THE
SWEEPING QUARTERS POSED SOME CHALLENGES.
"THE VAST ROOMS—THOUGH IDEAL FOR ENTER-
TAINING AND DISPLAYING WORKS OF ART—WEREN'T
OBVIOUSLY SUITED TO A YOUNG FAMILY," NOTED
ARCHITECTURAL DIGEST WHEN IN 2017 THE HOME
APPEARED IN THE MAGAZINE.

SO FRANCIS DEPLOYED HIS EXPERTISE AT RIGOR-
OUSLY EXECUTING LAVISH CUSTOM FURNITURE AND
FIXTURES, BOTH HIS OWN AND THOSE CONCEIVED BY
OTHER ARTISTS, TO EXACTING SPECIFICATIONS. THE
RESULT IS AN EXCEPTIONAL LIVING SPACE, WHICH IS
SPECTACULAR YET COMFORTABLE AND WELCOMING.

OPPOSITE: In the dramatic entrance hall, a light sculpture by Garouste
& Bonetti accompanies a Steinway grand piano to bring human scale to
the space. A Barnaby Barford sculpture on top of the piano and an over-
sized botanical arrangement provide a contrast in proportions. ABOVE:
Visually connecting the entrance and living area is a painting by Keith
Coventry above a console by Martin Szekely.

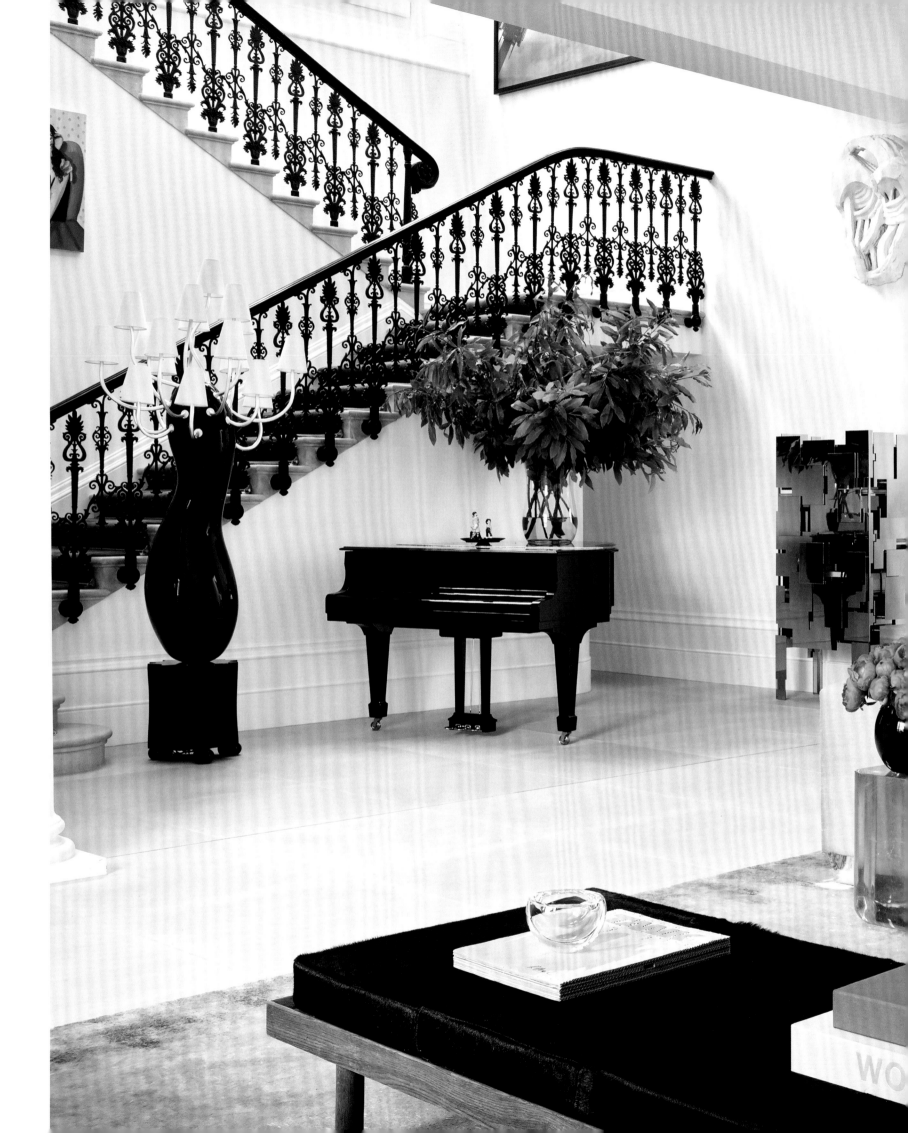

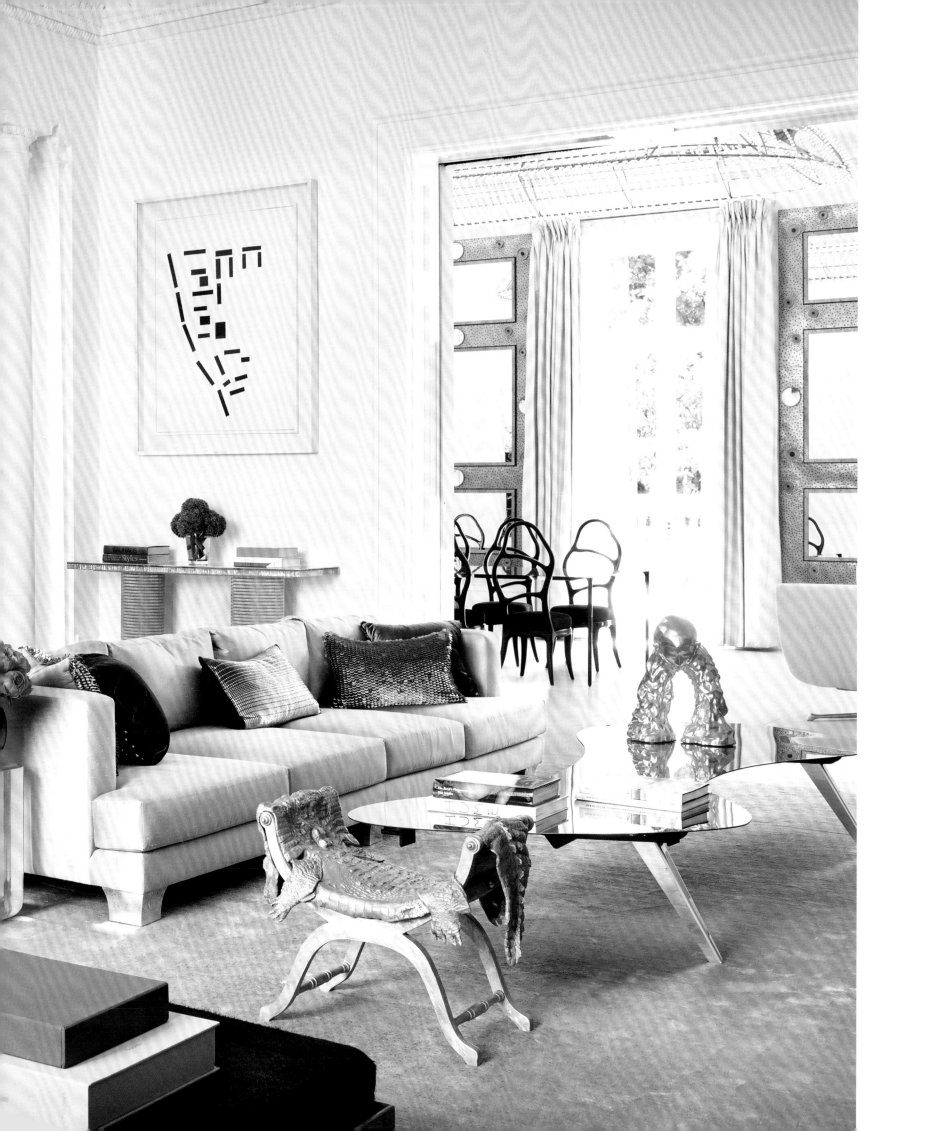

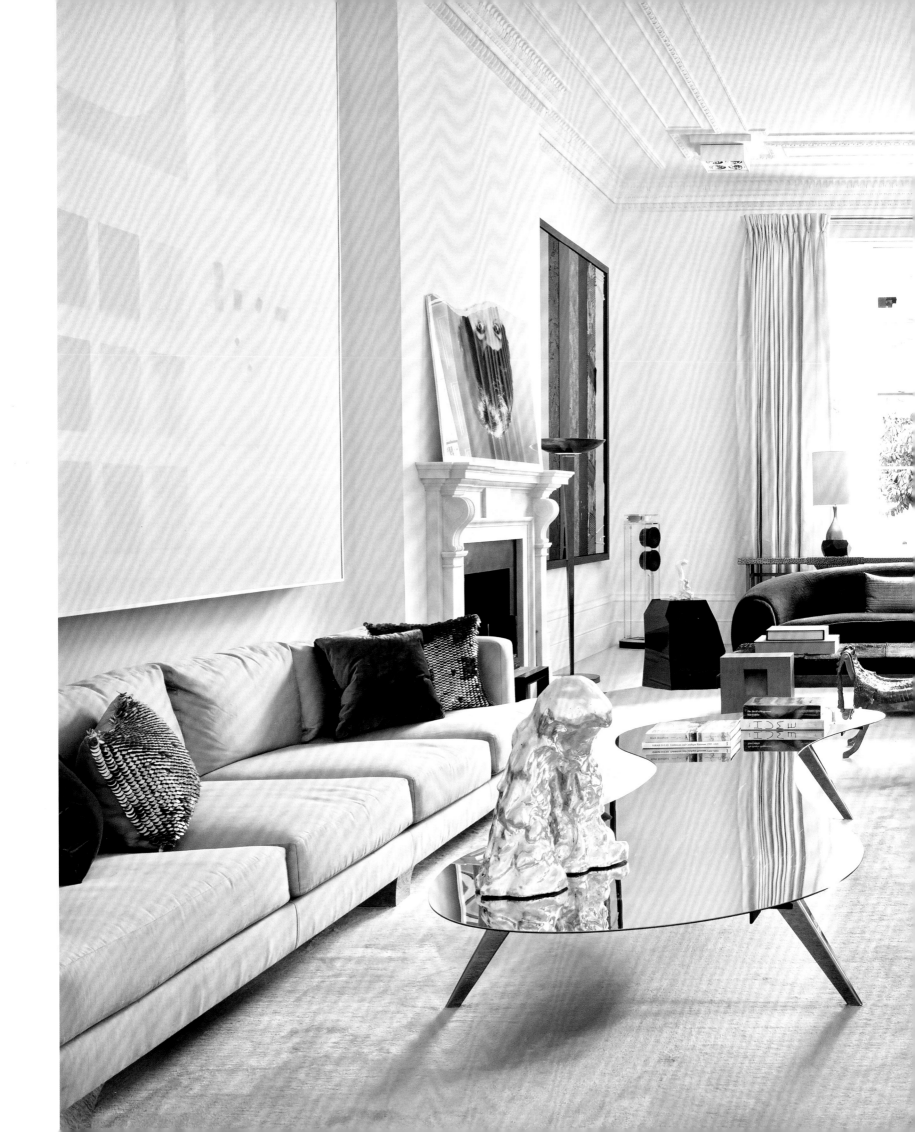

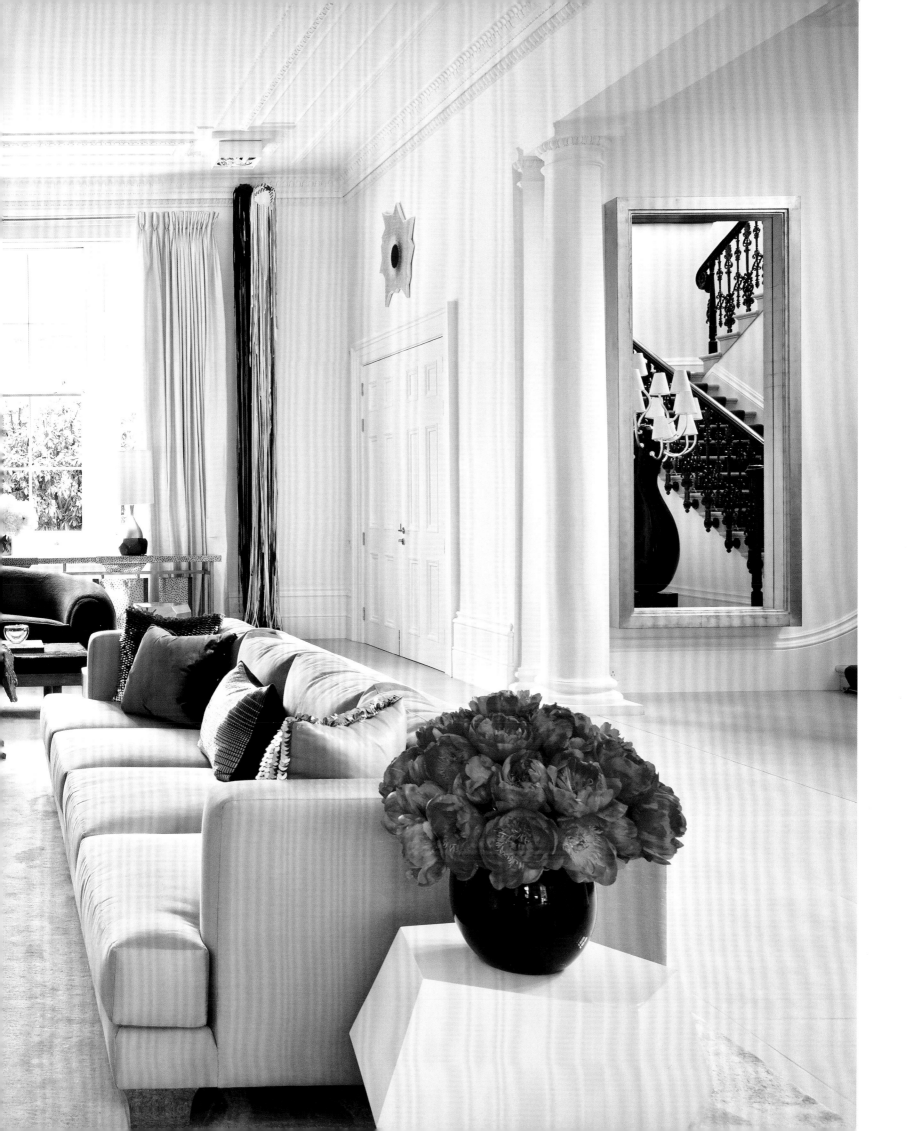

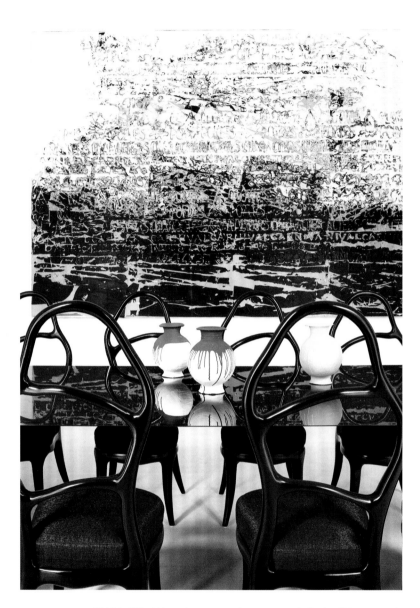

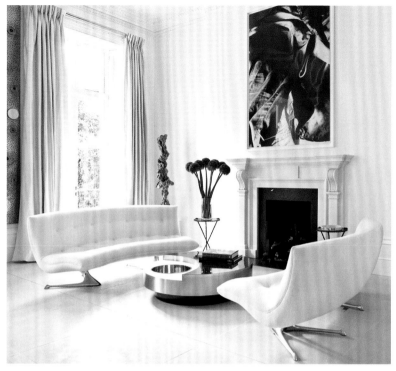

PP154–157: Although open to the entrance hall, the living room is demarcated by a columned architrave and carpet by Fort Street Studio. Twin sofas by Francis Sultana are positioned either side of a mirrored coffee table by Ron Arad. At the far end of the room is a purple Jean Royère sofa and a Charlotte Perriand bench with midnight blue cushions.

ABOVE, RIGHT & OPPOSITE: Mattia Bonetti chairs surround a dining table by Terence Woodgate, with vases by Ai Weiwei. The expanse of the dining room allows for a conversation area, delineated by sculptural white sofas by Vladimir Kagan, and a sinuous metallic coffee table by Willy Rizzo.

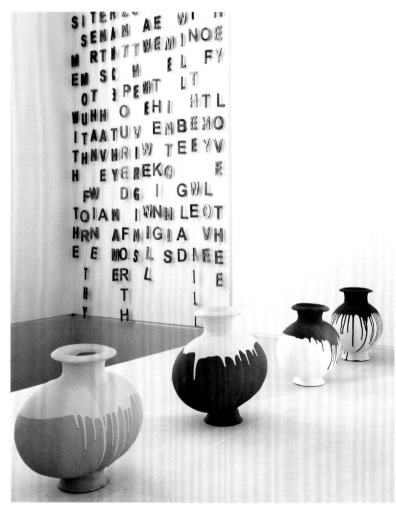

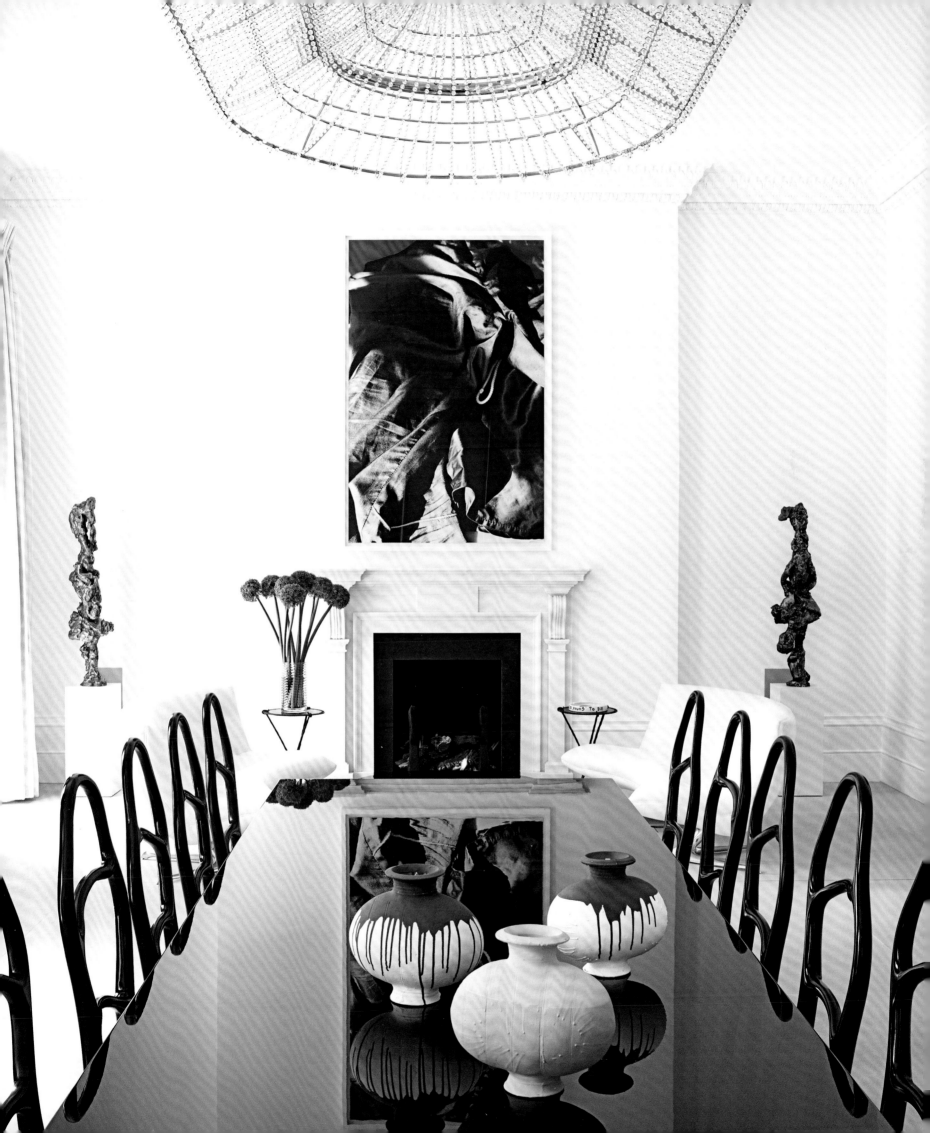

ABOVE: Echoing the Jean Royère sofa in the living area, a purple banquette lines one side of the garden-level dining area, together with a Martin Szekely table and chairs. The painting is by Fiona Rae.

OPPOSITE: The renovation included the addition of a stone staircase down to the lower ground floor, where a Minotti Cucine kitchen opens on to a spacious, parkside terrace with daybed by Francis Sultana, a pair of Fredrikson Stallard tables, and an André Dubreuil chair.

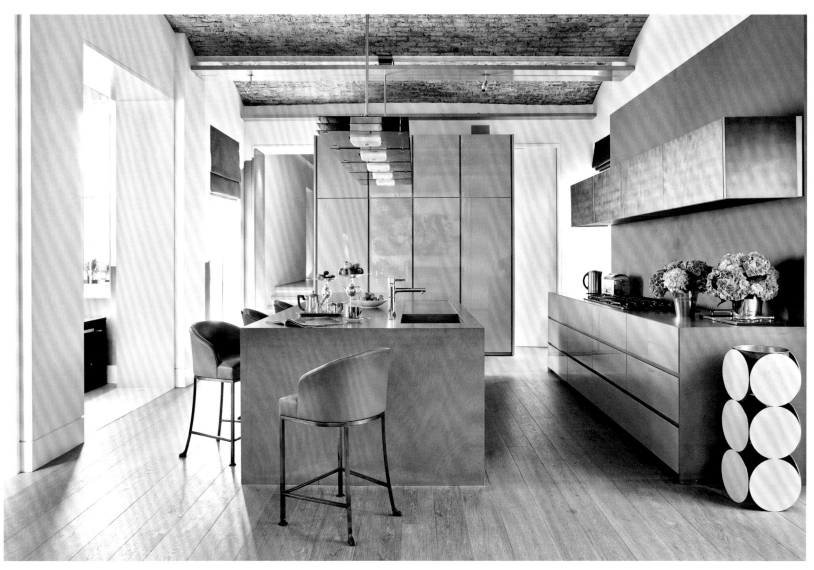

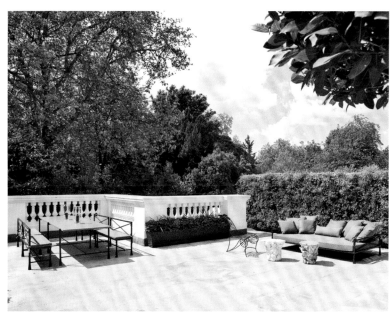

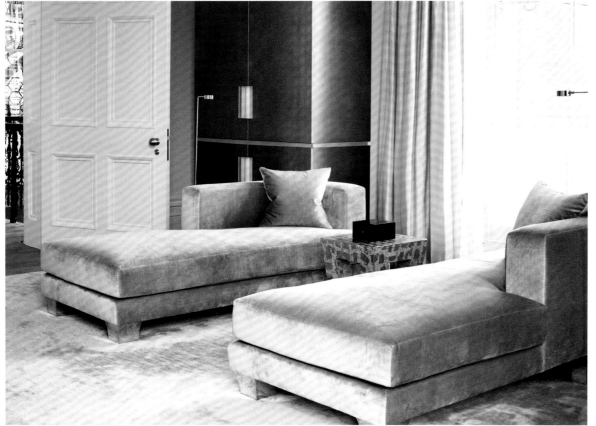

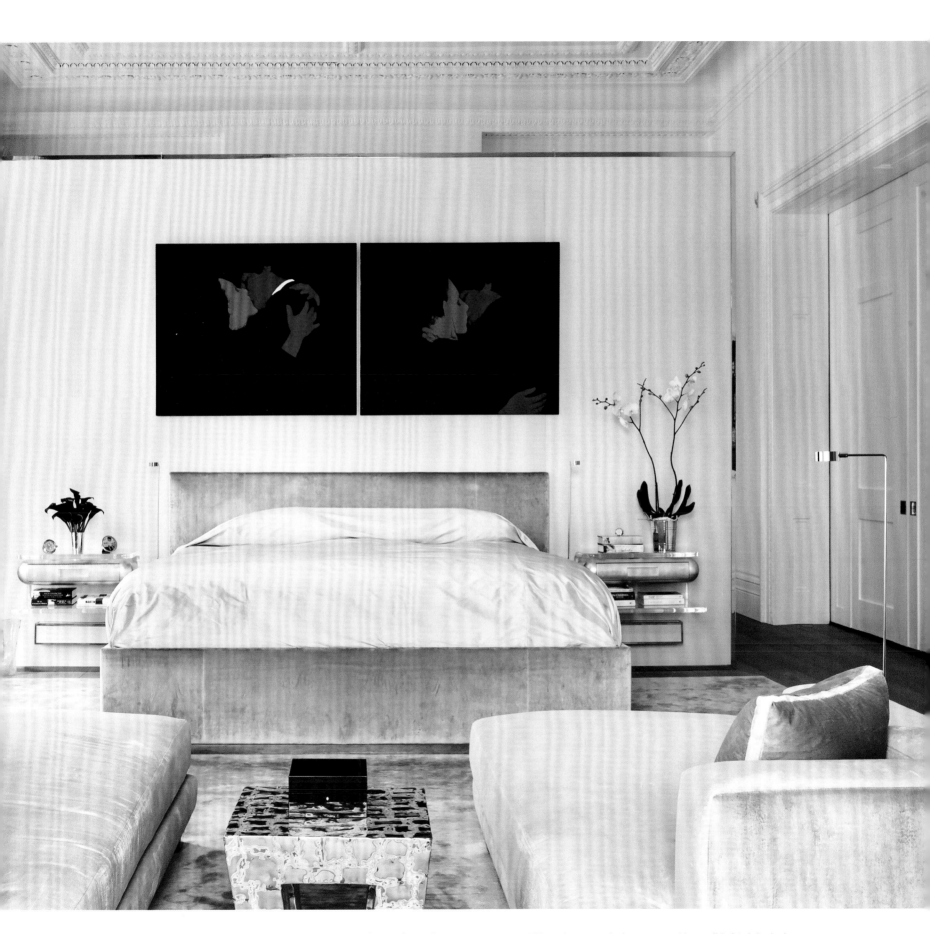

PP162–163: A light installation by Cerith Wyn Evans hangs above the first-floor landing, where a work by Keith Tyson extends across one wall.

ABOVE & LEFT: In the master bedroom, a partition wall behind the bed conceals a bathroom. The two-panel painting is by John Stezaker, and the bed and chaise longues are by Francis Sultana.

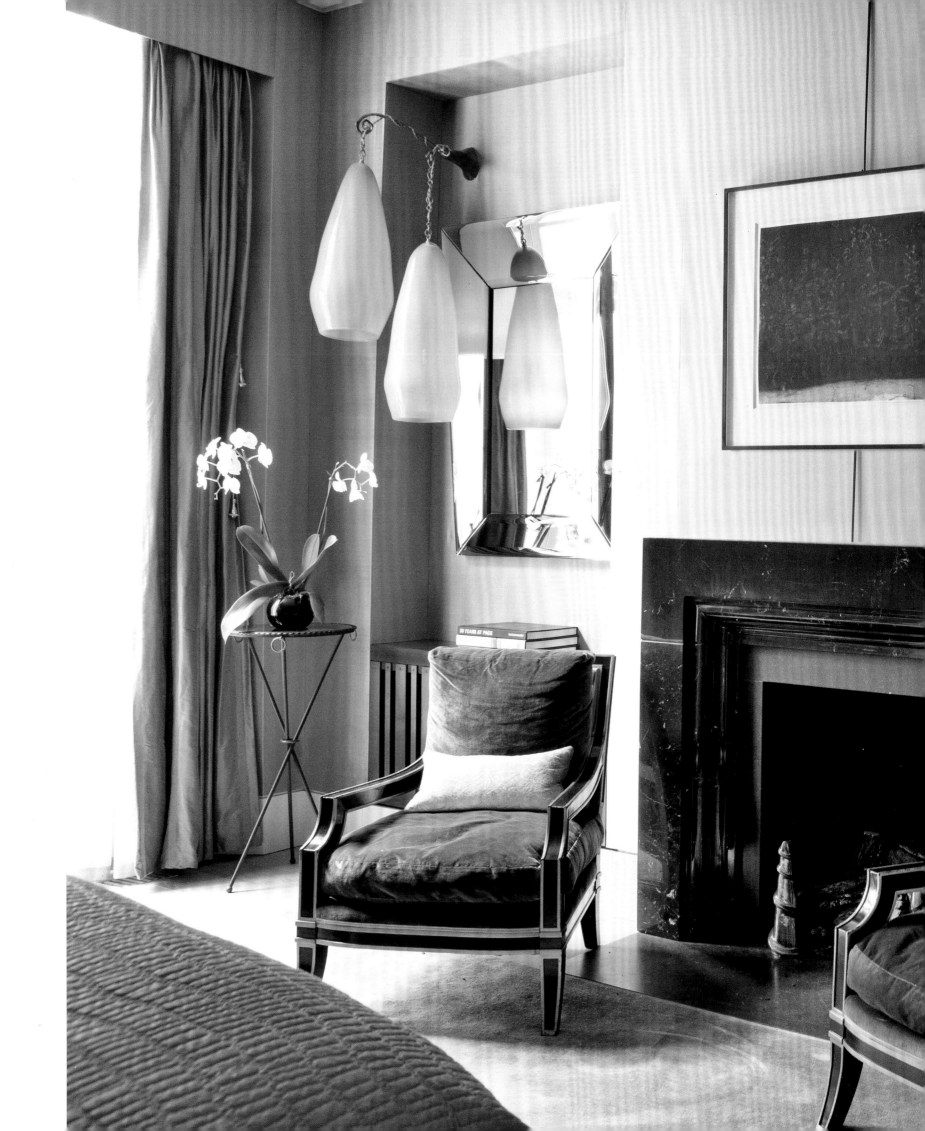

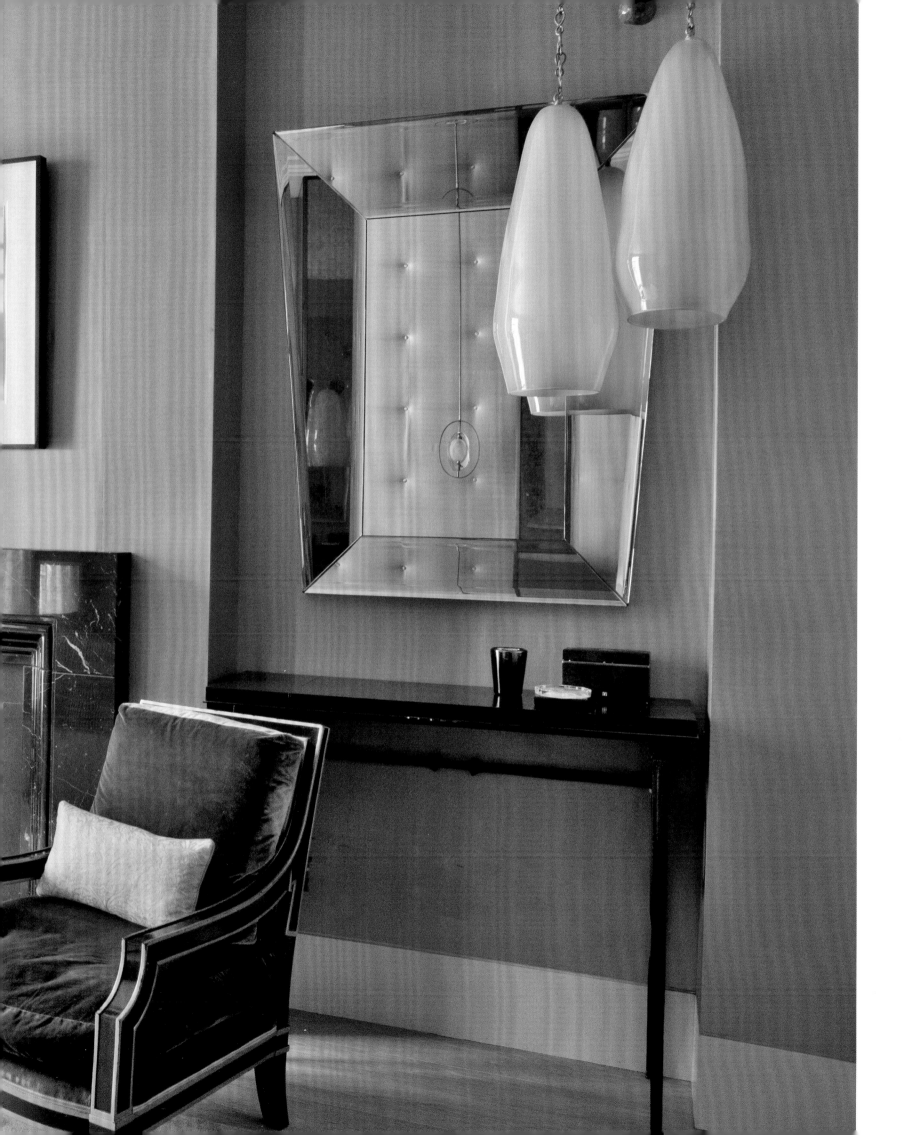

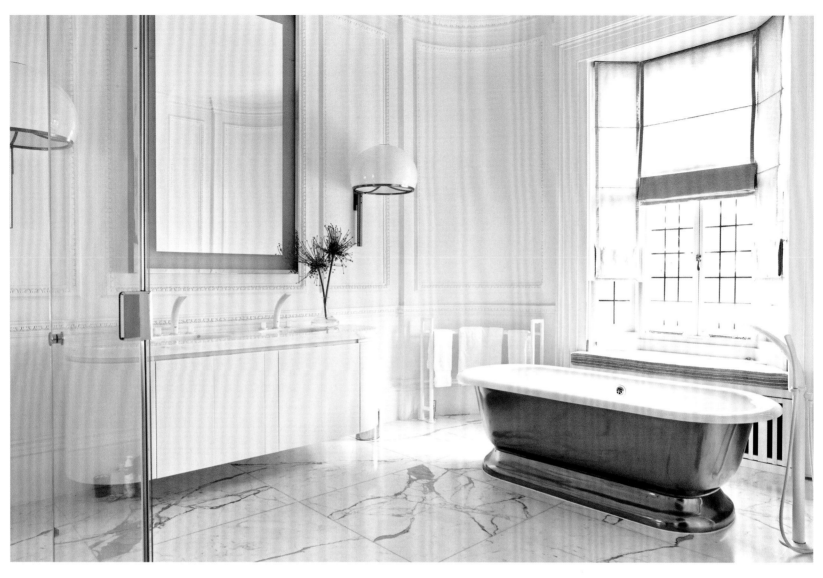

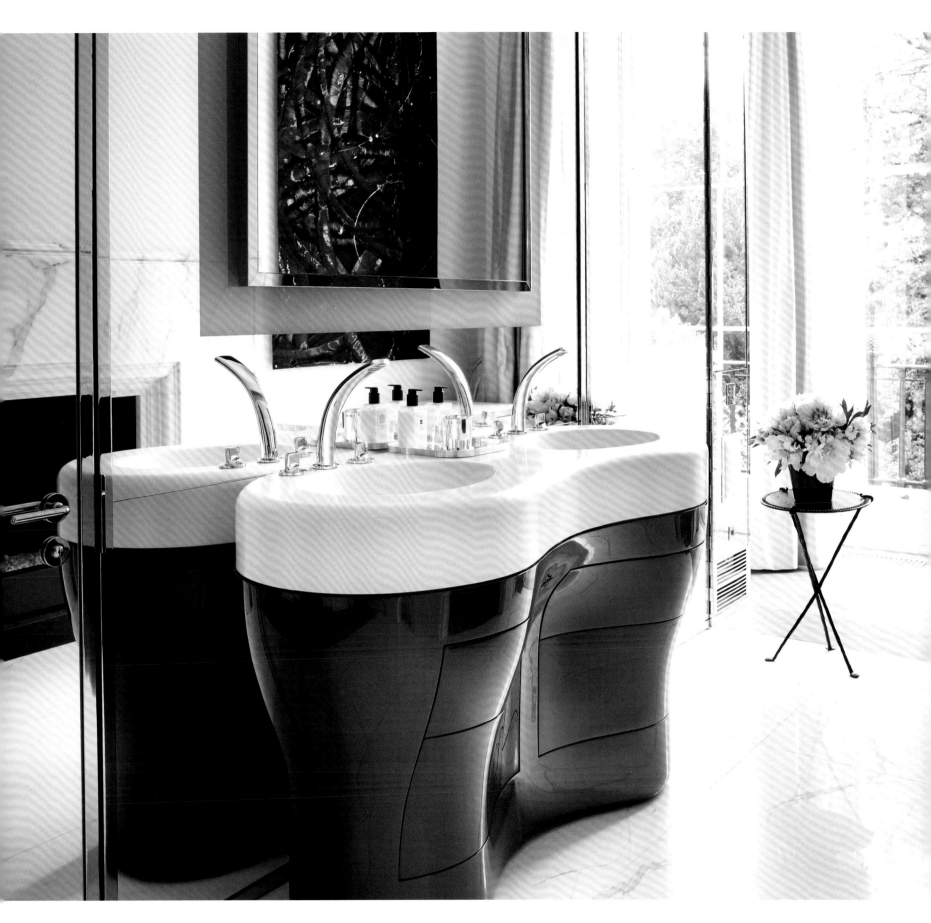

PP166–167: Francis's artful way with color is evident in the guest room where a pair of vintage, forest-green Jansen chairs flank the fireplace. The mirrors are by FontanaArte and the pendant lights are by Garouste & Bonetti.

ABOVE & OPPOSITE: Lighting design by Sally Storey for John Cullen is a unifying feature of the décor, as is the use of monumental sculptural fixtures in the bathrooms, including a bulbous black vanity by Bonetti in the master suite, and a tub by Water Monopoly in a 2nd floor bathroom.

PACIFIC HEIGHTS CHIC
SAN FRANCISCO

"WHEN I BOUGHT THIS APARTMENT, I SET OUT TO WORK WITH FRANCIS. HE UNDERSTANDS HOW TO LIVE WITH ART. HIS CONCEPTION OF SCALE AND PROPORTIONS IS UNRIVALED." SO SAYS THE OWNER OF THIS SWEEPING SAN FRANCISCO HOME. SHE IS A FORMER MIAMI REAL ESTATE DEVELOPER WHO SPEARHEADED THE RESTORATION OF THE CITY'S ART DECO DISTRICT. AND AFTER TWO YEARS OF RESTORATION WORK CONDUCTED WITH FRANCIS, SHE HAD HER IDEAL, OPEN-PLAN LIVING SPACE. LOOMING HIGH WITHIN A MEDITERRANEAN GOTHIC REVIVAL BUILDING DESIGNED IN 1927 BY THE "PREMIERE" BAY AREA ARCHITECT, CONRAD ALFRED MEUSSDORFFER, THE PACIFIC HEIGHTS CO-OP OFFERS PANORAMIC VIEWS OF ALCATRAZ.

THE LOFT-LIKE HOUSEHOLD THAT FRANCIS DEVISED EXHIBITS A CONTEMPORARY ART AND DESIGN COLLECTION RUNNING THE GAMUT FROM A VIBRANT JOHN GIORNO TEXT PAINTING TO A YAYOI KUSAMA SCULPTURE. AROUND ZAHA HADID'S 2012 "LIQUID GLACIAL" DINING TABLE ARE A COLLECTION OF FRANZ WEST CHAIRS. ART AND DESIGN EVOKING THE CLIENT'S FEARLESS PERSONAL STYLE AND FREE-SPIRITED NATURE INCLUDES CHANTAL JOFFE'S PAINTING *BLUE COAT ON GREEN*, AS WELL AS A GAROUSTE & BONETTI OTTOMAN SHOD WITH LOUIS XIV-STYLE BLOCK HEELED SILVER BOOTIES. (THESE WERE ONCE THE FEET ON THE BED OF THE CLIENT'S DAUGHTER.)

FRANCIS LIGHTENED HIS TOUCH, CONSTRUCTING HIS FIRST SECTIONAL SOFA, EACH PART OF WHICH IS UPHOLSTERED IN GREY VELVET AND PROPPED UPON WHEELS, SEATING "15 GIRLFRIENDS" ON THE CLIENT'S MOVIE NIGHTS. "MY HOUSE IS NOT A MUSEUM," ADDS THE CLIENT, NOTING THAT FRANCIS CONVERTED THE URS FISCHER SCULPTURES INTO COFFEE TABLES. "NOTHING CAN BE TOO PRECIOUS SO WE CAN'T PLAY."

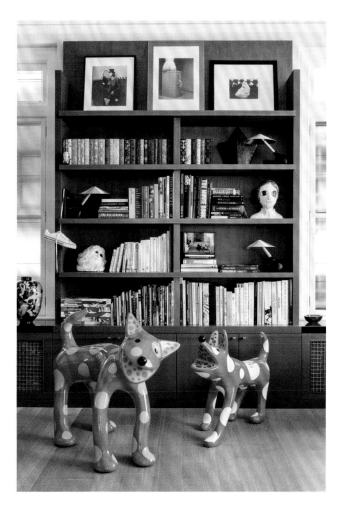

OPPOSITE & ABOVE: In the dining room, Franz West chairs surround a "Liquid Glacial" Zaha Hadid table, positioned in front of *Solar Catastrophe*, 2012, by Allora & Calzadilla. Meanwhile, in the adjacent library, Yayoi Kusama's playful pink dogs look ready to play.

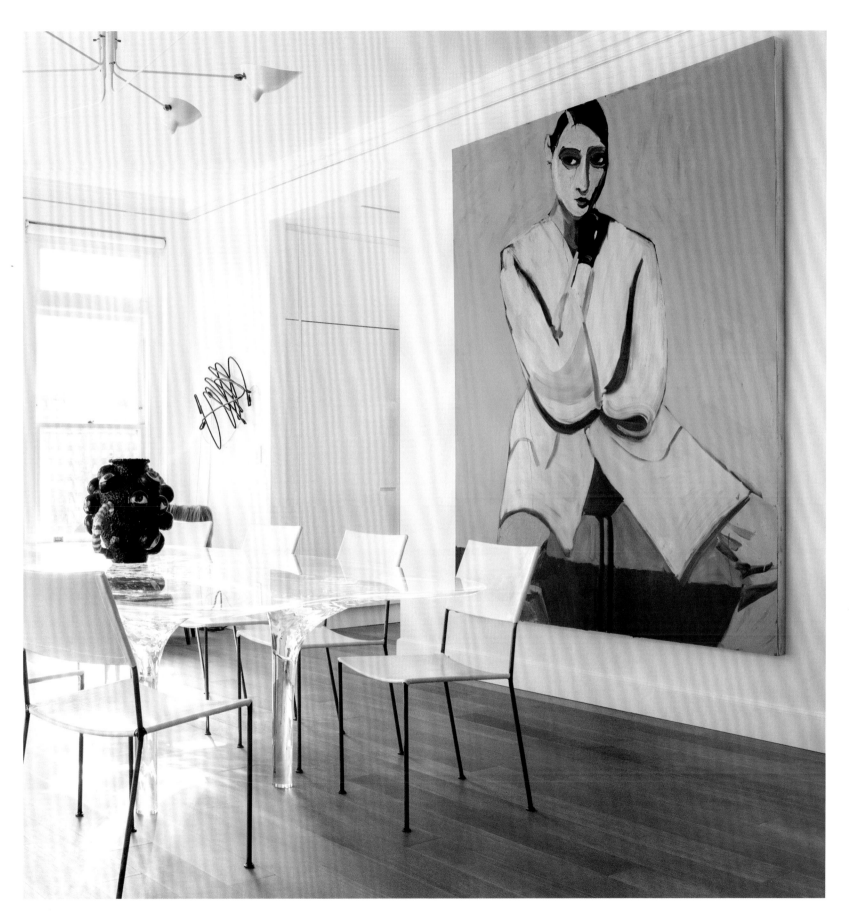

OPPOSITE: In the dressing room, a Jacin Giordano sculpture of different colored toilet seat covers towers over a Tom Dixon desk, and an ottoman and rug by Francis Sultana. The pendant light is by Property Furniture.

ABOVE: Chantal Joffe's figurative painting in shades of green looms over Zaha Hadid's polished plexiglass table, designed to represent water in motion. The vase is by Milena Muzquiz.

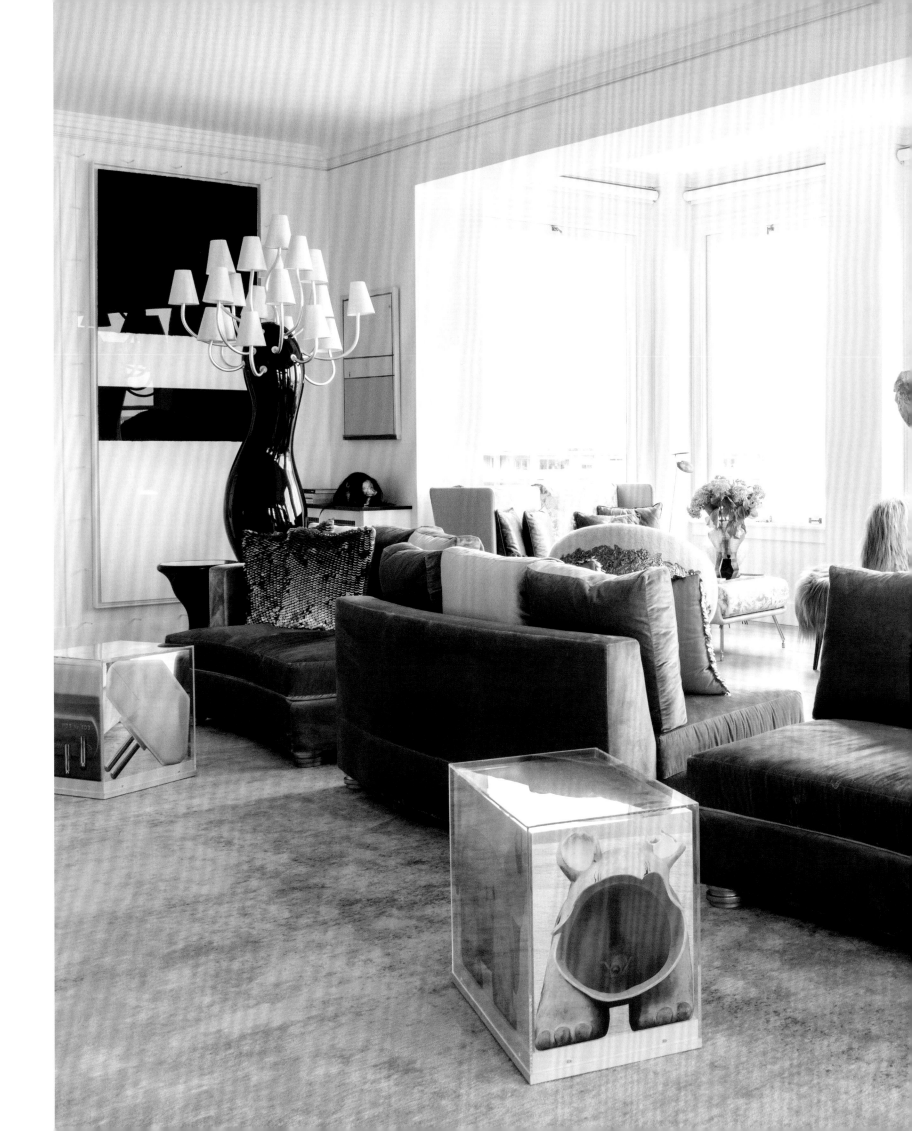

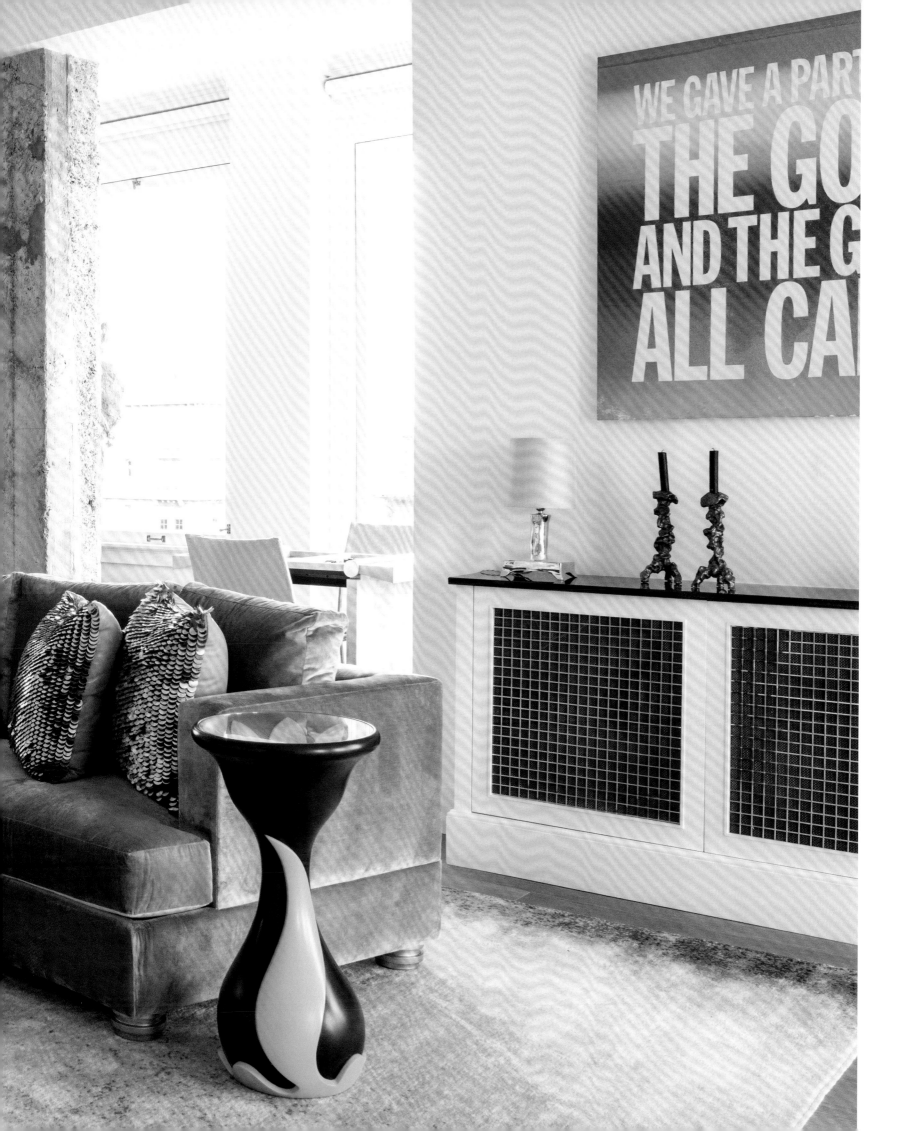

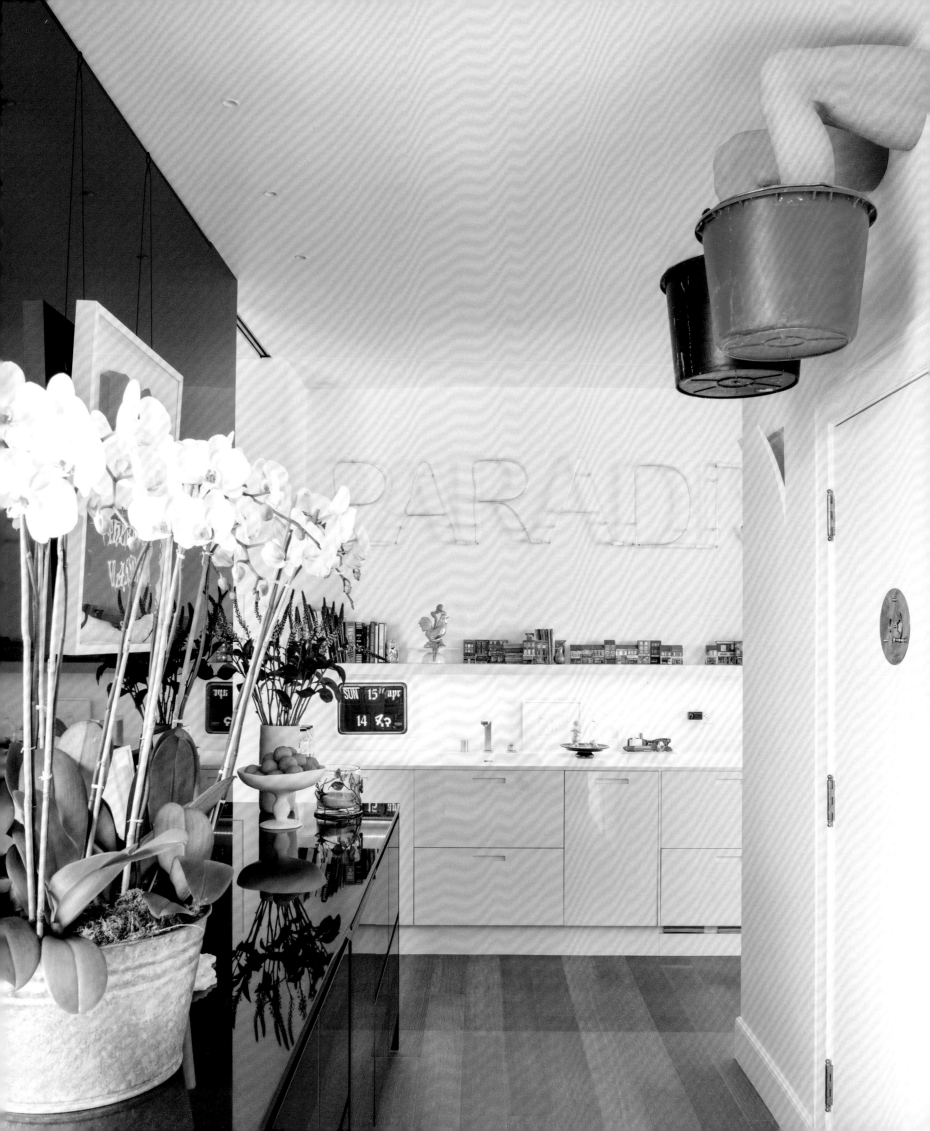

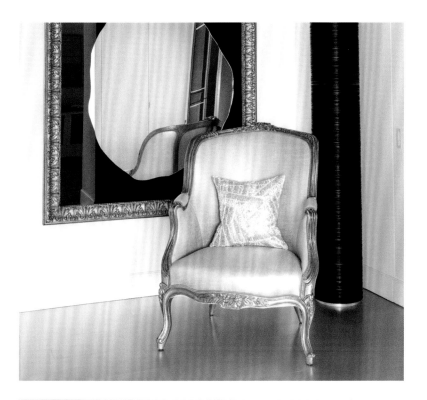

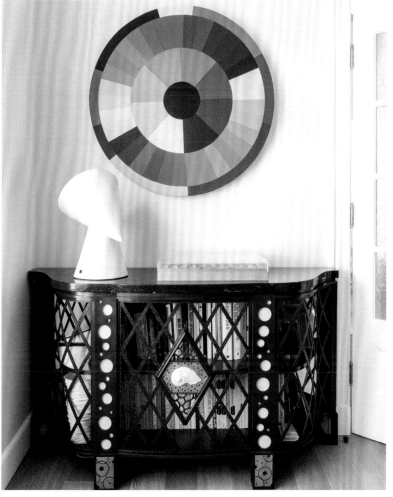

PP 174–175: A bespoke sofa in three parts is arranged with Urs Fischer cube sculptures and a Mattia Bonetti side table. At one end is a torchère by Garouste & Bonetti, with artworks by Richard Serra and Matt Connors.

OPPOSITE: Art invades the kitchen in the form of Adam McEwen's surreal sculpture of a pair of legs with feet in buckets. LEFT & ABOVE: Throughout the apartment, gallery-like corners that meld functional seating or storage with art contribute to a stimulating and visually charged atmosphere.

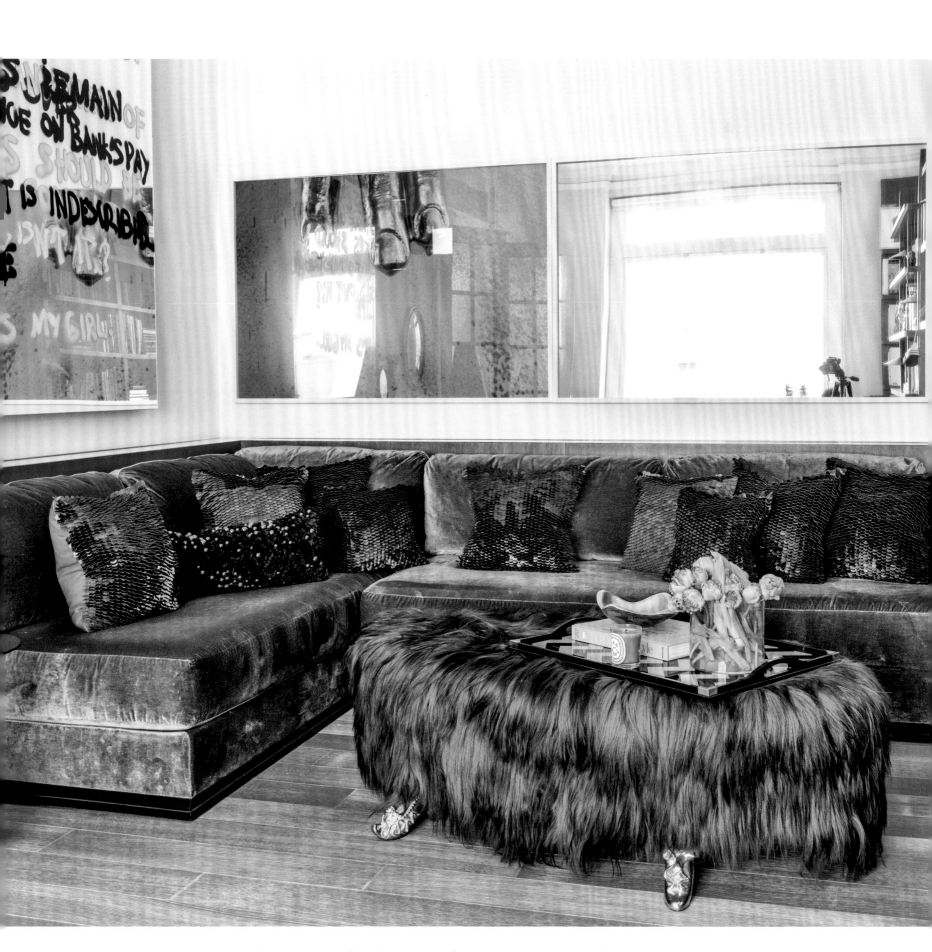

ABOVE & OPPOSITE: Making interior spaces fun to live in is part of Francis's approach. Examples include a green Kidassia ottoman by Garouste & Bonetti in the library and a flamboyant Yayoi Kusama sculpture in the master bedroom.

PP180–181: In a corner of the living room with views over Alcatraz and the Golden Gate Bridge, a "Skittle" bench by Garouste & Bonetti and a side table and chair by the Campana Brothers share space with a sculpture by Franz West.

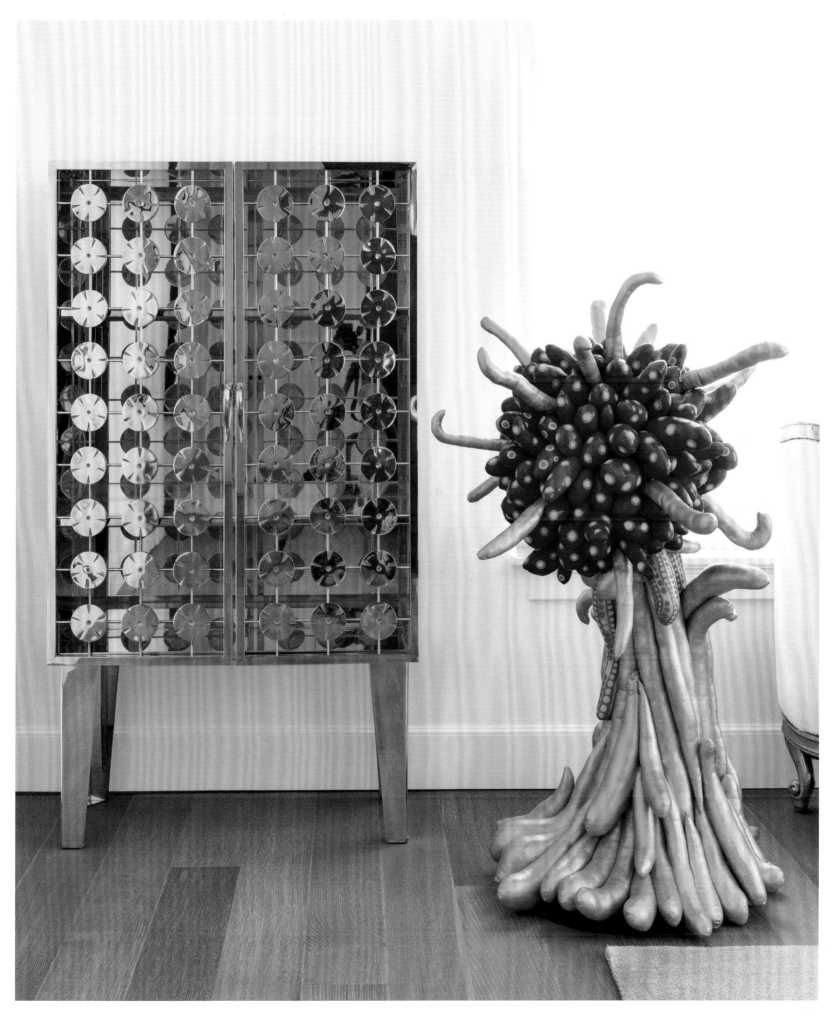

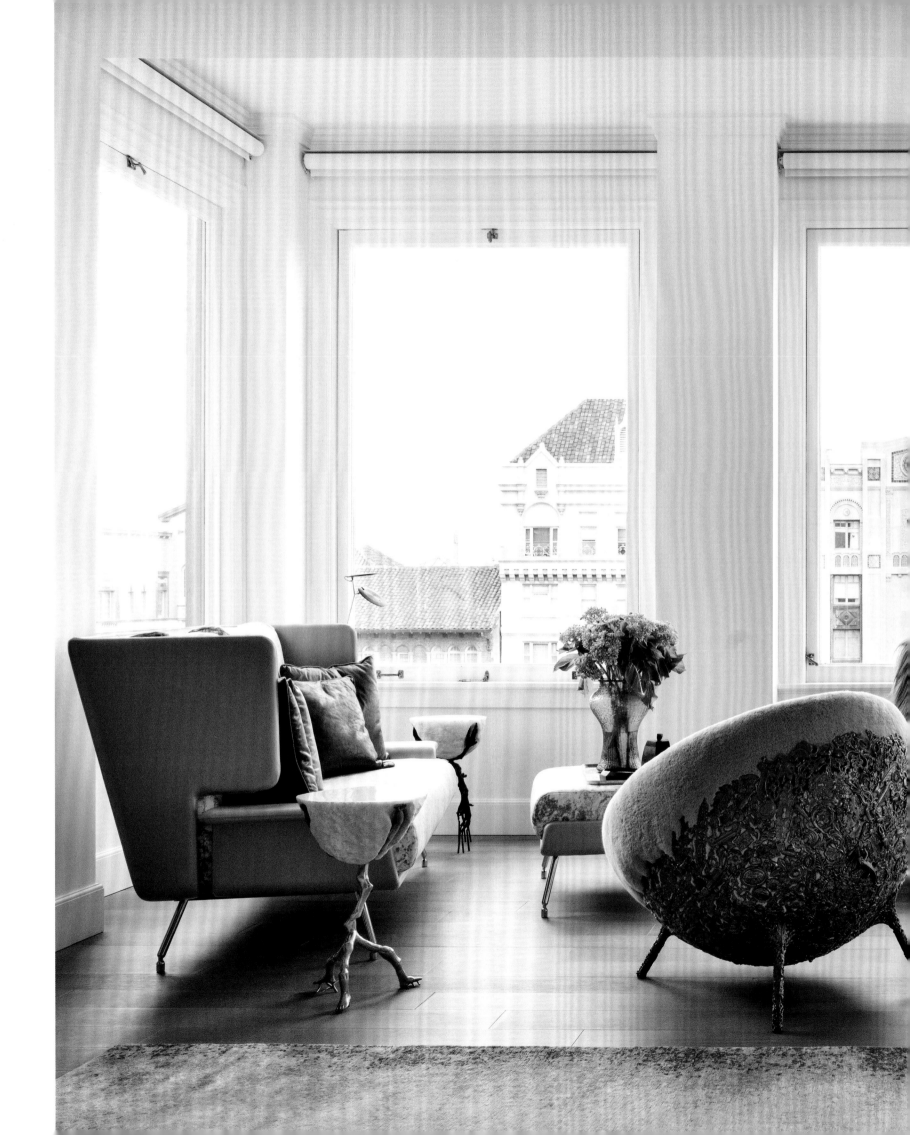

ART DECO REDEFINED
LONDON

SITUATED IN AN ELEGANT, RED BRICK EDWARDIAN-ERA MANSION BLOCK IN LONDON'S ROYAL BOROUGH OF KENSINGTON AND CHELSEA, THIS APARTMENT "WAS TAKEN DOWN TO BRICKWORK," RECALLS FRANCIS. "IT WAS MODERNIZED IN ITS LAYOUT IN A WAY THAT WORKS FOR A FAMILY."

TO DO SO, FRANCIS BROADENED THE APARTMENT'S ORIGINAL NARROW ENTRANCE HALLWAY AND DEVISED A NEW, ARCHED BARREL-VAULTED CEILING. FEATURING ARTISANAL MATTE WHITE-GOLD AND PALLADIUM GILDING, THE ENTRY HALL'S POLISHED PLASTER GREY WALLS CONJURE "WARMTH AND MYSTERY" AND ARE A "GOOD BACKDROP FOR THE ART COLLECTION, WHICH YOU NOTICE AS SOON AS YOU WALK IN," HE OBSERVES.

ELSEWHERE, INGENUITY—AS WELL AS A THOUGHTFUL, RENEWED INTERPRETATION OF ART DECO—PREVAILS, SUCH AS THE GLOSSY MICA FIREPLACE, WHICH A PARIS WORKSHOP EXECUTED ACCORDING TO FRANCIS'S DIRECTION. TO HIGHLIGHT THE FLAMBOYANT HUE FEATURED IN AN ANDY WARHOL WORK FROM THE 1975 "LADIES AND GENTLEMEN" SERIES (WHICH LOOMS ABOVE THE FIREPLACE), FRANCIS SOURCED A PAIR OF TURQUOISE-EMBELLISHED ANDRÉ DUBREUIL TABLE LAMPS.

IN THE ELEGANT KITCHEN, FRANCIS CONCEALED THE APPLIANCES WITH MAKASSAR EBONY-EDGED SHAGREEN SLIDING DOORS. LENDING DROP-DEAD GLAMOUR TO THE MASTER BATHROOM ARE CRYSTAL ADORNED LALIQUE TAPS AND FAUCETS PLUS ALLURING STORAGE UNITS FRONTED BY SHEER GLASS DOORS. SANDWICHED BETWEEN THE PANES IS A CUSTOM WOVEN METALLIC TWEED. WHY TWEED? "BECAUSE I LOVE CHANEL," EXPLAINS FRANCIS.

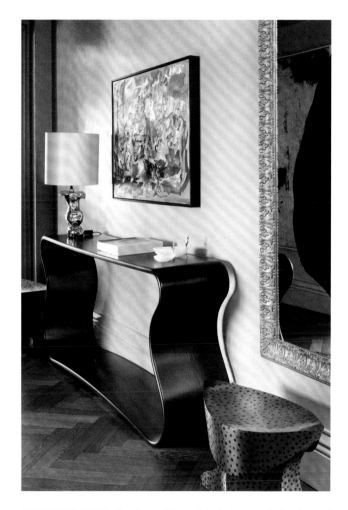

OPPOSITE & ABOVE: The sheen of the polished plaster walls is enhanced with artwork in gilded frames, a metallic console table by Mattia Bonetti, and a stool by Andre Dubreuil.

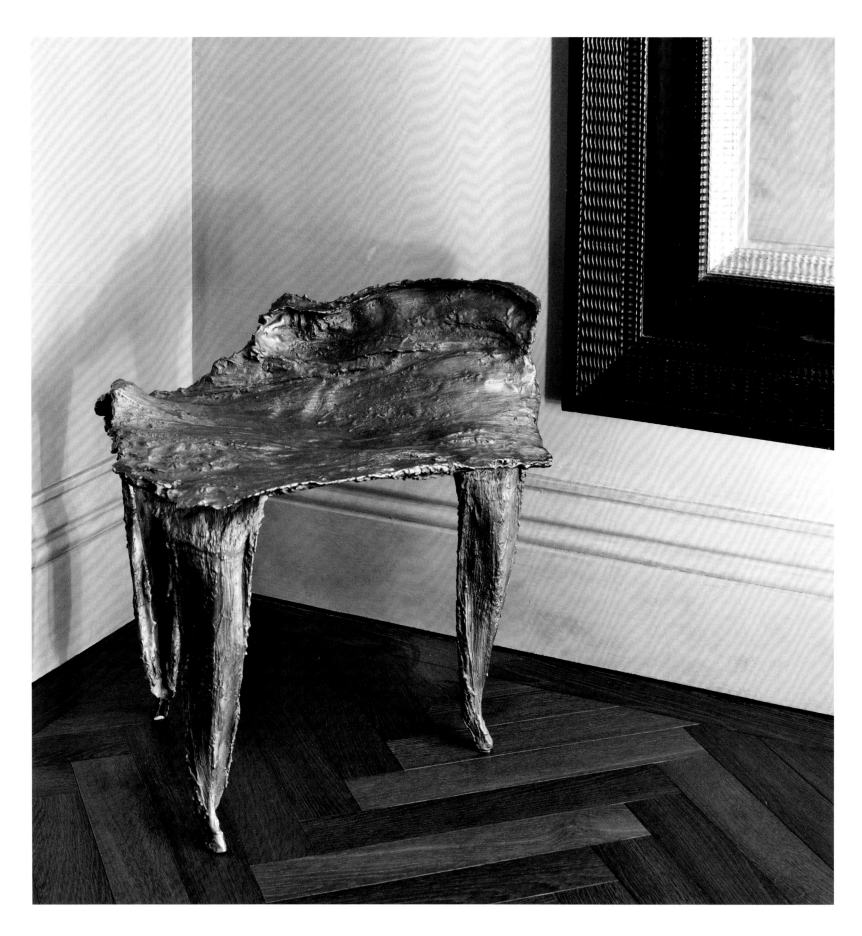

ABOVE: Michele Oka Doner's "Chair for Eve" features in the hallway, where its bronze surface catches light from above.

OPPOSITE: Recessed lighting and the golden hue of the wood parquetry flooring bring glamour to the hallway, hung with striking artwork.

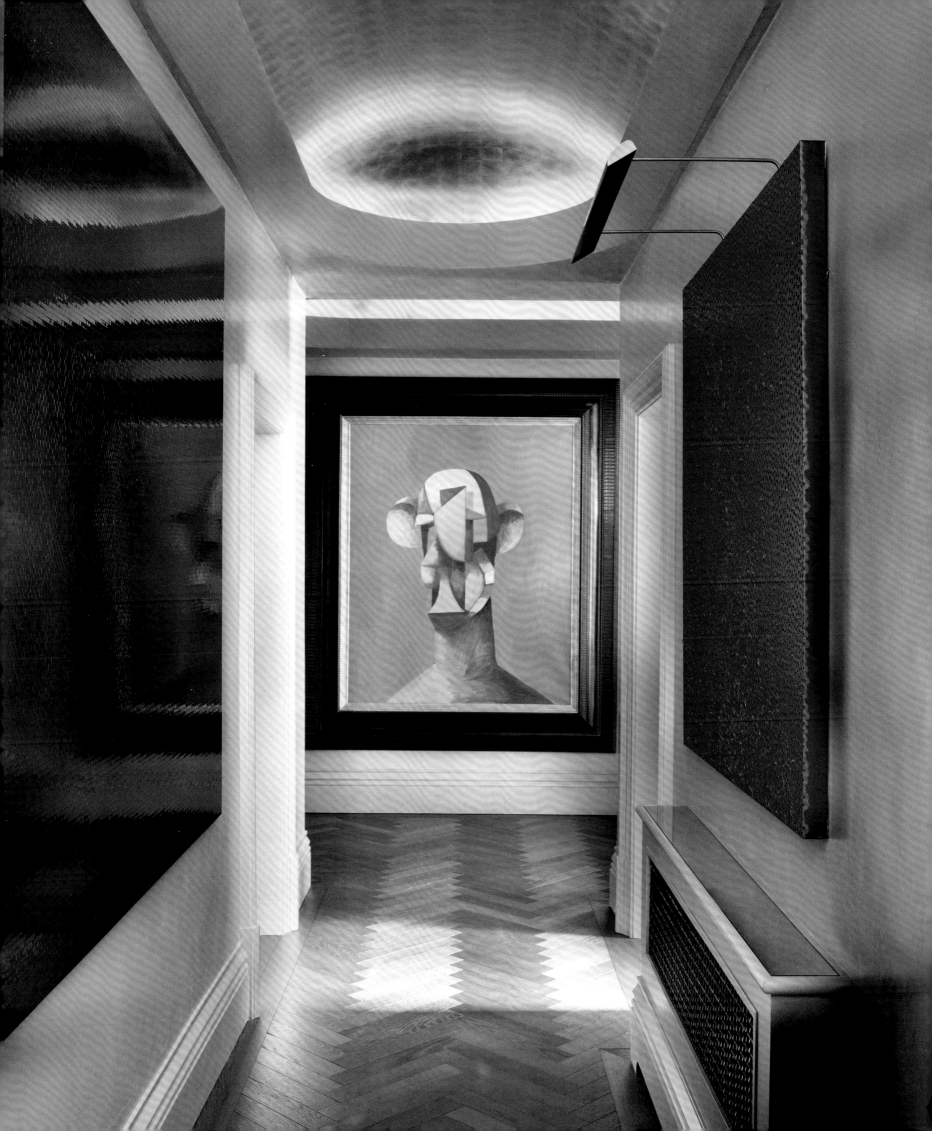

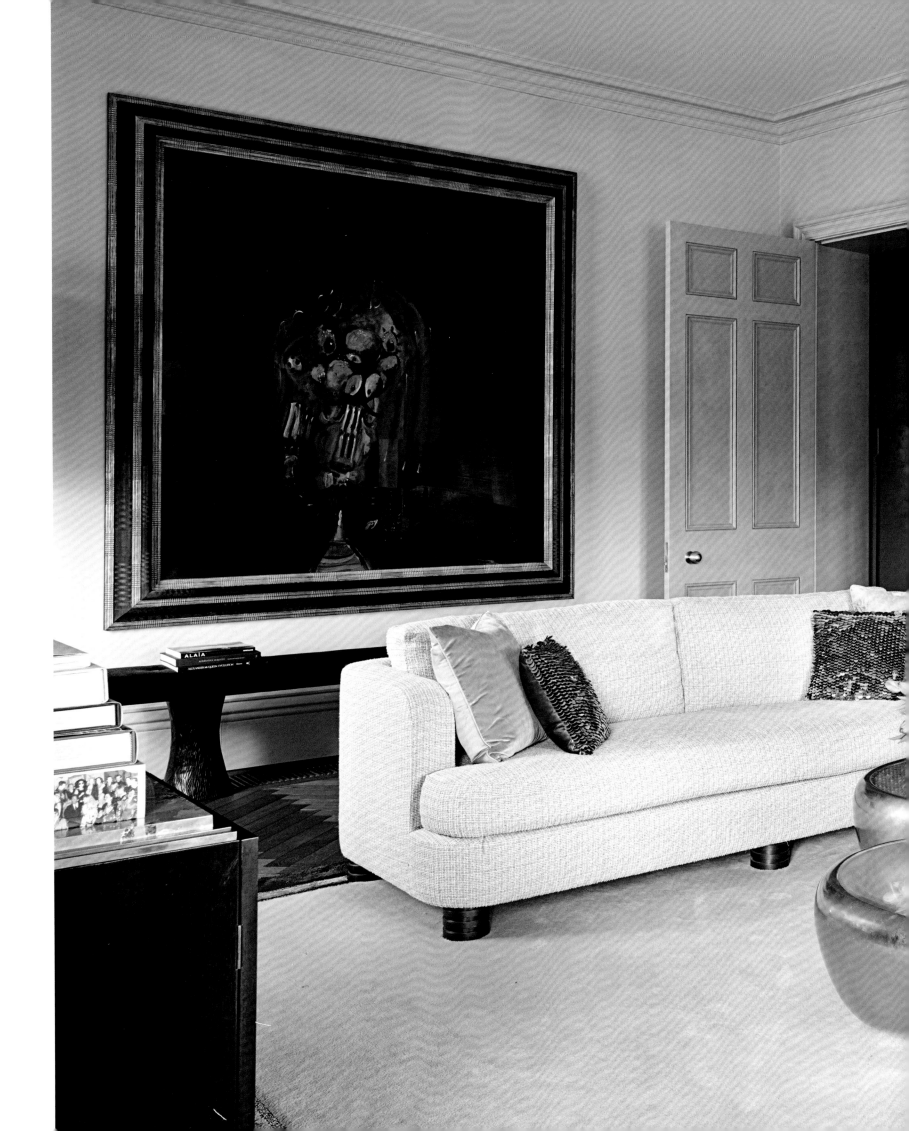

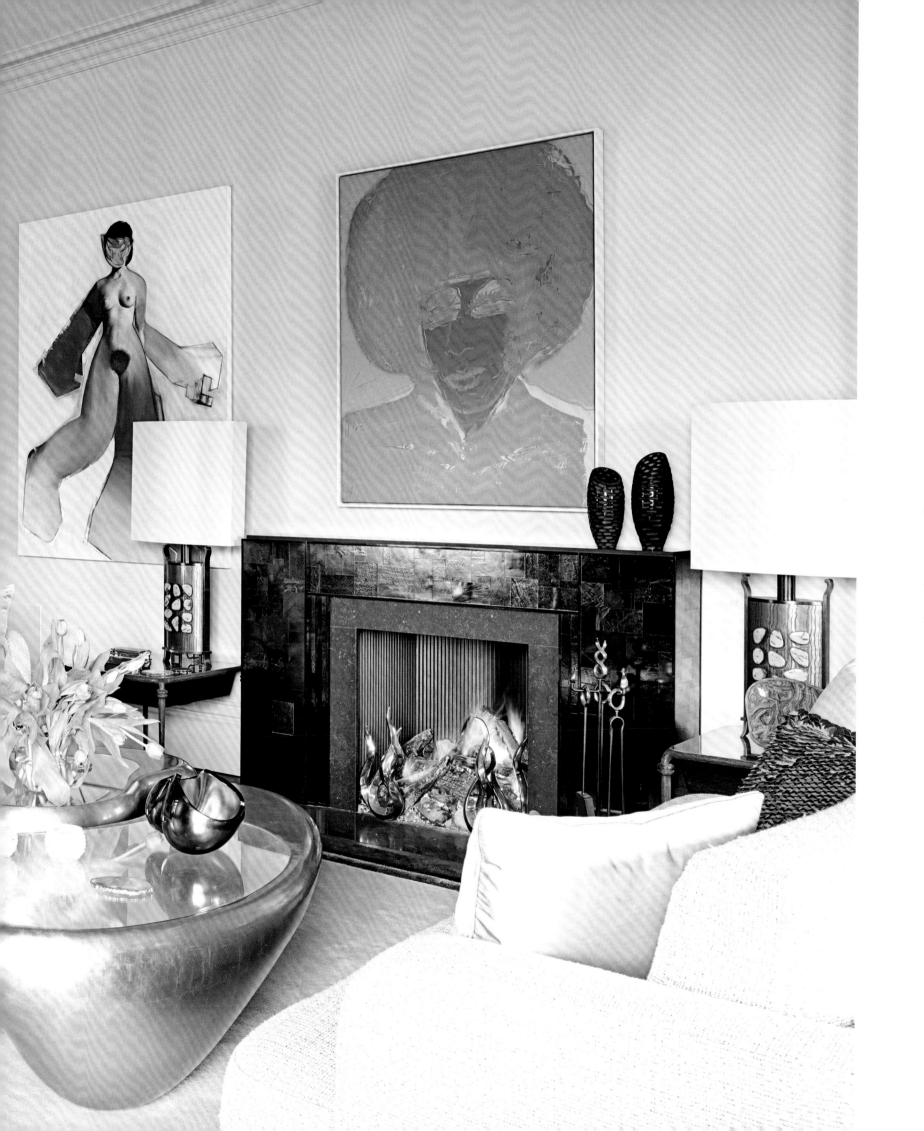

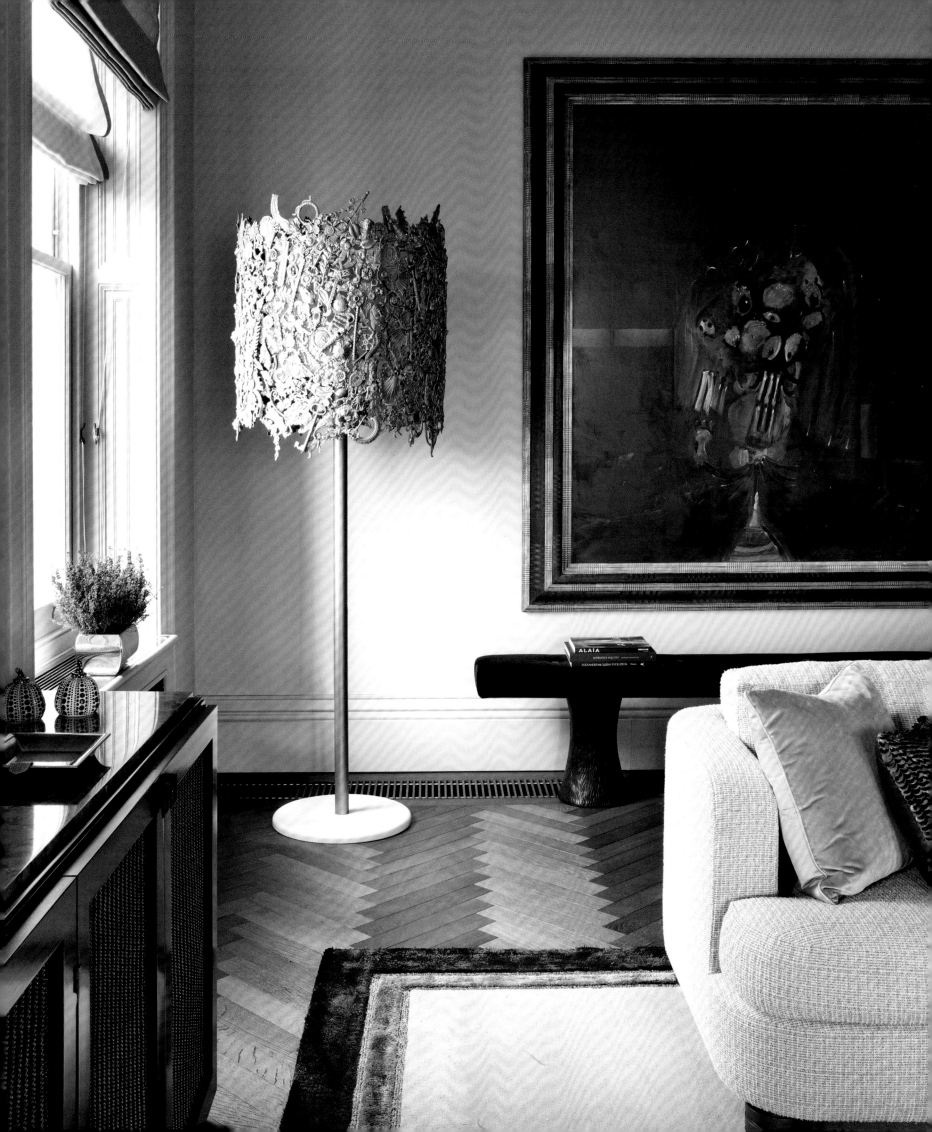

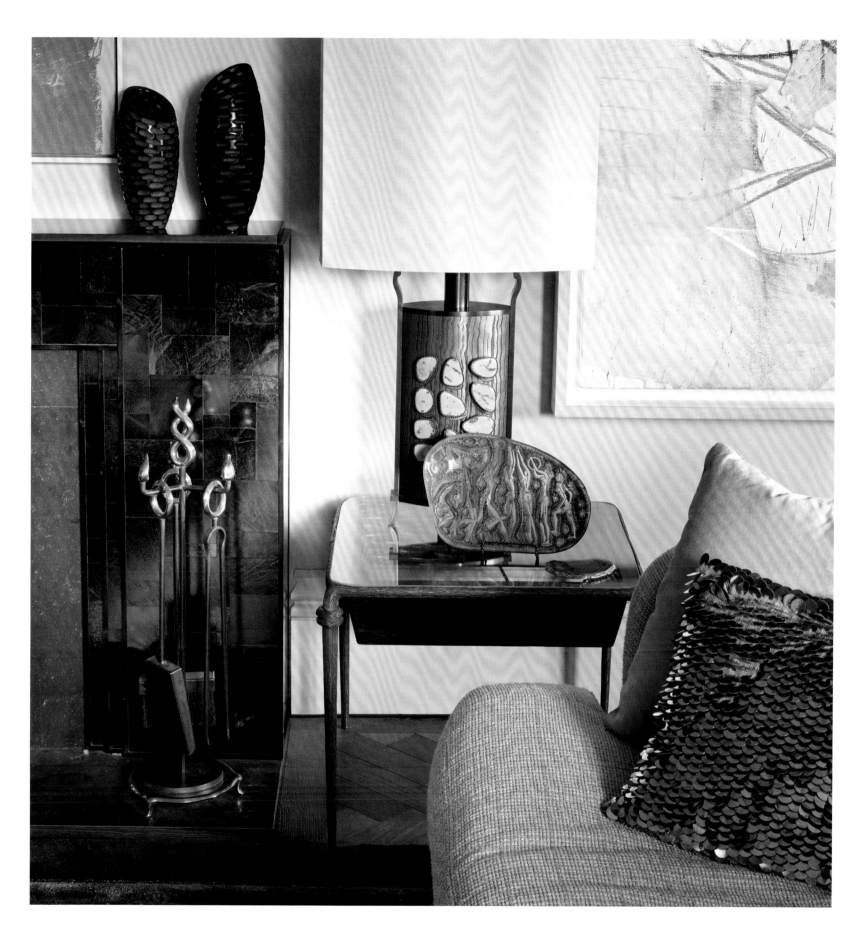

PP186–187: Sofas by Francis Sultana sit either side of gilded metal and glass coffee tables by Mattia Bonetti. Francis bolstered the aesthetic with turquoise-studded table lamps by Andre Dubreuil and a fireplace facade with a bronze finish.

OPPOSITE & ABOVE: Details from the living room reveal Francis's inclusion of glittering furnishings and design pieces including a gold floor lamp by the Campana Brothers and fire tools by Mattia Bonetti.

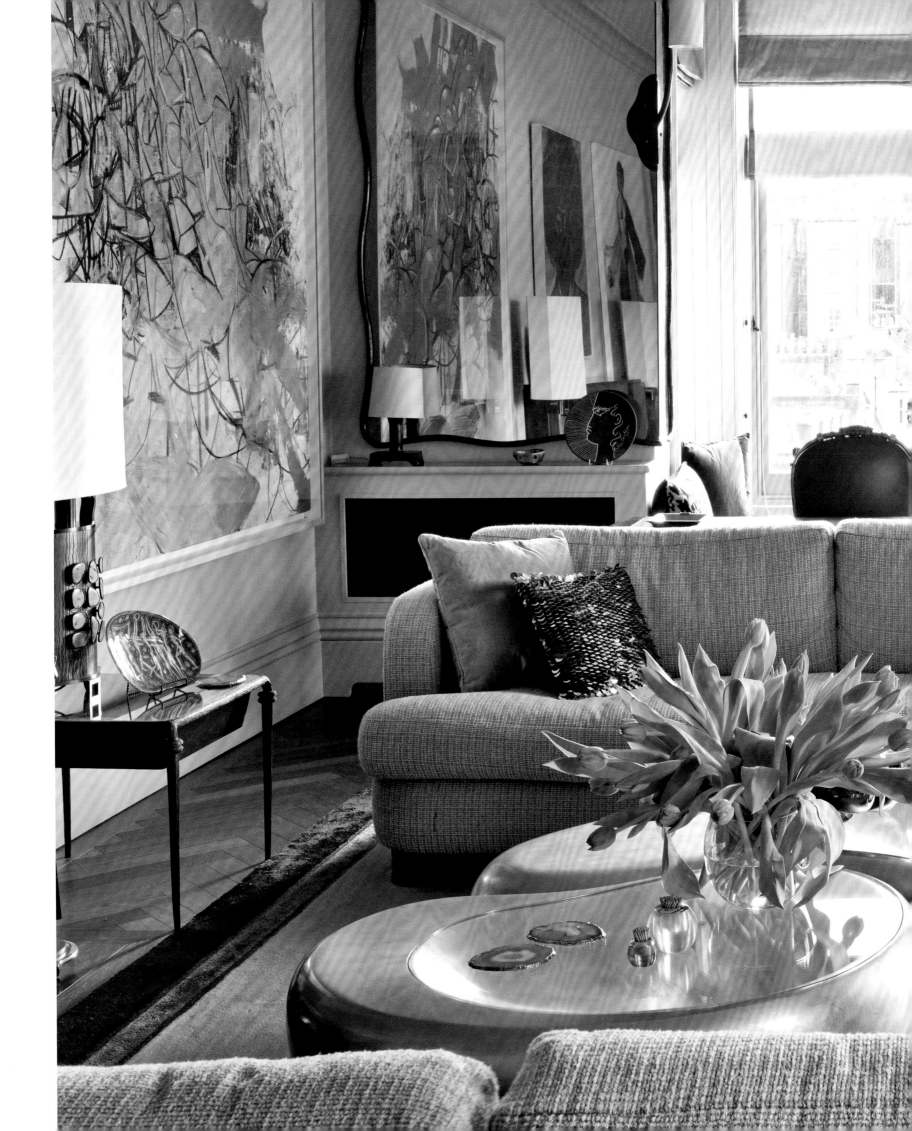

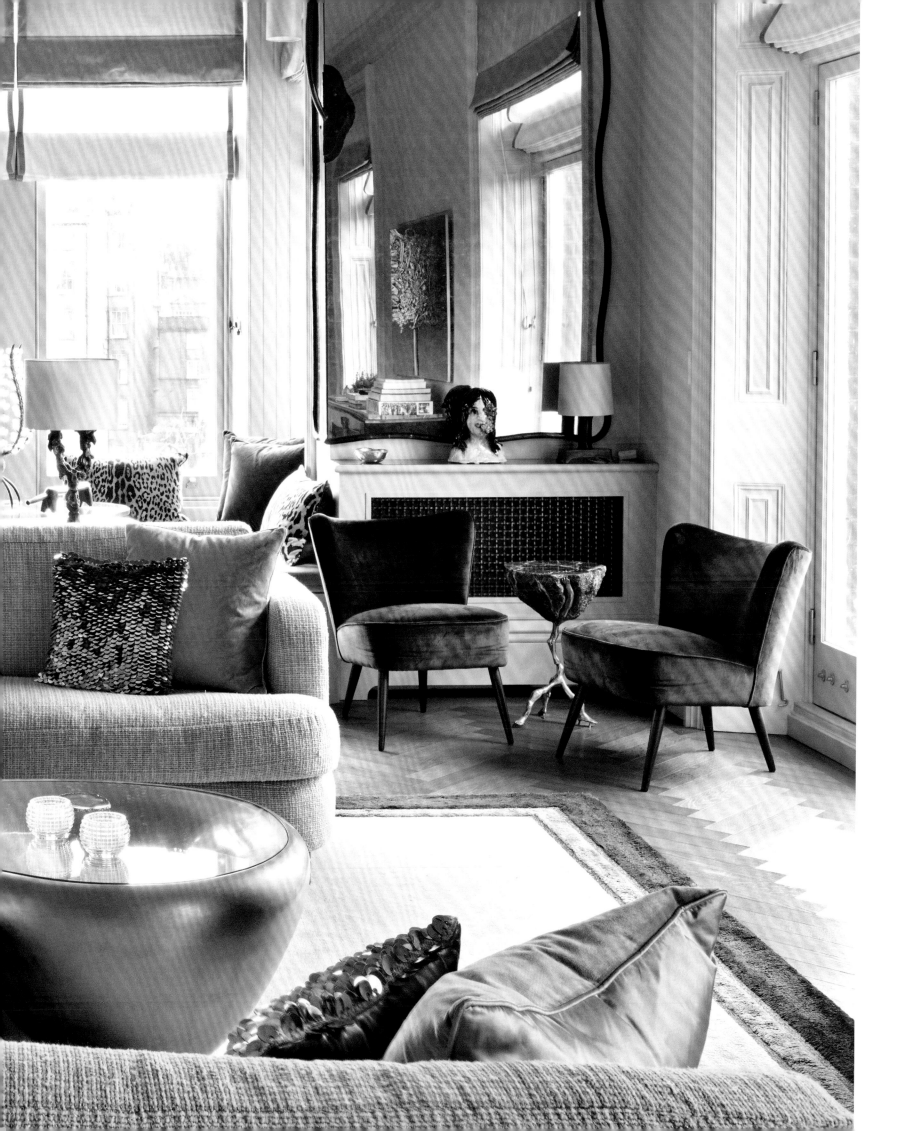

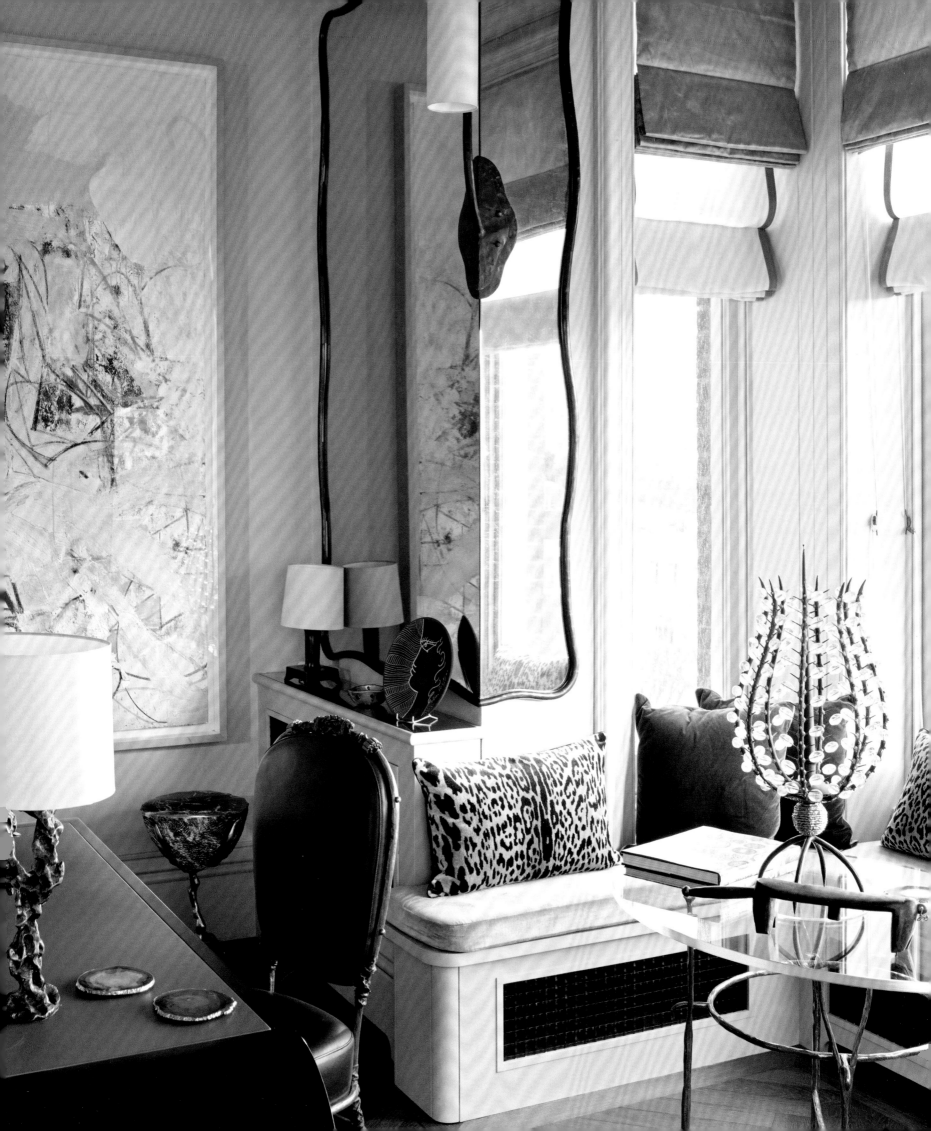

PP190–191: Amethyst tones, metalised surfaces, and crystal details evoke Art Deco jewelery.

OPPOSITE & ABOVE: The careful placement of gold, copper, and bronze metallic details brings a sense of decadence to the interior. Key pieces include fire dogs by Mattia Bonetti; Ulrika Liljedahl sequin cushions; a vase by Barbara Nanning; and candelabra by Andre Dubreuil.

PP194–195: In the kitchen and dining area, platinum-hued upholstery, a grey and white marble kitchen island, and contemporary glass chandeliers by Lindsey Adelman are balanced with warm-toned wood cabinetry and flooring.

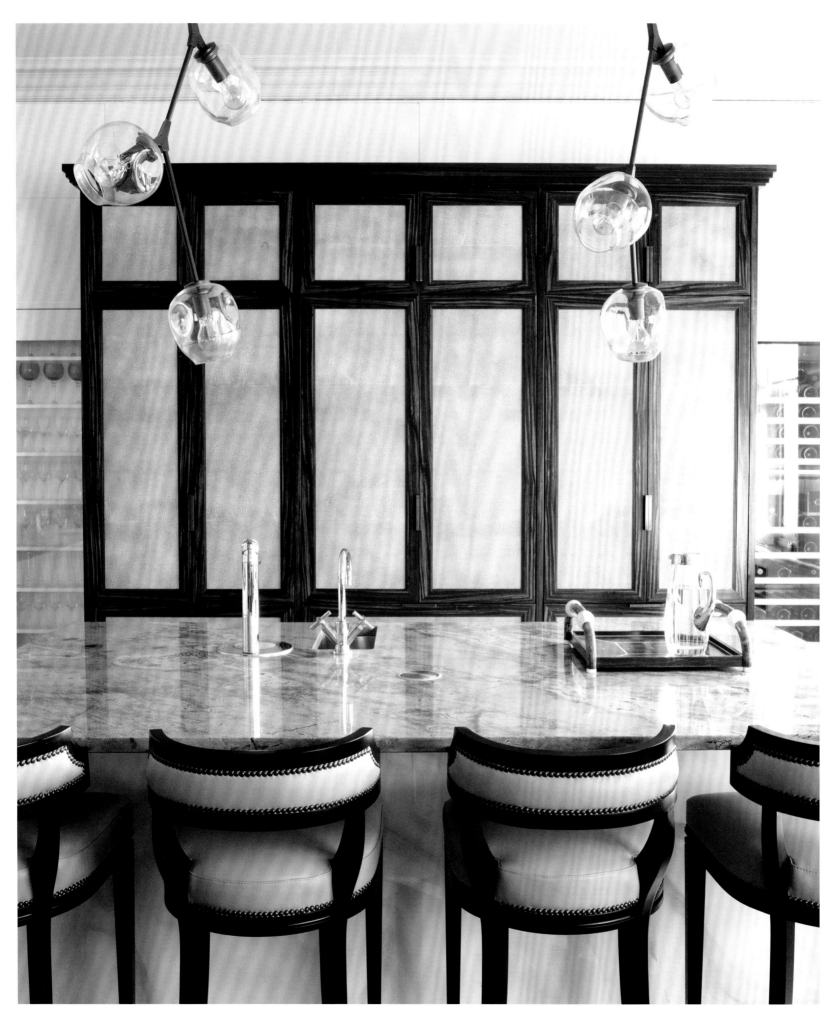

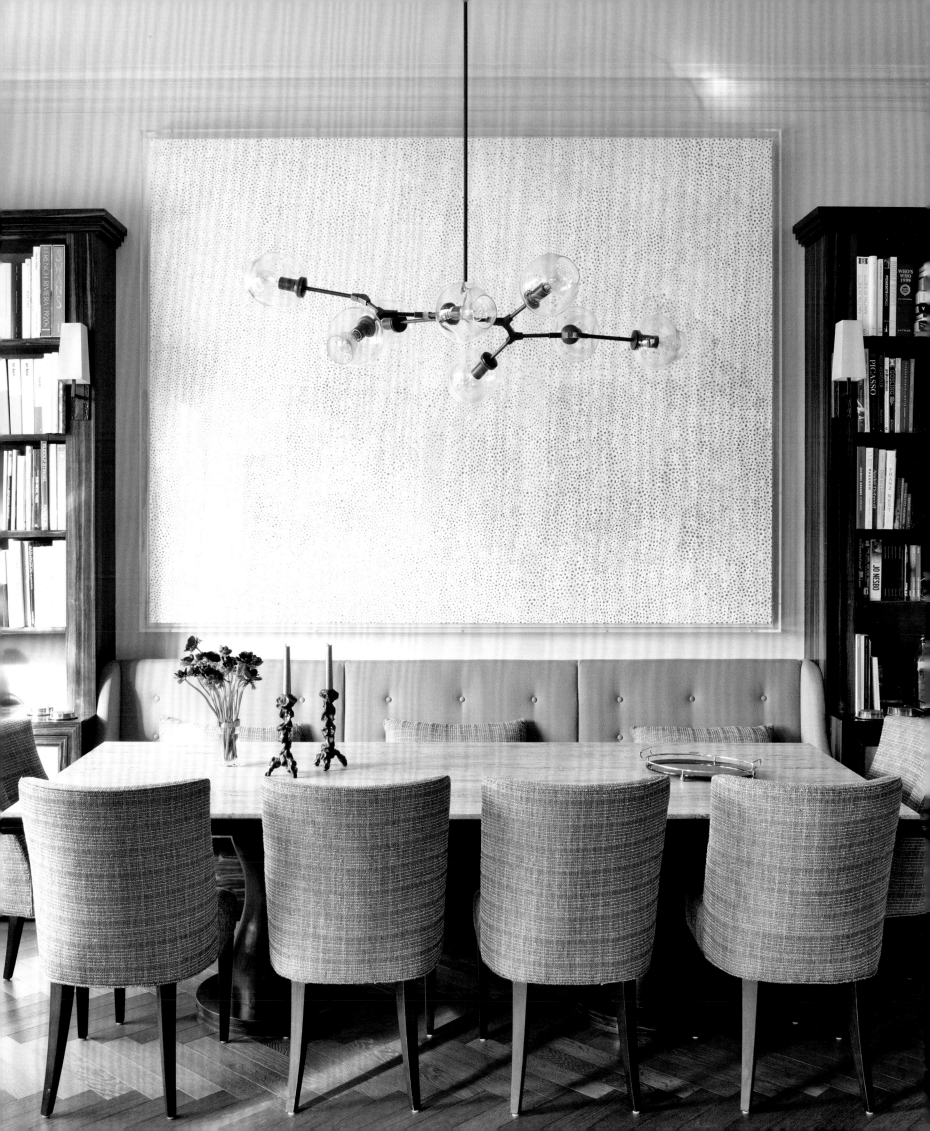

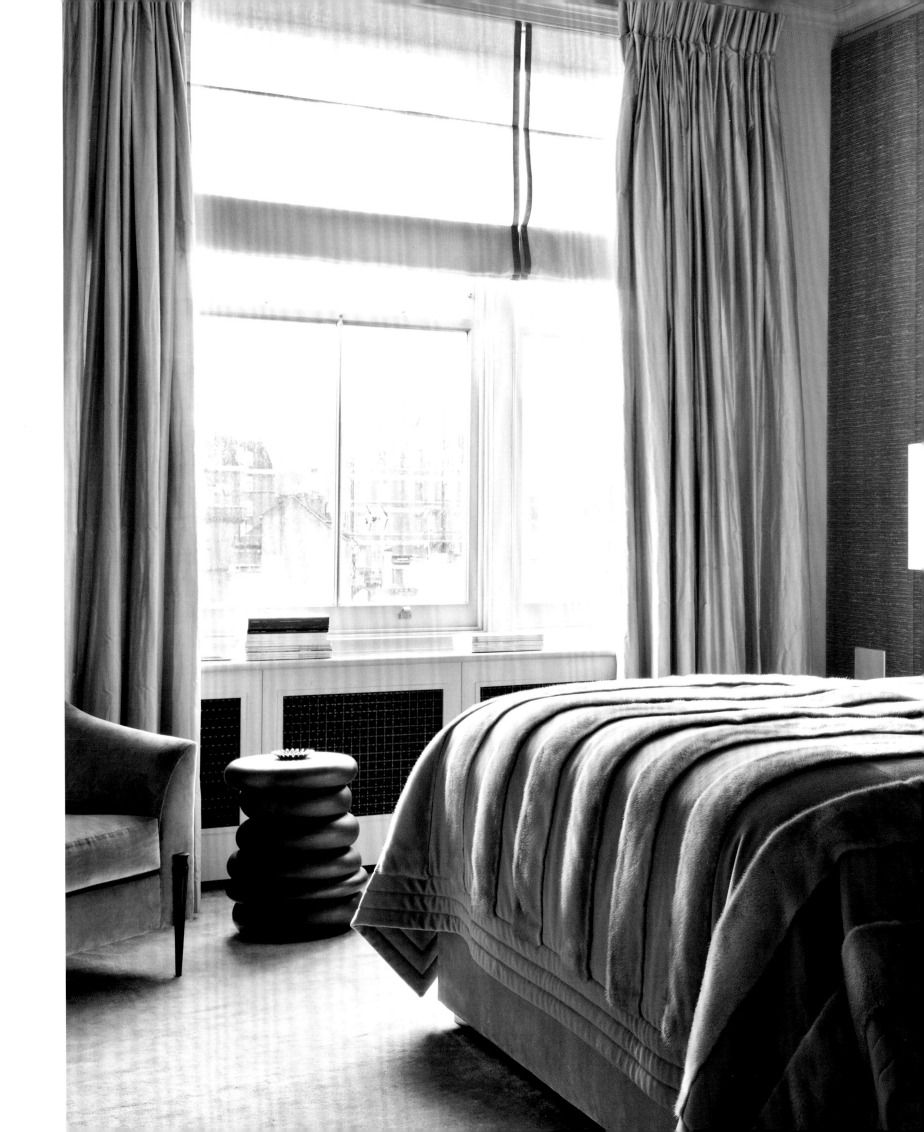

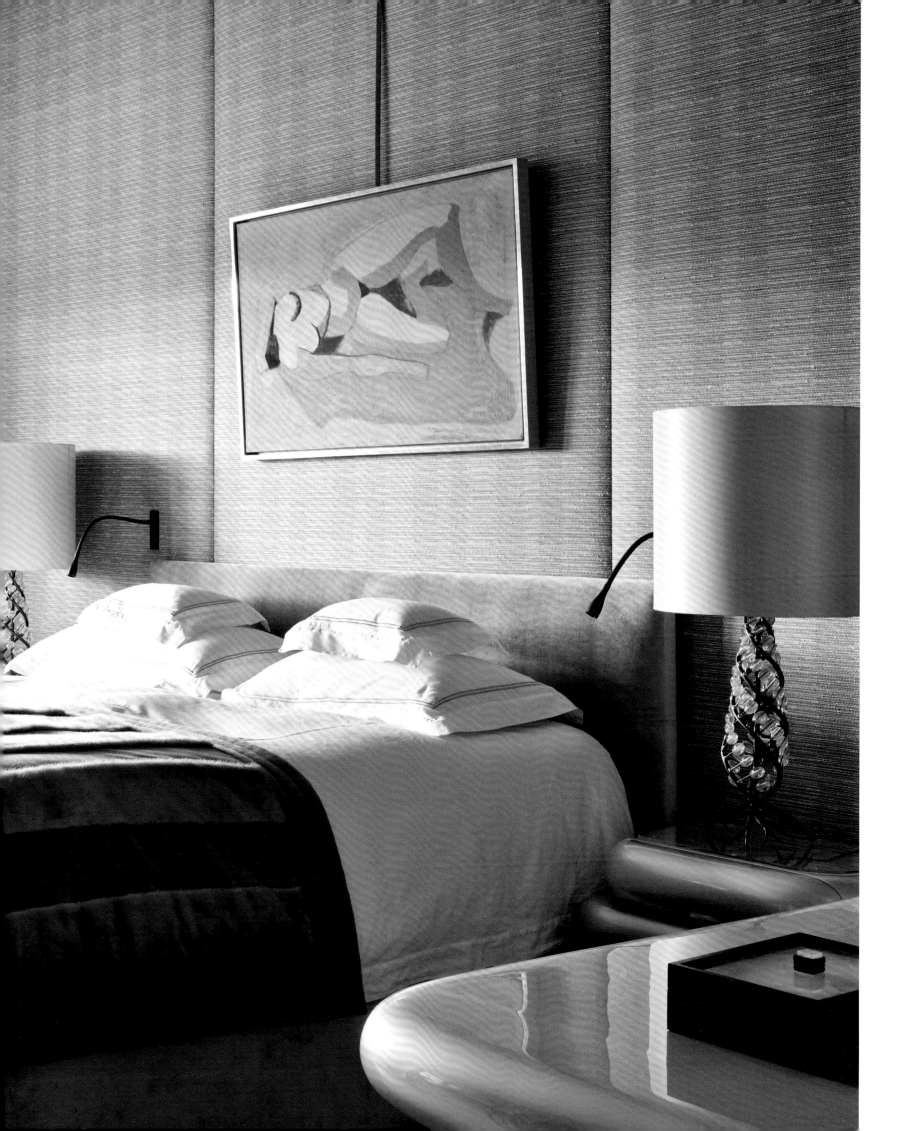

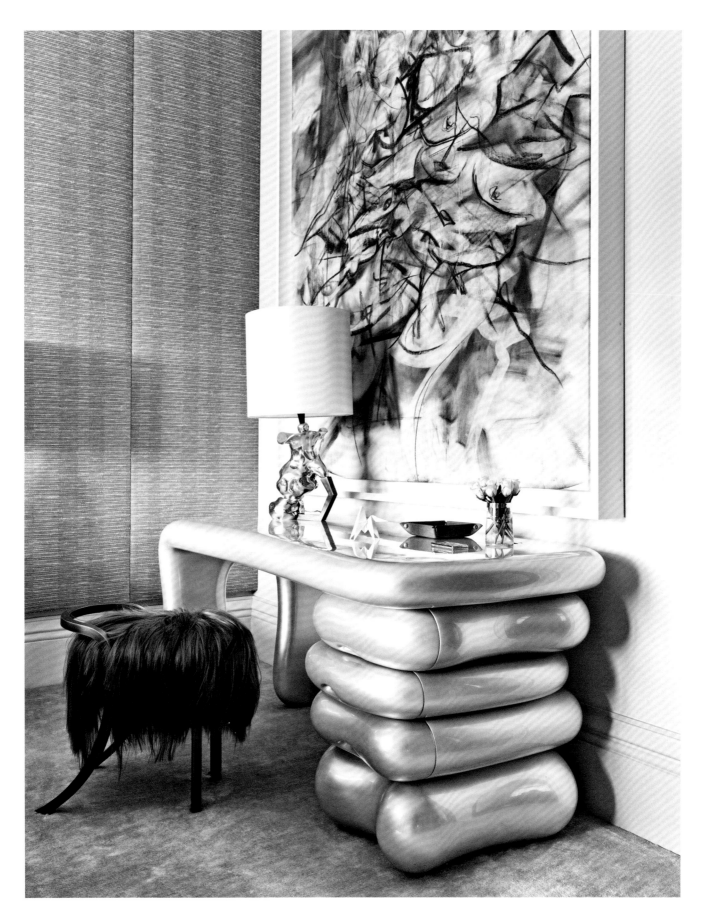

PP196–197 & PP200–201: The chicest of bedroom suites is achieved with a restrained scheme of white and grey. Tactile interest comes in the form of woven wall panels, a velvet bed cover and chair, and a side table by Mattia Bonetti that resembles a tower of smoothly polished pebbles.

ABOVE & OPPOSITE: The streamlined forms of Art Deco industrial design are recalled in Mattia Bonetti's monumental dressing table, which is paired with a Francis Sultana Kidassia stool. The velvet tub chair and vine-like wall light are also by Francis Sultana.

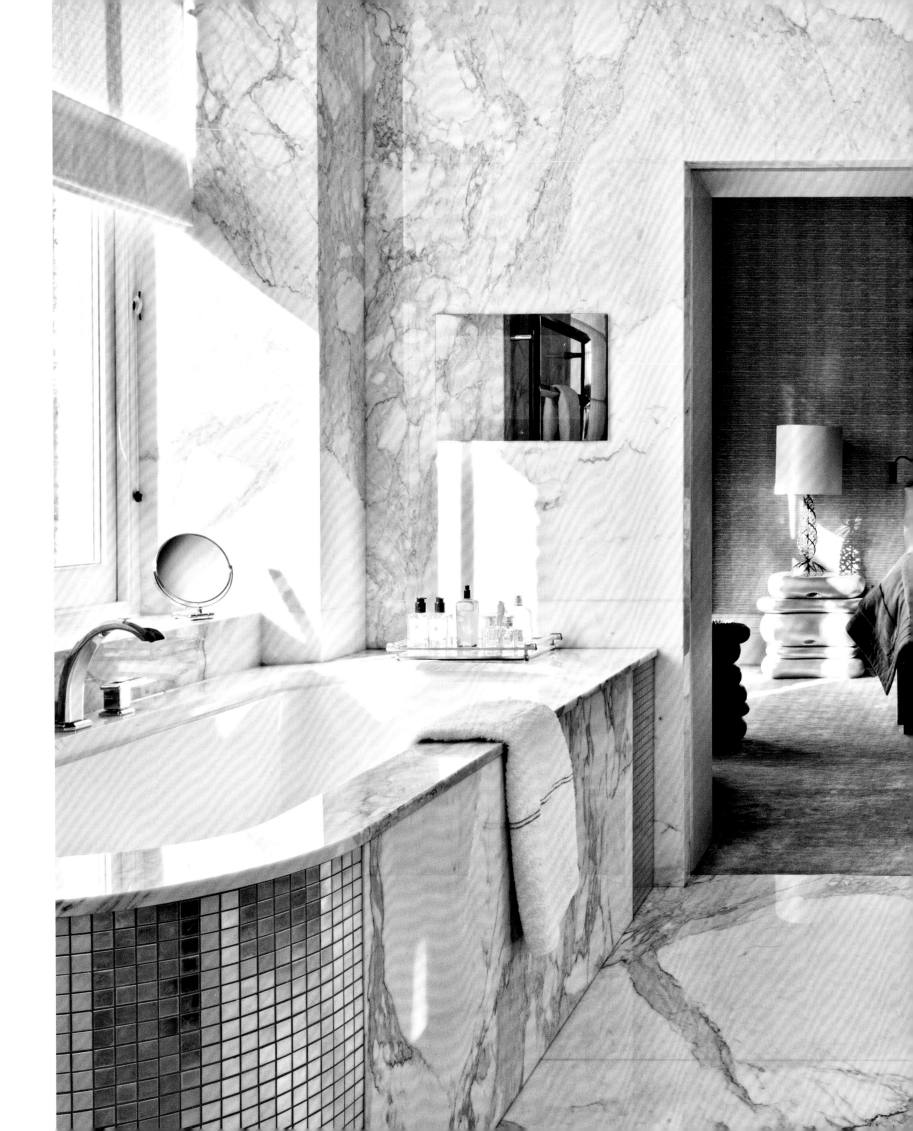

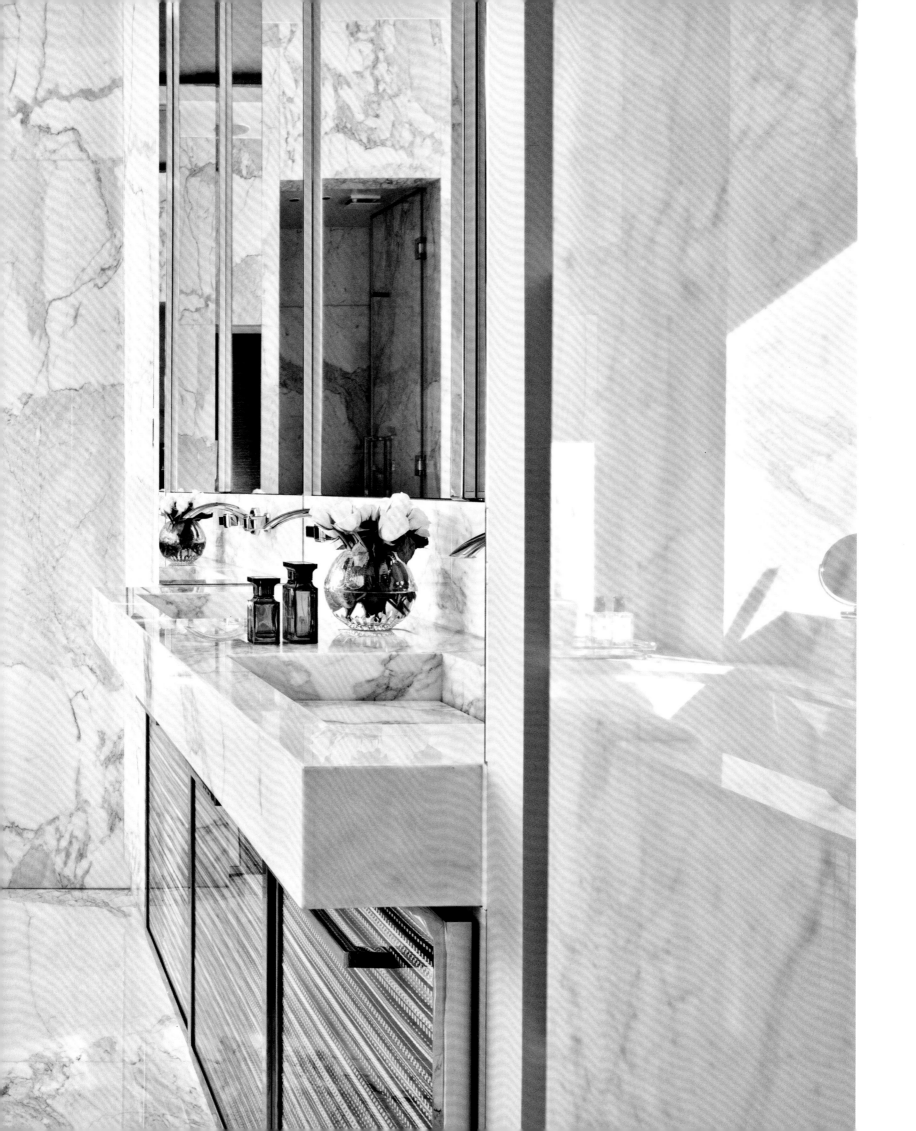

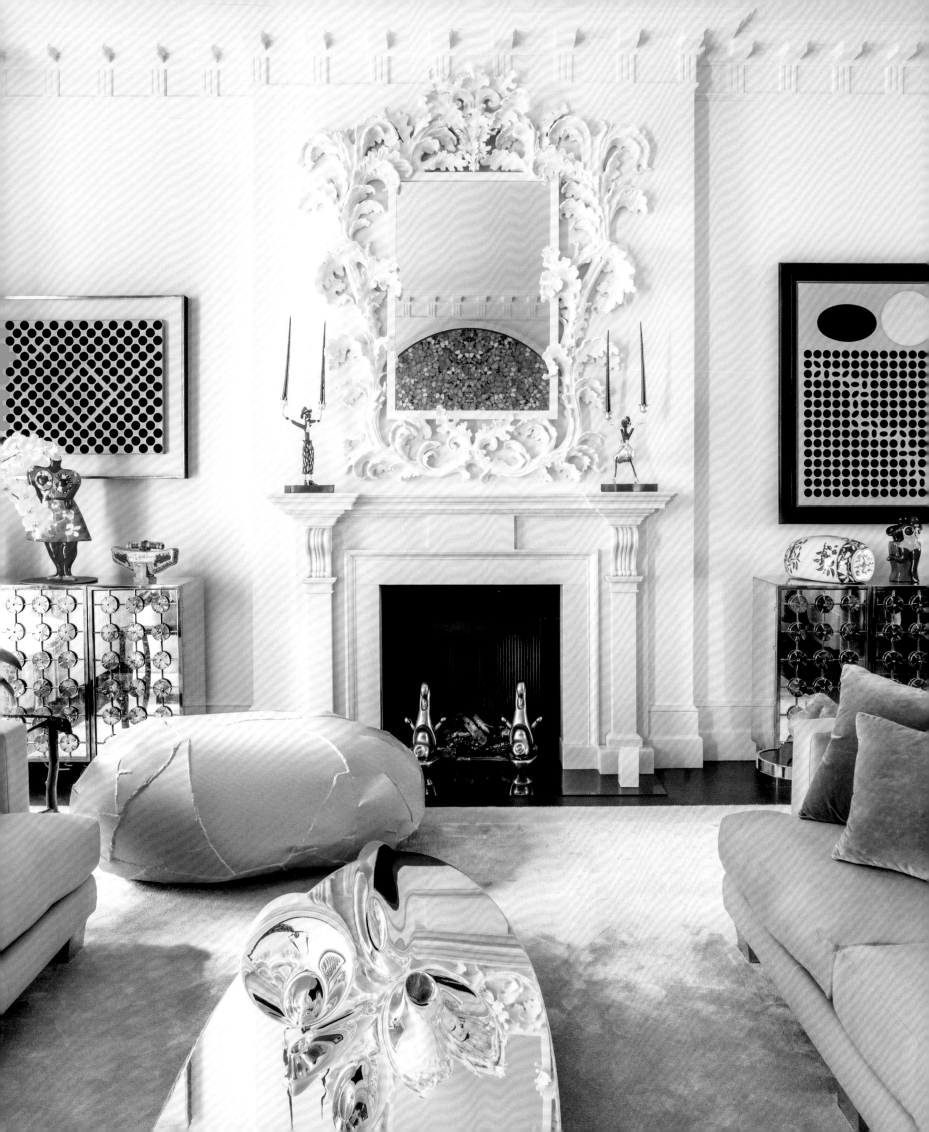

NATURAL BEAUTY
LONDON

THE BRIEF FROM THE EUROPEAN ART-COLLECTOR OWNERS OF THIS TRADITIONAL LONDON TOWN-HOUSE WAS TO LEND IT A "LIGHT, AIRY FEEL," RECALLS FRANCIS. "THE IDEA WAS TO CONJURE A SENSE OF TRANQUILITY BEAUTIFIED BY SOFT BURSTS OF COLOR."

THE COLORS RADIATE FROM A DYNAMIC ART COL-LECTION THAT INCLUDES WORKS BY CARROLL DUNHAM, DAMIEN HIRST, ANSELM KIEFER, NIKI DE SAINT PHALLE, VICTOR VASARELY, AND FRANZ WEST, AMONG OTHERS.

FRANCIS'S COLLABORATORS ON THIS GRAND-SCALE HOUSEHOLD WERE SOME OF THE DESIGNERS WITH WHOM HE HAS LONG WORKED, SUCH AS THE CERAMICIST ORIEL HARWOOD—WHO PRODUCED THE SPECTACULAR OVER-THE-FIREPLACE MIRROR, THE CANDELABRAS, AND THE CHANDELIER IN THE BREAKFAST ROOM. LENDING STRENGTH TO THIS SERENE AREA ARE EXQUISITE CARVED, GILDED AND COLORED MATTIA BONETTI CHAIRS. IN THE DINING ROOM, FRANCIS WORKED WITH MATTIA BONETTI AGAIN TO CREATE GILDED CHAIRS WHICH, UPHOL-STERED IN BRIGHT "APPLE GREEN" LEATHER, INFUSE THE ENVIRON WITH A NATURE-INSPIRED AURA INSPIRED BY THE OUTDOOR GARDEN SQUARE.

FRAMING THE DINING ROOM WINDOW WITH A CIR-CULAR EVA ROTHSCHILD SCULPTURE WAS A SPON-TANEOUS DECISION. "WHEN I SAW IT I THOUGHT IT WOULD WORK THERE AND WE JUST TRIED IT," ADMITS FRANCIS.

POSITIONING A TAXIDERMY TIGER FROM DEYROLLE (THE ICONIC PARIS SHOP AND CABINET OF CURIOSI-TIES) TO COMMAND A STAIRCASE LANDING WAS ANOTHER NATURAL MOVE. "THE CLIENT WENT TO DEYROLLE AND HE JUST COULD NOT RESIST IT," REVEALS FRANCIS.

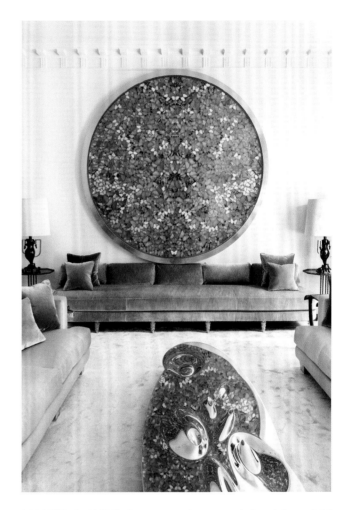

OPPOSITE & ABOVE: An ornate mirror commissioned from Oriel Harwood reflects the oceanic blues of Victor Vasarely's artwork on the opposite side of the living room. The art appears to surf across the room on the mirrored surface of Zaha Hadid's coffee table.

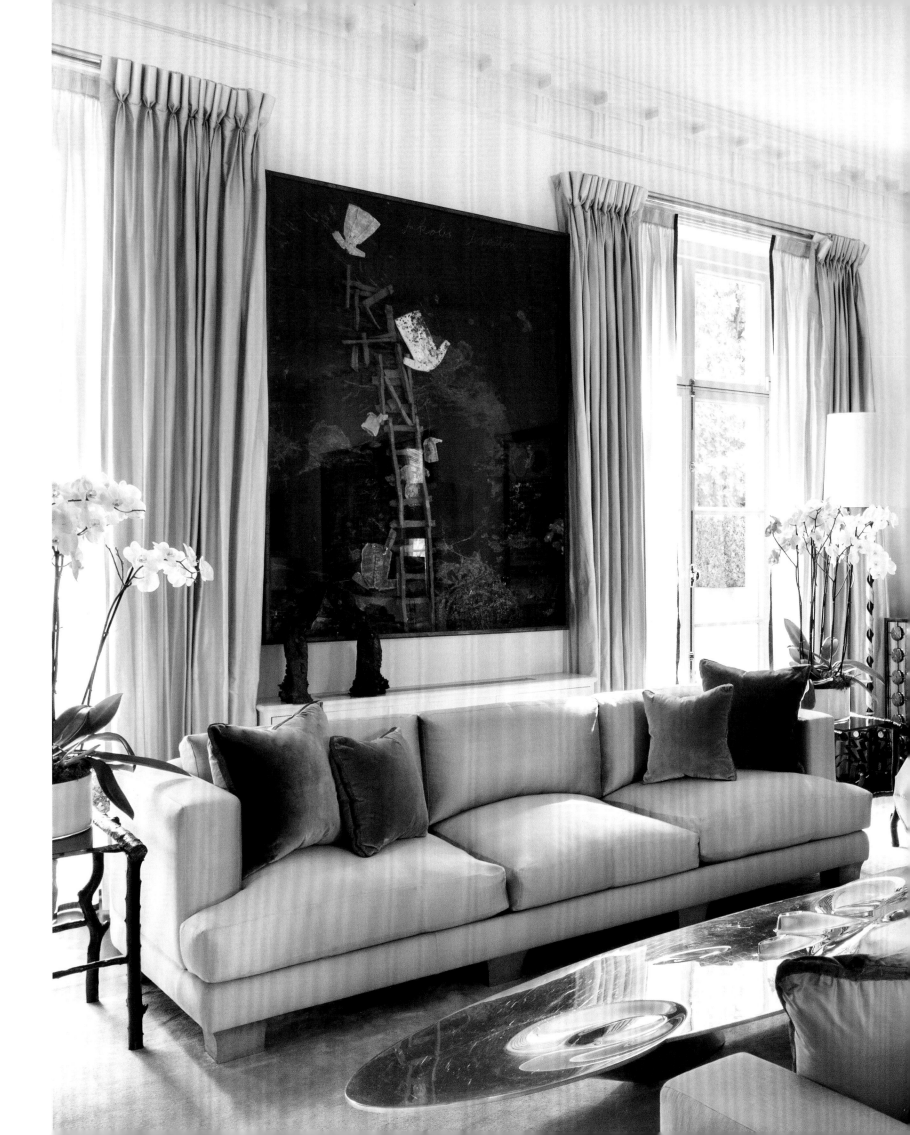

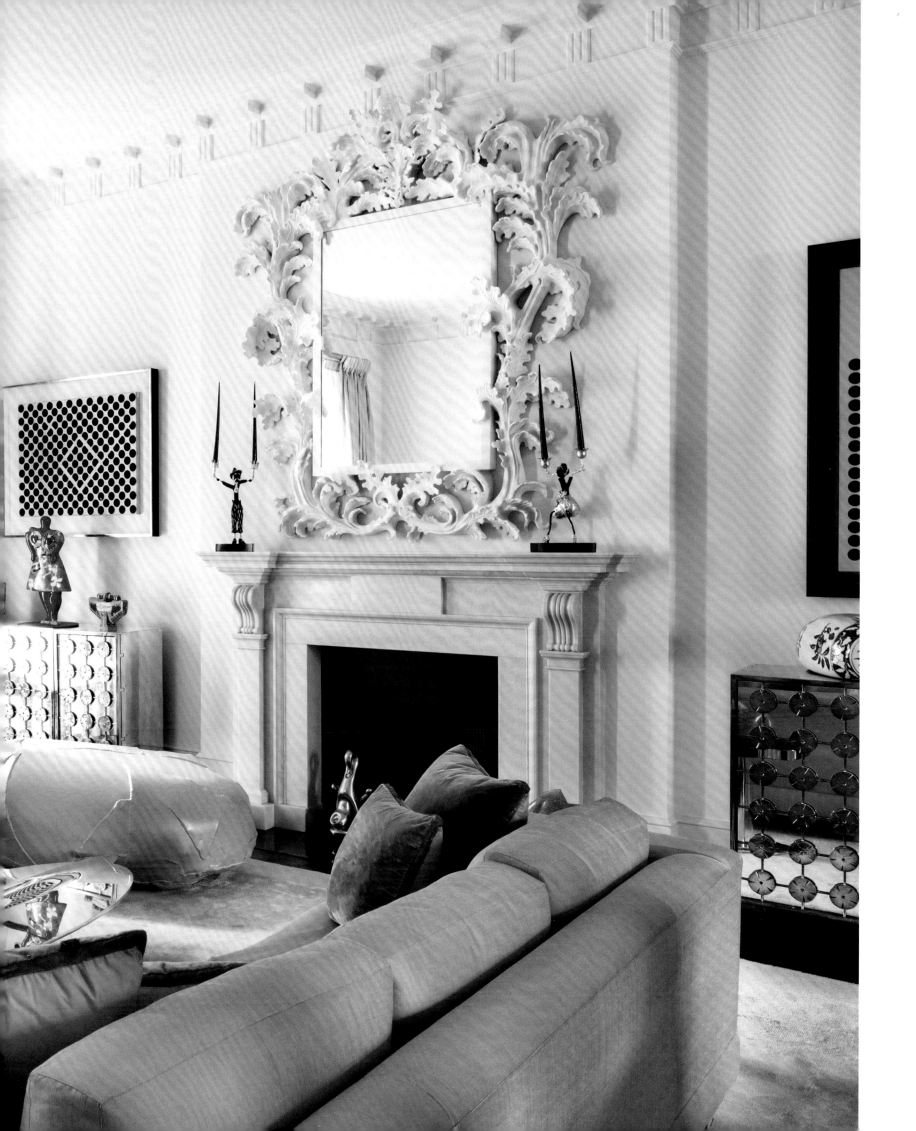

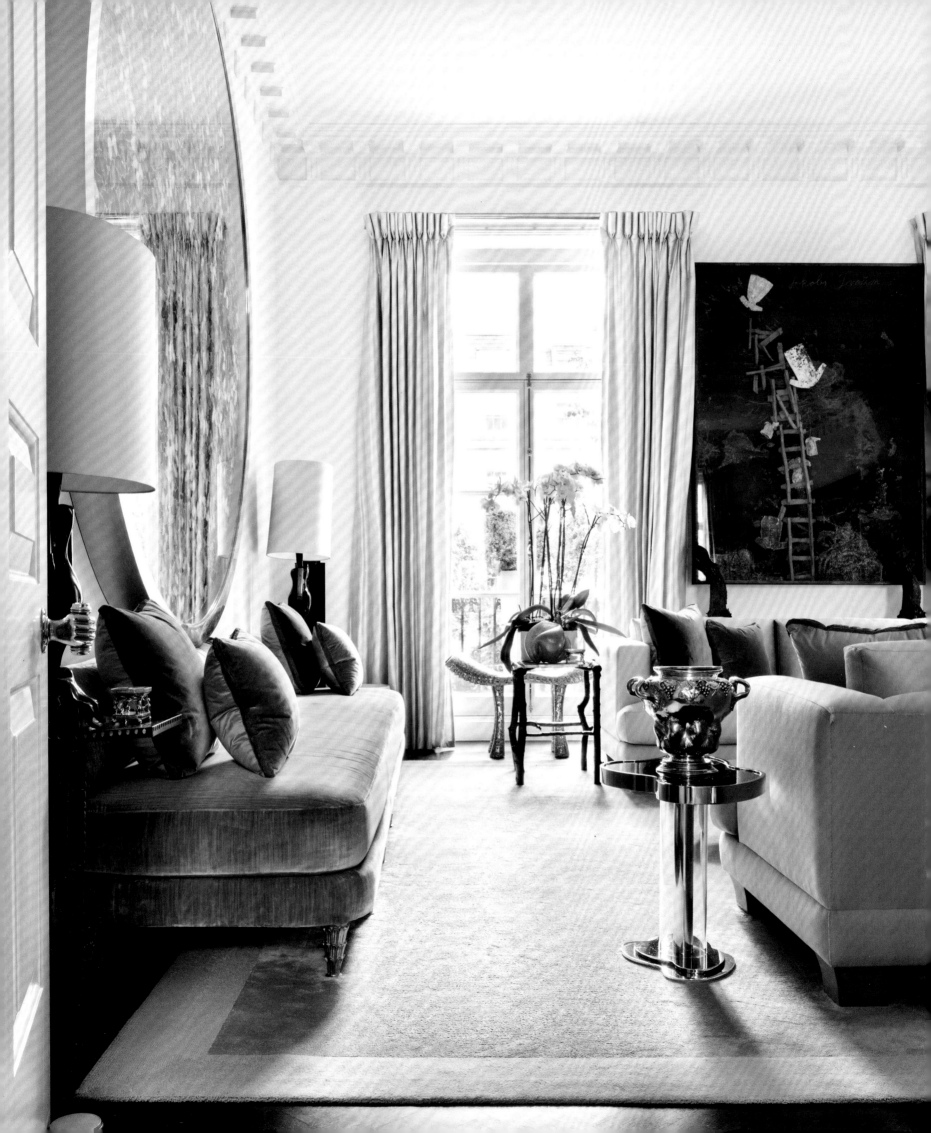

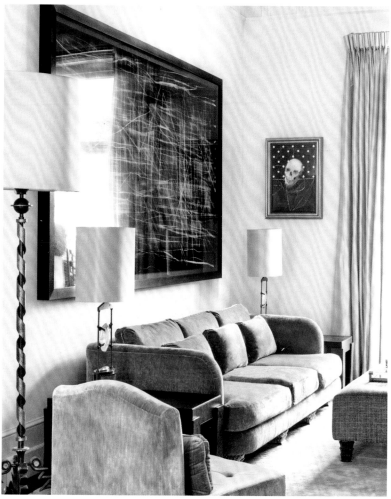

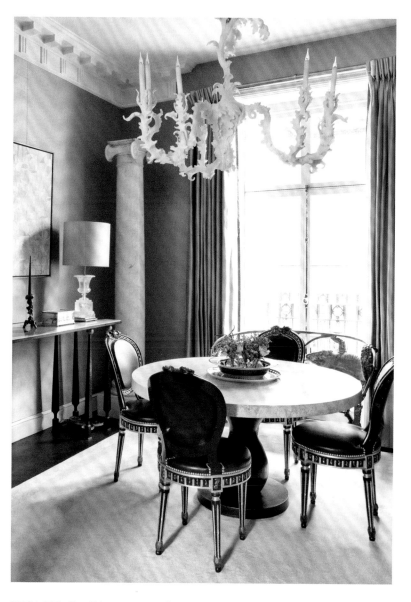

PP204–205: The living room exudes an overwhelmingly optimistic mood, with jolts of vibrant blue and baby pink vibrating across a backdrop of silvery-white tones. The sculptural pink ottoman is an artwork by Franz West and the silver buffet cabinets are by Garouste & Bonetti.

OPPOSITE & LEFT: Velvet sofas by Francis Sultana in shades of sea green and turquoise add luxuriant color and texture to a monochrome setting. TOP RIGHT & ABOVE: In the breakfast room, dainty dining chairs upholstered in glossy aubergine leather appear as jeweled rococo fancies under Oriel Harwood's ornate chandelier.

PP208-209: The essence of spring is captured in the dining room, with Francis's stylish take on nature encompassing verdant green dining chairs with "leafy" legs by Mattia Bonetti and a marble table top that seems to grow on silver branches sprouting from a bed of marble.

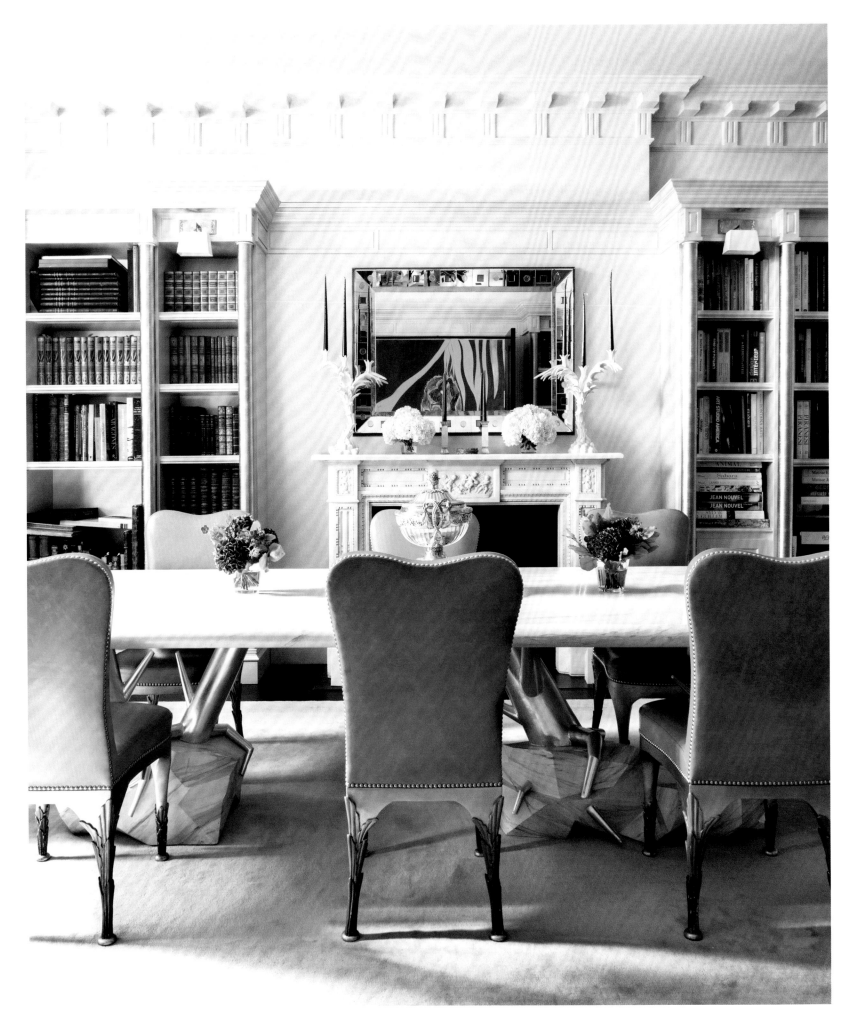

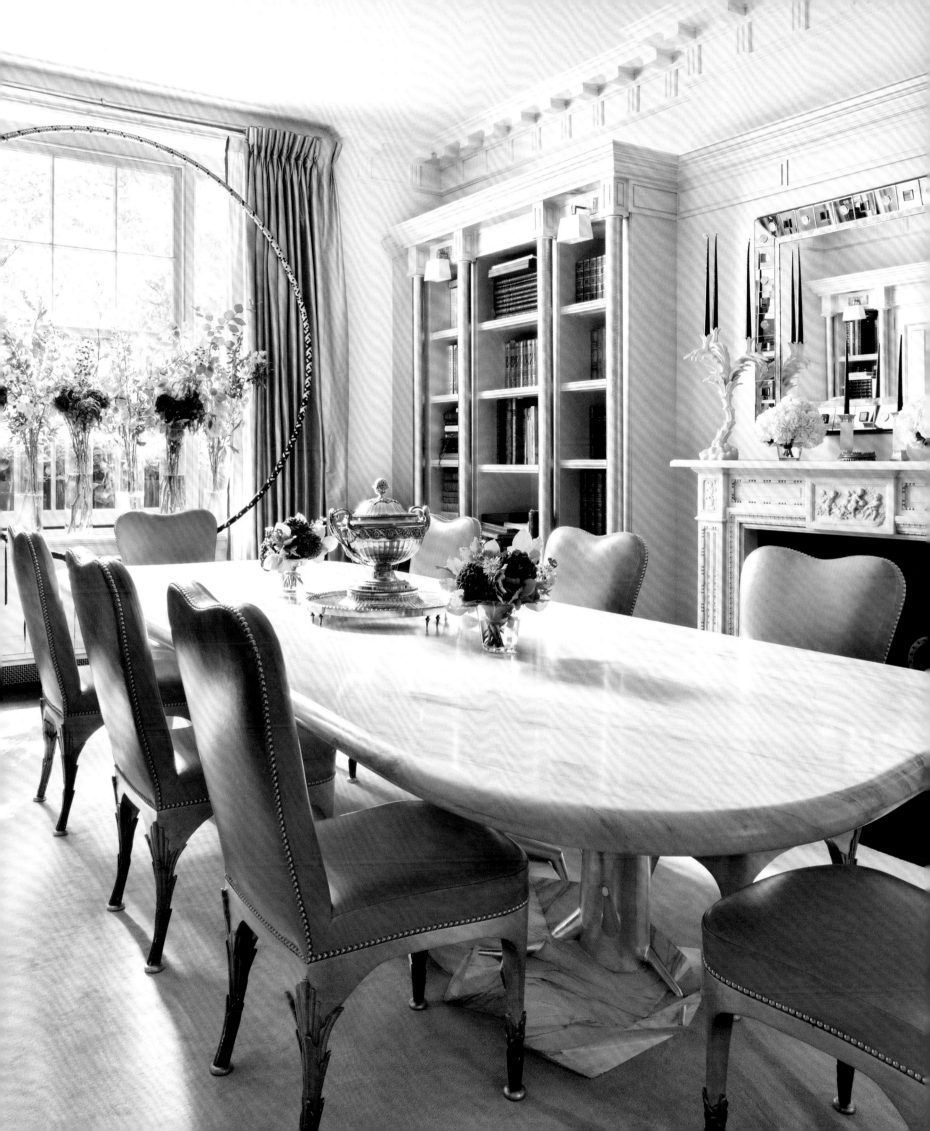

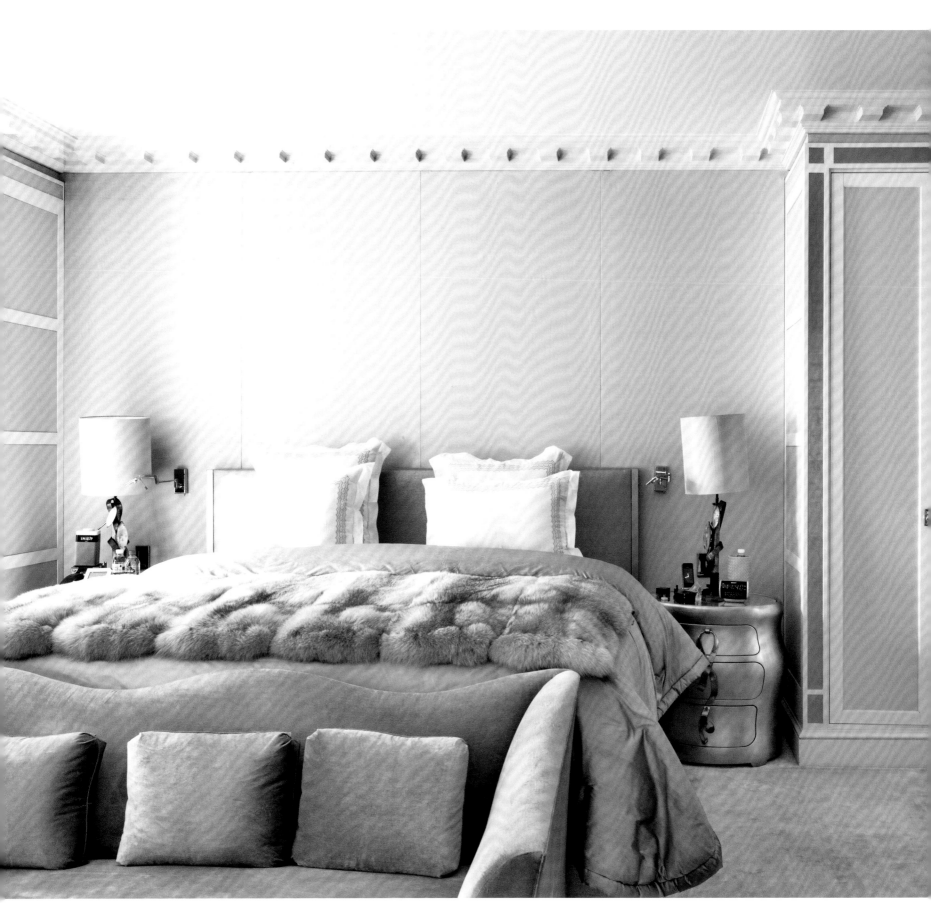

ABOVE & PP212–213: The master bedroom brings to mind the style of Hollywood Regency, with hints of silver and lilac against multiple shades of ivory. The curvaceous forms of the metallic bedside tables are echoed in a matching chest of drawers, both by Mattia Bonetti.

RIGHT: Francis's light-hearted touch is evident in the stairwell, where a taxidermist's antique tiger prowls beside bold artwork.

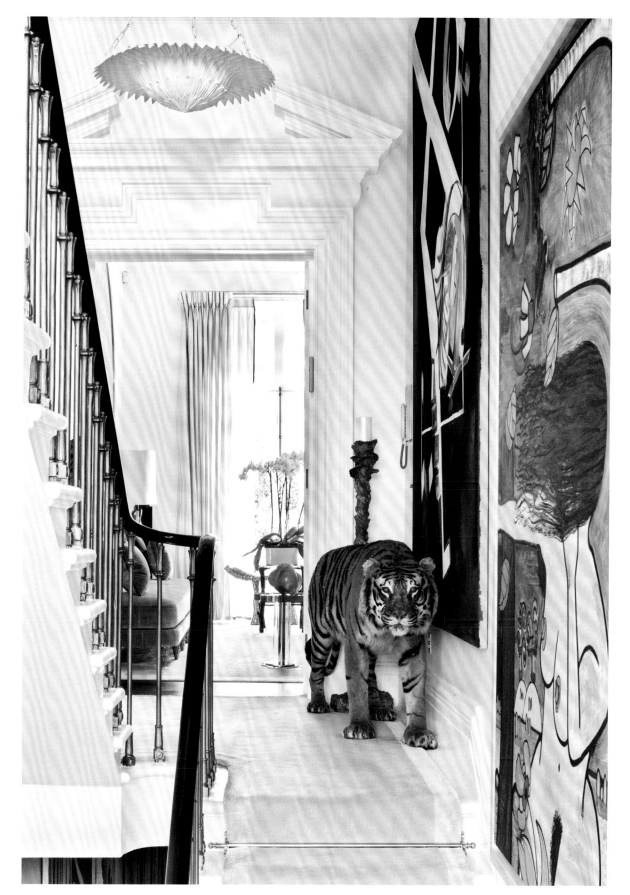

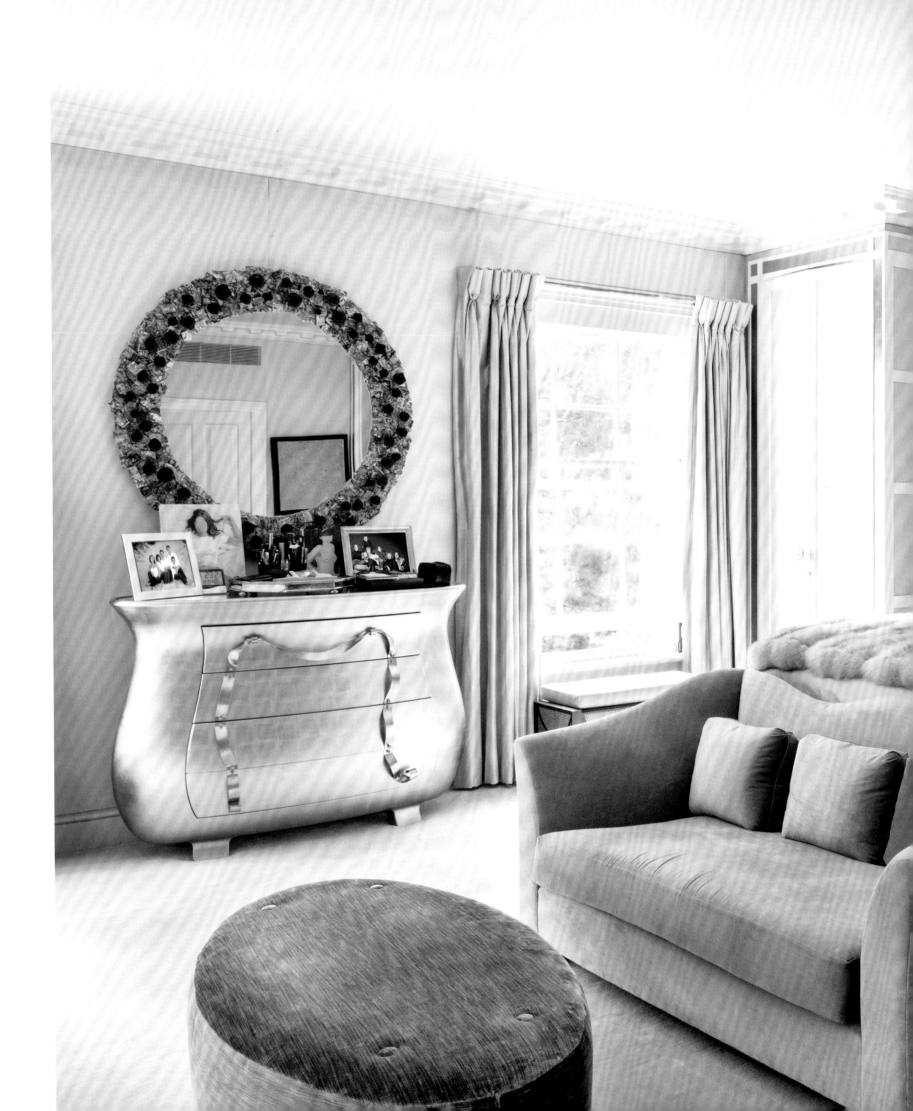

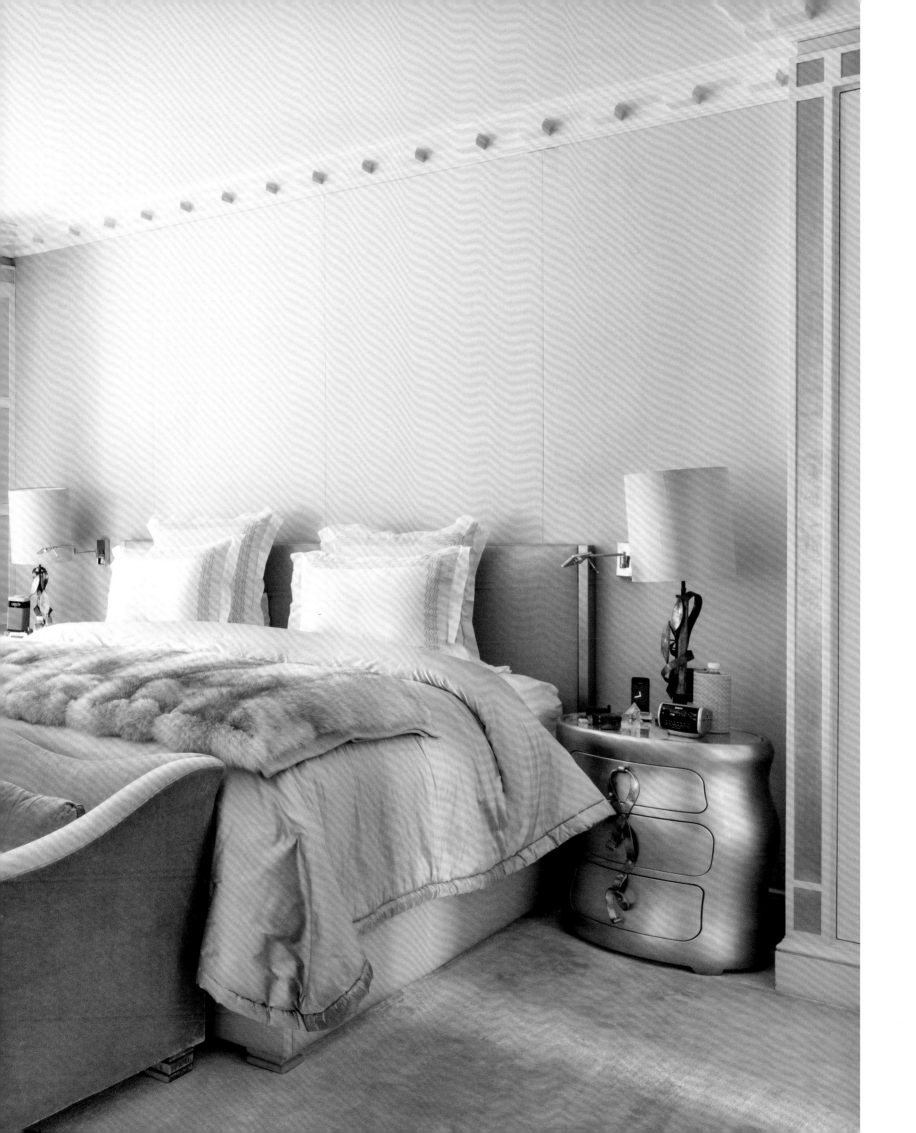

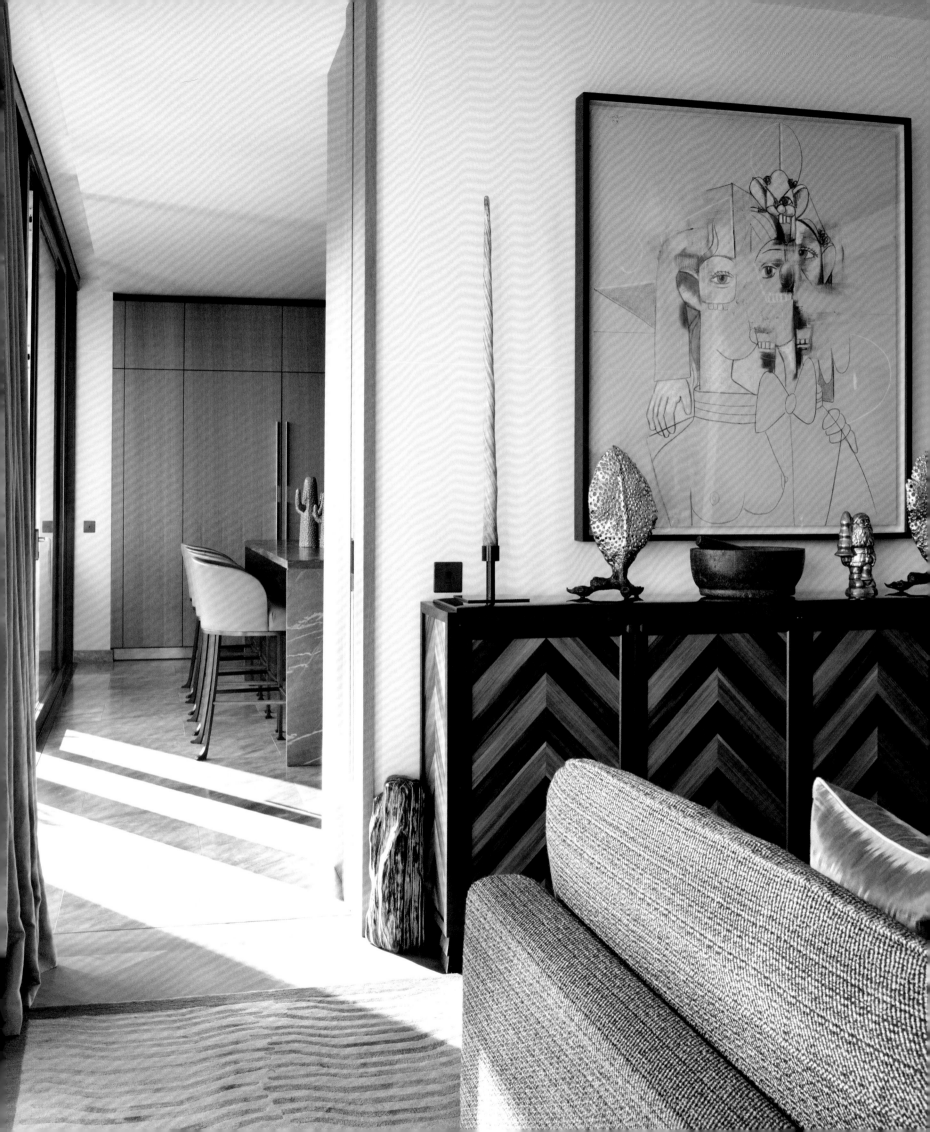

ELEVATED LIVING
LONDON

AMIDST A FAMILY HOME SET BACK FROM A HISTORIC ROYAL PARK OF LONDON—IN A BUILDING BY ACCLAIMED MODERNIST ARCHITECT, DAVID CHIPPERFIELD—FRANCIS FORMULATED A STRIKING INTERIOR IN RESPONSE TO AN ECLECTIC ART AND DESIGN COLLECTION. IT ENCOMPASSED ANTIQUITIES, MODERNIST, MID-CENTURY, AND CONTEMPORARY WORKS IN VARIED MEDIA.

HE ALSO DEPLOYED HIS FLAIR WITH COUTURE-QUALITY TEXTILES, AS WELL AS WORKING WITH HIS SIGNATURE ELEMENTS, SUCH AS BRONZE AND MICA, TO LEND LUXURIANCE AND WARMTH TO THE LIGHT-FILLED, MINIMALIST ABODE.

THE DECISION TO LINE THE ENTRYWAY WALLS IN A VINTAGE BRAND OF RAFFIA (ONCE UTILIZED BY CHRISTIAN DIOR FOR ACCESSORIES) ULTIMATELY RESULTED IN A PALE HONEY HUE, WHICH SERVES AS THE BACKDROP FOR WORKS BY GEORGE CONDO, FRANCIS PICABIA, AND LOUISE BOURGEOIS. PLAYING ON THE ANIMALIA THEME EVOKED BY THE PAIR OF INDIAN STONE LEOPARDS FLANKING HIS SHAGREEN AND WOOD CABINET, FRANCIS COMMISSIONED AN AUBUSSON WEAVER TO CREATE A CARPET THAT GENTLY INTERPRETS OF THE WILD CAT'S SPECKLED COAT.

BY CONTRASTING SHADES OF RED—A FAVORITE COLOR OF THE OWNER—FRANCIS CONJURED DRAMA IN THE GREAT ROOM. THE TIGER CARPET IS A SPECIAL SCARLET WEAVE, AND THE DOUBLE-SIDED SOFA FEATURES CUSTOM RUST-COLORED VELVET UPHOLSTERY. WHILE THE 1930S CHERRY LEATHER ARMCHAIRS ARE BY PAUL DUPRÉ-LAFON, THE ART DECO MASTER FAMED FOR HIS WORK AT HERMÈS, THE LIPSTICK-RED FRANZ WEST SCULPTURE IS PART OF A TRIO.

"THE FAMILY" BY LOUISE BOURGEOIS—ABOVE THE HEADBOARD IN THE MASTER BEDROOM—DETERMINED THE ROOM'S NAVY BLUE ACCENTS. FRANCIS MADE THE TERRACE AN "OUTDOOR ROOM—THINK OF IT AS A SALON" BY CRAFTING A TRELLIS-PATTERNED LINEN TO COVER THE SOFA AND CHAIRS. "I LOVE DESIGNING GARDEN FURNITURE JUST BECAUSE IT MAKES ME HAPPY," HE ADMITS.

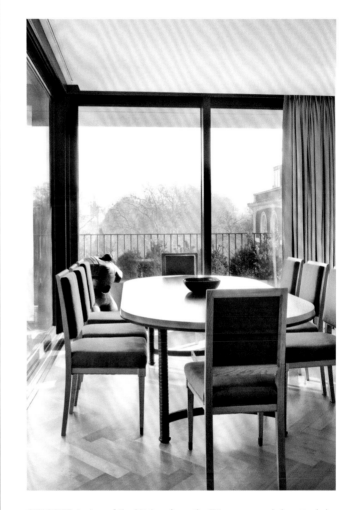

OPPOSITE: A view of the kitchen from the TV room reveals bar stools by Francis Sultana. Atop the "Jacopo" buffet by Francis Sultana are golden leaf lamps by Michele Oka Doner, and above is a painting by George Condo. **ABOVE:** Dining room table and chairs by Francis Sultana, with a "Henry Moore" sculpture by Paul McCarthy.

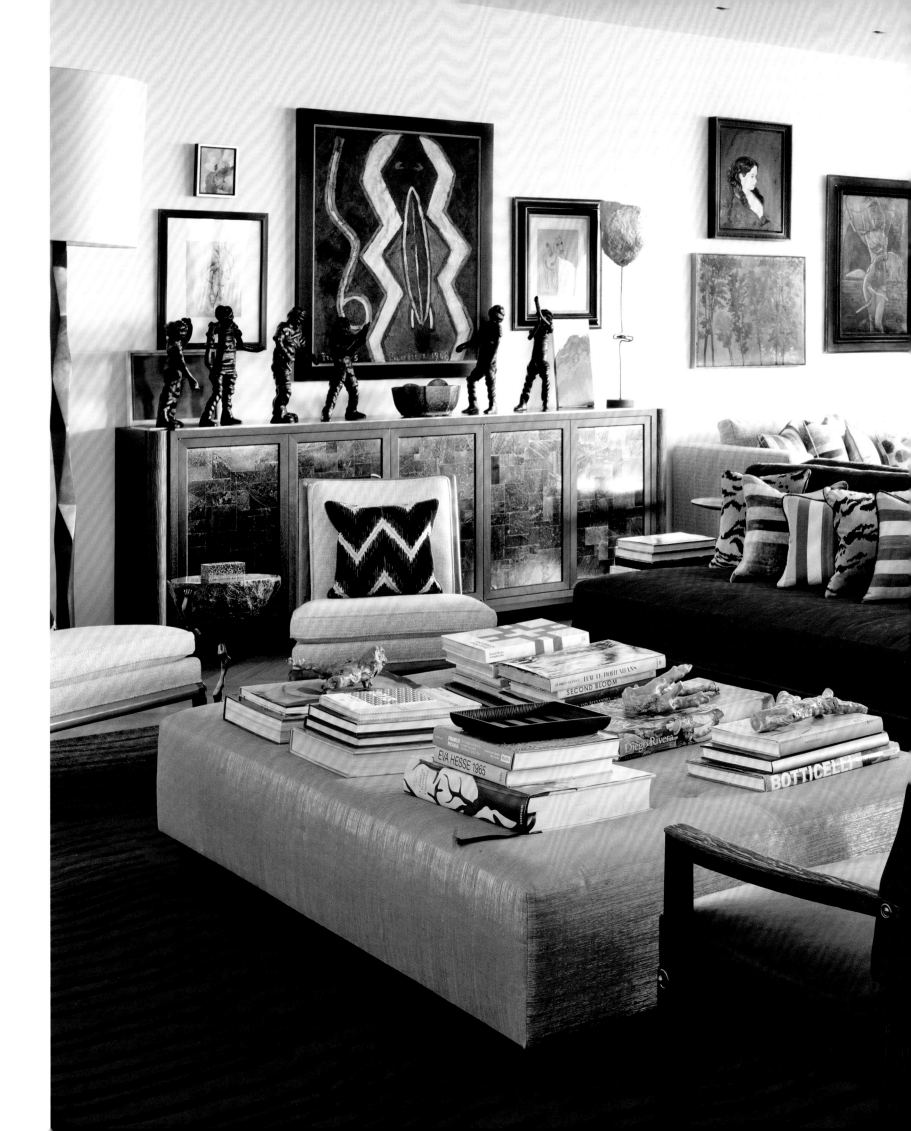

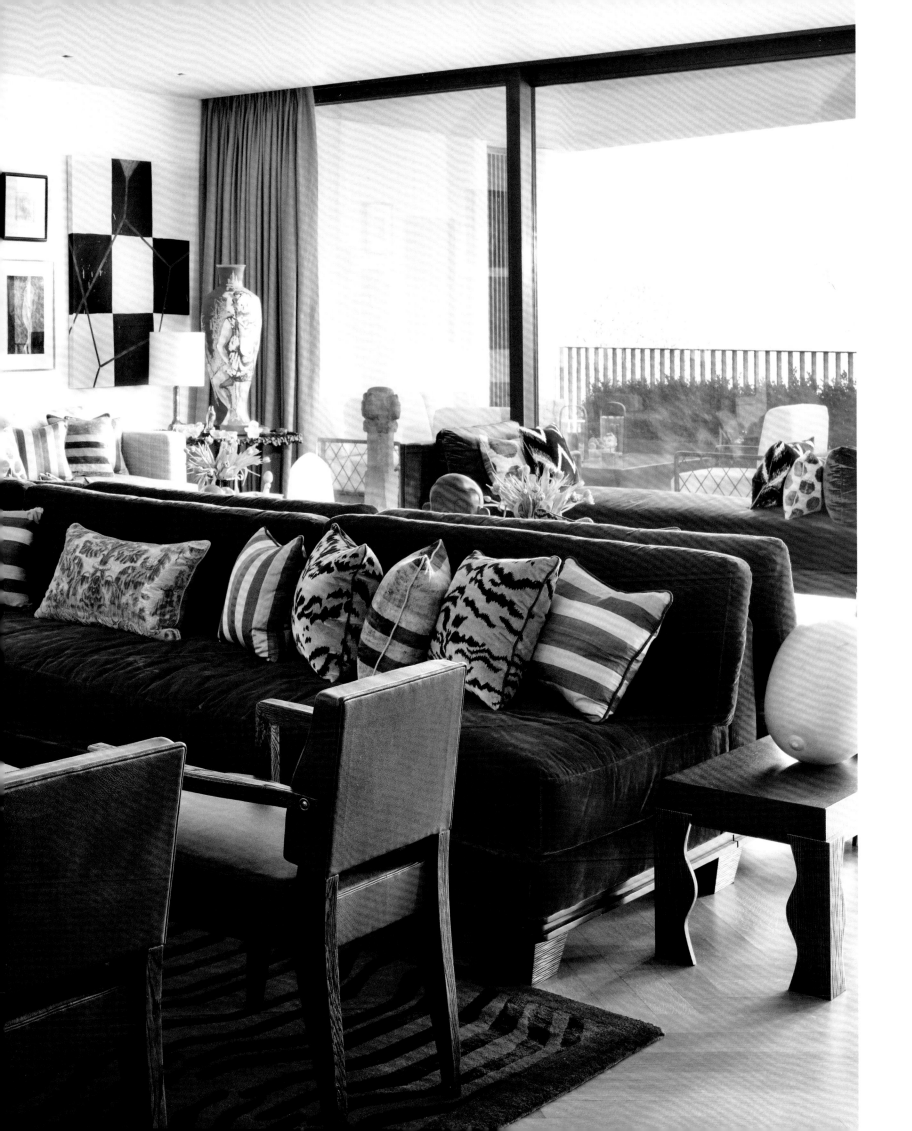

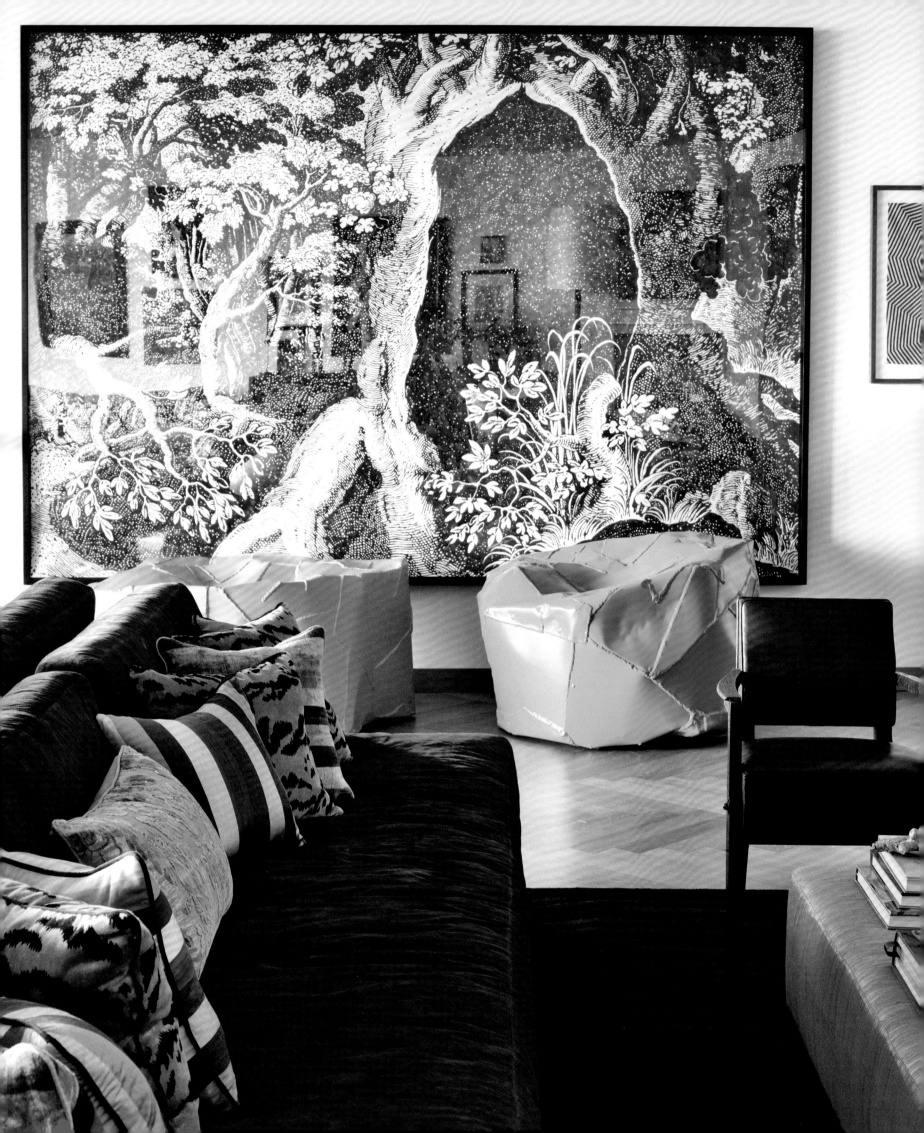

PP216–217: Within an expansive modernist space, Francis created a strongly textured living environment, layered with tactile elements.

OPPOSITE & ABOVE: A color scheme of fiery reds and warm neutrals is tempered by hints of blue and green, which recur throughout the apartment, providing a sense of unity. On one wall a painting by Ugo Rondinone is the backdrop for Franz West's sculptured ottomans, a red leather chair by Paul Dupré-Lafon, and Francis Sultana red velvet sofas.

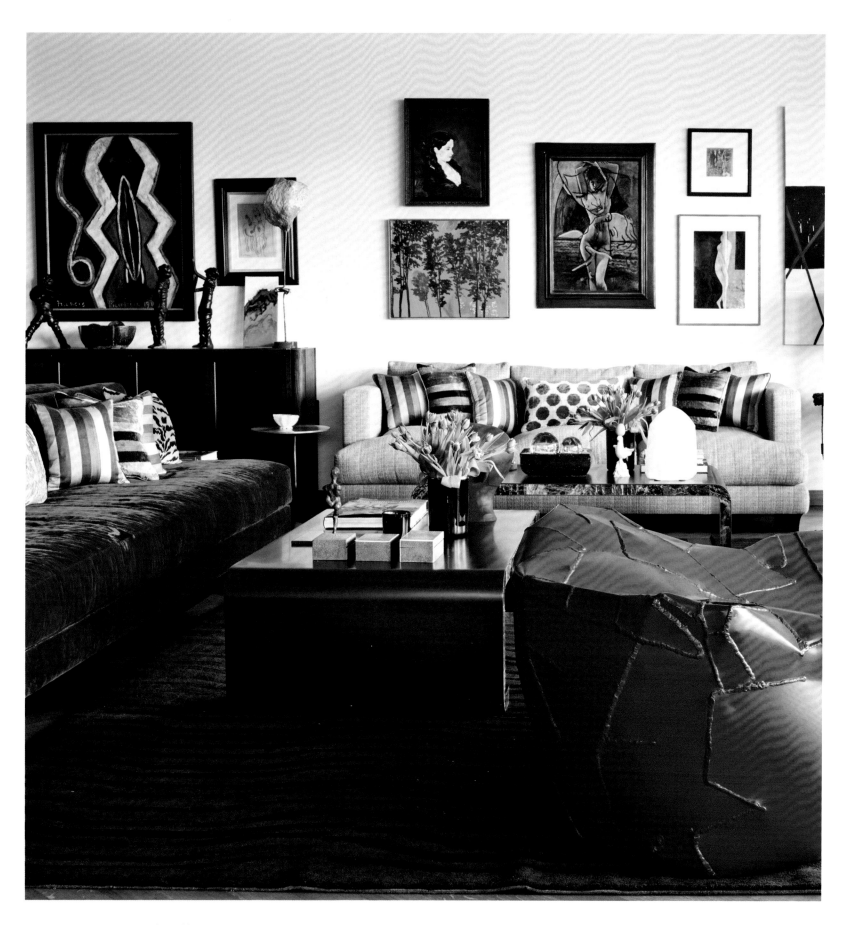

ABOVE: A coffee table by Mattia Bonetti and the third of Franz West's sculptural ottomans share space on a carpet woven with ribbons of blue, contributing to the room's dynamic energy.

OPPOSITE: The pale tones of a watercolor by Francis Picabia are echoed in the wall paneling and two chairs by Robsjohn-Gibbings. In one corner is a marble sculpture by Louise Bourgeois.

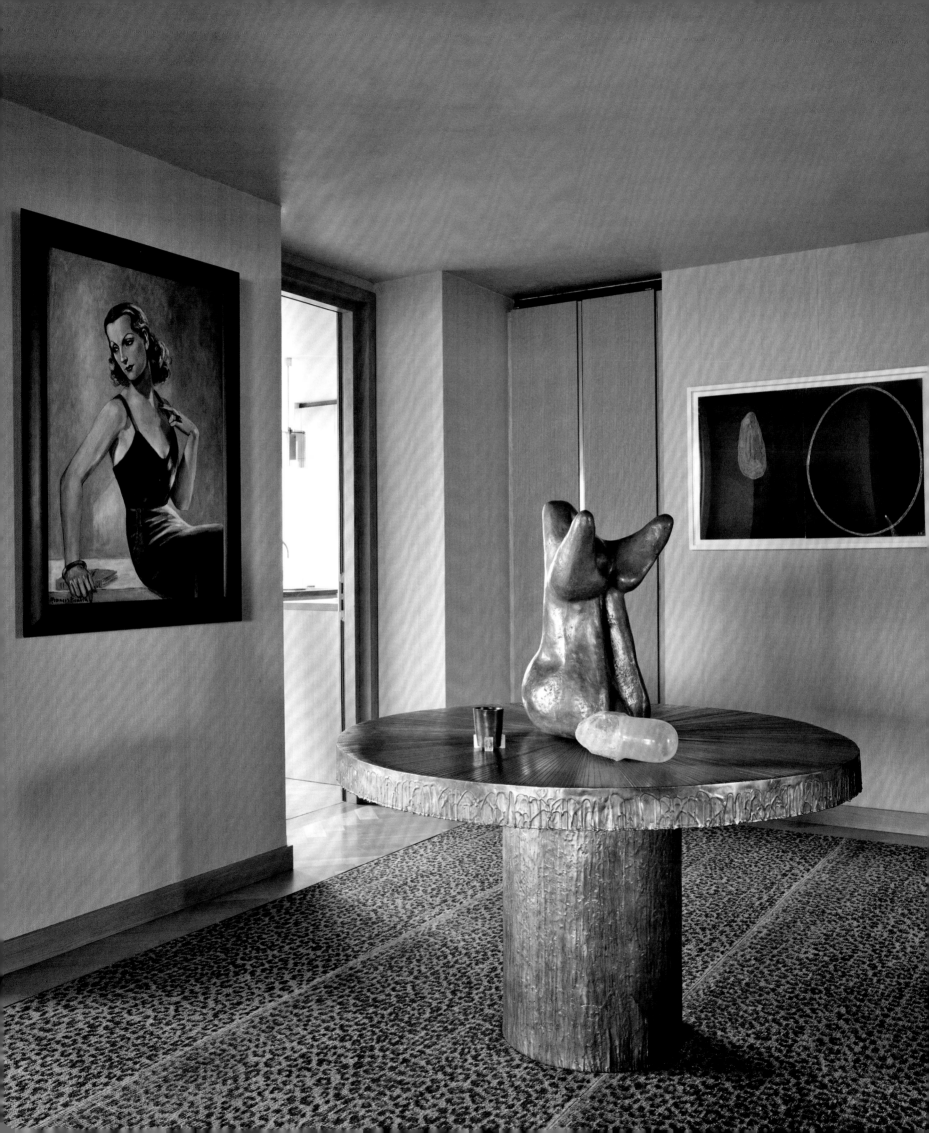

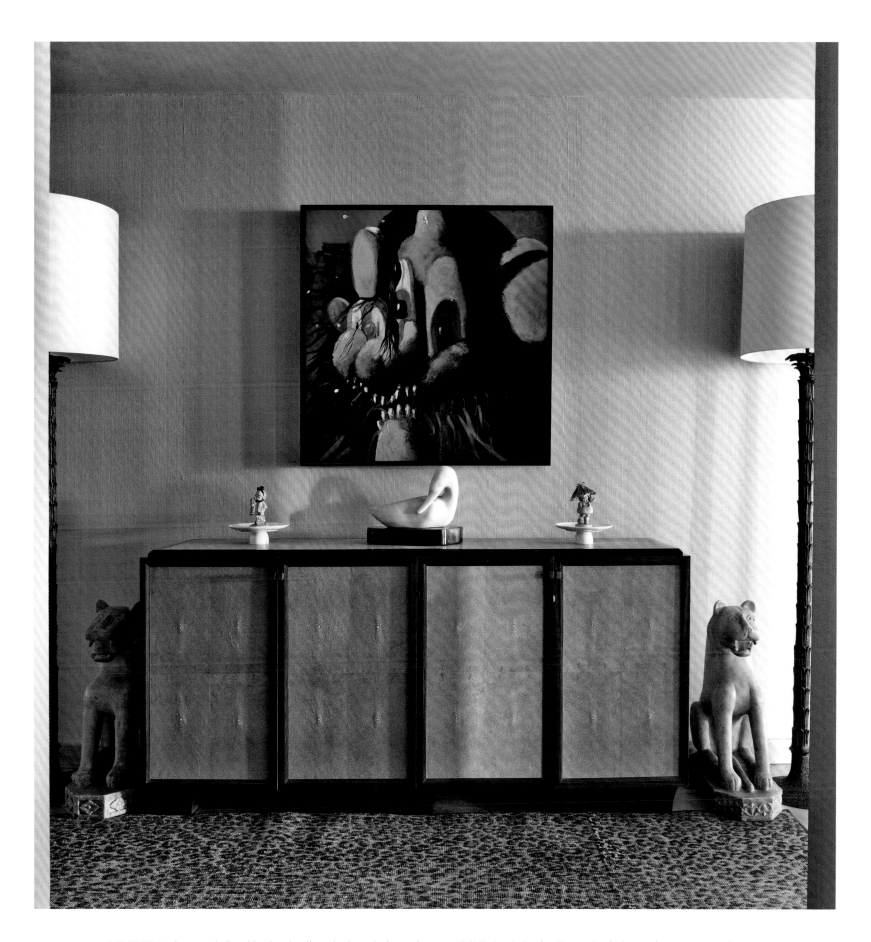

OPPOSITE: In the entry hall, golden-hued walls and a bespoke leopard print carpet help to create an atmospheric setting for a Louise Bourgeois sculpture set atop Michele Oka Doner's glimmering table.

ABOVE: A painting by George Condo hangs above a custom shagreen cabinet by Francis Sultana. A pair of whimsical ceramics by Barnaby Barford is displayed on top.

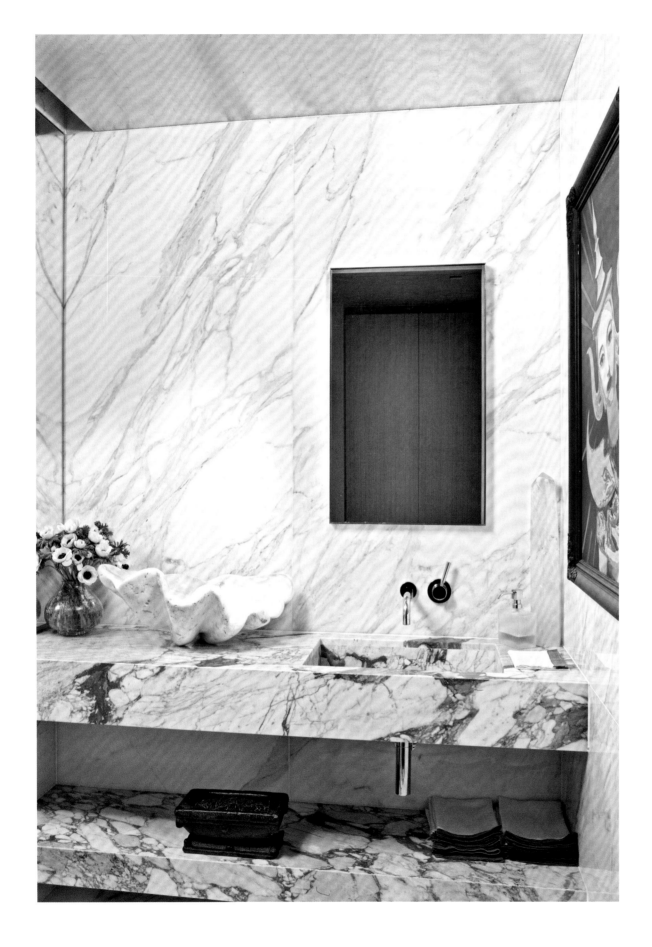

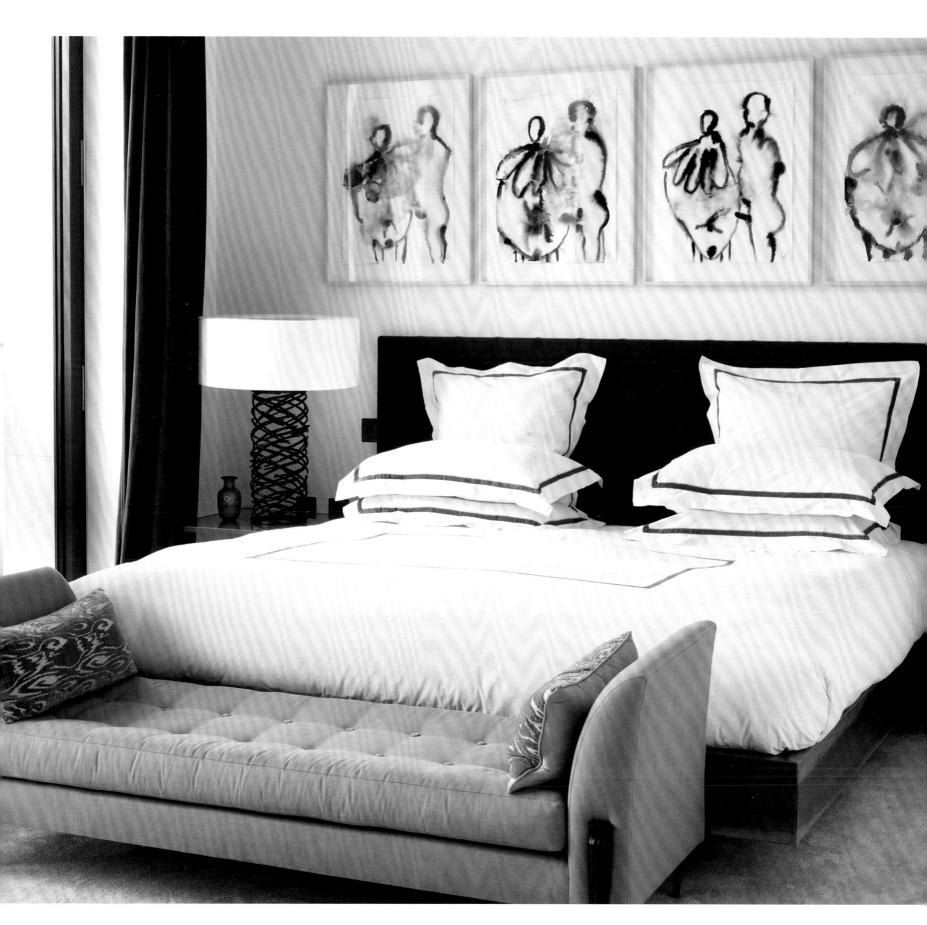

LEFT: A fossil shell and an Andy Hope painting add character to a small bathroom lined with marble.

ABOVE & PP226–227: The green and blue of the bedroom is echoed outside on the terrace, which overlooks London's Kensington Gardens. The artwork above the bed is *The Family* by Louise Bourgeois.

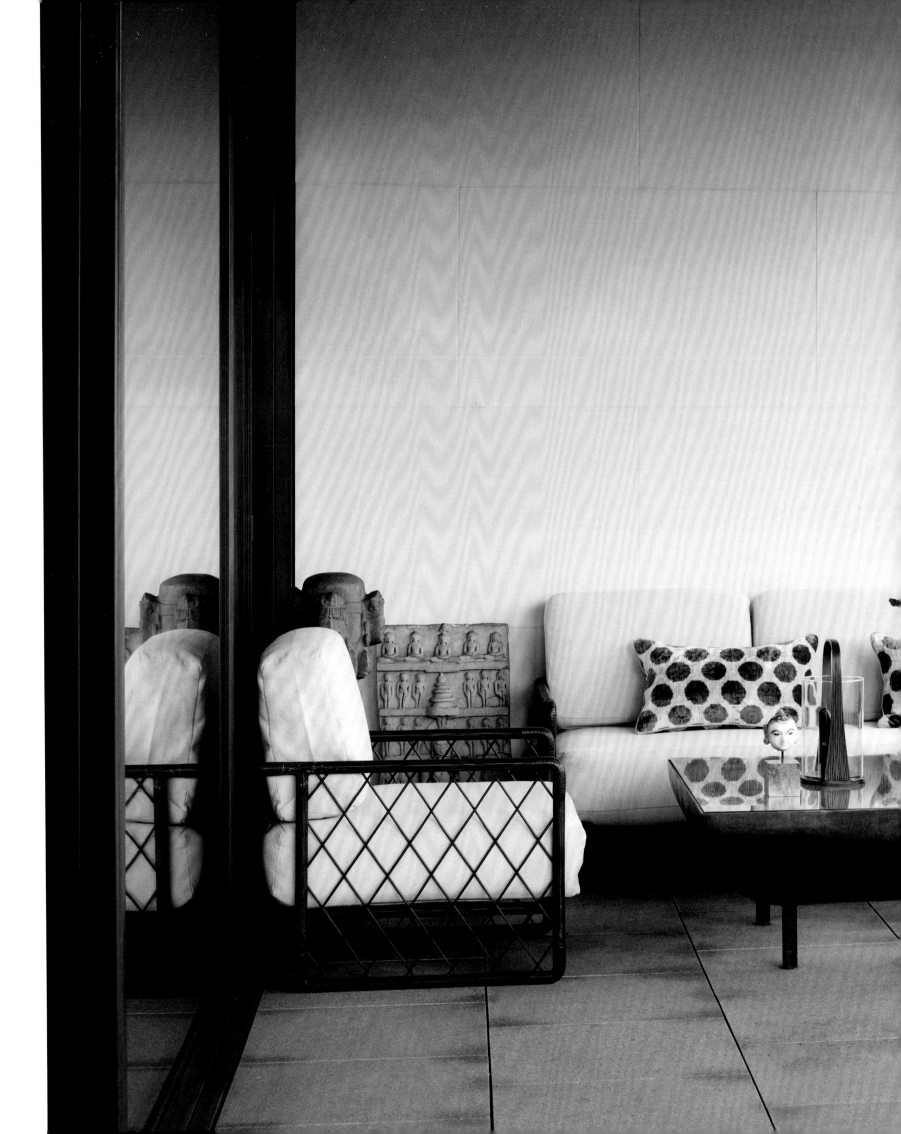

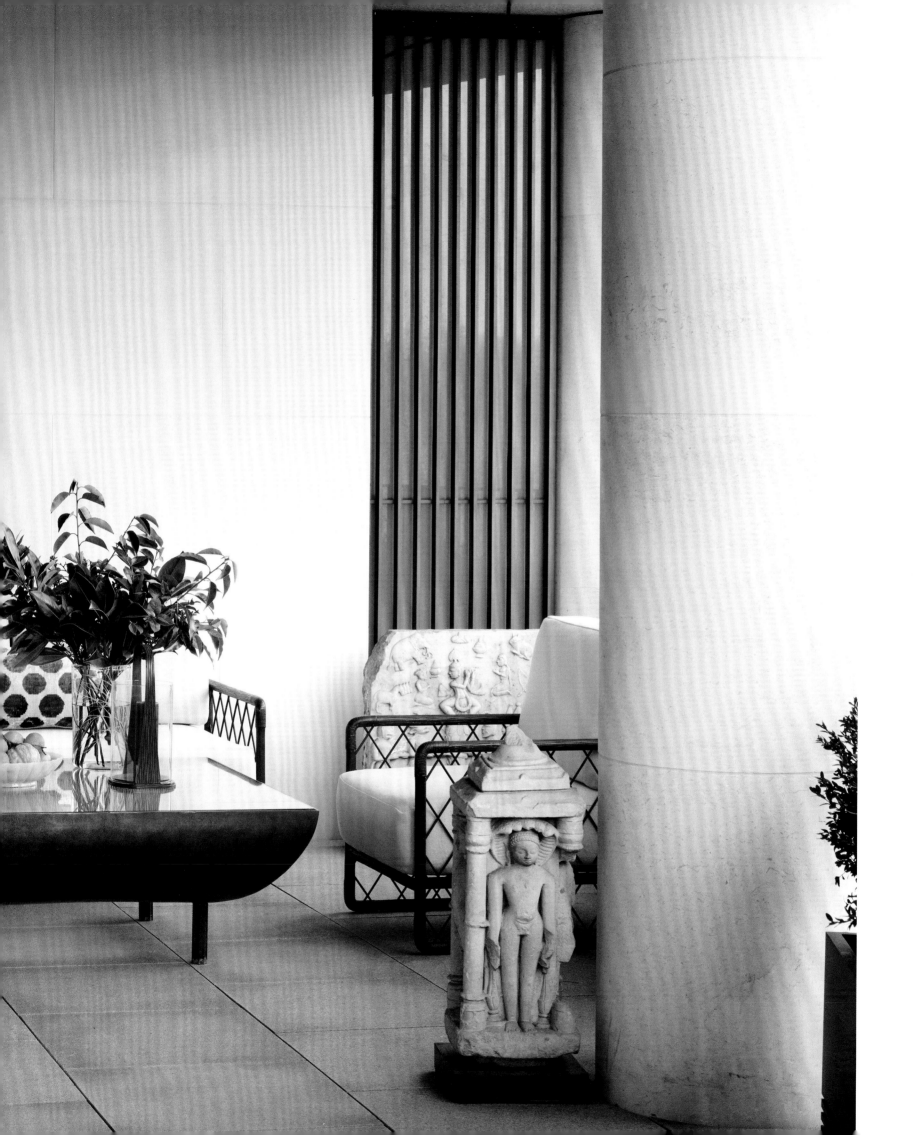

INSPIRATIONS

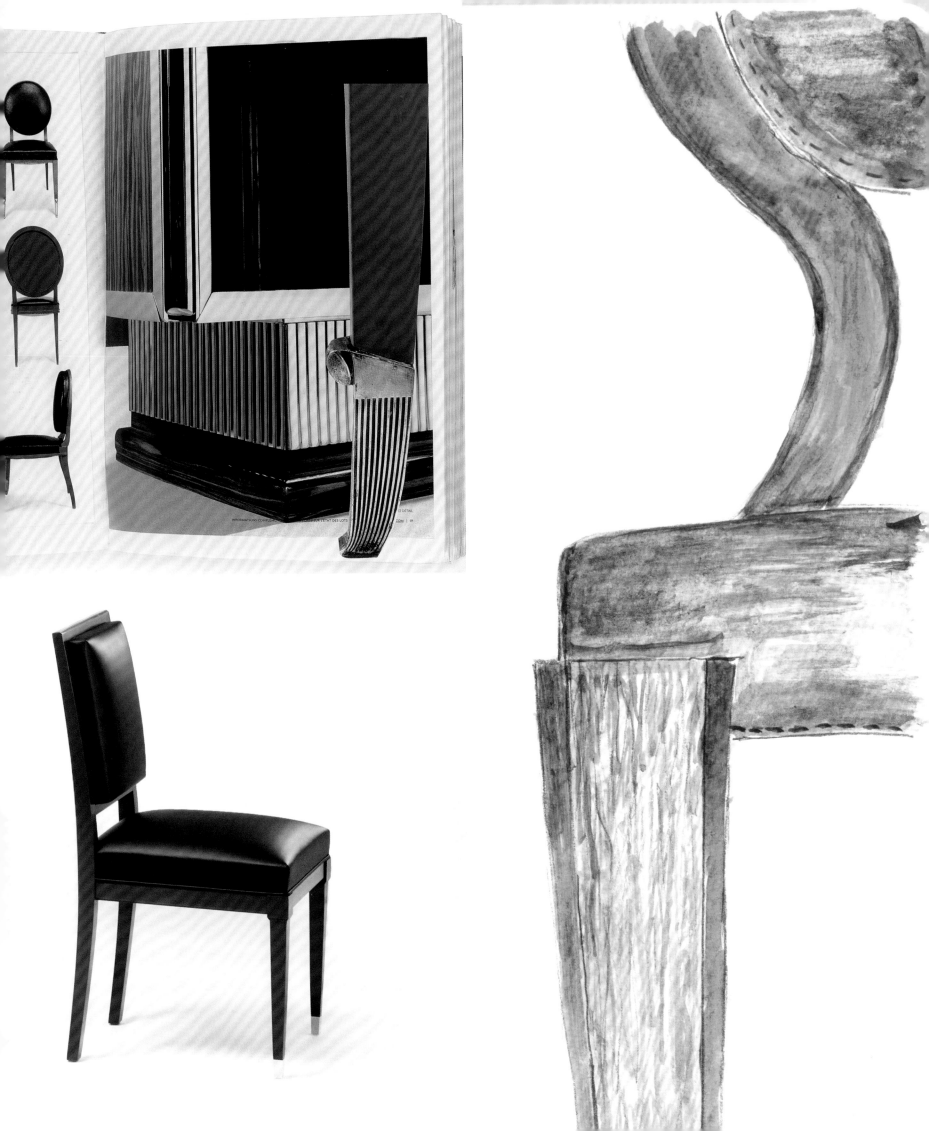

INSPIRATIONS
Brook Mason

FRANCIS SULTANA ESTABLISHED HIS EPONYMOUS COMPANY PRODUCING BESPOKE, LIMITED-EDITION FURNITURE, LIGHTING AND HOME ACCESSORIES IN 2011 AS A RESPONSE TO DEMAND. HIS EXPERIENCE WORKING AS A DESIGNER OF INTERIORS AND FURNITURE FOR INTERNATIONAL BUSINESS TYCOONS, ROCK STARS SUCH AS ELTON JOHN AND MADONNA, AS WELL AS VIRTUOSIC CONTEMPORARY ART COLLECTORS, PROMPTED HIM TO DETECT THE NEED FOR ORIGINAL FURNITURE THAT COULD HOLD ITS OWN IN A DOMESTIC ENVIRON BEAUTIFIED WITH DRAMATIC PAINTINGS BY THE LIKES OF JEAN-MICHEL BASQUIAT, RICHARD PRINCE, AND CHRISTOPHER WOOL, AND, ALL THE WHILE, STAND HARMONIOUSLY ALONGSIDE CHIPPENDALE FURNITURE.

THE CLIENTELE AND CRITICAL ACCLAIM FRANCIS'S WORKMANSHIP SWIFTLY GARNERED IS TESTAMENT TO THE UNRIVALED SKILL HE ACQUIRED OVER THE COURSE OF HIS CAREER. FRANCIS JOINED THE DAVID GILL GALLERY IN 1992. SEVEN YEARS LATER, HE WAS ITS CREATIVE DIRECTOR. TODAY, HE BALANCES HIS OWN DESIGN PRACTICE WITH MAINTAINING HIS ROLE AS THE GALLERY'S CEO.

AFTER DAVID—WHO IS FRANCIS'S LIFE PARTNER—ESTABLISHED HIS GALLERY AS THE FIRST IN LONDON TO DISPLAY LIMITED EDITION FURNITURE, HE BECAME THE LEADER IN THE FIELD. HE ALSO ACHIEVED INTERNATIONAL RENOWN FOR RECOGNIZING, BEFORE OTHERS DID, THE TALENT OF ART AND DESIGN VISIONARIES SUCH AS ELIZABETH GAROUSTE AND MATTIA BONETTI, AS WELL AS GRAYSON PERRY, AMONGST MANY OTHERS.

"FUTURE CLASSICS" WAS THE TERM THAT WAS DERIVED FOR THE AVANT-GARDE FURNITURE GILL CONCEIVED, TO EXACTING STANDARDS, WITH HIS STABLE OF ARTISTS. FRANCIS WAS WORKING BY HIS SIDE THROUGH THE MAKING OF MOST OF IT, FROM "KING BONK"—A GLOSSY, BLUE/BLACK ARM CHAIR AND FOOTSTOOL, WHICH FREDRIKSON STALLARD PRODUCED BY CARVING ITS FORM FROM POLYSTYRENE WITH A CHAINSAW—TO "DUNE FORMATIONS." THIS COLLECTION, CRAFTED FROM RESIN AND

METAL BY THE LATE ARCHITECT ZAHA HADID, DEBUTED TO ACCLAIM AT THE 52ND VENICE BIENNALE IN 2007.

"ANTIQUES OF THE FUTURE" IS THE TERM USED TODAY BY HENRIETTA "HATTA" BYNG, EDITOR OF THE UK EDITION OF *HOUSE & GARDEN*, TO DESCRIBE FRANCIS'S OWN FURNITURE DESIGNS, WHICH ARE OFTEN NAMED IN HONOR OF HIS CLOSE FRIENDS, MANY OF WHOM ARE CLIENTS, SUCH AS YANA PEEL, FORMER TOP MODEL CELIA FORNER, AND FASHION INVESTOR, NARMINA MARANDI. "FRANCIS'S CLIENTS TEND TO BE ART COLLECTORS; PEOPLE

WHO TAKE ART AND DESIGN SERIOUSLY," EXPLAINS BYNG. "YOU ACQUIRE HIS WORK LIKE YOU BUY AN ARTWORK, NOT MERELY TO FURNISH YOUR HOUSE."

"PEOPLE TEND TO ASSOCIATE FRANCIS'S FURNITURE WITH MASTER-OF-THE-UNIVERSE DREAM SPACES, A REGAL LONDON MANSION, A GRAND APARTMENT IN A PARIS HÔTEL PARTICULIER, AND EVEN AN ULTRA-MODERN ROYAL HUISMAN YACHT," CONTINUES AMY ASTLEY, EDITOR-IN-CHIEF OF THE U.S. EDITION OF *ARCHITECTURAL DIGEST*. "THAT BEING SAID, LIKE ALL GREAT DESIGN, WHAT HE CREATES CAN EASILY WORK IN A MORE INTIMATE BUT ALWAYS SOPHISTICATED CONTEXT."

Cecil Beaton at Ashcombe House, taken in 1937.

PUTTING IT ON
De Gunzburg, photographed by Horst, dressed as Archduke Rudolf for his Ball of the Waltzes, 1934. *Opposite,* the baron sunning himself, circa 1930.

VANITY FAIR | 197

FOR ME, THE 1920S WAS DEFINITELY THE MOST GLAMOROUS OF DECADES—THE FASHION, THE HOMES AND INTERIORS, THE CARS AND THE CULTURE—EVERY ASPECT OF DESIGN FUELS MY IDEAS.

The 'he's tied up just now please take a' seat

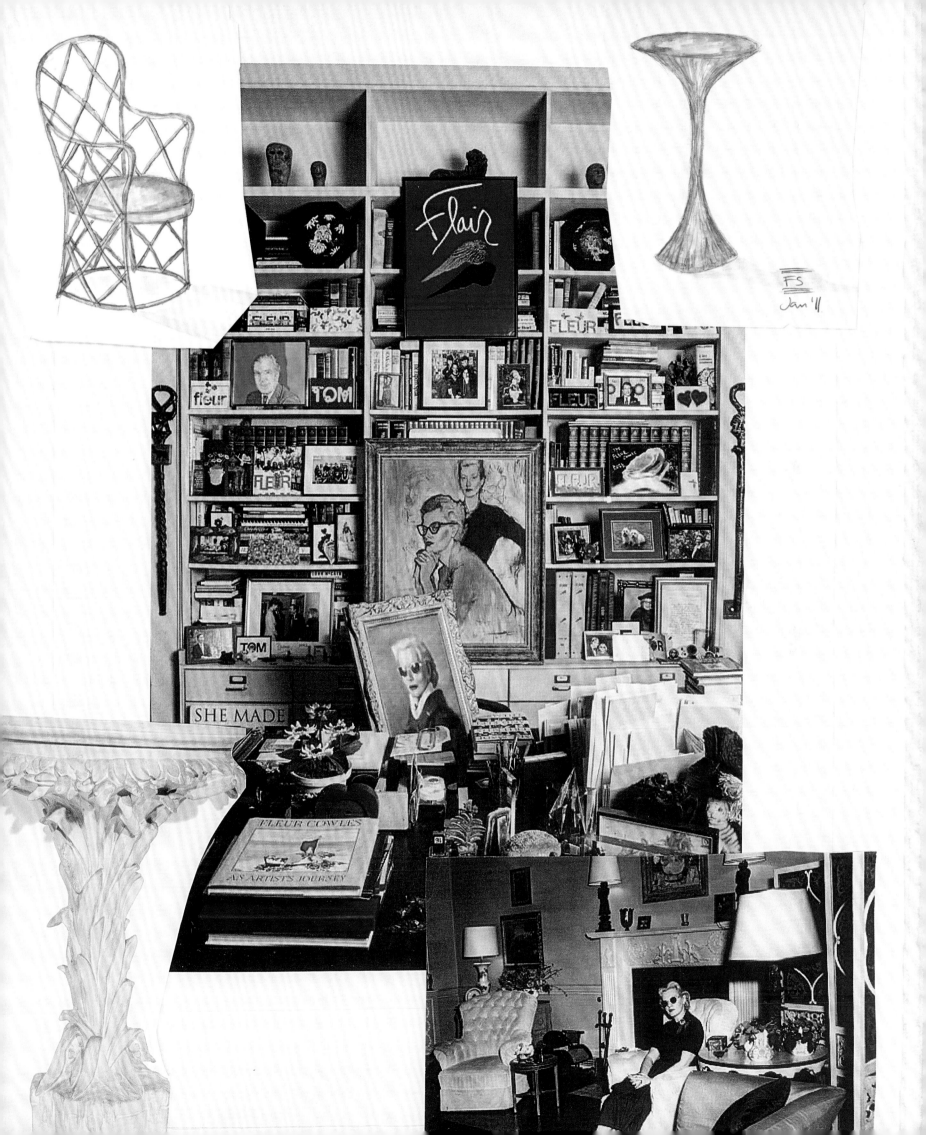

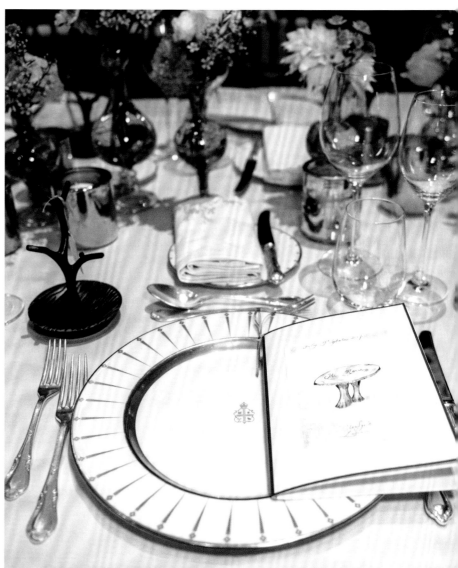

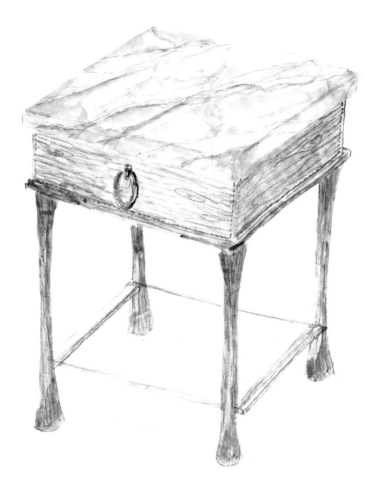

FRANCIS TRACES THE DEVELOPMENT OF HIS FUR-
NITURE COMPANY, FRANCIS SULTANA EDITIONS, TO
THE REMARKABLE PARIS HOME OF AN ART COLLEC-
TOR FOR WHOM HE DESIGNED A BRONZE AND GLASS
DINING TABLE. THE PIECE WAS MEANT FOR A ROOM IN
WHICH THERE WAS FURNITURE BY ÉMILE-JACQUES
RUHLMANN AND ARMAND-ALBERT RATEAU. AND
IN THE CLASSICAL DIRECTION OF THESE ART DECO
MASTERS, FRANCIS CARRIED ON. HE ENTITLED HIS
FIRST COLLECTION "HOMAGE TO THE ART DECO,"
AND THE OPULENCE AS WELL AS THE STREAMLINED
SIMPLICITY OF THIS DECORATIVE PERIOD REMAINS A
CONSTANT SOURCE OF INSPIRATION.

WHEN IT COMES TO LAUNCHING HIS FURNITURE
COLLECTIONS, FOR EXAMPLE, FRANCIS FORGOES
THE USUAL ROUTE OF EXHIBITING IN FORGETTABLE
SHOWROOMS, AND INSTEAD OPTS TO DEBUT THEM
AT CLARIDGE'S HOTEL, WHERE, IN ITS FOYER,
STAND GLASS SCREENS DESIGNED BY THE HOTEL'S
ARCHITECT, BASIL IONIDES, WHO WAS A LEADING
FIGURE IN THE BRITISH ART DECO MOVEMENT.
"THE SPIRIT OF ART DECO IS ALWAYS THERE, SOME-
HOW INFORMING MY WORK," ADMITS FRANCIS. "BUT
I HAVE NEVER SOUGHT TO MERELY COPY ANY OF ITS
GREAT DESIGNERS."

INSTEAD, HE ALWAYS INTRODUCES INTRIGUING
AESTHETIC TWISTS, WHICH HE DREAMS UP THANKS
TO HIS ARCHIVE-LIKE KNOWLEDGE OF DESIGN HIS-
TORY. TAKE THE STRIKING CUSTOM UPHOLSTERY
FRANCIS DEVELOPS FROM SCRATCH TO EMBELLISH
HIS FURNITURE. SHIMMERING, SILK-KNIT METAL-
LIC TWEEDS, NATURAL RAFFIA AND VIBRANT KIDAS-
SIA—THESE CUSTOM MATERIALS PRODUCED FOR
FRANCIS SULTANA EDITIONS CALL TO MIND THE
SUMPTUOUS FABRICS ORIGINALLY DEVELOPED BY
THE SWISS TEXTILE MASTER GUSTAVE ZUMSTEG,
WHOSE COMPANY, ABRAHAM, CONCEIVED AND PRO-
DUCED COUTURE-QUALITY TEXTILES FOR CRISTÓBAL
BALENCIAGA, CHRISTIAN DIOR, AND YVES SAINT
LAURENT, AMONG OTHER COUTURIERS. "I HAVE
ALWAYS BEEN INTERESTED IN WORK BY THE GREAT
COUTURIERS, AND BECAUSE NO ONE OUT THERE WAS

REALLY TRANSLATING TO FURNITURE AND DOMESTIC
ACCESSORIES THE LAVISH TEXTILES AND EMBROI-
DERY THEY PIONEERED, I DECIDED TO STRIKE OUT
ON MY OWN," SAYS FRANCIS. "DESIGNING MY OWN
UPHOLSTERY FABRICS IS REALLY ANOTHER WAY TO
EXPRESS MY IDEAS."

JUST LIKE COUTURIERS WHOSE COLLECTIONS ARE
FUELED BY HISTORY, MYTHOLOGY, AND FOLKLORE,
FRANCIS'S FURNITURE COLLECTIONS ARE NARRA-
TIVE DRIVEN, TOO. "NARMINA," FOR INSTANCE, REF-
ERENCES THE OPULENCE OF TWENTIES PARIS WHEN
COCO CHANEL FELL UNDER THE SPELL OF JOSÉ-
MARIA SERT, FROM WHOM JOHN D. ROCKEFELLER
JR. AND HIS SON, NELSON, COMMISSIONED MURALS
FOR THEIR MIDTOWN MANHATTAN SKYSCRAPER
COMPLEX. "SERT, WHO WAS AN IMPORTANT DECORA-
TOR, AND HIS WIFE, MISIA, A LEADING PARIS HOST-
ESS, PROVED HIGHLY INFLUENTIAL WHEN IT CAME
TO CHANEL FORGING HER OWN PATH IN INTERIOR
DESIGN," EXPLAINS FRANCIS. THE LANGUID SENSE
OF COMFORT EVOKED BY A DAY BED AND BRONZE
COLUMNED SOFA FROM "NARMINA" RECALL SERT'S

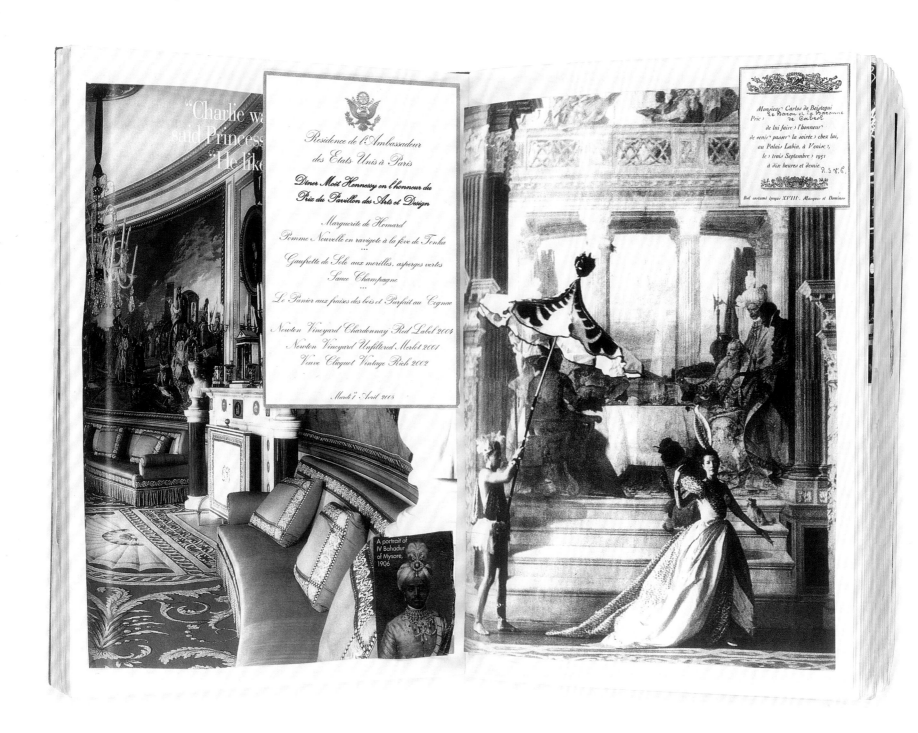

THE TEXTILES I DESIGN ARE INSPIRED BY THE LUSH, PAINTERLY MATERIALS PRODUCED BY SPECIALIST WORKSHOPS WHICH ONCE CATERED TO THE FAMED PARIS COUTURIERS. THESE INCLUDE LINTON TWEEDS, BIANCHINI-FÉRIER OF LYONS, JOHNSTONS OF ELGIN AND GUSTAV ZUMSTEG'S ZURICH BASED FIRM, ABRAHAM.

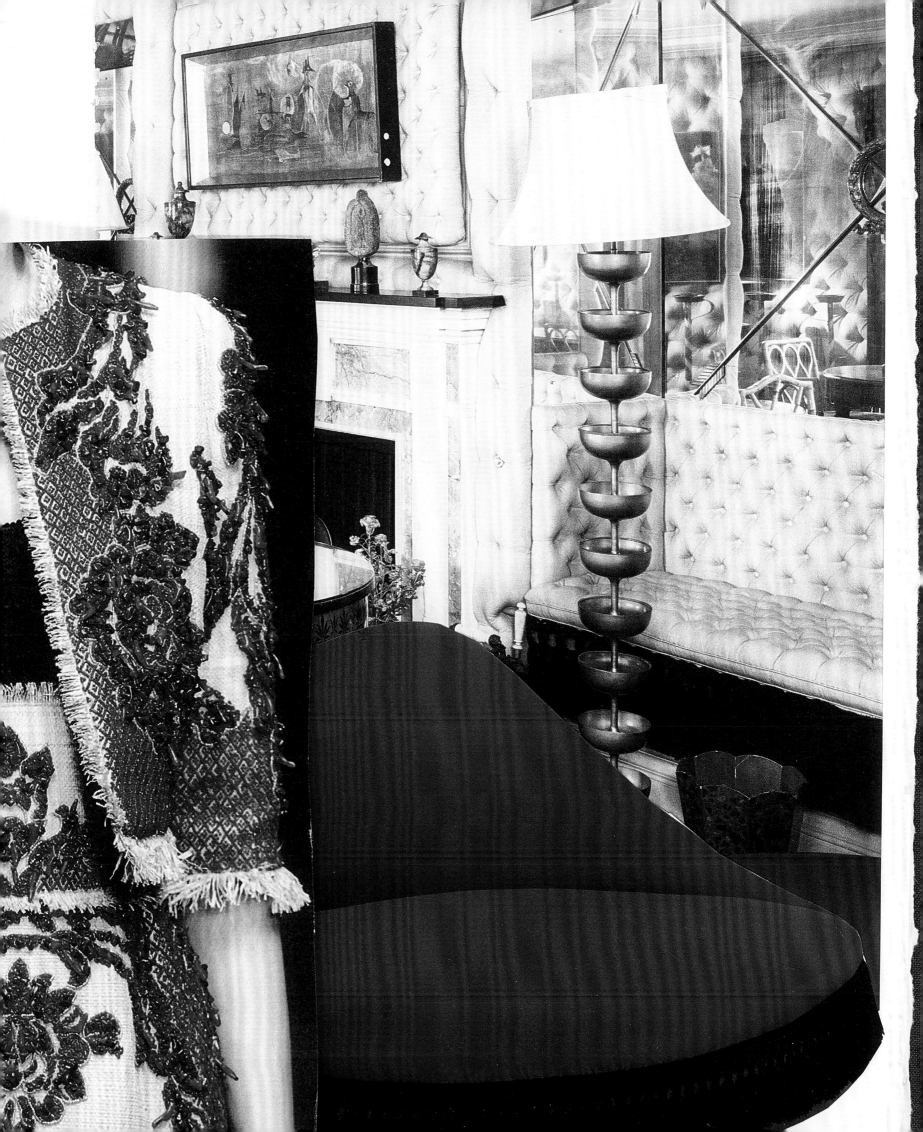

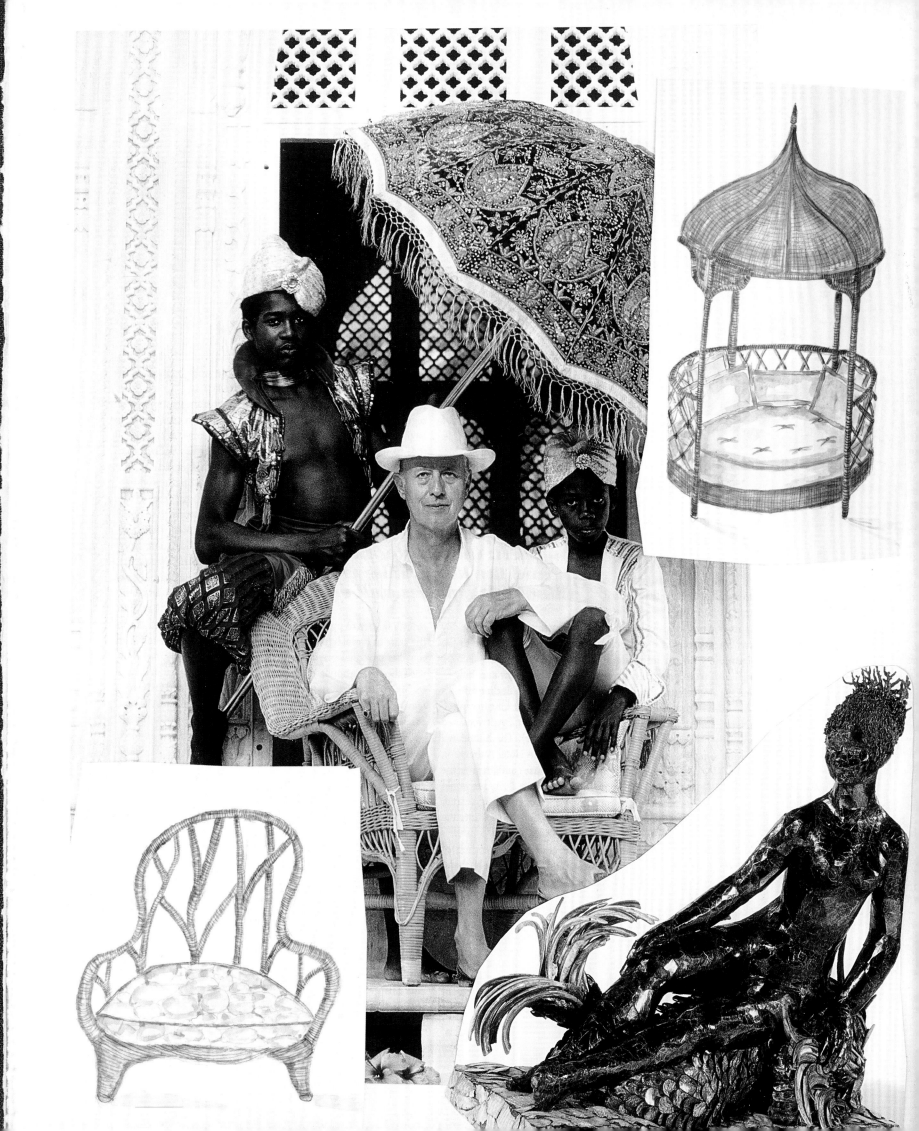

Tastemakers
Francis Sultana

Since founding his interior design practice in 2009, Francis Sultana has become the go-to designer for many of the world's biggest art patrons, including Yana Peel, chief executive of London's Serpentine Galleries. When the Maltese-born designer is not kitting out luxury residences, he can be found in the contemporary art gallery (he is the chief executive), run by his partner David Gill, also a designer. The couple live in a Georgian house in Mayfair, London.

Your biggest source of inspiration?
Vintage films, especially from the 1940s and 1950s.

Chintz or minimalism?
I have an eclectic taste, so although I like a bit of excess, I always want to pair with tailored lines.

Your design essential?
Be practical. What is the point of a beautiful room that doesn't work? You need to be able to enjoy it.

Your favourite interior design quick fix?
A lick of paint can make a world of difference. In the city, air pollution can settle down and change the colour of your walls. Paint revamps a space.

The next big interior-design trend?
The colour amber. I am using it a lot at the moment. It's wonderful and reminds me of the top of a crème brûlée.

most beautiful silk fabric that we couldn't really afford. We bought it, and years later it still looks wonderful.

What would you save on?
You can save money by being patient. Design in phases. Look at the essentials and then reassess. You may find that the room is complete and you don't need that piece of furniture you were convinced was necessary.

Best piece of design advice you have received?
Don't be afraid of putting overscaled furniture in small rooms — it can make a room feel grand.

What is your favourite thing about your home?
It's Georgian — my favourite British architectural period. It reminds me that I am in London.

Amy Fleming

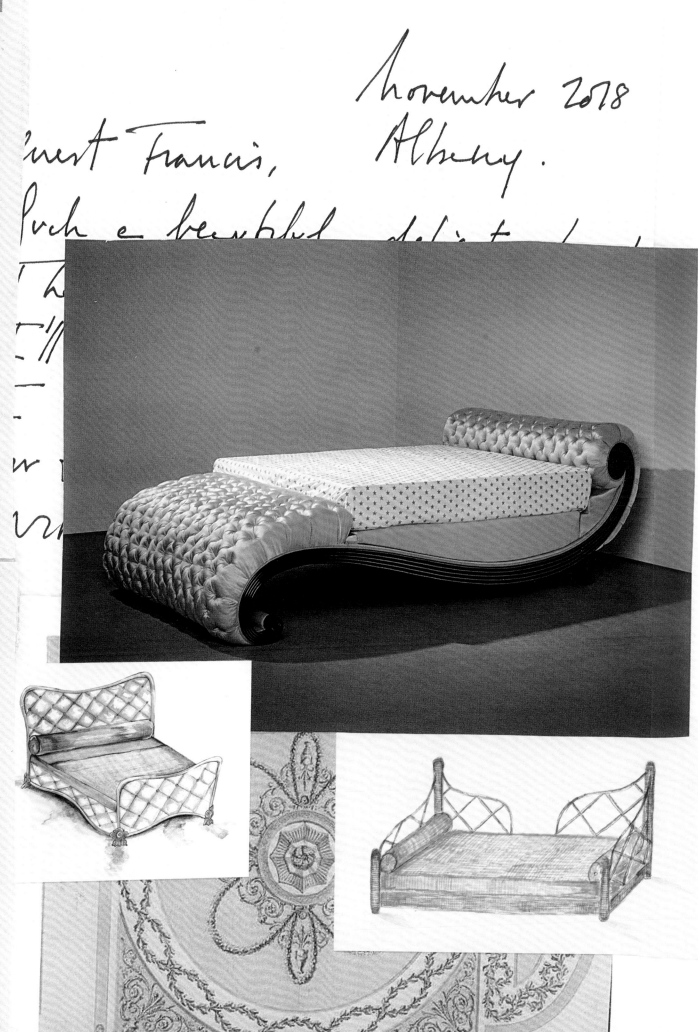

November 2018
Albany.

Dearest Francis,

Such a beautiful delightful...

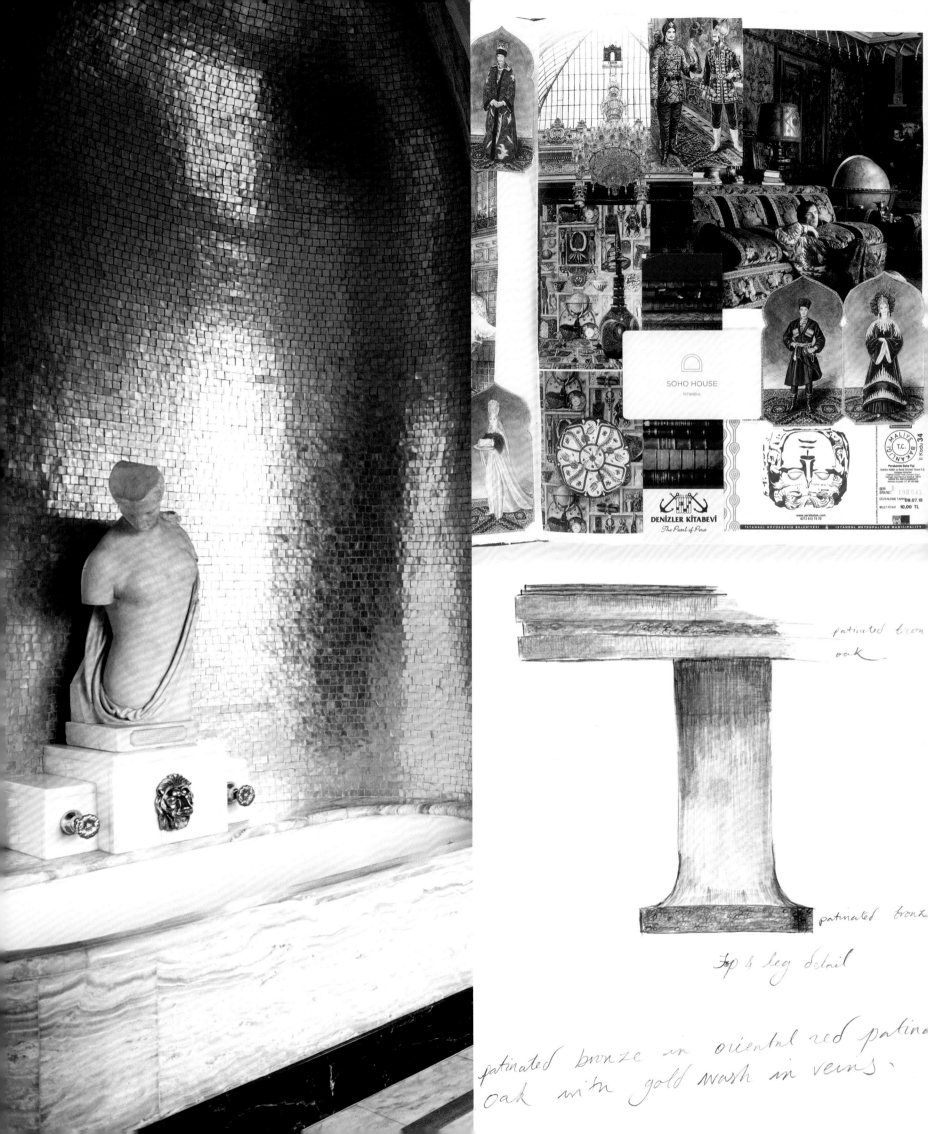

patinated bronze oak

patinated bronze

Top & leg detail

patinated bronze in oriental red patina oak with gold wash in veins.

DECADENT TOUCH AS WELL AS HIS PREFERENCE FOR GENEROUS PROPORTIONS. THE INTRODUCTION OF ROCK CRYSTAL TO "NARMINA" ALSO SUGGESTS THE TASTE OF MISIA SERT, WHO DARINGLY PLACED LIGHT REFRACTING CRYSTAL SHARDS AS DECORATIVE OBJECTS AROUND HER HOUSEHOLD. IN TURN, ROCK CRYSTAL BECAME ONE OF CHANEL'S DECORATIVE HALLMARKS AFTER SHE APPOINTED STÉPHANE BOUDIN, PRESIDENT OF MAISON JANSEN, TO MASTERMIND THE INTERIORS OF THE PRIVATE APARTMENT SHE OCCUPIED ABOVE HER RUE CAMBON ATELIER. INSPIRED BY ALL OF THIS, FRANCIS INTEGRATED CRYSTAL TO "NARMINA" BY WORKING WITH A SPECIAL TREATMENT PROCESS SO THAT THE TABLETOPS AND BASES OF LIGHT-FIXTURES EMIT A BEAUTEOUS SHIMMER RESEMBLING SEMI-PRECIOUS GEMSTONES. "WITHOUT MISIA, CHANEL WOULD NEVER HAVE INCORPORATED ROCK CRYSTAL IN HER RUE CAMBON APARTMENT, AND IN ADDING ROCK CRYSTAL TO MY OWN REPERTOIRE OF MATERIALS, I'M REFERENCING THAT ERA OF EXTRAVAGANCE," STATES FRANCIS.

HE HAS ALSO LOOKED TO HALSTON'S SEVENTIES HEYDAY AND ANDY WARHOL'S LATE PAINTINGS. SO A SINUOUS, HAND-CARVED ABSTRACT PATTERN ADORNING GILDED WOOD AND BRONZE NICKEL FURNITURE FROM THE "YANA," COLLECTION PROVED FRANCIS'S INTERPRETATION OF WARHOL'S 1986 "CAMOUFLAGE" PAINTINGS AND HIS ICON PORTRAITS.

IN MANY WAYS, FRANCIS IS ALSO FOLLOWING IN THE FOOTSTEPS OF JEAN ROYÈRE. LIKE THIS LEGENDARY 20TH-CENTURY PARIS INTERIOR DESIGNER, HE RECEIVED NO FORMAL ACADEMIC DESIGN TRAINING, YET HE QUICKLY ACHIEVED INTERNATIONAL ACCLAIM. AND JUST AS ROYÈRE FORGED A NEW DESIGN VOCABULARY, YET NEVER STRAYED FROM SUPERLATIVE MATERIALS AND UNCOMPROMISING CRAFTSMANSHIP, FRANCIS HEWS TO THOSE SAME PRINCIPLES. FOR EXAMPLE, COMPUTER-GENERATED RENDERINGS MAY BE INVOLVED IN THE MAKING OF FRANCIS SULTANA EDITIONS, BUT ITS PRODUCTION PROCESS BEARS LITTLE TO THAT OF THE CURRENT GENERATION OF FURNITURE MAKERS WHO RELY ON TECHNOLOGY.

FRANCIS'S BLUEPRINTS COME ONLY AFTER HE HAS PAINSTAKINGLY EXECUTED HIS DESIGNS MANUALLY BY APPLYING HIS WATERCOLOR SET TO HIS HERMÈS SKETCH BOOK. HE DEVISES MAQUETTES OF "HANDLES, LEGS AND ANYTHING THAT MUST BE CAST" TO ALLOW THE FINE-TUNING OF DETAILS AND TO ADJUST SCALE. PROPORTIONS ARE CONTINUALLY REVISED. "REFINING THE PROPORTIONS IS CRITICAL TO ENSURE COMFORT," OBSERVES FRANCIS.

Chain handles –
bronze & rock crystal

ULTIMATELY, THE MANUAL WORKMANSHIP INVOLVED IN THE PRODUCTION OF A SIZABLE PIECE OF FURNITURE CAN CONTINUE ON FOR AS LONG AS SIX MONTHS OR MORE.

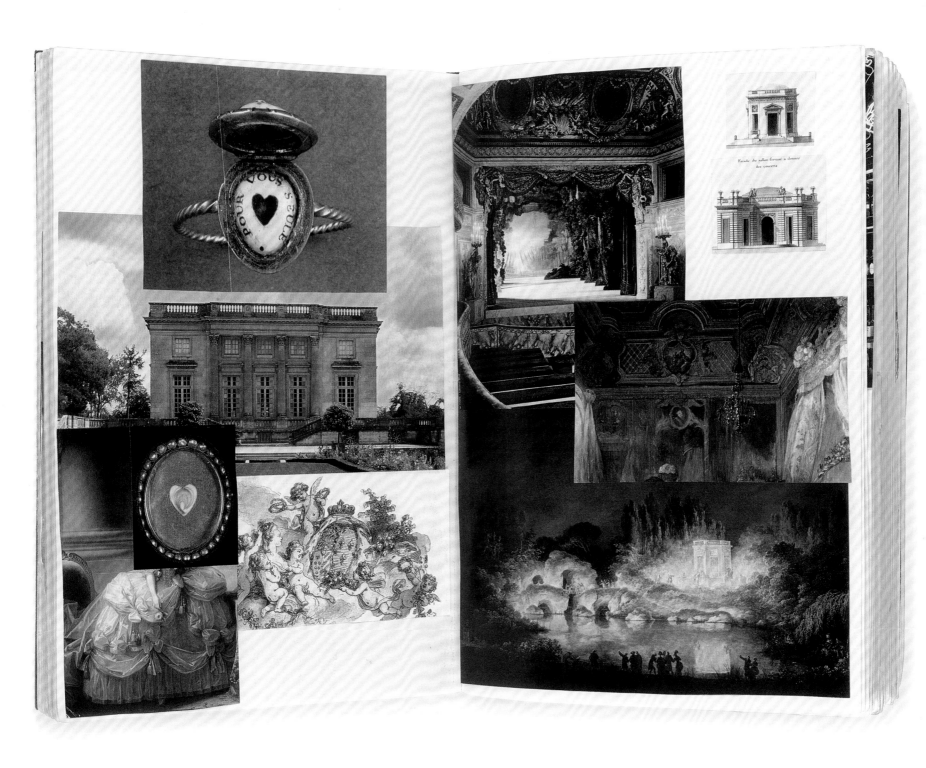

AQUATIC HUES—WATERY GREENS AND TEAL BLUE ARE AMONG MY FAVORITE
COLORS. RICH COLORS GO WELL TOGETHER; YOU NEED THEM IN A CITY.
PASTEL COLORS SHOULD BE SAVED FOR SUMMER HOUSES.

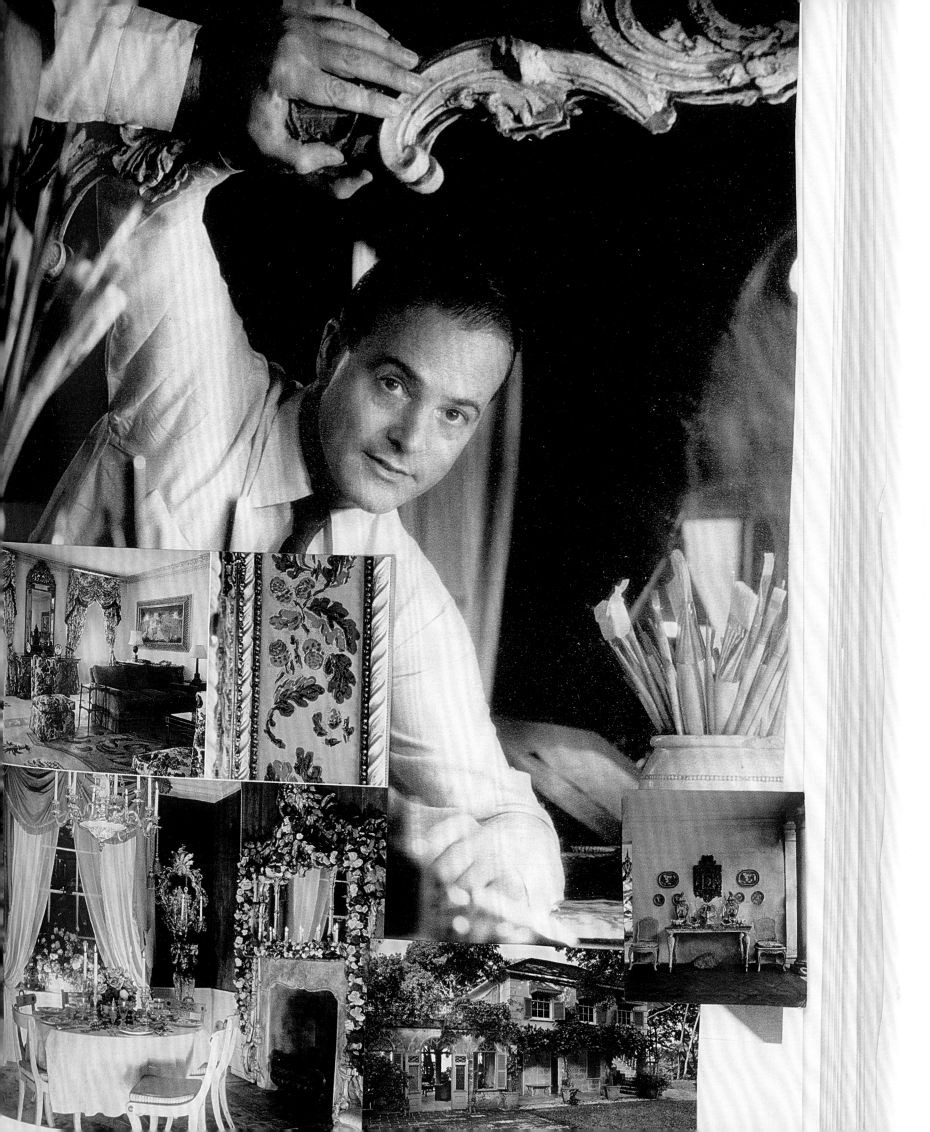

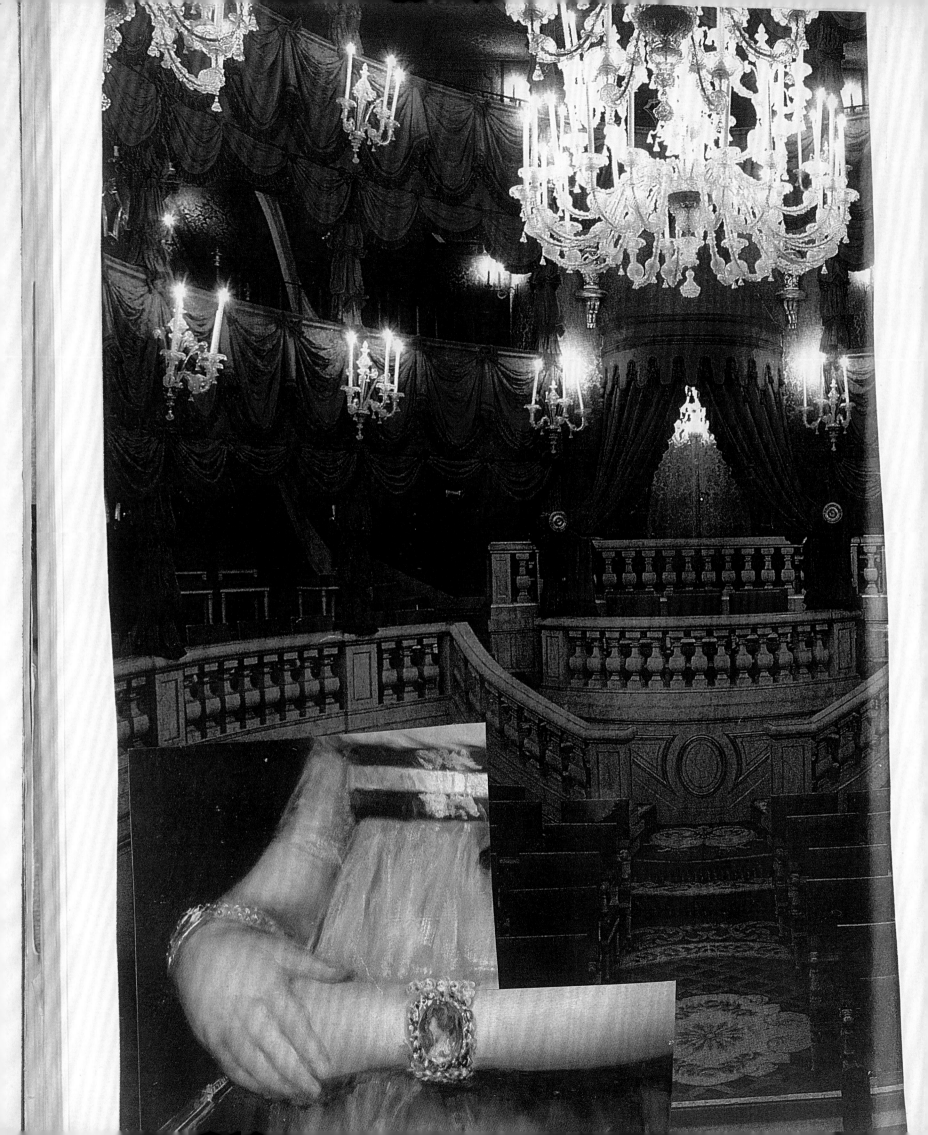

The Strand WC2E 7NA

age de gauche

PTER POUR
S MOTIFS BAROQUES
UBBINS en bourrette de soie,
rimés et brodés main
près des suzanis d'Asie
trale, 45 × 45 cm,
€ pièce, EMPORIO SIRENUSE.
ette en porcelaine, à 30 cm,
ambra, 165 €, fabriquée
Porcel, JILL BARNES-DACEY.
fond, CARREAUX de céramique
sign Ronan et Erwan Bouroullec,
mbini, 27,5 × 25,7 cm,
€ pièce, MUTINA.

age de droite
OFFRIR
NE ESCALE RAFFINÉE
HÔTEL SAN PIETRO, à Positano,
arie splendeurs et art de vivre
ine un esprit rafraîchissant.

Over time, Francis has developed a network of highly skilled artisans with whom he collaborates exclusively, such as a tight-knit Italian team who work flawlessly with bronze and execute ingenious patinations. "Casting bronze is virtually a lost tradition but when sourcing the finest artisans, there's no one else like Francis," says Sandra Nunnerly, the New York interior designer who commissioned him to design a pair of banquettes for a client's game room.

While Art Deco designers Jean-Michel Frank and André Groult elevated the humble craft of straw marquetry, which dates from the 17th century, Francis has also helped to revive this tradition. Highly labor intensive—because each blade of rye straw is first hand cut and then that single straw is split in half, dyed and later arranged to form striking geometric patterns—the craftspeople who have this expertise are hard to find. Nevertheless, three panels of straw marquetry—painstakingly arranged in a bold chevron pattern featuring alternating bands of deep lapis blue and shimmering gold—beautify a buffet from the "Narmina" collection, which is framed in patinated and textured bronze.

Veere Grenney—whose London interior design firm ranked alongside Sultana's on 2018's AD100 list—praises Francis's ability to unite the Renaissance technique of scagliola, in which plaster and paint render the subtle tonalities of marble, with contemporary forms as well as a textural quality.

Indicative of the rarefied way in which Francis updates age-old grandeur are a pair of consoles that stand in the Palm Room, the flamboyant ground-floor entertaining space at Spencer House. David Mlinaric, the British interior decorator, engaged Francis to design these pieces during his grand-scale

restoration of the 18th-century palace in St. James's, London, in 2004. The reincarnation involved workmanship executed by some of the world's most highly skilled craftspeople and designers. Francis's assignment came with the request to incorporate into the design of his consoles ancient Roman mosaics belonging to Jacob Rothschild, Fourth Baron Rothschild.

Looking back on working with these priceless relics, which Francis propped upon white cast-bronze legs, he reflects: "I could not refuse. Spencer House is one of the great palaces, and the assignment gave me the courage and conviction to create furniture that may be contemporary yet is informed by beauty from the past."

FRANCIS SULTANA

14 · 05 · 15

FS
March '14

Francis

DEUTSCHE
DEMOKRATISCHE
REPUBLIK

REISEPASS

GOLDEN BOY

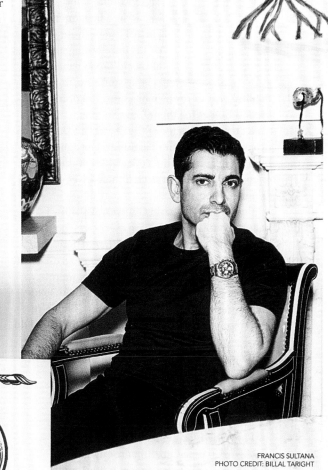

the move to Mayfair, **Marianne Dick** talks to
Sultana about his new showroom, art, and isla

ains self-taught interior
ana as we walk through
howroom above the
Street. "It can start
y in here."

ry haven, which
house through
A large, meditative
behind his desk and
tools are laid out
e are neatly pinned
ndle flickers gently and,
rniture draws the eye.
en here in Mayfair
a – who moved to
island of Gozo when
e area for the past

n, Chelsea and Belgravia
've been gradually
heading this way. I would prefer to stay in Mayfair
as I love the fact that I can walk everywhere; it's

FRANCIS SULTANA
PHOTO CREDIT: BILLAL TARIGHT

Richard Wagner - Der Ring des Nibelungen
September 2016 - Show beginnt um 20.00 Uhr
Eintritt: 1 Erwachsener

Komische Oper Berlin
präsentiert

September 2016
Show beginnt um 20.00 Uhr

CREDITS

P1: Illustration © Francis Sultana.

P2: Photo © James McDonald; Lamp © Mattia Bonetti/DACS; Art © Aldo Mondino/DACS.

P4: Photo © Simon Upton/Interior Archive; Carpet © Mattia Bonetti/DACS.

P6: Photo © Simon Upton/Interior Archive; Art © Yayoi Kusama; Torchère © Mattia Bonetti/DACS; Chair © André Arbus/DACS.

P8: Photo © Simon Upton/Interior Archive; Light Installation, "My Madinah. In pursuit of My Hermitage" © Jason Rhoades.

P11: Photo © Chris Floyd.

PP12–13: Photo © Brian Grech; Gilded Bosses © Oriel Harwood.

P14 & 15: Photo © John Laurie.

P16: Photo © Armin Weisheit; Art "Camouflage" Print, 1983 © Andy Warhol/DACS.

P17: Magazine covers © The World of Interiors & Architectural Digest/Condé Nast.

P18: Photo © Alastair Morrison and John Warman.

P19: Photo Courtesy of the Basilica of St. Peter & St. Paul, Nadur, Malta.

PP20–25: Photos Ricardo Labougle © The World of Interiors. **P20:** Bed © Oriel Harwood; Chairs © Garouste & Bonetti/DACS. **PP22–23:** "White Rose of Malta" © Grillo Demo; Candelabra, Mirror © Oriel Harwood. **PP24–25:** "Madonna" © Grillo Demo; Grecian Lamps © Nicky Haslam; "Minoan Bull's-horn" Mirror, Console © Oriel Harwood.

P26: Photo James McDonald; "Atlantis" Console © Matti Bonetti/DACS; Lantern © André Dubreuil.

P27: Photo © Brian Grech.

P28: Photo © Simon Upton/Interior Archive.

P29: Photo © Simon Upton/Interior Archive; Mirror, Lantern © André Dubreuil; Console © Mattia Bonetti/DACS; Plates © Jean Cocteau Estate/DACS

P30: Photo © Brian Grech; "Head" Vase © Oriel Harwood; Carpet © Madelaine Castaing; Art "Tracks" 2013 © Ida Ekblad/DACS.

P31: Photo © Brain Grech; Light Installation "Introvert Sun" 2010 © Olafur Eliasson; Art "Us Women" 2011 © Eva Rothschild.

PP32–33: Photo © Sean Mallia/Architectural Digest/Condé Nast; Art "Rising Sun" © Eva Rothschild; "Banana" Lamp © Mattia Bonetti/DACS; Mirror © Oriel Harwood; Light Installation, "My Madinah. In pursuit of My Hermitage" © Jason Rhoades; "Introvert Sun" 2010 © Olafur Eliasson; "Congo" Armchairs © Mattia Bonetti/DACS.

P34, ABOVE: Photo © Brian Grech; **BELOW:** Photo © James McDonald.

P35: Photo © Sean Mallia/ Architectural Digest/Condé Nast; "Abyss" Table, "Banana" Lamp, "Congo" Armchairs © Mattia Bonetti/DACS; Candelabra © André Dubreuil; Mirror © Oriel Harwood; Art "Untitled" 2018 © Secundino Hernández/DACS; Ceiling Installation, 2015 © Daniel Buren/DACS.

P36: Photo © Brian Grech.

P37: Photo © Brian Grech; Console © Oriel Harwood.

P38: Photo © Simon Upton/Interior Archive; Gilded Bosses, "Blue Coral" Candelabra © Oriel Harwood; "Palm" Chairs © Mattia Bonetti/DACS; Dining Table © Garouste & Bonetti/DACS; Art "Untitled" 2017 © Secundino Hernandez/DACS.

P39: Photo © Brian Grech; Dinner Service © Laboratorio Paravicini, Milano.

P40: Photo © Simon Upton/Interior Archive.

P41: Photo © Simon Upton/Interior Archive; "Salome" Table © Garouste & Bonetti/DACS; Art "Iznik Series" © Aldo Mondino/DACS.

PP42–43: Photo © James McDonald; "Grotto" Lamp, "Congo" Chairs © Mattia Bonetti/DACS; Ceramics © Andrew Lord; Plates © Jean Cocteau Estate/DACS

P44: Photo © James McDonald; Art "Study from a Human Body", "Sitting Figure", "Untitled" Prints © Estate of Francis Bacon/DACS; "Emperor", "Grotto" Lamps, "Congo" Chairs, "Fringe" Side Table © Mattia Bonetti/DACS.

P45: Photo © James McDonald; "Emperor" Lamp © Mattia Bonetti/DACS; Cushions © Luigi Bevilacqua.

PP46–47: Photo © Simon Upton/Interior Archive; "Big Jim" Armchair, Ottoman © Mattia Bonetti/DACS; "Antarctica III Gueridon" © Fredrikson Stallard.

P48, ABOVE: Photo © James McDonald; **BELOW:** Photo © Brian Grech; Bedside Table © Martin Szekely; "Glacial" Stools, "Dune" Shelf © Zaha Hadid; Collage © Grillo Demo; Ceramic Figures © Barnaby Barford.

P49: Photo © James McDonald; Art © Stefan Brüggemann.

PP50–51: Photo © Simon Upton/Interior Archive; Art "Semen" © Francesco Clemente; Lamp © Mattia Bonetti/DACS; Wicker Chair © Bonacina 1889.

P52, ABOVE: Photo © Brian Grech; **BELOW:** Photo © James McDonald; "Belgravia" Lamp © Garouste & Bonetti/DACS.

P53: Photo © James McDonald; "Spaghetti" Lamp © Garouste & Bonetti/DACS; Ottoman © Mattia Bonetti/DACS.

P54: Photo © Brian Grech.

P55: Photo © Brian Grech; "Minotaur" Candlesticks © Oriel Harwood; Vase © Constance Spry.

P56: Photo © Brian Grech; "Merveilleuse" Lamp © Mattia Bonetti/DACS.

P57: Photo © James McDonald; Art "Lufthansa" 1991 © Aldo Mondino/DACS; "Turandot" Side Tables © Mattia Bonetti/DACS.

P58: Photo © Brian Grech; Lantern © André Dubreuil.

CREDITS

P59: Photo © Brian Grech; Art "Antiquité Bouclée, Jeunesse de l'éternité" 1958, Plate © Jean Cocteau Estate/DACS; Candlestick © Oriel Harwood.

P60: Photo © James McDonald.

P61: Photo © Simon Upton/Interior Archive.

P62: Photo © Brian Grech.

P63: Photo © James McDonald; "Plastic Fantastic" Masks © Djordje Ozbolt.

P64: Photo © Brian Grech.

P65: Photo © Brian Grech; Light Installation "My Madinah. In pursuit of My Hermitage" © Jason Rhoades.

P66: Photo © James McDonald.

P67: Photo © Simon Upton/Interior Archive; Lantern © Oriel Harwood.

P68: Photo © Brian Grech.

P69: Photo © Simon Upton/Interior Archive. Mirror, Fireplace © Oriel Harwood; "Atlas" Planter © Garouste & Bonetti/DACS.

PP70–71: Photo © James McDonald.

PP72–73: Photo © Simon Upton/Interior Archive.

P75: Photo © Simon Upton/Interior Archive.

P76, ABOVE: Photo © Popperfoto via Getty Images; BELOW: Photo © Bill Brandt Archive.

P77: Illustration "Design for a ceiling by Sir William Chambers" © Victoria & Albert Museum, London.

P78: Photo "British fashion designer Michael Sherard is pictured sketching in his flat in Albany" © Lichfield/Popperfoto/Getty Images.

P79: Photo © Ezra Stoller/Esto.

P80: Photos © Francis Sultana.

P81: Photo © Chris Floyd.

PP83–84: Illustrations © Mattia Bonetti/DACS.

P86: Photo © Michael Paul; Eggs, Boxes © Line Vautrin/Line Vautrin Estate/DACS; "Incroyables" Table Lamp, "Homage to Henry Moore" Fire Dogs © Mattia Bonetti/DACS; "Belgravia" Table Lamp, "Petit Trianon" Side Table, "Ring" Coffee Table © Garouste & Bonetti/DACS; Armchair © Emilio Terry; Art "Untitled" © Richard Prince.

P87: Photo © Chris Floyd; "Salome" Dining Table, "Boy", "Girl" Candlesticks © Garouste & Bonetti/DACS; Armchair © Emilio Terry; Vase © Constance Spry; Art "Infinity Net" © Yayoi Kusama.

P88: Photo © Michael Paul; "Emperor" Lamp © Garouste & Bonetti/DACS; "Rubber" Gold Side Table © Fredrikson Stallard; Sofas © Eugene Printz; Art "Bullet Hole" © Nate Lowman.

P89: Photo © Michael Paul; Porcelain Figures "Shit! Now I'm Going To Be Really Late" © Barnaby Barford; Vase © Grayson Perry; "Alu" Console © Mattia Bonetti/DACS; Eggs, Boxes © Line Vautrin/Line Vautrin Estate/DACS.

PP90–91: Photo © James McDonald. Eggs, Boxes © Line Vautrin/Line Vautrin Estate/DACS; "Incroyables" Lamp, "Homage to Henry Moore" Fire Dogs © Mattia Bonetti/DACS; "Belgravia" Table Lamp, "Petit Trianon" Side Table, "Ring" Coffee Table © Garouste & Bonetti/DACS; ; Armchair © Emilio Terry; Art "Untitled" © Richard Prince; "Tinkerbellend" © Dinos & Jake Chapman/DACS; "Pinocchio" © Paul McCarthy, Courtesy of Hauser & Wirth; "Untitled (Brown Brown Rub Mask)" © Mark Grotjahn.

P92: Photo © Manolo Yllera; Eggs, Boxes © Line Vautrin/Line Vautrin Estate/DACS; "Belgravia" Table Lamp, "Chewing Gum" Side Table, "Ring" Coffee Table © Garouste & Bonetti/DACS; "King Bonk" Armchair, Ottoman © Fredrikson Stallard; "Dune" Shelves © Zaha Hadid; Armchair © Emilio Terry; Art "Tinkerbellend" © Dinos & Jake Chapman/DACS; "Pinocchio", "Piccadilly Circus Tea Party Pink" © Paul McCarthy, Courtesy of Hauser & Wirth; "Infinity Net" © Yayoi Kusama; "Untitled" © Christopher Wool.

P93: Photo © James McDonald; "Polyhedral" Side Table © Mattia Bonetti/DACS; "Dune" Shelves © Zaha Hadid; Ceramic Figures © Barnaby Barford.

P94: Photo © Manolo Yllera; "Salome" Dining Table, "Boy", "Girl" Candlesticks © Garouste & Bonetti/DACS; Silver Vases © Richard Vallis; Vase © Constance Spry; Vases © Grayson Perry, Courtesy of Victoria Miro Gallery; Candelabra © André Dubreuil; Art "Untitled" © Josh Smith; "Untitled" © Richard Prince; "Cattail Melting in the Snow" © Ida Ekblad/DACS; Ceramics © Jean Cocteau Estate/DACS.

P95: Photo © Michael Paul; "Alu" Console, "Polyhedron" Side Table © Mattia Bonetti/DACS; Vase © Grayson Perry; Art "Pirate Drawing" © Paul McCarthy, Courtesy of Hauser & Wirth.

P96 & 97: Photo © Manolo Yllera.

P98: Photo © Michael Paul; Mirror © Oriel Harwood.

P99: Photo © Michael Paul; Mirror © Oriel Harwood.

P100: Photo © Simon Upton/Interior Archive.

P102: Photo © Simon Upton/Interior Archive; Radiator Cover © Michele Oka Doner.

P103: Photo © Simon Upton/Interior Archive; Art "Portable Ocean" © Rosemarie Trockel/DACS.

P104: Photo © Simon Upton/Interior Archive; Bin © Michele Oka Doner.

P105: Photo © Simon Upton/Interior Archive; Bench © Michele Oka Doner.

P106–107: Photos © Simon Upton/Interior Archive; "Chambers" Lamp, Table, Stool, Mirror, Carpet © Mattia Bonetti/DACS; Boxes © Line Vautrin/Line Vautrin Estate/DACS; Art "Untitled" 2003 © Christopher Wool.

P108-109: Photo © Simon Upton/Interior Archive; "Chambers" Lamps, Table, Stool, Mirror, Carpet © Mattia Bonetti/DACS; Art "Ovid Bather" © Chris Ofili; "Untitled" 2003 © Christopher Wool.

P110: Photo © Simon Upton/Interior Archive; "Bust" shelves © Sebastian Errazuriz; Eggs © Line Vautrin/Line Vautrin Estate/DACS; "Incroyables" Lamp © Mattia Bonetti/DACS; Head "Never Sleep with a Strawberry in Your Mouth" © Andro Wekua.

P111: Photo © Simon Upton/Interior Archive; Ceramics "Brown Eyed Girl" © Klara Kristalova/DACS.

PP112–113: Photo © Simon Upton/Interior Archive; "Chambers" Lamps,

CREDITS

CREDITS

ACKNOWLEDGMENTS

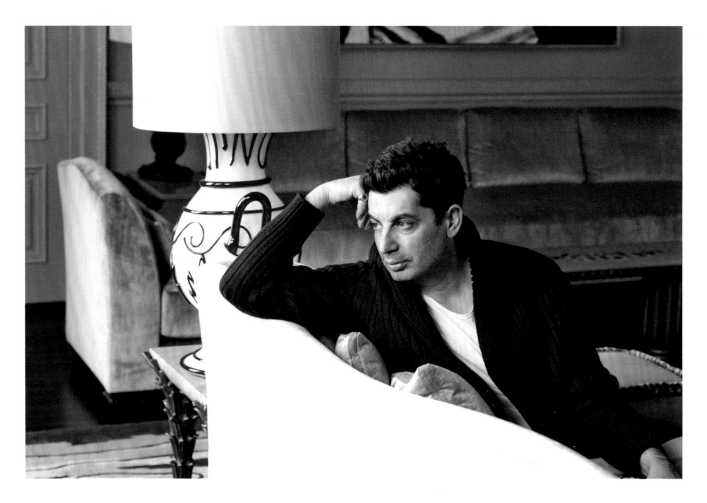

In loving memory of my dear mother Maria, and with deepest gratitude to David Gill, without whose love and support this book, and much more, would not have been possible.

Special thanks to Sarah Mathew, for her continuous support throughout the project; Giud Fabri and the team at Francis Sultana; the whole team at David Gill, especially Rachel Browne. I would also like to thank, for all their support over the years, Stephen & Luisella Barrow; Shaari Ergas; Pauline Karpidas; Panos & Elisabeth Karpidas; Manal & Murtaza Lakhani; Narmina & Javad Marandi; Stephen & Yana Peel; Ely Michel & Karen Ruimy; David & Anita Taylor; and Francesco & Celia Venturi.

All the artists, photographers and friends, whose works are featured in this book, especially: the late Zaha Hadid; Mattia Bonetti; Michele Oka Doner; Oriel Harwood; Ulrika Liljedahl; Grayson Perry and the Victoria Miro Gallery; Ian Stallard; Patrik Fredrikson; Barnaby Barford; Humberto and Fernando Campana; Elisabeth Garouste; Aldo Mondino; Grillo Demo; Paul McCarthy and Hauser & Wirth; Franz West; Ugo Rondinone; Berlinde de Bruyckere; Richard Prince and Gagosian Gallery; Kendell Geers; Chantal Joffe; Christopher Wool and Luhring Augustine; Nate Lowman; Giacinto Cerone; Dallas & Texas; Vanessa Beecroft; Mike Kelly; Don Brown; Francesco Clemente; Daniel Buren; Claude Lalanne; André Dubreuil; Edward Ruschka; Barbara Kruger; Josh Smith; Dinos & Jake Chapman; Mark Grotjahn; Yayoi Kusama; Ida Ekblad; Michelangelo Pistoletto; Stefan Shearer; Jason Rhoades; Eva Rothschild; Olafur Eliasson; Carroll Dunham; Martin Slivka; Simon Upton, Luke White and Karen Howes, Interior Archive; Esto; Getty Images; V&A Images; Historic England; Condé Nast; Bill Brandt Archive; Fulham Performance; Ricardo Labougle; Stephen Marwood; James Gifford-Mead; Luke White; Armin Weisheit; John Laurie; Michael Paul; Manolo Yllera and Cristina Giménez; Cuneyt Akeroglu; Brian Grech; Davide Lovatti; James McDonald; Chris Floyd; Jamie Kingham; Olivia Horsfall Turner; Antonia Deeson.

I would also like to thank the editorial, design and publishing team, including Bronwyn Cosgrave, Gianluca Longo, Brook Mason, Beatrice Vincenzini, Alexandra Black, David Shannon and Roger Barnard.

First published in 2019 by **The Vendome Press**
Vendome is a registered trademark of The Vendome Press, LLC.
www.vendomepress.com

NEW YORK
Suite 2043,
244 Fifth Avenue,
New York, NY 10011

LONDON
63 Edith Grove,
London,
UK, SW10 0LB

PUBLISHERS: Beatrice Vincenzini, Mark Magowan & Francesco Venturi.

ISBN: 978–0–86565–364–1
1 3 5 7 9 10 8 6 4 2

EDITED BY: Bronwyn Cosgrave
DESIGNED BY: Roger Barnard

Library of Congress Cataloging-in-Publication Data available upon request.

PRINTED IN ITALY